KU-763-217

ALSO BY MARK BRAUDE

The Invisible Emperor:
Napoleon on Elba from Exile to Escape

Making Monte Carlo:
A History of Speculation and Spectacle

Art, Love and Rivalry
in 1920s Paris

MARK BRAUDE

First published in Great Britain in 2022 by Two Roads
An Imprint of John Murray Press
An Hachette UK company

1

Copyright © Mark Braude 2022

The right of Mark Braude to be identified as the Author of the Work
has been asserted by him in accordance with the Copyright,
Designs and Patents Act 1988.

All rights reserved. No part of this publication may be reproduced,
stored in a retrieval system, or transmitted, in any form or by any means without
the prior written permission of the publisher, nor be otherwise circulated in any
form of binding or cover other than that in which it is published and without
a similar condition being imposed on the subsequent purchaser.

A CIP catalogue record for this title is available from the British Library

Hardback ISBN 978 1 529 30048 2
Trade Paperback ISBN 978 1 529 30049 9
eBook ISBN 978 1 529 30051 2

Typeset in Garamond Premier Pro

Printed and bound in Great Britain by Clays Ltd, Elcograf S.p.A.

John Murray policy is to use papers that are natural,
renewable and recyclable products and made from wood grown in sustainable
forests. The logging and manufacturing processes are expected to conform
to the environmental regulations of the country of origin.

Two Roads
Carmelite House
50 Victoria Embankment
London EC4Y 0DZ

www.tworoadsbooks.com

For Laura, Lucinda, and Eloise

The Armistice offered us influenza, inflation and loss. In such a seething epoch of personal tragedy, the only thing left in which we could believe was art.

—Bryher,
The Heart to Artemis (1962)

✚

People pay money to see others believe in themselves.

—Kim Gordon,
"I'm Really Scared When I Kill
in My Dreams" (1983)

CONTENTS

Prologue

THE JOCKEY,
SUMMER 1925, EVENING

KIKI'S NEVER SURE IF SHE'LL PERFORM, UNTIL SHE does. Sometimes she's not in the mood, says she's too drunk. It's different now that people come here to watch her, now that she stands in front instead of among them. They clang their cutlery and chant her name until she takes her place in the light and starts her slow-motion dance, no distance to lend her mystery, no stage to make her majestic, everyone sharing the same heat and smelling the same sweat.

She crafts her performances to suit the needs of their small society. She tells them stories about themselves they already know but want retold. Stories of orphanhood, widowhood, lovesickness, soul troubles, deceptions, gunshots, stories of ghosts, of sailors lost at sea. But also stories of pleasure, ingenuity, mischief, connection, of charming swindlers and sweet revenge, stories of good food and red wine, lucky cards and long-shot horses.

Her melodies are sweet and repetitive, music for organ grinders and dancing bears. She distorts her messages as she sends them, sways her head, runs a hand through her bobbed black hair, wrinkles her pointy nose, slumps her shoulders, fusses with her thin shawl, grinds her hips, flutters her hands. She knows when to purr, when to growl, is an expert in the well-placed sneer. She can be haughty, even cruel. But a warm bass note thrums throughout. She's carried along by joy. She tells the dejected they're worthy, only misunderstood. She promises

shelter to the misplaced and broken. She plays to the lie that village folk are simpler and so wiser than city folk.

She never strives for the sublime. Her voice is earthbound, she knows. If a singing voice could smell, hers would be garlic hitting a pan's hot butter and wine. And with her restricted range and lack of training comes the threat of disaster, though the anticipation of her fall only heightens the excitement when it fails to come. She hits her marks and stretches no further. She invites them to laugh with her and at her, so long as they keep laughing. She never blares. The city's noisy enough.

Unlike so many others performing to these kinds of small and discerning crowds across Paris, and in London and Berlin, she doesn't try to move like a machine. She moves like an animal, or many animals, impishly begging like a dog, or hunching her shoulders and raising her elbows to squawk like a bird, or stretching her mouth to bare her tiger's teeth. "A beautiful animal," as one who saw her put it, "wonderful like a deer."

Her words are ancient ones. Among so many would-be messengers from the future, she does no dealing in premonitions. Everyone's been told the best work neither stands still nor looks backward, which is why so much of their culture comes out half-baked under the pressure for so much fresh prophecy. But Kiki is older and slower than her time and place. Her songs don't run—they lilt. She reminds her audiences, in her various guises, how in this violent, money-mad world that makes no space for its Kikis, its Kikis have always found some way to make themselves feel at home.

Her friend Robert Desnos, half mystic poet, half junkyard gleaner, has helped to craft her persona as her sometime lyricist, digging through another generation's flotsam for scrap words to reinvigorate. Desnos who so loves music and sings so badly, who can recite Hugo and Baudelaire from memory and knows the plots of every *Fantômas* novel, who twists old jokes and bits of doggerel to speak to the problems at hand. Kiki can always find the sunken wreck beneath a song's placid surface. She takes pleasure in how certain words feel in her

throat, on her tongue, talking as much as singing. The words she and Desnos string together serve as shibboleths for the initiated.

Working the crowd is another friend, more like a sister, a dance instructor calling herself Thérèse Treize, a nickname coined by her sometime lover Desnos. She does acrobatic dances in front of Kiki as she sings, turning the performance into a kind of duet. And then she breaks from her dancing to go around with a hat taking collections, berating those she suspects of underpaying relative to their social station.

Kiki sings what has become her signature tune, an old folk song whose lyrics Desnos has reworked:

Every girl from Camaret swears she is a virgin
Every girl from Camaret swears she is a virgin
But when they're lying in my bed
They'd rather hold my little head
Than a candle for the Virgin

For this she has a candlestick she rhythmically swings. Next she sings about the man who, after a thug slices open his belly with a switchblade, stuffs his guts back into his body and patches himself together with tape while waiting for the ambulance.

The affection between Kiki and her most ardent watchers springs from the recognition of shared circumstances and the understanding that surviving them can be helped by striking several poses as needed: ironic, operatic, anarchic, tender, world-weary, sinister, excessive, fearless, threatening, bored. Kiki is no diva veiled in stardust, demanding submission. She will never *command* an audience. All she does is let her watchers imagine that by singing about her sins, she's hearing their confessions. Telling them that they too can live how she lives if only they could access her same supposed confidence. A lie but one they enjoy hearing.

To outsiders, come to observe the bohemian tribe at its ritual, she's an entertaining creature from the lower depths, a quick thrill before

returning home with reports of exotic fragrances, eerie sounds, and looming carnal violence. The tourists see only the sex and smoky eyes and miss the ceremony's sadness and solemnity. Again and again Kiki repeats her refrain to those who listen closely: that love is suffering, but suffering is beautiful so long as it's done with someone else.

They stand together in that tightness, the anthropologists and the initiates, everyone watching everyone else watching Kiki. Tonight at the Jockey they must feel as if they're standing at the white-hot center of the earth.

BUT HOW DID IT HAPPEN? Many of her watchers must have asked the question, thinking back, years later. How did it happen that this young woman, born poor, obscure, and illegitimate, who in her brief life barely made enough to eat, by singing old songs for tips, posing for the art of others, selling sketches to fellow drinkers spied from her barstool—how did it happen that this young woman should be the one to capture the spirit of their age like no one else, and by doing nothing more than making a performance of herself?

1

OLD SONGS SUNG FROM A MARBLE TABLETOP

THE MAN KIKI WAS TOLD WAS HER FATHER SOLD charcoal from his buggy. When making his deliveries, he announced himself by playing on a silver trumpet. The charcoal he made by tending bonfires deep in the forest beyond the village. She remembered him inviting her into the woods and her many refusals. She never knew if he meant to harm her or if he'd only wanted to embrace her, finally recognizing her as his daughter, someplace safe, away from the gaze of others.

She was born Alice Ernestine Prin on October 2, 1901 in Châtillon-sur-Seine, a village in Burgundy 150 miles southeast of Paris and 30 north of the source of the Seine. It was a place where life's rhythms flowed in concert with the duties of the land, as it did in most of France beyond the capital. Alice liked to tell of how, clamoring to be born, she'd forced her mother into a labor so fierce her mother had to lie down in the street, threatening to give birth on the sidewalk until someone carried her home. She said she arrived with the cord wound around her neck and was going purple until "fortune dictated" that she "be given the chance to live." She said she was named for an aunt whose own uncomfortable life had ended in reform school, dead at eighteen for reasons never known to her namesake.

Her mother, Marie Prin, was eighteen and poor. Her supposed father, Maxime Legros, was ten years older and a bit better off. They'd

seen one daughter stillborn and another reach only four months. They'd kept this third pregnancy secret for as long as they could. Maxime's parents opposed the relationship and later pressured him to marry a woman from another village deemed a better match than Marie. She brought a dowry of a thousand francs and a pig.

Alice joined five cousins born out of wedlock to her two aunts. All of them—three boys, Alice, and two girls—had been left to be raised by their grandmother, Geneviève Prin in her stone house on rue de la Charme. Marie went to Paris to work as a nurse at a maternity hospital, following the path of many unwed mothers sent to such institutions to escape their local scandals and, their guardians hoped, be reminded of the noise and blood waiting for them should they repeat their misdeeds.

From Paris, Marie sent home five francs a month. Grandmother Prin meanwhile took in the neighbors' cleaning and sewing. Grandfather Prin worked as a road hand, the first in generations of Prin men not to make his living herding sheep.

Twice weekly Alice and her cousins lined up before the Sisters of Charity of St. Vincent de Paul for helpings of vegetable broth and rice. Theirs wasn't an observant family, and the nuns dealt scorn with the soup. If Alice's mother was living it up in the big city with the rich folks, they would ask loudly, why was her girl standing in front of them hungry and in tatters? In a drawing she made of this memory, many years later, Alice placed herself as a skinny child at the end of a line of people waiting to be served by a nun rendered as a terrifying presence, three times the size of the villagers she feeds, her white *cornette* headdress spanning far beyond her broad shoulders. "You wouldn't believe what came out of the mouths of these representatives of God on earth!," she wrote later in her memoir; "those thin-lipped mouths, ravaged by all the bitterness and wickedness that poured from them."

Alice found happiness where she could. Pots of red beans made her happy. The bread soup they served when she went to kindergarten made her happy as well. But this was one of the few joys she found at the village's public school. She could tell the headmistress hated the

charity cases, with their tattered clothes and rickety legs, who were made to sit at the back of the classroom. The headmistress scratched at Alice hunting for lice with her sharp nails, even though Grandmother Prin had taken the precaution of cropping her hair like a boy's. If Alice fought against the scratching, it ended with her standing in a corner, nose pointed to the wall.

The other children adored her. Across from the schoolyard, she played at scaring them by walking on tiptoe along a low limestone wall running the edge of the Seine, a ten-foot drop below.

By the time she was ten, Alice spent most days away from school. She'd figured out no one could force her to go. Elementary school was by then compulsory across France, a bedrock of the modernizing mission to forge a national identity, which meant inculcating the peasantry with Republican values while trying to stem the influence of traditional folkways and "backward" local languages. For Alice, however, the rules went unenforced. "Grandmother often screamed at us," she wrote of growing up alongside her cousins, "but we always screamed louder." Neighbors chided Grandmother Prin for being too soft on her wards. She tried to fool them by smacking a broomstick against a table outside while her coconspirators wailed as if she were beating them blue.

Alice preferred life outdoors, where she could always find something to eat. After heavy rains, she would root out snails from freshly made crevasses and head off with mud-darkened fingers to find more in the cracks of old houses. She picked wild strawberries and mushrooms tasting of earth. And there were always dandelion roots that, when washed and separated from the leaves and stems, could be sold by the bowlful for making tea.

Among the cousins, Alice was the only one with a father still living. One day she heard one man telling another that a girl in the village was her half-sister, laughing as he remarked that the resemblance was obvious, since "one was just as ugly as the other." Alice and this other girl fought whenever they saw each other, as if by instinct. When the other girl threatened to tell her father about their fights, Alice answered that

she didn't care since he was her father, too. Grandmother Prin meanwhile told Alice that if she ever went to see her father, he would "kill" her "just like the others." Writing as an adult, she inferred this to be a reference to the two children that Marie and Maxime lost before her birth, whose deaths her grandmother somehow blamed on Maxime.

Another man, who Alice referred to in her writing only as her "godfather," helped to raise her. He collected the village trash in a horse-led dump truck. When he took his haul out for disposal in a faraway field, she rode along, digging among the rags and bottles, "playing Alice in Wonderland." After the job, they would stop at a bistro where she sneaked drops of Pernod from glasses not yet collected for washing while her godfather, who made moonshine, conducted some business. She would climb sometimes onto one of the marble tabletops to sing old drinking songs, belching out the well-worn rhymes with her licorice breath, after which she went around to be rewarded with coins and sips of wine.

ALICE WAS TWELVE WHEN her mother called her to Paris. With Grandmother Prin (her grandfather had died a few years earlier), she traveled the two hours to Troyes, where her aunt lived, and there was transferred to the care of a train conductor who put the crying girl in a first-class cabin hoping to calm her. When she unpacked her meal of pungent garlic sausage with red wine, whimpering for her grandmother between bites, she saw the woman across make a face as if someone had kicked her dog. Years later she could still summon the shame she felt there in the rumbling compartment, skinny and jaundiced, her crow-black hair spilling out in all directions from her blue beret with its pompom of red. She recalled crying all the way to Paris.

She loved the city the moment she stepped out from the Gare de l'Est and into its symphony of whistles, horns, and clacking hooves. As she and her mother mounted into one of the waiting horse-drawn

coaches, she asked her mother how long it took to wax the streets to make them so shiny.

But theirs was an unhappy reunion. Her mother was like a stranger, unseen aside from holidays when she'd whisked into the village laden with toys, pretty dresses, patent leather shoes, and other items from Paris meant to signal the middle-class respectability Marie so craved. She'd left her job at the hospital and was working as a linotypist at the Calmann-Lévy publishing house, preparing text to be set in molten lead. She lived at the edge of Montparnasse at 12, rue Dulac, the ugliest street in the neighborhood, sharing a ground-floor apartment with a man named Gaston, the foreman in charge of her linotype machine. The publishing house owned their apartment building, which made the rent manageable so long as they remained employees.

Marie sent Alice to a school, close by on rue de Vaugirard, to learn reading and numbers so she too could become a linotypist. She dreaded going back to a classroom and was embarrassed at being put in a class with kids five and six years younger than her. But there she discovered that alongside enjoying history—especially stories about Napoleon—she loved reading. Best were the pulpy *Fantômas* books, published monthly (thirty-two in all), each detailing the misadventures of the brilliant, occasionally murderous arch-villain Fantômas, the "genius of crime," forever escaping the Sûreté's Inspector Juve thanks to a revolving set of aliases. Each night Alice opened her window before getting into bed still dressed, ready for Fantômas to come get her. Her mother teased her for it, though Marie was also a secret *Fantômas* fan. But Alice knew he was coming to steal her away to wreak havoc on the sleeping city, their identities hidden behind domino masks and under capes as they dashed along the mansard roofs. It was Fantômas who initiated Alice into the power and pleasure of an effective disguise.

Marie pulled Alice out of school after a few months. She was thirteen and legal to work a factory job. "I know how to read, count—that's it!" she wrote in her memoir. She worked as a knitter's apprentice, a

bottle cleaner, and a bookbinder's apprentice, this last job offering the added excitement of exposing her to books she never would have seen at home, such as the Kama Sutra, whose pictures produced "a feeling between my thighs like the movements of a fluttering bird struggling to fly." And then with what was not yet called the Great War under way, she worked at disinfecting and oiling dead soldiers' boots before they went back into rotation, and at repairing fabric for observation balloons, and at soldering military equipment. Alice's earnings were vital to the household. They helped her mother feel less dependent on Gaston. Marie earned just enough to hover at the poverty level. The average Frenchwoman's salary, 2.25 francs a day for ten hours' work, was then a third of the average man's. Alice ate many of her lunches at the local soup kitchen, where they served a watery lentil soup that people joked had more pebbles than lentils.

Saturdays Alice and her mother helped some friends, the Guinoiseau family, run their flower stall in the open-air market on rue Mouffetard in the Latin Quarter. The eldest Guinoiseau daughter, a tall girl with brilliant blond hair, worked alongside Alice as they tried to make the withered low-quality irises and lilies look sellable, propping up broken stems with a bit of matchstick, and adding a touch of rosewater to old roses. (She recalled no great outrages over their deceptions but also that the stall didn't get a lot of repeat customers.) Admiring the Guinoiseau girl's fine hands, Alice wondered if she wasn't a secret princess in exile. They would play at making themselves up like *gitanes*, oiling their hair and plastering down their kiss-curls, whirling combs adorned with brass charms and many-colored stones to mimic the untamed Carmen who'd seduced an older generation a world away across the Seine amid the gold and velvet of the Opéra-Comique.

After their shifts, their mothers let them go unsupervised to the flea market at the city's southern outskirts to rummage for clothes. They shared meals of fried potatoes with white wine before heading back into Montparnasse to the movie house. There Alice would rub a stolen flower petal on her lips and cheeks before meeting Dédé, who must have been nineteen or twenty. She figured his wife supported

him since he never mentioned any kind of job, until the night he got caught trying to rob a shoestore, which only heightened his appeal to a teenaged devotee of Fantômas. Her time with Dédé came to an end when her mother discovered purplish blotches on her neck.

A FEW YEARS INTO the Great War, Alice was sent to live with her aunt Laure in Troyes. The mill there paid three times what she could earn in Paris. She liked her aunt, who looked to her like a policeman shrunken down a couple sizes and given the body of a woman. A big eater and a bigger drinker, reeking of snuff and always barking orders. She was generous with what little she had. She rented a two-bedroom house at the edge of town. Alice shared a bed with her thirteen-year-old cousin Madeleine, who she called sister. Aunt Laure slept with her oldest daughter, Eugénie, while Eugénie's baby, whose father had been killed in the war, lay between them. Alice would remember her time in Troyes as a happy one. She and Madeleine had come up together under Grandmother Prin until both turned twelve and were returned to their respective mothers. Now the two of them walked together to the mill as if they were grown-ups, rushing home on their lunch break for black coffee and herring. At dinners, Kiki would hide some of her meal to give later to Madeleine, who never got enough to eat since Aunt Laure thought that Eugénie, older and prettier than Madeleine, would make better use of the calories. But three months in, Alice hurt her foot. No more spinning. She was sent back to Paris in early 1916.

Her mother had split from her foreman by then and was living with a soldier named Noël Delecoeuillerie, who had returned from the front with an injury and was pretending to be her boarder for the sake of appearances. Alice heard them at night and wondered at the sounds. Noël was eleven years Marie's junior, closer in age to Alice. The apartment was tight. Marie decided it was time for Alice to leave.

She arranged a job for Alice in a bakery on Place Saint-Charles, just south of the Eiffel Tower. Alice got thirty francs a month and a room with the elderly couple who owned the bakery. She was up at first light

to serve the laborers who came for the morning bake, then went out for deliveries, came back to sift flour, went out again to buy supplies before running back to bring the last batch from the oven, the assistant baker leaning into her the whole time, stripping down in the heat to show her his prick, telling her she would "never see one so beautiful." Evenings she cooked and cleaned for the owners.

Nights were hers. She liked to look out on the lamp-lit square outside her window where couples met up on the benches. Watching their indiscretions would set her off. She was scared by how much she enjoyed her pleasure, how eager she was to know about bodies and what they could do. "Two or three times a day, I'd have to go off somewhere to be alone," she wrote. One night she invited a boy, "small, stocky, and mean-looking," to the bakery's backroom. He went to embrace her, but that frightened her, and she told him to stop.

She dreamed of falling in love with a poet, painter, or actor. She felt something big was going to happen to her. Badly educated country girls weren't meant for big lives, she knew, but she was hungry to see people and places. "I wanted to run away. But where was I going to go without money?" Still, she loved Paris deeply, even as she longed for Châtillon-sur-Seine and her grandmother's affection. Alice saw that her future lay in the capital, much as it hurt to turn her back on her first home.

Mostly she felt tired. She could never get enough sleep. And then one day she punched the baker's wife. She'd blackened her eyebrows with burnt matches, and the older woman, seeing her in makeup, called her a "little tart," so she hit her. The assistant baker had to pull them apart. Afterward, under his breath, he told Alice that she threw a great punch.

THE BAKER AND HIS WIFE refused to give Alice her final month's pay. She drifted from place to place, staying with friends, looking for another job. She ran into one of the bakery's regulars who'd always had an eye for her. A sculptor, he wore a huge beret. She never saw

him without the silver-tipped cane she mistakenly took as a sign of enormous wealth. She told him her story. He said if she needed money she could pose for him. He kept a studio a few steps from where her mother lived.

She'd never stood naked in front of a man before. She wasn't too concerned about this one, with his paunch and his silvery beard. She figured he was too old to do her any harm. She arrived at the Impasse Ronsin, a hive of artists' studios and workshops tucked away in a tiny oasis of a dead-end street overgrown with vines, where one heard song-birds, pigeons, cats, dogs, and the chickens that one of the other artists living there, the Romanian sculptor Constantin Brancusi, sometimes tempted into his kitchen so he could cook them for dinner. The place had earned the nickname Crime Alley for a double murder commit-ted there in 1908: the victims were the popular French miniaturist Adolphe Steinheil and his mother-in-law, the alleged murderer the painter's wife, Marguerite. Acquitted after a sensational trial, she was already notorious across France as the mistress of the late president Félix Faure, who'd reportedly died while in office—in his office—from a seizure suffered as they were having sex.

At first Alice felt anxious, "shivering as much from fear as from cold," as she wrote, and was shocked when the sculptor put a measur-ing compass to her thighs. But she found she liked the work, being captured in clay. It was simple enough, sitting, standing, lying there, becoming another version of yourself while someone watched. Out-side people were sweating, screaming at each other, chopping up meat, packing crates and unpacking them, running over the river to catch some early tram or motor bus. In the studio, all you had to do was be still and breathe. Who said work had to be hard? It was more exciting than running around with baguettes or pouring cream for the *gâteaux basques*. And for their three-hour session, he paid her as much as she made in a week at the bakery.

She posed for him three times. "My first contact with art!" as she described it in her memoir. But then a neighbor spotted her walking into Crime Alley, headed for the fourth session, and an hour later

Marie came banging on the sculptor's door, accusing him of corrupt-
ing her daughter and threatening to call the police. She pulled Alice
out into the street and hit her, called her a "miserable whore," and
screamed that she no longer had a daughter.

Hearing the words, Alice felt no surprise, only calm, understand-
ing that whatever last threads had tied them together were torn. They
would find other people to love.

SHE'D JUST TURNED SIXTEEN. She found occasional work posing
for other artists, knocking on studio doors, but not enough to keep her
going. Finally, like so many other Frenchwomen supporting the war
effort in industrial settings and enjoying the measured liberation that
came with their new circumstances, she landed a factory job in Saint-
Ouen, one of the northern suburbs. She found a cheap apartment, pre-
ferring to stay in Montparnasse despite the long commute.

At the outset of the Great War in the summer of 1914, the French
president Raymond Poincaré had called on the nation's citizens to
show their resilience against the enemy as a "sacred union" (*union
sacrée*). The first heady weeks were followed by terror at the sight of
Germans encroaching on the capital, then jubilation when they were
repelled in the "Miracle of the Marne," when the city's taxi drivers
shuttled troops to key positions (while charging full fare). Parisians
then tried to settle into something resembling normalcy. An impos-
sible task in the face of intermittent bombing raids from Taubes and
Zeppelins, which tore craters through the Tuileries Garden and just
missed Notre-Dame cathedral, whose stained-glass windows had been
removed and stored, replaced by panes of washed-out yellow. People
struggled to sort through the swirling rumors of imminent defeat,
and false stories in the press about German guns firing blanks and
German troops surrendering in exchange for a single slice of French
bread and butter. There were scattered reports of mutinies from both
sides of the front. There were mass strikes and shortages of food and
fuel. Wide boulevards once neatly lined with chestnuts looked ragged,

as swaths of trees were felled for firewood. And yet while more than twelve thousand square miles of France would be destroyed in some way during those years, Paris managed to escape massive physical damage. The war's most immediate wreckage in the city was psychological. People across the social spectrum were made to understand how tightly they were all held together by the same vise of history, how quickly and completely their lives could be broken by events far away and people they would never meet.

The war pushed and pulled at Alice just as it did everyone else. She woke often to air raid sirens, marching down with the building's other tenants to the black basement. One day she went to work to find that her factory's owner had to fire the unmarried female employees to free up spaces for women with children, or with husbands who were serving.

Alice had no savings and could no longer afford her rent. One night she stood hungry and alone, admiring the exquisite window display of a store, the falling snow having ruined her hair. She heard a man approaching from behind, offering to treat her to hot chocolate in his studio. She would remember being attracted both by the chocolate and by the hint of adventure in the word *studio,* which "made me think: artist." Robert was tall, thin, and angry and was indeed an artist, or rather he sometimes painted watercolors, but never sold any. He showed little interest in Alice once she'd moved in. He mostly used her for the money she earned from her occasional posing.

One evening, after modeling for someone who'd stiffed her for the day's work, she was crying on a bench, worried about coming home empty-handed, when an old man approached and said he would pay her three francs to show him her breasts, motioning to a spot behind the train station. She was hungry and worried about Robert's hunger, too. She cried on the way home. But as soon as she entered their studio, showing Robert the bread and cheese she'd bought with the old man's money, and seeing his expression, she "no longer had any regrets.... You'd have thought I was the sun, the way that empty-bellied man's fevered eyes lit up at the sight of me." They ate and drank, and he took

down his guitar and played. "Life was beautiful," she wrote. "Robert was beautiful playing the only two chords he knew. He was beautiful being ugly. I felt perfectly happy. . . . I sang and sang."

They didn't sleep together. Robert blamed her. One night he brought two women back from a café and had sex with them while Alice was in the bed beside them, telling her to watch, to show her how easy it was. She wrote that as deeply as it wounded her and as jealous as it made her, she refused to show any reaction. She wondered if her pain was just how it felt to be in love. (She would title her memoir's chapter about Robert "Is This Love?") Following that episode came an even harder period when she struggled to find any posing work, and they had so little money they went days without eating. Robert tried to put her out, taking her across town to rue Saint-Denis, well known for prostitution, and ordering her to go with the first American soldier she saw. She refused and survived his violence. "He beat me and yelled that I was 'good for nothing!'" she wrote.

And then one day Robert kicked her out without explanation and headed for Brittany with a friend. Alice wandered the city in a daze for weeks, sleeping in Robert's friend's studio. Eventually she moved in with a dancer she knew. She gave Alice a "Ninon" cut, styling her hair in long ringlets after the look of a famed French courtesan. Next she moved in with a painter who worked in an airplane factory and got her a job as a riveter. After getting her first pay, she found an apartment on the corner of rue de Vaugirard and boulevard du Montparnasse. It stank of mushrooms and mold, and the dramas of the pimps and prostitutes who were her neighbors kept her up. She got a brief taste of luxury during a short-lived affair with a Brazilian diplomat she met, who was notorious for the orgies he hosted in his villa west of the city. He or another admirer introduced her to cocaine. "It made me happy right away."

One night, wearing only an overcoat, she staggered to a nearby public assistance hospital complaining of a heart attack. She swore that a rival had slipped something into her drink. The on-duty nurse told her to stop taking cocaine. They kept her for four nights. The nurses

treated her roughly. She heard the wailing of unseen patients who shared the large hall where they placed her. She was horrified when the nurses mocked an elderly patient who'd wet herself before she could ask for a bedpan.

After they let Alice out, diagnosed with an untreatable "problem of the nerves," she suffered waking nightmares and fantasized about hurting strangers she passed on the street. At first it felt like she had a raging devil shut up inside her. And then the anger subsided as she felt herself disappearing into depression. She compared the feeling to wanting badly to dance but being unable to move. She got hold of some arsenic but, as she told an interviewer years later, "didn't have the courage to swallow it." She said that staring at the vial of poison in her hand was what saved her. "I knew then I would make it through." Gradually she started to feel lighter.

SEEKING MORE MODELING WORK, Alice set her sights on the Café de la Rotonde. Though its ornate facade belied a shabby sawdust-floored interior, the local artists prized it for its warmth in the cold months, for its wraparound terrace (nicknamed "Raspail Beach") in the warm ones, and because the owner, Victor "Papa" Libion, genuinely enjoyed their presence among the laborers, drivers, hawkers, and washerwomen who made up his regulars. Artists went there looking for models and models for artists, each side wagering something on the other's future. But you couldn't just walk in and announce yourself as one or the other and be taken seriously. Unspoken codes of conduct dictated who could be granted a place in the order and when.

The Rotonde occupied the northeastern corner of the carrefour Vavin, a wide crossroads dominated by two tree-lined arteries bisecting the heart of Montparnasse: boulevard Raspail, spanning much of the Left Bank, running south to the Parc Montsouris and the suburbs, and boulevard du Montparnasse, running northwest by southeast past the Luxembourg Garden and toward Les Invalides, Napoleon's resting place. So much modern art and literature could be traced in one way or

another to the cafés clustered around this crossroads that the novelist Henry Miller deemed it "the navel of the world."

The varied clientele of these cafés reflected the recent history of this mostly residential, largely working-class neighborhood. Montparnasse had started attracting artists as early as the turn of the nineteenth century. They came initially for the low-rent workspaces, many of them located on the ground floor and big enough to accommodate the creation of large-scale works, and because Montparnasse lay fairly close to the Parisian campus of the national École des Beaux-Arts, a half-hour's walk north. For centuries, the Beaux-Arts academy had trained and minted "master" artists, promoting its progeny across France and beyond in a lucrative operation reliant on long-standing traditions and networks of influence, which bred a conservatism among its teachers and students. A few smaller schools opened in Montparnasse in the late nineteenth and early twentieth century to offer an alternative. Schools like the Académie Colarossi and the Académie de la Grande Chaumière fostered an independent spirit that spread from the classroom to the neighborhood, but slowly. Many among the first influx of students at these academies were lured from abroad by France's reputation as a leader in the arts, and they took their vocations seriously. They spent more time training than they did lounging on café terraces. It was across the city in Montmartre, birthplace of Impressionism, where café life flourished most intensely.

In the years before the Great War, Montparnasse started pulling in a new generation of artists. They were still seeking cheap studios, but fewer of them had connections to any of the academies. Cafés started popping up around the neighborhood. Entrepreneurial art dealers opened galleries in modest spaces, mostly around rue de Seine. Developers built blocks of studios, quickly and on the cheap, to meet demand. The best known was La Ruche (The Hive), where Alice sometimes found work. A round three-story building at 2, passage Dantzig, originally built as the British India pavilion for the 1900 world's fair, it looked like a beehive. Alfred Boucher, a sculptor who'd come into some money, wanted to help his fellow artists and had converted the

pavilion into studios radiating out from a central staircase so that each was shaped like a wedge of pie, their fat ends dominated by tall windows. Small huts went up haphazardly around the central structure. The chaotic atmosphere extended to the management of the rentals, so that La Ruche functioned almost like social housing. The Hungarian sculptor Joseph Csáky recalled paying the first installment of a year's rent when he moved in and then never being asked for anything more, as if he'd been forgotten about.

By the 1910s, some of the Montmartre-based artists were relocating to Montparnasse, as their neighborhood filled with tourists and gaudy cafés. Leading the charge, as he did in so many other realms, was Pablo Picasso. In 1912 he moved to a newly constructed apartment building on the edge of the Montparnasse cemetery. (In 1918, after getting married, he returned to the Right Bank.) While Picasso's move set a very public precedent, the poet and artist Jean Cocteau suggested that Montparnasse's usurping Montmartre as the city's new hub for artistic experimentation happened organically. To Cocteau, certain districts simply emerged at different times for no clear reason, as if a group of people had collectively decided to reach toward the light of art and escape the drudgery of their lives.

Foreign artists, too, started looking at Montparnasse as the place to go to learn their craft and be taken seriously by dealers, buyers, and critics. Among the artists pining for Paris was the expressionist painter Chaïm Soutine, who grew up in the mostly Jewish village of Smilovitchi near Minsk. He'd read so many letters from artist-friends who'd left their own villages for Montparnasse, gushing over its Café de la Rotonde, that when Soutine emigrated in 1913 he walked three miles, luggage in hand, straight from the station to the Rotonde. Paris— sophisticated, cosmopolitan, modern, holding the potential for untold riches—functioned as a mythical site in the imaginations of many central and eastern European Jews, artists or not. Many would have heard the old Yiddish saying *Azoy gliklich wi a yid in Paris* (Happy as a Jew in Paris). Soutine had nothing on another eastern European when it came to walking: Brancusi first arrived in Paris after walking there

from Romania on an eighteen-month trek. He settled in Montparnasse in 1908.

Parisians in Alice's time called Montparnasse "the Quarter," as though it stood alone and absent of rivals, a district so distinct it required no other designation. And the Quarter did operate as a kind of special zone, where policemen tended to overlook infractions, satisfied to watch the mess of bohemia unfold unmolested so long as no one did anything too violent. Generations of French functionaries had been trained in an environment of official admiration and even respect for artists, which served the national interest by bolstering French notions of cultural superiority. And these functionaries came of age in a society largely swayed by the notion that artists had by their nature to live nontraditional and unfettered lives.

By the 1920s the idea of "bohemia"—named for the spiritual homeland of the Roma people, synonymous in the popular imagination with freedom from responsibility—as a separate world operating by its own rules was commonplace. So was the equation of bohemianism with the life of the artist, and vice versa. Officials recognized that enclaves such as Montparnasse served practical functions, both as pleasure zones, to which the rest of the city could come to release the pressures of their daily lives, and as informal testing grounds, in which people could make sense of their unstable identities amid sweeping social changes that promised greater personal freedoms. Places like Montparnasse clarified class and cultural boundaries by letting people, especially middle-class Parisians, experiment with breaking the rules so that they could ultimately be reminded that most of them were not rule breakers and were unwilling to pay the costs of living a truly free life. The Quarter, as an idea, never threatened to infect the rest of the city. And so while life in Montparnasse was far from orderly, a certain kind of order prevailed. Troubles were kept inside the magic circle.

As in much of Paris, navigating Montparnasse meant weaving among a dizzying mix of wide boulevards and smaller streets, some running with just enough sense to let you picture a grid as you walked, but not quite, others crisscrossing at forty-five-degree angles, and still

others dead-ending abruptly. The neighborhood's two visual anchors, the cemetery and the train station, were plain and utilitarian. On gray days especially, the neighborhood broadcast a heavy gothic gloom. Its gaudy thoroughfare of pleasure, rue de la Gaîté, surely inspired as much depression as it did gaiety among those who walked it. But Montparnasse's squalor had its value, offering relief from the oppressive beauty put out by so much of Paris, and scaring off all but the most risk-loving speculators, along with most among the initial trickle of postwar tourists.

The Quarter's denizens, the *Montparnos,* were an endlessly and happily self-regarding tribe. And yet this provincialism was paired with what Cocteau called "international patriotism," the dream of living "unencumbered by political, social, or national problems of any kind"—even as everyone knew there would have been no Quarter without the flow of ambitious, artistic, and overly intelligent youth from Livorno, Stockholm, Tokyo, Toronto, Málaga, Minsk, and so many other places to feed it, nor the very real and often violent "national problems" that unyoked those lives and put them into motion.

Those newcomers to Montparnasse were only drops in a wave of close to three million immigrants who would move to Paris in the 1920s. Contrary to the French myth of "color-blindness" stemming from the nation's universalist values, the French people could be as xenophobic as anyone. France's colonial policies were as cruel as those of any other colonial power. Still most Parisians, whatever their own private hatreds might have been, recognized how badly they needed foreign labor, ideas, and capital to revitalize the city, which had suffered neglect as so many of its resources were channeled toward making war. The city would see isolated attacks targeting immigrants, especially in the second half of the decade as the value of the franc dropped precipitously and the right-wing press stoked fears of an invasion by foreigners, with much teeth-gnashing directed at Jews coming from eastern Europe. But foreigners were mostly tolerated, and the artistic and intellectual communities of Montparnasse more often welcomed them. The neighborhood also had a vital and relatively open

gay and lesbian presence, with the prevailing attitude best expressed by Gertrude Stein: "I like all the people who produce and Alice [B. Toklas, whom Stein called her wife] does too and what they do in bed is their own business and what we do is not theirs."

While the Quarter was hardly devoid of tension or violence, people who would have been shunned as outsiders in most other places felt free there to conduct themselves as they wanted, although they experienced such feelings unequally across lines of class, race, gender, and sexual identity. That one of the great cultural flowerings of the twentieth century took place in an environment that was global in its makeup and progressive in its outlook, and where people felt unencumbered by the weight of a shared history, was hardly a coincidence. The expansion of worldviews in Montparnasse fostered new ways of thinking about human relations and how to explore them in one's work. Marcel Duchamp suggested that the Montparnasse community constituted "the first really international group of artists we ever had," and that it was precisely this "internationalism," and its resulting sense of openness and possibility, that made it superior to any of the century's other artistic hubs.

For Alice, the most direct route into Montparnasse's social world was through the backroom of the Rotonde, where the neighborhood luminaries gathered. But to get there, you first had to charm "Papa" Libion, who let his favored artists treat the space as if it were their office. There they collected mail, arranged loans, and handled other transactions. They lined up, especially in the colder months, to scrub themselves in the Rotonde's washroom. To Libion, this was all just "good business," as he put it. "Artists and intellectuals don't have much money, but when they do, they spend it." Libion was known to extend credit until debts grew embarrassingly large, and then he might still take a painting in lieu of cash. He had no problem with drug use, refused to call the police for a fight he could break up himself, and threw out drunks only when he had to. And if he yelled at someone caught ripping a chunk from the long loaves he kept by the bar, everyone knew his threats were for show. Aware of how many of

his drinkers came from elsewhere, he subscribed to the major foreign newspapers, an attraction worth advertising in bold letters on the Rotonde's canopy.

But he didn't like Alice. She wore filthy clothes and a cheap hat, which might have contributed to his aversion. Most likely it was simply that Libion didn't yet know her and was protective of his backroom regulars. He was fine with Alice sitting in the front like anybody else, but let her go no further. "I would have put my ass on my head to get into that room," wrote Alice later, using a bit of country slang. Instead she spent days at the long wooden bar watching them pass by, the painters and models everyone knew by sight. Aïcha Goblet, so stately in her green turban, said to hail from Martinique (in truth from the North of France), a former bareback circus rider, presided as their unofficial queen. They sat around marble-topped tables drinking, smoking, laughing, gossiping. Arguing, above all—about the war, books, Communism, the genius of Charlie Chaplin, the small and large failings of a rival's latest performance. To Alice, they seemed always to be plotting some kind of revolution.

The backroom offered the Rotonde's only washroom, another major attraction for Alice. At that time she was cycling through various friends who would put her up for a night or two, and she wasn't always sure when her next chance to clean up would come. Some nights, if the weather was fine, she would let herself into a storage hut behind the train station, belonging to a friend's rich uncle. She would pile sandbags to make a bed. The lights from the station shined in her eyes all night but made her feel safe.

To pass time at the Rotonde and pay for her coffees, Alice would pick someone out, watch them closely, and draw. She sometimes sold her pictures, most often to soldiers and tourists, by approaching a subject with a finished portrait in hand and asking if they wanted to buy it. She wrote, "I'm not a great artist but I know how to keep track of how much wine someone's had and how much they've been spending on cigarettes. The portraits might not have been spitting images, but they were easy to do, and I pocketed ten cents for each one." She was

a better illustrator than she claimed. She drew as she spoke, in lines that were barbed and ironic and warm and tenderhearted all at once. Along with her portraits, she also sketched and sold images inspired by the French writer Henri Murger's 1848 book *Scènes de la vie de bohème* (Scenes of Bohemian Life), a series of episodes tracing romanticized versions of the lives of his friends. Alice specialized in drawing nineteenth-century *grisettes,* independent women, usually from working-class backgrounds and often working as artists' models, who entered into liaisons as they wished, seeking love, money, social capital, or all three.

Libion got used to seeing Alice around. She was always ready to tell an off-color story or show a funny picture. It got to the point where Libion could hardly look at her without laughing. One day he said to her, "For god's sake, why don't you just get yourself a decent hat already?" letting the two of them pretend that Alice's clothing, rather than Libion's initial snap judgment of her character, had been the only thing keeping her from the backroom. She found some lace fabric samples in a dumpster and cut them up to work into shirts. She fashioned a hat, trimming it in tinsel like a Christmas tree. Eventually Libion let her go to the backroom. She made friends with some of the staff. The cook would warm a pot of water that Alice lugged to the bathroom so she could wash herself in one sink while the bathroom attendant washed her clothes for her in the other. They caught up on the neighborhood gossip as the clothes dried on the radiator. "When you went to the Rotonde it was like coming home," wrote Alice. "You were with your family."

IN THE LAST YEAR of the Great War, Alice fell in love with a painter named Maurice (Moishe) Mendjizky, who lived at La Ruche and was popular at the Rotonde. Libion had once let him have an informal exhibit on the café's walls, the first time such an honor was ever extended, and one of the few times Mendjizky showed his work in public. Alice had recently battled the Spanish flu, as it was then

called, and was feeling "sad, desperate, and lonely," when she met him. He was Jewish, Polish, thin, and alluring with wise, laughing eyes and twenty-eight to her seventeen. He'd come to Paris in 1906 to train at the École des Beaux-Arts, but his studies were interrupted by the call of the Imperial Russian Army and then by war, injury, and a long recuperation during which he stayed in the same hospital bed for two years. Now back in Paris, he put little effort into selling his work and wavered between painting and composing music, studying for a time under a disciple of the French composer Hector Berlioz. Alice admired his paintings and thought they had some of the best qualities of Cézanne's work with their tight brushstrokes, warm colors, and dense shading.

Mendjizky first painted Alice in 1919, when she still had long hair, and before they'd grown to know each other intimately. For whatever reason, the painting fell well short of his other work from the time. It was a listless profile that looked as though done by a stiff academic painter from the previous century, the subject posed at an unimaginative ninety-degree angle and unremarkable save for her large and pointed nose. This is the first known painting of Alice Prin.

Mendjizky started calling Alice "Kiki," which stuck only because they liked how it sounded, two quick breaths pushed with clenched tongue through bared teeth. It was a fairly common nickname for women as well as men. People used *kiki* as a bit of slang to describe all sorts of things: chicken giblets; someone's neck (usually strangled or hanged); a cock's crow; having a chat; having sex. Prostitutes used *kiki* as a catchall word for client, like the use of *john* in English.

Kiki and Mendjizky took an apartment together in Montparnasse halfway between the train station and the cemetery, early in 1919. Aside from a few quiet streets where grass still grew through the cobblestones, the neighborhood was changing quickly. Montparnasse was gaining hulking concrete apartment blocks and parking garages boasting space for two hundred cars. And yet while modernizing, it remained a patchwork of small-time operations.

Kiki would live with Mendjizky for three or four years. She

described him as her first "true love" and her first mutually satisfying sexual experience. Over those years, Mendjizky painted her with great care and little ambition. Besides the first portrait, five oils survive, as well as a pen-and-ink sketch, all done between 1919 and 1921. The finest among them is *Kiki* (1921), one of the oils, a frontal portrait in which she looks dangerously chic in a green cloche hat and matching dress, with a hint of white lace peeking out from the low neckline, emphasizing Kiki's long neck, which earned her the second nickname "Gazelle" among her friends. The portrait also reveals Mendjizky's struggle to escape his influences. Kiki holds in one hand, resting on her lap, a tempting apple that could have been lifted straight from a Cézanne still life. And Amedeo Modigliani has left his trace in Mendjizky's semiabstract rendering of Kiki's eyes, all dark pupils and mystery.

Kiki credited another painter, Kisling, as the one to "discover" her. Kisling, who'd grown up in the Jewish ghetto in Kraków, had arrived in Paris in 1910, a teenager speaking no French, hoping to study at the École des Beaux-Arts but lacking the funds. He sometimes slept rough, went days without eating, and fell in with the crowd at the Rotonde. At the war's outbreak, he numbered among the many foreigners living in France who enlisted in the Foreign Legion, which earned him a night of the best champagne from Papa Libion. In battle, Kisling suffered a chest wound from an exploding shell. He was just back from a convalescence in Saint-Tropez when Kiki first saw him at the Rotonde. He wore loose overalls on his broad, bullish frame, and metal bangles around his wrists, looking as if he'd just come from the beach, a style just starting to come into vogue.

By Kiki's account, the first words she heard from Kisling were, "Tell me, Papa Libion, who's the new whore?" motioning at Kiki as if there had been a changing of the guard while he was gone. Then he spoke to her: "Come on, kid, join us for a drink." Always a reckless spender, he was treating a table of friends to champagne. Kiki, feeling somewhat intimidated, decided to go over, and they traded a few mocking insults, with Kiki at one point calling him a "syphilitic old bitch,"

which seemed to bring him immense pleasure. By night's end, she'd booked a three-month engagement to pose for him exclusively. Kisling was highly possessive of the models he worked with, demanding exclusivity for extended stretches of time and that they make themselves available at all hours, as he liked to paint them again and again until he found the composition that pleased him most.

Many in Montparnasse suspected that Kisling would one day rank among the greatest painters of the era. Cocteau thought him an absolutely "pure painter," while Picasso, not generally effusive with praise for his contemporaries, also numbered among his early admirers and sometimes exchanged paintings with him, knowing that Kisling could sell them if he hit hard times. Kisling didn't seek to create any great rupture in the theory or practice of art. His gifts lay in how finely he handled color and light, and the clarity of his vision, one "charged with a profound awareness and meaning," as his friend the avant-garde writer Antonin Artaud said of him.

Kiki wrote of being a poor model in those days, always laughing and breaking pose. She helped herself to soap, toothpaste, cheese, and other useful things. She traipsed around the studio barefoot, forcing Kisling to paint around the fact of her dirty feet. (She preferred to be shoeless whenever possible.) He had her lounge on a low-slung table fitted with casters, which he slowly spun, turning Kiki as he wanted her in the changing light. Whenever she looked like she was getting bored, Kisling would tell her that her nose was losing its pointiness. She made him laugh by imitating opera singers. He enjoyed her voice. Then they might compete to see who could make the loudest fart. She liked his cowboy shirts, which he wore to look like his fashion idol Tom Mix, America's first western film star. Kiki and Kisling could have passed for brother and sister. For a while, they sported identical short haircuts, with bangs flopping down to their eyebrows. Further complicating matters was that Kisling sometimes went by Kiki, too, which led them to argue over which of them held the nickname's rightful claim.

Getting along was a bonus to their main transaction. Kisling no

doubt saw some special quality in Kiki, felt her unusual energy, and hoped that through her he could, when staking his claim in the grand gallery of images, offer something wholly new. While on the surface Kiki never took any modeling session too seriously, she clearly understood her appeal, and was proud of her body. "I can say without bragging that I have splendid breasts," she wrote. "Small as I am, I have breasts shaped like funnels, white with small, pink tips and pretty blue veins running through them."

For all the merrymaking they enjoyed in the studio, Kisling imbued Kiki with the melancholy he gave to all his female portrait sitters, none of whom smile and all having big, sad eyes. He presented Kiki as a gothic vamp, hair sleek, makeup heavy, contrasting the pallor of her chest with a low-cut black dress, and enlarging her eyes to such proportions that they became at once haunting and cartoonish, emphasizing their black rims, which Kiki achieved with kohl. In *Kiki* (1920), he painted her gazing somberly at the viewer, slumped in her seat, chin resting on her hand, her long fingers drumming on her cheek, seductive and menacing at once. When a Parisian magazine ran a piece consisting of answers to the question "What do you think of Kisling?"—"my best client," said Libion; "a sheep disguised as a wolf, but what a good painter," said the Swedish writer Thora Dardel—Kiki gave the slyest answer of all: "I have to whisper it in your ear."

Lucky for Kiki, Kisling had a lot of friends, many of them numbering among a motley group of artists, as well as some dealers and collectors, whom the French critic André Warnod would dub "The School of Paris." They were united not through their formal similarity but by a shared sensibility and a desire to revolutionize painting, and by the fact of living so close together. Many of them were émigrés, and many, like the Belorussian-born painter Marc Chagall, the Bulgarian painter Jules Pascin, the pioneering Russian abstract painter Sonia Delaunay, and the Lithuanian Cubist sculptor Jacques Lipchitz, were also Jewish. Warnod, then, meant to be provocative in judging these foreigners as the representatives of Paris.

Fellow artists and other friends piled into Kisling's studio, which he

plastered with photographs and sketches of seemingly everyone he'd ever met, its big windows looking onto the trees of the Luxembourg Garden. A gramophone blasted the latest dance tunes. People would laugh, argue, and pass around a bottle, while Kisling remained at his easel, listening but never talking as he worked, finding the chatter stimulating. Someone might bring a balalaika or an accordion. Kiki recalled a constant stream of beautiful women coming by, and the phone forever ringing. No matter how late he had been up the night before, Kisling maintained his schedule of starting work at daybreak.

The Polish art dealer Léopold Zborowski, one of the School of Paris's most prominent dealers, would come from his apartment below Kisling's studio to watch him and Kiki at work and be "treated to an eyeful," as Kiki put it. So did the art critic Florent Fels, appraising her "as if he were looking at a nice piece of meat on display at the butcher's." Posing for Kisling and meeting Zborowski and Fels led Kiki to introductions to another Paris Schooler, the remarkably talented Soutine, also Jewish, and who, as Kiki wrote, "unsettled me with his savage looks." As the tenth of eleven children of an impoverished tailor, Soutine was used to sharing small spaces, and he let Kiki stay with him at La Ruche whenever she needed a break from living with Mendjizky, making a fire and giving her his bed while he slept on an old wicker chair. Soutine was anxious and shy. Kiki helped get him out of the studio. They would wander the neighborhood, Kiki wearing her usual outfit from that time, which consisted of "a man's hat, an old cape, and shoes three sizes too big." Soutine painted a few portraits of her, though they haven't been found. He would likely have used one of the repurposed canvases he made by scraping off the original images from flea-market-bought paintings, due to his fear of starting a work on a blank, unused canvas. Their sessions would likely have lasted for weeks as Soutine was a notoriously slow, detailed-obsessed painter.

Through Kisling and his crowd, Kiki met Modigliani. She knew of him before she met him. She would see him at the Rotonde in the front room, which he preferred to the clubby back one, posing as a misfit even among his fellow misfits. She recalled how he ate with

one hand while drawing with the other. He would go from table to table around the neighborhood terraces peddling his paintings, which he kept rolled up in a newspaper, for a few francs each, enough for a drink or a tin of sardines. Kiki enjoyed watching him hurling insults at the stoic Rosalie Tobia, a former model, from Italy, who at age forty-six, with no restaurant experience, had opened her four-table café on rue Campagne-Première, Chez Rosalie, where down-and-out artists appreciated her willingness to make half-portions of her minestrone when they couldn't afford the full bowl, already cheaper there than anywhere else.

Modigliani, originally from Livorno, had settled in Montparnasse the same year Rosalie opened her restaurant and, despite or because of his carrying on, became her most beloved regular. "His shouts made me tremble from head to toe," Kiki wrote of watching Modigliani haranguing Rosalie. "But was he ever handsome!" In Modigliani, charming and mercurial, Kiki found someone who could stay out just as late as she could, though his wild living masked a burning professional ambition. He would borrow studio space from friends— most often Kisling, later Zborowski, his dealer, who also paid him an allowance—and as Kiki discovered, he furnished his temporary quarters with the Rotonde's cutlery, plates, glassware, stools, and a side table, courtesy of the willfully blind Papa Libion.

Because of his use of stylized, elongated heads and figures, it's not clear which of Modigliani's pictures drew on Kiki as a model. But between him, Kisling, and Soutine, she was on her way to semiregular work. "The painters adopted me," she wrote. "End of sad times."

ALONG WITH HER MODELING, Kiki hawked copies of a slim arts and letters review, *Montparnasse,* through the summer and fall of 1921. The journalist Paul Husson, a nodding acquaintance, put out the review, basing his operation out of the Café Parnasse next door to the Rotonde. Kiki went there to pick up the latest issue and some complementary croissants—as valuable to her as the pay, she said—and

then worked the neighborhood, weaving her way through the rows of wicker chairs like the palmists and mystics who haunted the cafés in search of trade. Kiki reported, "I get five sous for every copy I sell. That puts a little butter on my spinach!" As she passed, someone might call out for her to flash her breasts for a few coins more, and if she felt like it, she obliged.

One night toward the end of fall, Kiki and a friend with the same job met up at one of the cafés to celebrate another shift's end. They'd done themselves up like French gangsters' molls with thin skirts and heavy makeup. Kiki and her friend went hatless to show off their curled bobs, cut short, a provocative, borderline revolutionary act at a time when the French papers told of men punishing, locking up, and in a few cases killing daughters or wives for bobbing their hair.

On entering the café, Kiki waved to another friend, the artist Marie Vassilieff, whose tiny frame, browless blue eyes, and wide moon face made her easy to spot in a crowd. Born in Smolensk, Vassilieff had moved to Paris in 1907. Though a skilled painter, she earned most of her money hawking leather dolls fashioned after celebrities of the day. Kiki would have heard the rumor that Vassilieff enjoyed years of secret financial support from her admirer the Tsarina Alexandra, until the execution of the Romanovs in 1918, a rumor all the more wonderful if true, given Vassilieff's vocal support for Communism. Vassilieff had also worked as the head of Paris's Russian Academy until a difference of opinion over some misappropriated funds prompted her to leave and open the Marie Vassilieff Academy based out of her studio. She was beloved in Montparnasse for the artists' canteen she'd run in the narrow courtyard adjoining the studio, its walls adorned by the works of her friends Modigliani and Chagall, the meals often accompanied by a lecture from one of the locals, often the painter Fernand Léger, who lived a few doors down. When wartime blockades kept foreign-born artists from accessing money from back home, they'd sought out Vassilieff's cheap, hearty servings of ham and pea soup, making her canteen a kind of international outpost, with the dinners giving way to parties, city-wide curfew be damned, the festivities capped by their

host's nimble Cossack dancing. American soldiers came, too, bearing gifts of whiskey and gin. A brief house arrest by the French police in 1917, reportedly for sheltering her compatriot Vladimir Lenin or for being a Bolshevik spy, or both, lent Vassilieff an added air of mystery.

By the war's end, Vassilieff knew every artist, writer, dancer, decorator, actor, and café loafer in Paris worth knowing. On this night, she was sitting with a man Kiki had never seen before. Short, dark, and thin, with sad, slightly bulging eyes. No film star, but magnetic in his own way.

2

A CAFÉ ISN'T A CHURCH

K IKI SAW THE PEOPLE TURNING IN THEIR SEATS AS her voice cut through the tangle of conversations and laughter. Just as she'd wanted. They could witness her mistreatment.

Again the waiter refused to serve Kiki and her friend. Because they wore no hats, he explained. He was only following his orders.

"A café isn't a church!" Kiki yelled at him. And besides, she added, "all the American bitches come in without hats."

A manager rushed over, armed with his own explanation. Anyone could figure that a bareheaded American woman was another confused tourist, he told them, but a couple of unaccompanied local women dressed as they were would be mistaken for prostitutes, and this wasn't that kind of place.

Kiki swore to tell the neighborhood about the insult. They would organize a boycott, she said. And then before anyone could answer, she jumped onto the table, did a playful jig, and jumped off laughing, ending the discussion.

Marie Vassilieff, who'd watched the spectacle unfold, motioned from across the room for Kiki and her friend to join her at her table. Vassilieff was with an American, who ordered them all drinks, putting bass in his voice, trying to pull rank on the waiter.

Man Ray introduced himself in his Brooklyn drawl, gruff and nasal at once. Half longshoreman, half professor. Kiki would recall liking

the sly way he talked from the side of his mouth, like some hard-boiled detective. She spoke little English, and he knew only basic French but they managed to understand each other with Vassilieff helping to translate. As they talked, he rarely said much more than was needed to get a point across. Kiki would learn he was just as taciturn in his native tongue. He seemed to her a man with secrets, not sinister but aloof, and on the run from something.

BY THAT WINTER OF 1921, Man Ray had been in Paris nearly half a year. He'd passed his thirty-first birthday, alone. He'd met some of the local writers and artists, including Vassilieff, who'd been devoting the night to showing him her version of Montparnasse. He'd noticed Kiki as she'd entered and had asked about her. From her heavy makeup, he'd mistaken her for a teenager trying to pass as older. Vassilieff told him she was no girl but a young woman, Kiki, a new favorite among the painters. Watching her jump from the table after her scuffle, Man Ray thought she moved "as gracefully as a gazelle," possibly choosing this animal to reference her nickname.

He invited them all—Vassilieff, Kiki, and Kiki's friend, whose name is lost to history—to dinner at a nearby bistro, an impulsive extravagance. There Kiki got drunk and pretended to argue with people at the other tables, who enjoyed the entertainment.

Stories flowed out of her. She told about Maurice Utrillo, how she'd lain naked on a couch while he guzzled his wine staring at her, never letting her see his canvas until finally he showed her a lovely landscape: mountains, trees, and a pretty river, but no sign of the naked Kiki he'd been eyeballing for three days. She was furious, but then the more she looked at the painting, the better she thought she understood what he'd done. What else could he see when looking at her but the countryside that had made her? She told about the day she brought Soutine some bread and herring, fighting the urge to eat the food on the way since she knew he needed it more than she did. She got to his studio, and it smelled awful, and there was Soutine painting a still life; he

hadn't eaten in days but was surrounded by food. He'd let some good vegetables and a thick side of beef go rotten because he wasn't about to eat his props. (Soutine often painted animal carcasses, despite, or because of, a fear of blood and gore. Eventually he learned to inject them with formaldehyde to avoid the rot.)

After dinner, the four walked to a movie house. Kiki remembered them seeing Rudolph Valentino and Alla Nazimova in the tragic and romantic *Camille,* but it hadn't yet been released in France. Maybe she misremembered, seeing something of their relationship in that movie. In Man Ray's version, he said nothing of the movie's title, claiming he hardly looked at the screen. Both agreed that at some point during the film, each felt for the other's hand, a silent agreement passing between them.

Out on the street, Man Ray asked Kiki if she would pose for him. He wanted to photograph her. Kiki said no, she didn't like photography. It was too "factual," as she put it, and left you nowhere to hide. She preferred painting, where you could always find a way to put some poetry into a body or face. She alluded to a "physical defect" she wanted kept from the camera's scrutiny. And she didn't want naked shots of her spread all over town.

Man Ray countered that the paintings she'd posed for nude were shown in public, sometimes with her name in the title. And he promised to record only her beauty. He'd mastered his instrument, he said. The camera obeyed his orders. "Light can do everything," he told her in his wobbly French. "Shadows work for me. I make shadows. I make light. I can create anything with my camera."

Maybe he would paint her portrait later from the photos. He couldn't paint her from life, he said, because she would be too distracting, she was too beautiful. Kiki laughed, told him there was nothing he could do to shock her, that artists made passes at her all the time. But right now she posed only for people she knew well.

Vassilieff cut in to vouch for her friend's intentions, telling Kiki that Man Ray was like "a magician" while flashing him a complicit smile; he would give her no reason to complain.

They spent a few more hours walking around Montparnasse, lit by the winking neon signs and the gold clouds of the winter streetlamps. Kiki asked Man Ray when he was going to take them all to America. Before they parted for the night, she agreed to pose for him a few days later, for a single session.

3

SEE THE DISAPPEARING BOY

M ELACH RADNITZKY SAILED STEERAGE FOR AMER-
ica in 1886, escaping service in the army of the tsar, a crime for
which his father had to serve six months in a Kiev prison on his behalf.
Once settled in New York, Melach sent for Manya Louria, a teenaged
orphan who'd been working in a pharmacy until the senior Radnitzky
spotted her and decided she would make a good match for his son.
Melach knew her only from photographs.

When she stepped from the ship in New York Harbor, awkward
and slouched, far from the trim beauty promised by her pictures, the
deception so angered Melach that he refused to carry her bags. Only
after she'd stripped down to reveal her elegant frame did he discover
she'd worn nearly every item of clothing she owned to cut down on
luggage fees. A rabbi married Melach and Manya a few hours after
they met.

In America, they became Max and Minnie. He was a gifted tai-
lor, gentle and dreamy. She was a nimble seamstress, quick-witted and
caustic. They settled on the south side of Philadelphia, where a friend
had a job for Max in a garment factory. Emmanuel Radnitzky was
born to them on August 27, 1890.

For his seventh birthday, around the time his parents traded Phil-
adelphia for Brooklyn and a slightly better-paying rag trade job,
Emmanuel received a box of crayons with which he drew the fiery

sinking of the battleship *Maine* in Havana Harbor, copying it from a newspaper photograph. His unfaithful use of colors left his parents confused.

Emmanuel inherited his father's dexterous hands. He put his to different use. He started out pilfering art supplies from general stores before progressing to training boys to steal for him, like some Fagin of Brooklyn. His conscience never pricked him since the thievery served a higher cause. He considered artists "privileged and sacred beings," as he would later write.

One day Emmanuel stole the wheels from another child's toy and fastened them to a wooden plank he'd connected to a soapbox topped with a bit of stovepipe. His mother smashed this makeshift train with an axe before he got a chance to ride it, either to punish the theft or to keep him from getting run over by a milk truck, depending on who in the family you asked. Over the course of his long life, he returned many times to the story of the train and the axe, as though it were the original sin pointing to everything that led to his eventual break from his parents.

As Emmanuel grew into adolescence, the Radnitzkys zigzagged through a series of apartments. In each place, a room would be devoted to Max's vest-making trade, his clients filing in as soon as he returned from his dayshift across the East River. By midnight the floor would be littered with cloth samples, spools of thread, skeins of yarn, stray bits of paisley, houndstooth, and stripes, all of which Minnie gathered up to weave into patchwork quilts while her children slept. Emmanuel and his siblings, Do (Devora), Elsie (Elka), and Sam, helped out as they could by sewing, embroidering, and making deliveries.

Emmanuel, whom the neighborhood kids called Manny, shared his father's tendency to daydream. When he closed his eyes, he saw throngs of people walking the streets, he said, except the people weren't people but moving jumbles of geometry, coming at him in every color. His parents took pride in his drawings and paintings, but it disturbed them to think they were raising an artist. In their patch of the world, you might as well have said you were raising a *schnorrer* (mooch) or,

worse, a *gonif* (crook). They understood that their son wasn't meant for medicine or law, but if he had such devotion to drawing, why not focus his talent toward a respectable profession? And so when, in his senior year at Boys' High, he secured a scholarship to study architecture at New York University, it was as if a great miracle had befallen the family.

MANNY PASSED THE IDLE SUMMER after high school wandering Brooklyn, hopping the Union El to the borough's ramparts, where you could still get lost among potato fields and big red barns, or taking the Reid Avenue trolley out to the beach at Coney Island to be carried along by the churning crowds bound for Luna Park and Dreamland, the big amusement parks of their day. Sometimes he brought an easel and painted in the open air. Some days he set up at the Ridgewood Reservoir, in the wetlands straddling Brooklyn and Queens, surrounded by bogs, woods, and great stretches of green; others were spent beneath the scarlet oaks in what was then called Brooklyn Forest Park. He found it intoxicating just to hold his brushes and smell the paint. The Nick Carter dime novels of his boyhood were meanwhile giving way to Whitman and Thoreau. Whitman's poetry unveiled for him the beauty that lay so close at hand in Brooklyn's hills and on its teeming ferry. Thoreau spoke of freedom through renunciation, solitude, and distance. Life felt richer the farther from home Manny traveled.

He decided not to go to college. He got a job as an engraver making designs for umbrellas and canes, cheering himself with the knowledge that Goya and Rembrandt had been expert etchers in their times. He moved on to doing layouts and lettering at a publishing house overlooking the Hudson. The view—of bridges being crossed, containers being loaded and unloaded, pallets being lifted and lowered—held more of his attention than the job. From his desk, he could hear the fading foghorns of ships bound for Europe. He was still living with his parents.

He explored the city, gathering any information he could on how

to live. He haunted movie palaces, hotel bars, cafeteria automats. He saw *Salome* and *Elektra* performed at Oscar Hammerstein's Manhattan Opera House. He heard Bach played at Carnegie Hall and got to see Isadora Duncan dance. At the Palace Theater on Broadway, he was entertained by wire walkers, jugglers, comedians, ventriloquists, and illusionists. He took an evening life-drawing class, later claiming he did so as much to glimpse his first naked woman as for the chance to draw her. When making studies of Greek statues or nineteenth-century nudes, he was as eager to learn how to reproduce their beautiful lines as he was to conjure the forms that inspired them. "Sex had been bothering me," he wrote of these years, as though desire were a problem he needed to solve. He took more art classes at the Ferrer Center, named for the Spanish anarchist Francisco Ferrer, who had been executed in 1909 for his radical convictions. In a few years, Manny would come to identify as an anarchist himself.

He rarely showed his parents his work. For a time, he imagined becoming the next John Singer Sargent, painting high society on the Upper East Side. Two years out of high school, with limited connections, he went out seeking portrait commissions, attracting a single client, a Mrs. Medvedev from his neighborhood, who sat for him in the front room of his parents' apartment while his giggling siblings crouched in the hall to peep through the keyhole. He failed to turn Mrs. Medvedev into the next *Madame X*.

Lunch breaks he spent in the galleries along Fifth Avenue. Best of all was the 291 gallery run by the photographer Arthur Stieglitz, a fifteen-foot-square room at the top of a nondescript brownstone. There Manny learned names that were still new to most Americans: Cézanne, whose watercolors held so much white space, they looked unfinished; Brancusi, who dazzled him with his shining sculptures; Rodin, with his unruly sketches; and Picasso, the one who touched him deepest of all with his Cubist acrobatics, trying to make the fourth dimension of time visible on a two-dimensional surface, bringing about the greatest upheaval in visual art since Brunelleschi's first experiments with perspective five centuries earlier.

Stieglitz, at 291 and through his own work and publications, likely did more than any other person in the first half of the twentieth century to promote the visual arts in America. In Stieglitz's magazine, *Camera Work,* Manny read of his efforts to advance the then-novel idea that photography should do more than mimic the subjects and modes of painting. Stieglitz argued that a great photograph proposed its own rules, unique to the medium. He wanted artists to develop their subjective views of everyday life through the lenses of their cameras, playing to the medium's strengths of producing rich tonal ranges and sharp detail, while seeking out striking formal arrangements through different angles and cropping strategies. Manny would have seen Stieglitz's breakthrough image, *The Steerage,* shot on a 1907 Atlantic voyage and documenting conditions similar to those Melach Radnitzky had experienced sailing two decades earlier.

Stieglitz sometimes asked gallery visitors to sit for portraits. One day he approached the young man, small and wiry, with twisty thick hair, who'd lately become a lunchtime fixture. He told Manny to stand against a wall and stay put while he brought out a hoop of stretched cheesecloth and held it inches from his subject's face, uncapping the lens and moving this way and that, staring at his subject the whole time. Stieglitz's ten-second performance struck Manny as both wondrous and intimidating. He looked like a ballerina commanding center stage. The resulting portrait was a bit of a blur.

They formed a friendship. Manny drew inspiration from the older man's conviction that geniuses were those who could still see the world like children while refining that vision with the wisdom of experience. Stieglitz believed that artists must travel, especially to Europe, helping to stoke Manny's wanderlust. Most important, Stieglitz modeled for Manny how an artist should move in the world. He preached that a modern artist had to strive for nothing less than revolution, had to change the very ways that people saw and thought. He started inviting Manny to the informal salons he hosted for artists, obscure and famous both, who listened, rapt, as the magnetic, occasionally overbearing Stieglitz held court over lavish meals—always at Stieglitz's

expense—at Holland House on Fifth or Mouquin's on Sixth, run by a wine dealer who gave many New Yorkers their first tastes of French dining. Manny's lunch breaks grew longer and longer until they grew so long, he got fired from his job.

AT TWENTY-ONE, Manny constructed a large tapestry out of dozens of fabric samples from his father's workshop. Perhaps he meant to celebrate his mother and her ingenious kaleidoscopic quilts. Or he wanted to show his father that his humble trade was a kind of artistry. Maybe he was trying to break free from them both by declaring himself the finest of the three craftsmen, the one touched by the Graces to turn the scraps of their workaday lives into objects of lasting beauty, the family's only "privileged and sacred being."

He sewed the tapestry to a sheet of linen canvas, titled it *Tapestry*, dated it 1911, and signed it with a new name: Man Ray.

America moved quickly. Who had time for Emmanuel Radnitzky?

He was far from alone in trying to make his way in the great national maw by crafting an identity out of whole cloth, one among countless fresh believers looking to shrug off someone else's past in their bids to belong to America and its century. And yet if in clipping the name of his ancestors to Ray, he wanted to join in, then by going from Emmanuel to Manny to Man, perhaps he sought invisibility above all. To become no man and all men at once; indiscernible, a stranger, an empty vessel through which some larger message could be transmitted.

THE INTERNATIONAL EXHIBITION OF Modern Art opened in the decommissioned 69th Regiment Armory on Lexington Avenue, on February 17, 1913. Roughly thirteen hundred works went on display in the armory's giant drill hall, which had been divided into eighteen octagonal rooms by wooden partitions covered in burlap. There were offerings from Brancusi, Picasso, and the French painters

Georges Braque, Henri Matisse, and Francis Picabia. Stieglitz, who'd helped organize the exhibit, told visitors to his gallery to leave immediately and walk the few blocks over to Lexington, promising that anyone who looked at the works there with unprejudiced eyes would find their worlds completely changed for the better.

Strips of gold cloth had been hung from the drill hall's barrel-vaulted ceiling down to its walls, tenting the artworks and lending the show a festive feel. A quarter-million people attended the Armory Show, many of them more excited by the controversy than by the pictures, especially after someone from the Senate Vice Committee declared the exhibition immoral. Matisse's crude colors so outraged the public that he was hung in effigy as "Henry Hairmattress" after being put on mock trial for treason. Marcel Duchamp's *Nude Descending a Staircase,* a tweaking of Cubist ideals more radical in its titling than anything else, was the show's greatest scandal, ridiculed in the press for looking like an "explosion in a shingle factory." It sold to a San Francisco antiques dealer for $324.

Though the presentation was slapdash and chaotic, the whirlwind of modern art on display at the Armory Show shocked a generation of artists and their patrons into action. The exhibit also introduced a mass public to a quick survey of the roots of modernist thinking in European and American visual art, with a focus on France, tracing a line from the Romanticism of Eugène Delacroix, to the Impressionists and Post-Impressionists, to the Fauvists and their uninhibited use of color and vivid brushstrokes, to the Cubists. A work of art, more and more people were beginning to see, could be many things at once beyond a pretty picture: it could be demented, blasphemous, childlike, mashed together from incongruous parts with no guiding logic, fully conscious of its own falsehood, filled with mistakes and accidents, a question with no possible answer, a distorting mirror, an accusation, something made for no reason other than to delight in its newness.

For Man Ray, the show's most immediate effect was paralysis. He said he needed six months to make sense of what he'd seen there. The show must have galvanized him in some way, though, because in the

spring of 1913, not long after wandering the armory's halls, he finally moved out on his own, his mother crying as he packed.

With his friend Samuel Halpert from the Ferrer School, an avant-garde painter six years older than him, Man Ray rented one of the bungalows that formed part of an artists' colony nestled in the hills of Ridgefield, New Jersey, a couple of miles due west of Harlem across the Hudson and largely populated by Ferrer School faculty or students. Their little stone hut stood on a bluff dotted with fruit trees and gave an unobstructed view onto a valley. Man Ray thought of the move as a "return to nature," the closest he could come to emulating Thoreau at Walden Pond.

In Ridgefield, he felt at once cut off from the world yet unable to escape the pull of the family apartment on Kosciusko Street, where he still slept a few nights a week in the safety of his old bed. Along with family duties came professional ones at the McGraw Book Company, doing calligraphy and layouts, making atlases and maps. Commuting from Ridgefield meant a half-mile walk, a ferry ride, the subway to the office, then back again at night.

Not long after moving to Ridgefield, he met a Belgian poet, Donna Lacour, who used the pen name Adon Lacroix. She was a few years older, living in the city, and amicably divorced from another Belgian poet, Adolf Wolff, with whom she had a nine-year-old daughter, Esther. Wolff had taken some classes with Man Ray at the Ferrer School and was friendly with Stieglitz. Man Ray had seen Lacroix occasionally at the school, and they got to talking whenever they saw each other at Ridgefield parties.

During one of their conversations, Lacroix let slip that she found New York a lonely place and longed to escape it. Man Ray suggested that they move in together, along with Esther, to another of the colony's properties. They did so a few days later, taking a house with four bedrooms and a view clear to Paterson, more than ten miles away. Man Ray's dejected former roommate Samuel Halpert moved back to New York and cut off all contact with him.

Lacroix, widely read and revolutionary in her outlook and work,

already experienced in marriage and motherhood, tall and blond with sharp cheekbones, chic and bohemian with her carefully chosen brooches and beads, couldn't have been more different from the young women Man Ray had grown up with. He quickly fell in love with her and with the dream of cultured Europe she embodied for him. "Oh talk about the whole world and tell it in your own way," he wrote, as if to her, in his journal. "I am very quiet and interested when you talk that way. . . . I unbind your strange pale hair which falls down about your strange pale face and rests on your pale shoulders. My hands tremble when I hold the pencil to draw from you. . . . When you are my wife and I sit down to draw from you I shall not think of drawing."

They were wed by a minister in the spring of 1914, having known each other just a few months. Man Ray's mother didn't approve of her son marrying a non-Jewish divorcée but kept mostly quiet, confiding to her daughter Do that she knew if she'd objected, she would have lost her son for good.

The newlyweds spoke of going to Europe to see Lacroix's native Belgium and visit Paris, but war got in the way. Instead they embraced a bucolic existence in Ridgefield, working, taking turns strumming their guitar, debating politics and art with friends, playing boozy games of pickup baseball, and reading in front of the fire. Writers, musicians, painters, and political radicals came to visit. The poet William Carlos Williams, who had a medical practice a few miles away in Rutherford, was a frequent guest. Sometimes Lacroix and Man Ray would host a showing of a friend's work in their attic. Their lifestyle got them a piece in New York's *Morning Telegraph,* written by their friend the poet Alfred Kreymborg, who praised the couple's ability to pursue their art while spending little beyond the cost of food, art supplies, and the eight-dollar-a-month rent.

Lacroix introduced Man Ray to the writers who thrilled her, particularly the revolutionary French poets of the second half of the nineteenth century and early twentieth, translating for him as she went. Together they read Baudelaire's unflinching observations of urban life, battling with boredom and the particular angst wrought by overstim-

ulation and freedom from want, the first truly modern poet. Through Lacroix, Man Ray encountered the work of Arthur Rimbaud, shaken by this surly teenager's call "to make oneself a seer," poking holes in the observable world to discover deeper truths through a "long, immense, and deliberate derangement of the senses." Having recently abandoned his birth name, he must have felt a particular affinity for Rimbaud's suggestion that "I is somebody else" (*Je est un autre*).

Lacroix drew his attention to one of their closer contemporaries, the poet and critic Guillaume Apollinaire, and his writings on the Marquis de Sade, putting Man Ray on the path to a lifelong obsession with Sade's stories of debasement, domination, pleasure, and rebellion, with Sadean imagery, and most of all with the character of Sade himself. Man Ray came to see Sade as a martyr, a misunderstood outcast imprisoned not for criminal actions but for his beliefs as he pursued total freedom in his art, throwing off the shackles of morality, decency, and public opinion. Sade's shockingly violent *Salo, or The 120 Days of Sodom* would serve as a kind of bible for Man Ray, a document of the extremes to which the artist must be willing to take his vision, and of the openness with which he must be able to explore the horror of his own mind. And under Lacroix's guidance, Man Ray first learned of the obscure hallucinatory novel *Les Chants de Maldoror,* penned by the Comte de Lautréamont, pseudonym of the Montevideo-born French poet Isidore Lucien Ducasse, twenty-two when he wrote it, dead at twenty-four. The book haunted Man Ray with its uneven prose-poem form and its celebration of chaos, evil, and Sadean eroticism. He was haunted by a passage the Surrealists would later adopt as a kind of motto: Lautréamont's enigmatic framing of a boy so pure and unsettlingly beautiful, he can only be described irrationally, as being "as beautiful as the chance encounter of a sewing machine and an umbrella on an operating table."

In the winter of 1914–15, to present "an epitome of their work since their partnership," as they described it, Lacroix and Man Ray collaborated on what they called *A Book of Divers Writings*, a twenty-copy run of a leather-bound booklet featuring her poetry and his pen-and-

ink drawings, from which they turned a decent profit, as Man Ray ran around Manhattan finding buyers. They worked on a broadsheet filled with their hand-drawn words and images, *The Ridgefield Gazook,* limited to a single issue. Its nonsensical, irreverent style filled with puns and visual gags anticipated some of the hallmarks of the Dada movement that would soon become the main artistic influence on Man Ray.

He painted a few portraits of Adon, using a relatively realistic style, tamping down the Cubist elements he was putting into his other canvases. He painted one in oil of her sleeping serenely. Working by the light of a single lamp, he'd thought he was reaching for white to do the base of her flesh tones but grabbed lemon yellow without realizing, and then decided to keep the mistake, which yielded a tender honey-colored scene. He did a quick watercolor of Lacroix nude, her fleshy back turned to the viewer. And he produced a dual portrait, superimposing his profile onto a frontal view of her face. None of his pictures of Lacroix hold up as especially good. During their time together he painted scenes of his surroundings, or drawn from his imagination, more often than portraits of her.

ON AN AUTUMN DAY IN 1915, Man Ray met Marcel Duchamp, whose new American patron Walter Arensberg had brought him to see the Ridgefield colony, a few of whose poets were published in *Others,* the literary magazine funded by Arensberg. Man Ray knew of Duchamp only from seeing *Nude Descending a Staircase.* A few hours after they met, they struck up a game of tennis using old rackets on a court with no net in the field in front of Man Ray and Lacroix's bungalow. Man Ray counted off the strokes in the fading light, more to make some kind of conversation than to keep score—*fifteen serving love, thirty serving fifteen*—and every time Duchamp, who spoke little English, answered only *yes.*

A heart murmur had kept Duchamp out of the war, a fate he happily accepted. An outwardly sturdy young man walking Parisian streets, however, with flags and patriotic banners in every window, would have

been heckled constantly. That spring, after writing to friends, "I do not go to New York I leave Paris," he'd sailed from Le Havre, his ship leaving in darkness for fear of German submarines. With the burn of the Armory Show still raw in the city's consciousness, Duchamp likely ranked as the most famous French name in New York after Napoleon Bonaparte and Sarah Bernhardt, as his friend the writer Henri-Pierre Roché said at the time. Yet Duchamp chose to burrow into a life of relative quiet, giving French lessons and working as a librarian at the French Institute. His time in New York offered him a temporary secession from the public role of "Artist." And America excited him with its lack, to his European eye, of cultural baggage. In Europe, he complained, young people were taught to see themselves as the descendants "of some great man," offering as examples Victor Hugo for the French and Shakespeare for the English. "This doesn't exist here. You don't give a damn about Shakespeare do you?"

Man Ray was easily seduced by this dapper Frenchman who seemed to take in the world from an Olympian distance yet saw things so sharply, who seemed to glide through every space he entered. And quiet Duchamp would have seen in this tailor's son, with one foot in bucolic Ridgefield and another in bustling Manhattan, all the joyful inconsistencies and wild promise of the American experiment on display. He must have taken some pleasure in watching this not-much-younger man with a whole career still in front of him.

Physically and by temperament, they had the makings of a vaudeville double act. Duchamp was tall, slim, and classically beautiful with his long, thin nose, deep-set eyes, and prominent brow, a measured, sometimes slow conversationalist, prone to clearing his throat softly before he spoke, a master of understatement, and the scion of a cultured Normand family. Man Ray was short, scrappy, and swarthy, burning with ideas, with a hawkish nose, dark eyes, and a weak chin. He delivered cutting remarks and silly puns with an arch of his thick eyebrows, alert with his whole compact frame to everything around him, five steps ahead of everyone else in the room, a pure product of immigrant America. They founded their fifty-year friendship on a

shared appreciation for wordplay and complicated in-jokes. Alcohol, chess, and time took care of the rest.

Georges Braque once said that as he and Picasso worked their way toward Cubism in the early 1900s, they "were like two mountaineers roped together," meeting daily in Montmartre, each stimulating the other just by showing what he'd produced for the day. Allowing that Duchamp did more of the heavy lifting than Man Ray, the same simile could apply to their relationship, as they advanced the idea of a modern art whose beauty had as much to do with tickling the mind as with pleasing the retina. Duchamp believed that the artist's sensibility was everything, the work almost an afterthought. To wit: the readymade. Duchamp showed that he could take a bicycle wheel, mount it upside down onto a wooden stool, and present it as a work of art, an object with no discernible uses other than the pleasure it gave and the curiosity it provoked. And then there were the pranks and put-ons. Disfiguring the Mona Lisa with a moustache and a dirty French anagram produced something fine to look at, but far more exciting was the idea that you could even do such a thing, and the possibility that the author of such vandalism might have as much to say about the world as it stood then as Da Vinci had had to say about his own time. Duchamp would soon abandon painting altogether.

Man Ray, too, wanted his own work to bounce around people's heads long after they'd left the gallery. But he was then still searching for how to bring some of Duchamp's conceptual experimentalism to his own painting.

In October 1915 Man Ray had his first solo show at the Daniel Gallery in midtown Manhattan, opened two years earlier by Charles Daniel, a saloonkeeper turned collector and dealer. A poet friend from Ridgefield who managed the gallery had secured Man Ray a meeting with Daniel. He showed thirty paintings, mostly abstract work informed by Cubism, and a few pastoral scenes. The show closed quickly. The reviews were unkind, sales nonexistent.

Man Ray retreated to Ridgefield, ignoring his parents and siblings, skipping his brother Sam's wedding, and refusing an invitation from

a friend to join a group show. But a few days later, Daniel contacted him. A corporate lawyer from Chicago, Arthur J. Eddy, had stopped in at the gallery and seen Man Ray's paintings, not yet boxed up to make way for the incoming show. Eddy bought six of Man Ray's canvases for $2,000, a huge amount, the most money Man Ray had ever seen at one time. Daniel even offered to waive his commission, perhaps thinking he'd played too passive a role in this fortuitous connection between buyer and seller to merit payment, but just as likely because he saw promise in Man Ray and wanted to keep him in the fold. Arthur J. Eddy was a sharp collector, an early buyer of works by Manet and Whistler.

With their momentary prosperity, Man Ray, Lacroix, and Esther moved into Manhattan. Man Ray wanted to keep making new connections in the city, and none of them felt excited about another winter out on the Palisades. First they took a studio across from Grand Central Station. The place shook as workers dug and drilled, pushing the Lexington Avenue subway line northward. The city was one long snaking construction site, a place where people joked you could *see* the noise. Man Ray enjoyed the rumble of concrete mixers and steam drills, which he said pushed everything from his mind. But the studio's lack of heating began to wear, so they moved to a second-story studio at 11 West 26th, with a view of a churchyard and a location close to Brentano's bookstore, where they would pore over art books that they finally felt flush enough to buy. Three blocks from their door stood the Flatiron Building, which as a boy Man Ray had watched going up in fits and starts on visits to see his father in the Garment District, seeming to defy gravity as it rose higher and higher on its slender base.

Inspired by Duchamp's readymades but taking the process further, with a more hands-on approach to altering and manipulating the materials, Man Ray assembled a piece he called *Self Portrait*. It consisted of two doorbells, a handprint of paint on stretched canvas, and a button that did nothing when you pressed it. He liked how angry people got over its failure to work, the undelivered promise of an unopenable door and an unringable bell. He featured it in his second show at

the Daniel Gallery in the winter of 1916–17. The show also included a piece called *Portrait Hanging,* a painting he hung crookedly, with a second hidden nail keeping anyone from being able to straighten it. He hoped that by seeing the painting fighting against their good intentions, they would feel like participants in "the creative act." The highlight was a marvelous oil, maybe the best of Man Ray's life, titled *The Rope Dancer Accompanies Herself with Her Shadows,* a large work (four feet by six feet) inspired by watching a tightrope walker at a vaudeville show. He painted a multipointed star with many legs representing the rope walker and her skirt, captured in several positions and points of time in her crossing a wavy rope. Below her are wide color blocks, mapping her movement in form while evoking a child's colorful cutouts. Each block could be one of the shadows of the title, cast by the dancer at different moments. It is an image of detachment in the face of danger, showing an expert surveying her scene, in control of her destiny. The public received the second Daniel show only somewhat better than his first.

In 1917 Lacroix and Man Ray moved again, to a studio steps from Washington Square Park. Greenwich Village ("the Village," just as Montparnasse was "the Quarter") was at the center of New York's modernist current, a neighborhood filled with small cafés, independent theaters, informal salons like that of the wealthy arts patron Mabel Dodge Luhan, and the single-room offices of various literary and arts magazines and leftist journals. Lacroix and Man Ray might have hoped that the change of scene could revive a marriage that was fraying.

Money played a part in their difficulties. So did chess. After selling his paintings to Eddy, Man Ray had cut his work at McGraw down to three days a week. He soon blew through everything he'd made from the sale of his art. And he meanwhile went mad for chess. He could spend days losing himself in the order of the grid with Duchamp, a player of world-class talent. They both prized the knight, unable to travel a straight line but capable of hopping all barriers.

Evenings usually led Man Ray and Duchamp to the basement

restaurant of the Village's French-owned Hotel Brevoort. They drank Manhattans with a regular crew, including the painter Joseph Stella, who lived upstairs, the composer Edgar Varèse, actress Beatrice Wood, and the chain-smoking Berenice Abbott, the photographer-to-be, an iconoclast with her bobbed hair and penchant for trousers, then working as a waitress, office assistant, sculptor, and sometime actor, having dropped out of Columbia University. Abbott sometimes brought along her roommate, the avant-garde writer Djuna Barnes, who with her deep voice and fleet mind could pull a conversation in any direction she wanted, "a rough-diamond sort of genius," as the writer and *salonnière* Natalie Clifford Barney described her, "who cut everything to pieces and then blamed the cut." Barnes often invited the poet and visual artist Mina Loy. And Loy sometimes brought along her lover, the Swiss writer Arthur Cravan, famous not only for being Oscar Wilde's nephew but for orchestrating a spectacle in 1916—half money-making scheme, half performance-art piece—in which he passed himself off as a prizefighter to secure an exhibition bout in Barcelona with Jack Johnson, the first Black American heavyweight champion of the world. Johnson made a show of it for six rounds so the film crew capturing the event had sufficient footage before he soundly knocked out his shaking opponent with one punch.

The Cuban-French painter Francis Picabia, another proselytizer for the cause of art that was more conceptually vexing than visually pleasing, joined too when he was in town. Man Ray already knew him by reputation, from his show at the 291 gallery, and for his entertaining interviews in *The New York Times* during the Armory Show's run and a subsequent manifesto in *Camera Work* in which, among other incendiary statements, he had said that since the Cubists had done away with form, color should be next on the chopping block. While he was in New York, Picabia advised Man Ray on the latest happenings among the avant-garde in Paris and elsewhere.

Lacroix saw Man Ray rarely and she made clear how much his lack of attention hurt her. She tried to get her revenge by flirting with the

male sitters he brought to the apartment to paint. And eventually she started spending her own nights away. She found a new lover.

They separated in 1918 after a final fight, during which Man Ray beat Lacroix with his belt, saying he wanted her to have to explain the marks to her lover. He left their apartment and moved into the basement of the brownstone next door, which was being used as a storage unit. He left behind a painting for Lacroix. She "said it had been painted under her influence; I'd probably never do anything as good again," he wrote. They remained legally married.

Man Ray quit his job. His work got harder and darker. The world had grown chaotic and violent. Or maybe it had always been that way and it was only that the chaos and violence were becoming easier for him to see. The war had produced such strange and incongruous sights, even there in commercial Manhattan, thirty-six hundred miles from the trenches. Walking through Union Square, he passed a fully rigged, twenty-eight-gun battleship built of wood, the *USS Recruit,* anchored in some dirt by the subway station, complete with straight-backed sailors who rose daily at six to scrub the decks without ever seeing the sea. The navy was learning the modern art of advertising like everyone else. A pacifist with anarchist leanings, Man Ray avoided enlisting and was never drafted.

The embrace between humans and machines was growing tighter every day, and he adjusted his vision accordingly. He had many conversations about how best to capture the Machine Age in one's art, especially with Duchamp and Picabia, who in 1915 had told a reporter, "The machine has become more than a mere adjunct to life. It is really a part of human life—perhaps the very soul." Man Ray tried incorporating industrial methods and materials into his painting. In 1917 he made a work he titled *Suicide,* using an industrial-strength airbrush, enjoying being able to paint without touching the canvas or leaving any brushstrokes. He imagined putting a gun behind the finished canvas, its trigger tied to a string that he could hold, facing the blankness from the other side, and then pull to kill himself. After fighting

through a months-long bout of depression, he decided not to end his life. He would remain in the basement studio for the rest of his time in New York. He set up a work desk, using *Tapestry,* the first work he'd signed as Man Ray, as a tablecloth. *Tapestry* would figure in one way or another in the decor of every place he lived from then on.

And then just at the close of the Great War came the influenza epidemic, called the Spanish flu though who knew where it started. It ripped through the city with the same uncaring ferocity with which it terrorized the rest of the world, killing more people globally than the war itself, perhaps as many as a hundred million. The first of its three waves hit New York in September 1918, the last in February of the following year. The city's board of health warded off a far higher death count through quick action, regulating the hours when businesses could open and close, staggering them in the hope of thinning out the morning and evening rushes of the public transit system; amending the sanitary code with a covenant requiring all New Yorkers "to protect their nose or mouth while coughing or sneezing" or risk a fine; printing bulletins announcing "actual daily deaths"; and speeding up the burials of bodies. Men wore masks as they swept the streets, directed traffic, made arrests, sold meat. Patrols of Boy Scouts handed out cards to anyone seen spitting, an offense that could result in a fine, and explaining the dangers of their actions. Berenice Abbott caught it while rehearsing a play by her friend Eugene O'Neill, star playwright of the Provincetown Players theater collective headquartered in the Village. She narrowly survived after lingering for weeks between life and death in crowded St. Vincent's Hospital, her lungs coursing with fluid.

DADA AROSE AT THIS TIME of death from war and pandemic, a wartime howl of contempt for all fixed values and sacred ideas that began its own global spread from a Zurich nightclub, the short-lived Cabaret Voltaire. Man Ray appreciated how the Dadaists wanted to alienate themselves from the times and places they happened to be

living in. The idea was to make themselves into strangers wherever they went. Whether in Santiago or Berlin or Tokyo, the Dadaists saw themselves as foreign correspondents filing noisy, unintelligible reports for the uninitiated, claiming allegiance to all nations and none at all, speaking in nonexistent tongues and signifying in nonsense symbols untied to any matrix. Man Ray understood that beneath the veneer of nihilism lay a serious political mission. All of Dada's grand, gratuitous acts were meant as a collective rebuke to order and borders and languages and traditions—to everything that makes war inevitable. Dada rejected everything that had come before Dada, because everything that had come before Dada had failed. Which was why Dadaists could be so vehemently antiviolence and yet so in love with destruction, because destruction brought hope.

No one could agree on what Dada meant or stood for or what people were supposed to do with it. Dada artists and writers posed as founders of something closer to a multinational corporation than an artistic movement, promising that "the orders of the Dada bank are accepted all over the world," and that "all members of the Dada movement are presidents." Dada words, sounds, and images circulated freely, demanding no other interpretation but that all interpretations were pointless, and insisting that the purpose of an artwork was only to make clear its purposelessness.

> No more painters, no more writers, no more musicians, no more sculptors, no more religions, no more republicans, no more royalists, no more imperialists, no more anarchists, no more socialists, no more Bolsheviks, no more politicians, no more proletarians, no more democrats, no more bourgeois, no more aristocrats, no more armies, no more police, no more fatherlands, enough of all these idiocies, no more anything, no more anything, nothing, NOTHING, NOTHING.

So went one of the many Dada manifestos, this one recited by the poet Louis Aragon at a meeting of Dadaists in Paris in 1920. The idea that

you could simply choose to wipe away everything that had ever come before, in the name of creating unprecedented art, offered a welcome jolt to Man Ray, who was then still emerging from his identity as a dutiful student beholden to the greats who'd come before and not yet settled on his own direction.

In early 1921 he began corresponding with the Romanian poet Tristan Tzara (born Samuel Rosenstock in a small oil town in the Carpathian foothills). Tzara wanted Man Ray, Duchamp, and their mutual friend the American gallerist and patron Katherine Dreier to put out a magazine of New York Dada, which they did in April 1921, titled just that, drawing on the contributions of poetry and images from friends including Stieglitz. But spreading the Dada word around New York was an act in futility. After publishing the first and only issue of *New York Dada,* Man Ray joked to Tzara that "dada cannot live in New York. All New York is dada, and will not tolerate a rival,— will not notice dada.... There is no one here to work for it, and no money to be taken in for it, or donated to it. So dada in New York must remain a secret."

Which isn't to say that Man Ray, Duchamp, and other friends didn't pull off their share of prankish gestures in New York that, whether consciously influenced by Dada or not, were in keeping with its spirit. Picabia had been telling people about the Cabaret Voltaire since 1917, and Duchamp had a copy of Tzara's 1916 book, *La première aventure céleste de Monsieur Antipyrine* (The First Celestial Adventure of Mr. Antipyrine, Fire Extinguisher), featuring the first use of the word *dada* in print. In January 1917 Duchamp, John Sloan, three actor friends from the Provincetown Players, and a Texan poet and painter named Gertrude Drick had climbed the spiral staircase to the top of the Washington Square Arch, after Drick noticed the door at its base was left unlocked and the policeman on duty took hours-long breaks. After garlanding the arch with Chinese lanterns and red balloons, they started a cookout in a small pot, uncorked some wine, and fired cap guns from the parapet as Drick read what they called the Declaration of Independence of the Free Republic of Greenwich Vil-

lage, announcing its secession from the United States. The declaration, likely conceived by Duchamp, had only one word, "Whereas," which Drick chanted over and over like a mantra. Later that same year Man Ray had watched gleefully as Duchamp under the pseudonym "Richard Mutt" submitted *Fountain,* a porcelain urinal bought from a local sanitation equipment supplier, to the first exhibition of the American Society of Independent Artists—of which Duchamp was head of the hanging committee: the pissoir that changed the world.

As with Duchamp, Man Ray appreciated Tzara's anarchic energy and hoped one day to meet him in Paris, where Tzara had based himself since 1919, making the city the closest thing to the center of a movement that didn't believe in centers. Unknown to Man Ray, in Europe the idea of Dada no longer felt as dangerous as it once had. What still sounded to some like the cries of revolution were registering for others as distracting trills of entertainment. Audiences already familiar with Dada antics were proving increasingly difficult to arouse. Not that Dada was ever truly dominant, even within the limited confines of the Parisian avant-garde.

MAN RAY BOUGHT A secondhand camera with the idea of using it to create images he could see in his mind's eye but that didn't feel suited to painting. The move into photography marked a logical enough progression from his Duchampian object making: a photograph was in some ways similar to a readymade, a mechanized and easily reproducible recording of something already in existence, which although it bore none of the traditional marks of the artist's hand— brushstrokes, or sculpting lines—could become a work of art through the artist's specific choices and the context in which it was presented. His early photos drew heavily on visual puns: a shot of an egg beater, lit suggestively and titled *Man,* paired with *Woman,* two round metal reflectors and some clothespins arranged to look like breasts and a spine. As a Dadaist joke, he entered a picture of Berenice Abbott into a Wanamaker's Department Store photography contest under the title

Portrait of a Sculptor. It won ten dollars, enough for them to share a good meal, and an honorable mention. He meanwhile used the camera to document his paintings and objects and then thought of providing the same service to friends who wanted to send shots to out-of-town dealers and buyers. This earned him a little bit of money, but he under-charged and didn't work at it very often.

With his camera, he collaborated on Duchamp's feminine alias, *Rrose Sélavy,* a pin-up character invented to perform in front of the recording lens, the act of her creation offered as a work of art. Duchamp explained that the point of this shape-shifting gender play was not to change his identity but to create a second identity that could coexist with the first. Sélavy was a play on *C'est la vie,* with its Semitic sound adding another layer of meaning, while the full name evoked the phrase *Eros, c'est la vie.* They put *Rrose* on the cover of *New York Dada* in 1921.

With the theatrical photographs of Duchamp-as-*Rrose,* Man Ray was, without fully being conscious of it, pushing photography into new territory, by not only exposing but embracing the artificiality of the portrait process, the suspension of disbelief that governed the rela-tionship between the viewer and portrait sitters, who'd supposedly had themselves captured in a completely natural and realistic fashion even while so much artifice—posing, lighting, retouching, cropping—went into producing their likenesses on film. If every portrait sitter was already playing some version of themselves for the benefit of the camera, why not call attention to that fact and push it to the point of absurdity? While Dada paintings, poems, and plays were working to subvert and question all received notions about their respective art forms, Man Ray and Duchamp showed that Dada's iconoclastic energy could be applied to photography as well.

And if there could be Dada photographs, then there could be Dada films. With Duchamp, Man Ray made a short movie, *Elsa, Baroness von Freytag-Loringhoven Shaves Her Pubic Hair,* which delivered what the title announced. The German baroness was a visionary Dadaist sculptor and poet and a well-known Village eccentric whose husband's

death had left her in New York with her title, five dogs, and not much else. She waltzed through her days as though on a smoky Berlin stage, favoring black lipstick, sometimes dyeing her hair bright red, sometimes shaving her head down to nothing, pinning stuffed birds to the short kilt she wore along with her preferred ornaments, a hat with gold-lacquered carrots hanging from the brim, teaspoons as earrings, and a bra made of green string and two tomato cans, adorned with a canary in a wooden cage strung to hang between them. She made collages and sculptures using stuff she'd found in garbage cans or shoplifted. "She's not a futurist," Duchamp said of her. "She's the future." Man Ray and Duchamp ruined most of the *Elsa* film during the development process, conducted in a trash can's lid filled with developer, which apparently sounded to them like more fun than doing it in a darkroom.

In June 1921 Duchamp sailed for France. Rather than endure the problem of renewing his expired visa, he'd opted for a temporary return home. Man Ray wanted to join him. He had no projects under way. Charles Daniel didn't seem keen to offer him any more shows at his gallery. He lacked only the funds to travel. Luckily, through Stieglitz he met an Ohio coal man, Ferdinand Howald, who liked to patronize unknown artists, so long as they showed themselves willing to break away from European traditions and establish their own identities as American modernists. Man Ray convinced Howald to give him a $500 advance against paintings he would produce during a short trip to Paris.

Funds secured, he packed an old trunk with a few of the paintings and assemblages of which he was proudest, hoping for a chance to show them at a gallery during his time abroad. He destroyed some of the early paintings he didn't think worthy of storage, a decision he later regretted. At his parents' house, he took a snapshot of his brother and sister-in-law and their two daughters, also capturing Minnie hunched over a big soup pot in the kitchen, eyes down, resisting the camera's stare. The night before sailing he went out celebrating in the Village with some actor friends who managed to deposit him in the right cabin an hour before his ship, the *Savoie*, set off. It was July 14,

1921. The French passengers were toasting to Bastille Day. Mimicking his mother's original crossing in reverse, he was wearing all the clothes he had brought for the trip, with some sheets stuffed into a bag and a steamer trunk full of art.

America was gone from sight. Identities were receding. *Jewish husband. Immigrant's son. Brooklynite. Philadelphian. American. Russian. Emmanuel Radnitzky.*

ON JULY 22 Man Ray disembarked at Le Havre and took the boat train through Normandy to Paris. (He would later falsely claim that he'd arrived in France on Bastille Day 1921, as though willing his French initiation to coincide with this day of national celebration.) Duchamp met him at the train station and took him to meet some Dadaists in the passage de l'Opéra, a crumbling walkway by the former site of an opera house that was one of Duchamp's favorite places in the city. The Dadaists prized these iron and glass shopping arcades, strange interstitial spaces exposing a city caught in a moment between old ways and new ones, still illuminated by indoor gas lighting. The arcades that had been so modern when they were built a century earlier now stood out as eerie remnants of the time before Baron Haussmann ripped through the city with his boulevards to speed the flow of consumers while clearing paths for troops and cannons should these consumers fall out of line.

Man Ray and Duchamp made their way to the Café Certa, midway down the arcade, frequented mainly by petty gangsters and those who enjoyed being in their radius. The Dadaists liked the atmosphere more than the food. There were barrels for tables and mismatched stools and armchairs in wicker and cane. Louis Aragon was there, along with the writers Philippe Soupault, Jacques Rigaut, Paul Éluard (who looked to Man Ray like a picture of Baudelaire he'd seen in a book) and his wife Gala, later to become Gala Dalí. Finally there was André Breton—"the Pope," as Breton's friends called him behind his back—who seemed to present himself as the leader of this assembly.

America was the first thing they wanted to talk about with Man Ray and the last thing he wanted to talk about with them. *Buster Keaton. Jazz. Skyscrapers. Jack Johnson. Krazy Kat.* He spoke American to them until they got their fill, never divulging that all he really knew was New York, some of New Jersey, and a few stories told to him of Philadelphia. The rest of the country was the same secondhand news to him as it was to them. Later Breton, Aragon, and Éluard went back to Man Ray's room to see the artworks and Dada-inspired objects he'd brought from America. They talked about arranging a show for him.

Man Ray was as eager as any newcomer to buy into a certain myth of bohemian Paris as an enchanted place free of normal rules or repressions, where art and literature and music were all that mattered, and no one ever talked about real estate or taxes or the getting and raising of children. The city charged him up all at once. The scale of it, the layers. A gothic church, a Haussmann boulevard, a Morris column plastered with posters; the smells of horseflesh, chicory, gasoline, Guerlain perfume, wet wood, and stone; the calls of the cheese-mongers at the covered markets; how the sun spilled in through the thin trees of the Tuileries, and how the dust danced in each angled beam: there were new truths to discover in these details all around them.

Being an American bowled over by the beauty and energy of Paris had no more originality in 1921 than it has now. But among those few thousand Americans seeing Paris for the first time in the early 1920s were some who prized the city for much more than its beauty and its liveliness. Some people, whose identities or affiliations made them the objects of American scorn, sought in Paris a place they imagined to be more tolerant of difference. Some felt pushed out by Prohibition, not because it was difficult to find a drink in America but because the law so plainly revealed the country's hypocrisies and seemed a harbinger of worse to come. Some hoped that by disorienting themselves in Paris, they might see themselves more clearly, and maybe America and its place in the postwar world more clearly, too—like Ernest Hemingway who, amid the noise of Montparnasse's Closerie de Lilas, found himself able to conjure Michigan so keenly. Some were (mis)led by a

deceptively simple equation: "They do things better in Europe: let's go there," as the critic Malcolm Cowley, another American expat chasing "the idea of salvation by exile," put it. Some no longer recognized the America they'd been born into, feeling that its emergence as a global power had made it a more frightening place and somehow a more boring place, too. Some just wanted to blow up marriages or run out on debts. Some wanted to exchange dollars for francs. Some had no dollars or francs and wanted to make some. Some just hoped to escape themselves.

Man Ray in his way fell into all these camps at once. (He later joked that Paris offered the bonus of having no skyscrapers, which made it easier on the ego of a man of his height, a hair over five feet, than New York.) Within days of getting there, he knew the city would become his new field of research. Just as his parents had followed visions of better lives across an ocean, so he sensed that only on the Atlantic's other side could he get out from under the old ways they'd carried with them like luggage to Brooklyn, that only in this great capital of the nineteenth century could he start living like a child of the twentieth.

4

SESSIONS

S OMETIME LATE IN 1921, KIKI WENT TO SEE MAN
Ray in his room, six flights up in the former maid's quarters at the
top of a charmless hotel. Below them ran rue La Condamine, taper-
ing through the sleepy neighborhood of Batignolles in northwestern
Paris, far from tourist sites. Man Ray still lacked a real mental map of
the city. Like most Americans who came over in the early twenties, he
would have placed the soul of Paris on the Right Bank, home to the
Louvre, the Jardin des Tuileries, the Champs-Élysées, and the *grands
boulevards* around the Opéra. He knew as little about Montparnasse
as he did about Kiki, limited to his impressions from the night he saw
them both for the first time.

Kiki was nervous. She found Man Ray more nervous than she was.
He asked her to stand against a wall where the dark of her simple dress
contrasted with the washed-out wallpaper. She cocked a shoulder and
turned her face away while keeping her heavy-lidded and heavily shad-
owed eyes to the camera, a standard *ingénue* pose, taking cues from
memorized photographs of actors Theda Bara and Dorothy Gish.
Their first portrait, artless and plain.

Kiki was seeing Man Ray for the first time, too, in a way, as she
walked among the canvases, collages, assemblages, talismans, and
totems that he'd brought in his steamer trunk, the sad catalog of his
past. To avoid a hassle with customs inspectors, he'd described them

all as souvenirs, preemptive remedies against homesickness. Kiki would have seen a narrow jar filled with ball bearings swimming in olive oil; a broken alarm clock's guts in a glass box into which smoke had been puffed and imprisoned; and hanging on a wall, the piece with the most sentimental value of all, *Tapestry*. She would likely have found the canvases, collages, and *Tapestry* more to her taste than the assemblages. She preferred painting, drawing, and eventually photography to three-dimensional art, and while she enjoyed invention and the occasional abstract (and later Surrealist) flourish, figurative representations thrilled her more than all-out abstraction or overly conceptual work.

Kiki undressed behind a screen and came out covering herself with a bashful hand, shy about her relative lack of pubic hair, the "defect" she'd mentioned when they first met. Sometimes before a session, she would draw in some darkness below her belly with black makeup. (The state of Kiki's pubic hair was a detail both she and Man Ray highlighted in their respective memoirs, as did others, including the Canadian poet John Glassco.)

Man Ray failed at first to register her clearly. He could think of her only in relation to his private pantheon of muses. Something in the way she moved called to mind Jean-Auguste-Dominique Ingres's painting *The Source,* of a young woman, nude, pouring water from a pitcher. He would have seen it at the Louvre. Ingres had struggled with the canvas for three decades, conjuring an idealized nymph as an allegory for artistic inspiration, but painting her in a way that made the work double as a semirealistic portrait of a flesh and blood woman, an ambiguity that frustrated viewers when it was first displayed. Evoking that Ingres pose, Man Ray had Kiki stand before a white backdrop with one leg bent, her right hand covering herself, her left arm draped languorously over her head. He tried another shot with her perched on a dark sheet, more kneeling than lounging, her right hand just too high up on her hip to look natural while the other clung to the fabric, drawing the eye to the oversize costume jewelry bauble she wore on her ring finger.

What was Man Ray wearing? We have no record. Likely the best version of his usual getup, which, judging by the photos from these years, meant an American-cut broadcloth shirt (16 neck, 33 sleeve) with striped tie, thick slacks, and a good wool or cotton jacket, all finely tailored if threadbare and hanging just so on his compact frame. Perhaps on a peg somewhere hung the lightly colored homburg he favored for going out. No artist's smock, no eccentric ornaments. The beret would come later. To Kiki, he looked younger than his thirty-one years. But he wasn't beautiful. The artist's model Jacqueline Barsotti, a friend of Kiki's who posed for Man Ray in the 1930s, said of him: "He wasn't handsome, his nose had no opinion and went all over the place.... It was a great pity that he did not smile a lot. That little grin of his changed him altogether." Some women found his dark, hangdog looks alluring in combination with his guardedness.

Midway through the shoot, Man Ray lost focus. Kiki recalled him saying, "Kiki! Don't look at me like that! You trouble me!" He would tell it this way: "I got her to take a few poses, concentrating mostly on her head; then gave up—it was just like the old days in the life-classes; my mind wandered, other ideas surged in."

THEY ABANDONED THE SESSION and went out for a dinner she devoured. He wondered how often she got a proper meal. "All I need is an onion, a bit of bread, and a bottle of red wine," Kiki liked to say. "And I'll always find someone to give me that."

At dinner, she recounted stories from her childhood, from her jobs. A painter had adopted her, she said, alluding to Mendjizky, and was waiting for her on the coast. But she refused to leave Montparnasse for anyone. Someday, she told Man Ray, she might return to take her place among Châtillon-sur-Seine's five thousand villagers, a quiet life, maybe she would raise some pigs. For now, she wanted to have fun. She mentioned the room she was then sharing with a girlfriend on rue de Vaugirard. An imperfect setup because she always had to find

somewhere to sleep on short notice whenever her roommate's lover popped by.

Man Ray in turn told Kiki about home and why he'd left it. He'd come to Paris to connect with a few artists "who were doing advanced work." And to make pilgrimage to the museums, to sit in silence with his imagined ancestors, hoping to see as they did. Vermeer for interiors. Hans Holbein the Younger for faces and hands. Rembrandt, whom he revered for painting a scullery maid like a queen, for everything. He'd given himself three months, intending to return to New York. But now that the months had stretched to six, he could no longer say he was passing through. "Everyone is on the streets," he'd written to his brother a few days after arriving, "with wine and beer everywhere. Something is surely going to happen to me soon."

Kiki's story about Mendjizky on the coast was more complicated than she let on. It was true that Mendjizky had asked Kiki to travel south with him, but at the time of her first session with Man Ray he was still in Paris. And Mendjizky and Kiki were still together, loosely. But Man Ray, taking Kiki's mention of her uncomfortable living arrangement as encouragement, ended the night by inviting her to stay with him anytime she liked. He wasn't the rich American she might have imagined, he told her, but he was happy to share what he had with her. She told him that she would think about it. And in the meantime she would come for a second session.

He developed their first shots that same night. They looked rigid and rehearsed. He thought Kiki stood like a badly made statue, her body in jarring disharmony with its borrowed pose. He thought that maybe if you squinted, you might mistake the photos for reproductions of academic paintings, but otherwise they were failures.

Kiki went to Man Ray's room a few days later for the second session. She looked at the shots from the first session. She was satisfied that at least the nudes weren't vulgar.

They prepared to work and wound up on the bed. This time with both of them undressed, they took no pictures.

5

GRAND HÔTEL

KIKI AND MAN RAY MOVED INTO THE MISNAMED
Grand Hôtel des Écoles, popular among artists because its small
and modest rooms came cheap. In their cell were a bed, a window,
three cameras, and some lighting equipment. A bittersweet perfume
flooded the place whenever one of them opened the door to the closet
they'd turned into a darkroom. Their street, rue Delambre, ran short
and narrow, shadowed for much of the day by a stretch of buildings
spanning either side. The carrefour Vavin, at the end of their block,
lacked streetlights, and motorists honked twice while navigating webs
of streetcars, bicycles, wagons, pedestrians, dogs, and the occasional
herd of goats. At daybreak men doused the streets with pails of water,
washing away the night. Kiki introduced Man Ray around Montpar-
nasse. They were steps from the Rotonde.

Some of the locals swore Montparnasse's best days belonged to the
previous era, the anxious, bloody years that a later generation would
decide hadn't been anxious or bloody at all but a *belle époque*. The loud-
est parties had all been had, they said, the most dangerous personalities
had all left for some other utopia, or flamed out young like Modigliani
(thirty-five, tubercular meningitis) and his common-law-wife Jeanne
Héburterne (twenty-one, jumped from a window on the day of his
funeral). But people talk that kind of nonsense anywhere a new scene
is taking shape—the privilege of each generation to make the new one

feel they've arrived just too late for the main event. For Kiki and Man Ray it must have felt as if the bright days were just beginning.

MAN RAY SAW HIMSELF as a painter above all. But paintings were hard to sell. He was worried about money and wasn't doing good work. He wrote to his patron Howald, saying he still felt like an "infant" in the city, yet asking for fifty dollars a month for another six months to break from this fallow period. Howald wired him some money. Next he wrote to his parents asking them to send what they could.

While painting and making assemblages, he figured he could take on jobs photographing portraits, as well as catalog and magazine work. And he would keep shooting the work of friends who wanted to send prints to dealers and clients, but he would now ask for proper pay. He meanwhile took assignments as a society photographer, betting on his camera as the siege weapon with which to breach a world he imagined well stocked with buyers for his paintings: the rich in need of beautiful distractions who might one day make him rich as well.

These fashionable and cultured rich were a community even smaller and more insular than the Quarter's and regimented by a stricter schedule, with its revolving parade of Diaghilev ballets, concerts by members of Les Six, and costume balls where each night's new masks hid all the same faces. Man Ray got a taste of their world shooting a fall line for Paul Poiret, set up by the critic and musician Gabrielle Buffet-Picabia, wife of Francis. Man Ray had photographed her in New York. Poiret had once been the premier figure in haute couture but had to curtail his business during the war. The Poiret aesthetic, reveling in its own luxuriousness, had felt radical in the prewar years but no longer kept rhythm with the times; nor did it suit the realities of mass production and mass consumption. That Man Ray had no experience shooting clothes might have heightened his appeal for Poiret, who told him only to make sure his pictures looked different from anything else out there.

Lacking a proper studio, Man Ray went to work at the designer's

rambling headquarters on the Right Bank. It had its own open-air theater and nightclub, L'Oasis, built to pump some cash into the business and help cover the design house's losses. Man Ray brought only his secondhand camera.

On entering the atelier, he noticed *Maiastra* (1911), one of Brancusi's polished bird sculptures, perched on a mantel in front of a tall mirror. He saw that all he needed to do was pose the model, Poiret's wife, Denise, by the Brancusi piece. Its dazzling modernity would make her and her clothes dazzling and modern, too. In a single frame, he caught model, dress, bird, and their reflections in the long glass, each one amplifying the beauty of the other. (In so doing, Man Ray invented the practice of shooting models in designer clothing against a work of modern art, roughly thirty years before Cecil Beaton shot his iconic *Vogue* photo-story with models posed in front of Jackson Pollock's drop paintings.) Next, Man Ray had another model lie on a pile of fabric bolts in different colors, arms stretched out at ease, a coy expression on her face. He used long exposures to compensate for the room's low lighting. The shots came out as informal and dreamy, unlike any previous fashion images. Roughly half a century later Richard Avedon would credit Man Ray with creating the concept of the fashion photographer whose style was as recognizable as that of the labels for which they shot.

The Poiret job was quick work and paid well. Man Ray sensed he could prosper so long as he delivered photographs that helped the designers and magazine editors sell whatever it was they wanted sold. And if he gave them pictures of quality, rivaling works he would have shown in a gallery, who could say they lacked merit? In his view, the directive was the same regardless of venue: to wake people up and point them toward some other more fully realized life. And to make money while doing so.

A bonus from the shoot: Man Ray acquired (or borrowed) an exquisite geometrically patterned Poiret dress, along with an embroidered blazer and matching headband. It would have been an unattainable purchase. Kiki posed in the ensemble seated on the floor of their

studio, the skirt splayed out around her as she held up one edge of its fringe to display the pattern to full effect. In the photograph, Kiki looks almost buried by the extravagant outfit, which takes up most of the frame, her personality getting lost as a result. Of the hundreds of images Kiki and Man Ray made together, the finest were those in which she wore the simplest clothes or none at all.

By the end of 1921, Man Ray secured his Parisian debut. One of the Quarter's most stylish couples, the wealthy Dadaist poet Philippe Soupault and his wife Suzanne "Mick" Verneuil, were launching a modest gallery space in their bookstore. The venue's location was obscure enough that the show's catalog included an intricate map pointing to its location, a few blocks from Les Invalides north of Montparnasse. Soupault and Verneuil wisely chose the recently arrived American for their inaugural exhibition. Picking from among the usual Montparnasse crowd would have led to infighting. Man Ray was like Switzerland, a nonbelligerent state.

Tzara drafted an artist's bio for the flyers, pure Dada hokum: Man Ray, before stumbling upon Paris, had been "a coal miner, a millionaire several times over, and the chairman of a chewing-gum trust." His exhibition would be held "under the sponsorship of the Dada Movement. Neither flowers, nor crowns, nor umbrellas, nor sacraments, . . . nor metric system, nor Spaniards, nor calendar, nor rose, nor bar, nor conflagration, nor candles. Don't forget."

Dozens of red balloons crowded the inside of the bookstore so that people on arriving couldn't see any of the works on display, or too much of each other. When Man Ray gave a signal, some co-conspirators took lit cigarettes to the balloons, revealing the walls to the sounds of popping and cheering. There were some Cubist-inspired paintings, a few of the garish canvases he'd done with an airbrush, a spiral paper assemblage, and some readymade-like objects. Most of the works dated from his New York and Ridgefield days. There were no photographs.

People seem to have had a good time. The American journalist Matthew Josephson recalled of the opening night that the guests were young and "very bourgeois in appearance and dress, but full of laughter

at one another's sallies and capers. . . . Evidently they did not make the mistake of taking Art seriously—with a capital A." But Man Ray failed to attract any buyers despite pricing his work aggressively. "All our friends lack money as I do" was how he explained it to Tzara. Though interest in the movement was waning, Dada-related events could still make news on shock value alone. But the show garnered only a couple of sentences in a single newspaper listing gallery openings.

The best thing to come from the exhibition was a work inspired by Erik Satie. He showed up a few hours before the opening, more undertaker than composer with his black bowler hat, black umbrella, black frock coat, silvery goatee, and pince-nez. (Cocteau liked to tease Satie by saying he looked like a civil servant.) Meeting Man Ray for the first time, Satie, who spoke fluent English, challenged him to create an object on the spot for the show. They went together to a hardware store where Man Ray bought a flatiron and some shoemaker's tacks. He glued the tacks to the iron's base, creating a compact machine for destroying clothes, which he titled *Gift*.

Man Ray's iron-seething-with-nails got lost during the show's run. But before it disappeared, he'd documented it with a photograph that in turn became the work of art he titled *Gift*. By Man Ray's twisty Dada logic, this secondhand representation exuded even more aura than the original, the idea superseding the thing itself. Who could prove there ever had been an actual iron-with-nails before the photograph came into being? (Nearly fifty years later he would oversee the production of five thousand replicas of the original iron-with-nails. Now these objects were presented as the works of art. He signed each of the five thousand replica *Gifts* and sold them for $300 apiece.)

No recollections of the show, which ran from December 3 to New Year's Eve, remarked on Kiki's attendance. And Kiki was not someone whose presence at an event tended to go undocumented. She may have been in Châtillon-sur-Seine to celebrate the holidays with her grandmother. Less likely, but possible, is that she stayed away, perhaps not yet sure how she felt about Man Ray, or still hesitant about so publicly associating herself with him. Although she and Man Ray lived

together, Kiki at that time remained reluctant to quit Mendjizky out-right. As one of her friends recalled, Kiki was sad to leave Mendjizky and didn't do it "at once but rather stayed away one night here, one night there, and soon did not go back to him."

Despite Kiki's apparent absence from the show, her relationship with Man Ray clearly grew stronger as 1921 gave way to 1922. She was soon writing to friends of her excitement for her new love. In a postcard to Tzara ("Zara," she called him), she drew herself and Man Ray embracing. She emphasized their large noses, hers pointy and his beaklike, writing, "Our two noses make sparks because we're both well born," a pun in French, as *bien née,* "well born," sounds like *bien nez,* "good nose" or "big nose."

Kiki encouraged Man Ray in the wake of his show's failure. He worked constantly. He photographed Francis Picabia, imperious behind the wheel of his 85-horsepower Mercer. Through an intro-duction from Picabia, he photographed Gertrude Stein, in a first shot looking aloof beneath her rows of Cubist explorations, and in a sec-ond, pensive, seated next to Picasso's portrait of her in which she leans forward as if listening to someone out of the frame. He captured Stein and Toklas in a wide shot to take in the gorgeously peeling walls, the fresh-cut flowers, and the wood and stone fireplace decorated by a ceramic jug on the mantel, as big as Toklas's torso, and slim terracotta figures. And finally Stein again, alone, at a second session in the far less luxurious setting of the Grand Hôtel des Écoles, of which she wrote, "I have never seen any space, not even a ship's cabin, with so many things in it and the things so admirably disposed." Recalling their first meeting, Stein wrote, in the voice of Toklas, that Stein told him "she liked his photographs of her better than any that had ever been taken except one snap shot I had taken of her recently. This seemed to bother Man Ray."

Shortly after the Stein sessions, he photographed Cocteau, holding up a picture molding to frame his birdlike head. He photographed a monocled Tzara balancing on a high landing, cigarette held between thumb and pointer while an axe and a clock loom overhead like the

sword of Damocles on a timer. He photographed a close-up of Artaud's hands, playing sugar cubes on a black table as if they were piano keys. He photographed Philippe Soupault, shirtless and menacing, looking more prizefighter than writer, if prizefighters boxed while smoking and sporting fedoras and polished Malacca canes. He photographed the American writer Sinclair Lewis seated in front of a big wooden wine press that Brancusi had spotted in a secondhand store and that looked like one of his sculptures through Man Ray's lens. He photographed a head-and-shoulders shot of a smiling Erik Satie, looking like a cuddly grandfather.

Everyone led to someone else. Man Ray went to Adrienne Monnier's bookshop and lending library to hear James Joyce read from his soon-to-be-published novel *Ulysses,* and a few weeks later he got hired by Monnier's lover and protégée Sylvia Beach to shoot publicity stills for it. Beach would sell *Ulysses* at Shakespeare and Company, her shop across from Monnier's, while Monnier sold the French translation. The Joyce session ended up being a frustrating one. Joyce had undergone eye surgery and, despite his thick smoked glasses, struggled to look into the lens, blinded by the glare from the lamps. Beach gave Man Ray free advertising by hanging some of his portraits on her bookshop's walls alongside the William Blake etchings and the pictures and writings of Wilde, Whitman, Poe, and dozens of others occupying nearly every inch of wall.

Man Ray photographed quickly, usually about ten or so feet away from his sitters to avoid distorting their features while using a long lens to flatten out features. He allowed for some blur if it should happen organically, trusting he'd get what he wanted by cropping, enlarging, or playing with the grain of the picture in the darkroom. He was a compulsive retoucher of his photographs. Let there be chaos in front of the camera, because there would be coolness behind it, was his thinking. The scenarios he shot at that time could be imaginative, but he lit his scenes simply. He would place a single bulb on a stem between the sitter and the wall to ring the subject in light, or hang a bulb from above to highlight the sitter's hair while the sitter held a

metal sheet out of the frame to reflect the light from below. He was almost antitechnique. He wanted to make images that could "amuse, annoy, bewilder, inspire reflection," he once said; "not to arouse admiration for any technical excellence."

IN HIS FIRST YEAR in Paris, more than all the clients and friends combined, he photographed Kiki. She was the sitter who had the most patience with him as he figured out what he was doing, in the safety of their studio. Their shots from 1921–22 didn't feature elaborate costuming or theatrical poses, as in some of the images they would make a few years later. Instead they look dashed off, the photographed equivalents of pencil sketches or watercolor studies, and with the intimate feel of casual snapshots taken of a loved one, which on some level they were.

A few months into their relationship, Man Ray photographed a spare, head-and-shoulders portrait of Kiki sweetly smiling, looking like someone you would want as a confidante. He used a short depth of field, bringing her eyes, nose, mouth, and the edges of her bobbed hair into focus while the edges of her head and body blend softly into the hazy background. Unlike many of Man Ray's portraits of others from around the same time, the shot doesn't try to make a joke, or pose a question, or even excite the senses. There is only Kiki as she is, radiant and happy, waiting to hear your secrets.

Kiki and Man Ray produced three nudes in this same period. Each one showed Kiki's body in a fragmented form. First he photographed her at close range, framed from the waist up, lying down with her eyes closed as if sleeping, but with her lips parted to reveal her teeth, almost snarling. The combination of sleep and snarl produces an uncanny, borderline frightening effect. This photo of Kiki, tightly focused on a closed-eyed model who lies west to east across the frame, her right cheek pressed against sheets, offered a counterpoint to Man Ray's earlier painting of Adon Lacroix, tightly focused on a closed-eyed model, lying east to west, her left cheek pressed against sheets. Maybe he just liked

the composition. Or maybe he sensed that his encounter with Kiki was both a continuation and a reversal of his relationship with Lacroix.

The second and third nudes Kiki and Man Ray made in 1922 play with erasure. In one photo, she holds a silk cloth against her hip bones. Her exposed upper half floats against a deep black backdrop offering no discernible separation between her hairline and the drape behind her. She hides her right hand behind her back and stands far enough away from the lens that her face turns into a semiabstract signifier of femininity: two black arched eyebrows, two dark patches of eye shadow, the two nostrils of a nose that the camera's low angle turns retroussé, and a slash of red lipstick. The viewer sees only the edited version of Kiki that Man Ray wanted to present. Or we're seeing only what Kiki wanted to show us.

In the other photo, posed against the same black drape, Kiki's individuality comes across more, though she still appears in an abbreviated form. Again, she hides her right hand from view, this time behind her head, while her right arm drapes backward as if she were stroking the back of her slicked hair, a pose found often in classical sculpture that Man Ray used regularly. And again, like some recovered marble sculpture whose limbs have been lost to time, Kiki's legs have been chopped off, this time by some white fabric draped against her thighs, on which rests her left hand and wrist, displaying a thin gold bracelet. She engages the viewer directly, looking down from above as if in judgment, but with a sense of being simultaneously appraised.

If Man Ray put a huge amount of thought or labor into composing, lighting, or retouching these early nudes, it was well hidden. He seemed to understand Kiki's innate gift for performance—although she had yet to appear on any stage—and that his main task was to be there to capture her as she presented herself. He could at this time have said about Kiki something similar to what the photographer Clarence Bull said about Greta Garbo: "Others had tried before me to solve the mystery of that beguiling face. . . . I accepted it for what it was—nature's work of art. . . . She was the face, and I was the camera. We each tried to get the best out of our equipment."

Outside the studio, they took two snapshots that survive from 1922. These are relatively rare artifacts among Man Ray's thousands of negatives. He wasn't the kind of photographer who carried a camera wherever he went, waiting for the right moment. The snapshots look not much different from the kind any other young couple in Paris might take, if more skillfully executed. In one Kiki stands alone in a cobblestoned street on the hill of Montmartre, finding the spot just where the bright sunlight ends and the street behind her trails into darkness, while the outline of one of the domes of the Sacré-Coeur basilica peeks through in the background. Later that same day Man Ray caught Kiki leaning alone against a fence by the stairs behind Sacré-Coeur, displaying her cloche hat and the boxy handbag she took with her everywhere. The pattern of her long coat echoes the maze of northern Paris behind her, receding into shadow, in a visual rhyme with the first image's cobblestoned street.

Kiki's favorite picture from their first year together was neither a carefully posed nude nor a casual snapshot but a straightforward if slightly blurry portrait, in which she wears a simple dress and a prim felt hat. She sits casually in a wooden chair with her hands clasped on her lap, a faraway look in her eyes, like a bored schoolgirl waiting for the end of class. Kiki cut a print of the picture into an oval and gave it to Man Ray with the inscription, "1922, all my love to sweet little Man Rey, little Kiki," misspelling his name as a joke, maybe to play on *rey*, meaning king in Spanish, or maybe just trying to take the piss out of someone who took his identity so seriously.

Man Ray didn't yet try to show or sell anything they'd done.

6

ALL TOMORROW'S PARTIES

KIKI'S BODY TOLD HER WHENEVER SHE'D REACHED her fill of city living, eating too little and drinking too much, at which point she would buy a ticket for the next train bound for Châtillon-sur-Seine. She spent a few weeks there in March 1922. Evenings she walked under broad canopies of oak and hornbeam. Nights in her old bed were quiet as a tomb, the skies outside bursting with stars. And then, as soon as she felt restored by Grandmother Prin's cooking and the country air, she'd be itching again for Paris.

From a café in the drowsy village square, she wrote Man Ray. She was always first to start a communication when they were apart. Man Ray subscribed to the idea that a romantic relationship was a kind of war, and the winner was whoever revealed less of himself to the other. Among their friends, he made sarcastic pronouncements about love's impossibility, playing the jaded lothario even as everyone saw how smitten he was with Kiki.

She wrote to him in her spidery scrawl:

You shouldn't complain because you have one of the most beautiful little women of the Rotonde. Not dumb, in love, not boring, not a woman of luxury, not a whore, and not syphilitic (a little miracle). . . . I love you too much. To love you less I'd have to be around you more. And that would be good because you're

not made to be loved, you're too calm. I have to beg for a caress, for a little bit of love sometimes. . . . But I have to take you as you are. . . . I bite your mouth until it bleeds and get drunk off of your cool mean stare.

We have no record of Man Ray's response.

She wrote to "Dear beloved-Tzara," too, complaining with comic exaggeration of her sadness. "The trees are still bare . . . and you and Man Ray are probably right now in the middle of sitting down to a nice coffee. Is there no justice? What have I done to deserve such suffering? I wander around without seeing a thing, like a sleepwalker." She signed the letter "poor crying Kiki."

Tzara kept Kiki's letters until he died and reportedly drew on them for sections of his unfinished novel (circa 1923), *Faites vos jeux* (Place Your Bets), though the connection is not explicit. His responses to Kiki do not survive.

IN PARIS, Man Ray wrote his own letter, to his patron Howald, telling him about having released himself "from the sticky medium of paint." He was working "directly with light itself," tinkering with a process he dubbed Rayography. He discovered this new method in the darkroom after dropping a blank sheet of photo paper into the developing tray. When he fished it out, he saw ghostly markings wherever the sheet had brushed against the measuring glass, funnel, and thermometer submerged alongside it in the bath. He repeated the accident on purpose, and it again yielded weird spectral silhouettes.

He used whatever he found in the studio. Thumbtacks, tumblers, an egg, keys, a cheese grater. He mashed them together or paired them with abstract cutouts and placed them onto dry photosensitive paper. Coiled wire, a candle, a comb. He moved lights around to cast their beams from various angles, flashing them on and off, or jiggling them, lending depth and movement to the images so that each one looked like an entire movie reel compressed into a single still. He'd trim a

bit from one piece of developed film and place it on another as the chemicals worked in the tray. Rayography freed him to make photographic images in layers, applying light and shadow like brushstrokes, rather than trying for it all in the moment of a shutter's release. Later came lit matches, incandescent bulbs, a pistol, a silhouette of Kiki's head drinking from a wineglass, and another of his and Kiki's heads pressed together in a kiss. Sometimes he had a finished idea in mind. More often he was seeing what came from his conjuring as the images bubbled up before him.

Man Ray wasn't the first to play with ways of circumventing the camera by drawing directly onto film. But he pushed camera-less photography in a new direction by showing how light, paper, and developer could be used to make the stuff of dreams and fantasy. And he did so at a time when people still debated whether photography even qualified as an art form. Each Rayograph hinted at the possibility that photography's greatest value lay not in its supposedly indexical nature but in how it could reveal the ways we fail to see anything clearly. The Dadaist writer Georges Ribemont-Dessaignes interpreted the Rayographs as truthful recordings of scenes that had themselves been falsified. Man Ray "invents a new world and photographs it to prove that it exists."

Duchamp, back in New York where he'd helped to open a shop specializing in dyeing ostrich feathers for the fashion trade, sent a joking note of congratulations, one scientist acknowledging the other's latest breakthrough. Howald wrote as well to voice his concern about this unexpected swerve. And he warned that those few Americans who knew Man Ray's name might forget it if he stayed out of the country much longer. Man Ray answered by telling Howald to help himself to as many paintings as he wanted from among those he'd left behind. He had removed himself from "the fierce competition amongst the painters here," he told Howald. "I have something unique."

BY THE EARLY SPRING, Kiki had recuperated and returned to Paris. Sometimes, alone in the studio while Man Ray was off on a

job, she would draw or paint watercolors. They were mostly of recollections from childhood, by turns tender and sardonic. If she didn't feel confident painting some part of her tableau, she would cut out a photograph or illustration from a magazine and paste it onto her picture. Her scenes were sunlit and uncluttered, giving the impression of endless space and lazy time, everything open and unfinished and airy. She showed no interest at that time in having a showing of her work, though she might sometimes gift a picture to someone stopping by. Man Ray admired Kiki's skill and encouraged her to continue. And yet he considered her image making as little more than the solution to "her own problem of what to do with her spare time, [which] hung heavily on her hands," as he wrote in his memoir.

One night toward the end of May, the dealer Henri-Pierre Roché came to the Grand Hôtel des Écoles to see about hiring Man Ray to photograph some paintings that John Quinn was thinking of buying. Quinn was Roché's most lucrative client, a wealthy New York insurance lawyer who helped to launch the Armory Show, fought against obscenity laws, and lobbied his government to abolish taxes on imported art, saving himself a fortune in the process. Roché was at that time relatively novel in buying works for his clients while showing them only photographic documentation and describing the pieces by telegram.

Parisian, tall, and urbane, Roché also collected contemporary art for himself and did it well, with perfectly timed taste. Having no academic training, he'd developed his eye for emerging talent by paying attention to the comments and habits of friends like Duchamp and Léger. Parallel to his writing work, he cobbled together a career combining the roles of artists' agent, publicist, talent scout, curator, buyer, and dealer. (In his seventies, Roché would draw on memories of his bohemian youth to pen *Jules et Jim,* which François Truffaut adapted to film. While the ceramicist Beatrice Wood is widely credited as the model for the character of Catherine, it's worth considering whether Roché threw Kiki into the mix as well.) Roché was a "general introducer," in Gertrude Stein's words. He'd been the one to introduce

Stein to Picasso. He knew how to connect person A with person B so they would lead him to person C, his true quarry.

Roché was the first of anyone who knew her to take Kiki's art seriously, including Man Ray. Having come to their apartment to hire Man Ray, Roché left having bought two watercolors by Kiki. (Which ones aren't known.) Roché wrote in his diary that with their summery tones and quick lines, they reminded him of Matisse. His purchase shouldn't be understood as a friendly gesture. Roché was no philanthropist. He was also cognizant of Kiki's status in the neighborhood. He described going after his visit to the Grand Hôtel studio, with Tzara, Man Ray, and Kiki "to the Rotonde, where she is one of the queens." He also understood Kiki's position as outsider and insider at the same time. He described her in his diary after that first meeting both as "the mistress of Man Ray . . . of whom I see beautiful nude photos," and as "a Burgundian, smart, knows her way around."

By Roché's account of that visit, we can deduce that Man Ray had started producing nude photographs that viewers would have understood as meant for private enjoyment rather than public display, apparently with a commercial angle in mind. Man Ray showed him some "very moving pictures of lesbians, in the most luscious poses," as Roché described, which have not survived. In his memoir, Man Ray seems to describe making these shots. He wrote of how one day an artists' model asked if he would take nude photographs of her that she could give to painters so she wouldn't have to undress every time she auditioned for a posing job. Man Ray agreed so long as she returned with another woman, as he wanted to make some shots that went beyond "a single static nude." He wrote that the women "were more at ease than if they had been alone; at my suggestion, they even took some intimate poses with arms around each other, making for rather complicated anatomical designs."

Roché also wrote of being shown explicit photos of "love-making between a man and a woman." His accounts are supported, somewhat, by Jacqueline Barsotti's claim that when she first began posing for Man Ray, she heard rumors that he'd "started [his career as a photographer]

with pornography." Roché also wrote of bringing over his own erotic photographs taken of various lovers for Man Ray to develop.

Roché hired Man Ray to shoot three Picasso paintings for Quinn's inspection, offering him thirty-five francs a print. This led to Man Ray's first meeting with his idol, that spring of 1922. After completing the job, he took Picasso's portrait as well, rendering him as a commanding presence in front of his paintings, his severe look softened by the slouchy cable knit cardigan he wears over his shirt, vest, and tie.

THAT SUMMER, with Man Ray's steadier income from portrait work, they took a studio in a well-appointed block of artists' flats on 31 bis, rue Campagne-Première. Now they were five minutes rather than five feet from the Rotonde. From their double-height main room, a wooden staircase twirled up to a narrow balcony, dappled for much of the day by light seeping in from an *oeil-de-boeuf* window. The balcony stretched just wide enough for a bed. They had the luxuries of central heating, gas, electricity, a rented telephone, and a bathroom that doubled as a darkroom, as well as the relative rarity of a doorbell. It felt palatial, this studio slightly less tiny than the last one. They found a worn Persian rug and some creaky chairs from the flea market, splurged on a wind-up gramophone, and decorated the main room with a big Rayograph of some ferns, a few of Man Ray's paintings, and a favorite photograph that he took of a menacing-looking Duchamp.

They adopted a routine that Kiki called their "little life." She organized his workdays and handled his appointment book. When she spotted the names of women she didn't know, she altered the letters to make them indecipherable. He took this as a sign of devotion, evidence, as he put it, that "Kiki had been domesticated." She answered the phone and door. She helped him interact with French-speakers. Their friend Malcolm Cowley referred to Kiki as Man Ray's "bedside dictionary." Afternoons she kept away so he could shoot sitters uninterrupted. If she did happen to be home when a client called, he told her to hide up on the balcony until the session's end.

In the evenings Kiki and Man Ray would meet at one of the cafés for a drink before returning home for dinner. If he'd been invited to anything that might lead to a commission, he could cancel without notice. There is no record the same privilege extended to Kiki if she found posing work. Kiki did the shopping and cooking and serving. She stretched their money to create fabulous Burgundian dishes with artfully prepared salads and expertly chosen cheeses, always paired with good wine and followed by brandy. Kiki's seemingly innate ability to serve just the right food and drink according to the social situation, and to have attained that knowledge without money or much exposure to traditional forms of "high" culture, should have been a wonder to Man Ray, just as this aspect of French life surprised so many visiting Americans. "Certainly, a dominant part of the aesthetic civilization of France is based upon the creative faculty of choice," Janet Flanner, at that time the Paris foreign correspondent for *The New Yorker,* said in an interview. "Taste, based upon nothing else. In America, buying just what is advertised—that is not taste. That's opportunity."

When they had guests, Kiki sang folk songs after dinner. She would emphasize a lyric here and there with a knowing smile or well-timed gesture, singing as though in sole possession of a song's secret truth, which could be hinted at but never revealed. Pitched for the pleasure of an audience no larger than three or four (any more would have made her too self-conscious), her voice rang out clear and strong and perfectly tuned.

At night's end Man Ray usually returned to the slow tactile labor of the darkroom where he often stayed until dawn. "I spread out on the bed while he works in the dark," wrote Kiki. "I see his face lit by the little red light. He looks like the devil incarnate. I have no patience. I can't wait for him to be done."

THE 1922 BASTILLE DAY CELEBRATIONS in mid-July kicked off a nightly bacchanal that many Montparnasse memoirists would recall as continuing nonstop all the way to summer's end. On the

night of the fourteenth, a young woman named Thérèse Maure was out celebrating with some dancer friends and a few Russian artists at the Rotonde. They sat on folding chairs lined up to face out to the street like a theater's rows and watched as Kiki danced in the boulevard Raspail, dodging traffic while leading the terrace crowd in a new craze, *le fox* (the foxtrot). *Le fox* represented a shockingly modern stylistic leap relative to how people had been dancing just a few years earlier. Kiki, still unsure of how exactly the dance was done, rocked with laughter at her poor performance, getting everyone to laugh along with her.

Having fled a cosseted childhood in an affluent suburb of Paris and now trying to live in relative anonymity in Montparnasse, Maure was drawn to this dancing woman, whom she'd never seen before. She seemed as unbridled as Maure was reserved.

Later in the night they got to talking and discovered they lived next door to each other. As they got to know each other better, they found they'd been born a few months apart, and both were fascinated by tarot. Kiki and Thérèse would take turns that summer reading cards and offering consolation when one felt troubled. Together they spent hours in the evenings getting ready to go out. Sometimes Kiki painted her eyes in triangles to match the shape of her earrings, or matched her eyebrows green to her dress's color. After going to the annual Bal des Quat'z'Arts (Four Arts Ball), they held hands, joining in the custom of ending the night by jumping into the fountain at Place de la Concorde. Each would eventually keep a mouse as a pet—Kiki's white, Thérèse's black—which they brought to the cafés in tiny baskets.

Thérèse took on the role of Kiki's protector, a dynamic most apparent whenever Kiki drank. Thérèse had studied the experimental methods of Georges Hébert, a former naval lieutenant whose rigorous course for women adapted classical ideas about perfecting one's body and spirit to suit the modern age. She was now teaching it, training women in boxing, modern dance, and gymnastics in Paris and at a camp in the seaside gambling resort town of Deauville. Whenever she and Kiki went to one of the big costume balls (Man Ray rarely joined),

they would dance with each other the whole night. If you danced with a man, he assumed you were his property, Thérèse later explained to an interviewer. And when Man Ray left Paris for work, Thérèse would often share Kiki's bed, as Kiki hated to sleep alone.

Thérèse would remember Kiki as "an extraordinary girl . . . beautiful [and] pure . . . an artist." Like many of Kiki's admirers, Thérèse appreciated her wicked sense of humor. (For Kiki, the grimier the joke, the better: she once suggested that the appropriate punishment for a journalist who'd been found guilty of blackmail was to throw him into a public toilet and pull the chain.) Kiki in turn called her friend "a walking encyclopedia." She was known among their circle for her impressive memory and her wide-ranging curiosity. "She and I make one person," wrote Kiki. "If something happens to one of us, it happens to both of us—even punches, whether given or received."

Following Kiki's lead, Thérèse recognized that Montparnasse's cafés were where you went to change your life. It was at the Dôme café, across the boulevard from the Rotonde, that Kiki and Man Ray introduced her to the poet Robert Desnos. He was just back from two years of mandatory military service in Morocco, a quiet charmer with floppy hair, oyster-colored eyes, and a sensuous mouth. Thérèse tried, unsuccessfully, to teach him how to throw a good punch after he showed up one night sporting a black eye of mysterious provenance. He took to calling her Thérèse Treize (Thirteen). As they became involved, she adopted the nickname as her own.

There was power in an alias. As one artist's model from that era, Zinah Picard, put it, "the liberation of women after the war . . . was instinctual. . . . It was important to leave one's family—for example, Thérèse, taking the name Treize so she would not be known by her family. You visited your family, but they never knew what you were doing." And people who'd grown up in the city could still break from their families through a change of address. Desnos had also rebelled against his family's expectations. His father, who ran a wholesale butchery at Les Halles, was embarrassed to learn that his son lived in converted artists' studios in Montparnasse on the same patch of grass

where he used to buy vegetables to sell alongside meat from his market stall.

For Treize and Kiki, and for other young Frenchwomen who came to Paris from elsewhere, seeking to live an unconventional life in Montparnasse meant more than fun and familial rebellion. Reinventing oneself took bravery. As personal desires merged with political ones, pursuing one's own happiness constituted a genuine attack on the country's Catholic conservatism, even if it started with something as seemingly small as a name change. In the wake of the Great War, as neighboring Germany threatened to grow stronger and more populous each year, French women lived under immense pressure to marry and produce children. The unofficial collusion of the state and the Catholic Church, both concerned about dwindling birthrates, yielded such repressive measures as the outright banning of the sale of contraceptives in 1920.

But in Montparnasse, you could drive your own car, your lover in the seat next to you, both of you smoking, wearing whatever you wanted, your hair cut however you liked, and no one seeing you would think twice about it. No one would laugh at your calling yourself an artist, either. It was a job title, as valuable to a modern society as any other. And while you worked to have enough to eat while dreaming of the break that might see you living comfortably, the prevailing idea was that the process should be as important as the product or its rewards. "We were not then concerned with the results of our actions," wrote Cocteau (if decades after the fact, and by then wealthy and famous). "None of us saw things from the historical viewpoint— we merely tried to live and to live together."

LATE IN THAT SUMMER OF 1922, Kiki and Man Ray hosted a housewarming party. Kiki did an enormous shop that morning. Everyone was told to bring a bottle of something, whose contents Tzara immediately poured into a communal pail as guests arrived. The Japanese painter Tsuguharu Foujita, who drank only mineral

water, played jazz records that he and Desnos had scored at a flea market. Jacques Rigaut, another poet, notorious for slicing a button from the clothing of everyone he met to amass a huge collection of stolen mementos, suspended himself by one hand from a hook high in the ceiling, to which he'd jumped from the balcony. For Man Ray, the night offered a chance to display himself as main consort to the Quarter's beloved Kiki.

At one point late in the night, Kiki looked down from the balcony to see Man Ray chatting up the two daughters of a decorated general— and bolted down to smack him on the head. She swore at him and then the two sisters before dashing back upstairs. He rushed up to her and said that he'd only been trying to ascertain whether they'd held more value as models or potential clients. He and Kiki had made up by first light, when the building's concierge arrived waving a signed petition from the neighbors demanding their eviction. Man Ray slipped him a few bills to quash the issue.

Some other current had pulsed alongside the night's jokes and impromptu doggerel and invitations to share meals and beds. People showed their public faces in the cafés and raised public voices in the chalky pages of obscure journals, but the real Montparnasse was created nightly over spilled drinks and free-flowing conversations in small rented rooms like theirs on rue Campagne-Première. Out of their intimate clash of incongruous personalities, Kiki, Man Ray, and their friends were developing a shared sensibility, their private lexicon of nonsense words and secret signals, the whole system shored up by their sense of self-fascination.

Only when they were together could they recognize how profoundly they'd been shaped and misshaped by the hard facts of the recent past, even as they tried to deny the power of history. Only when together could they sort through the problems unique to their generation, one not so much lost as scattered. And lonely above all. A generation unable to see three young men huddled to share a joke at a table without picturing the missing fourth taken by the war. One that saw plainly in the women wearing black what the officials would eventu-

ally confirm: a quarter of France's male population aged eighteen to thirty, gone.

"Those who in early youth were witnesses of nothing but death and destruction, those who survived that cataclysm of stupidity (which seemed as if it would never end) turned with a kind of fever toward life," wrote Soupault, who'd been injured in battle. "My generation wanted to be *alive* at all costs. We wanted to love life—with which we had good reason to be disgusted. And we did love it. The greatest evil was to be dead. We would always distinguish among persons we knew, by saying that so and so was 'alive,' but so and so was 'dead.' "

The feelings Soupault described weren't limited to former soldiers. Anyone their age, born around the turn of the twentieth century, had already witnessed so much, so quickly: the tumult of great cities growing skyward; the discovery of radioactivity and the X-rayed exposure of inner mysteries; Einstein's smashing of Newtonian conceptions of time and space, and the shocking proposal that one person's subjective experience of time could unfold differently from someone else's; the spread of thick cables across ocean floors and the building of radio towers; Freud's suggestion of a subconscious mind, irrational, illogical, and secretive; a hardening of positions in an increasingly polarized mass press and the invasion of propaganda into every facet of daily life; the newfound ability to massacre from the air; food riots; bank runs; the revolution in Russia and the fall of a three-hundred-year-old dynasty; reports of men on both sides executed by their own officers for failure to kill.

One could hardly be expected to make sense of the era's cruel mathematics, when people spoke calmly of one man dead for every meter of soil gained, say, in this battle or that one; of more French dead than any one country had yet lost in the history of armed conflict, and that number reached even before the waves of influenza had completed their own terrible accounting. How to make sense of the new technological wonders: tear gas, chlorine gas, phosgene gas, mustard gas, flamethrowers, depth charges, machines guns, tanks? And meanwhile the language of their newspapers and books held no relation to the

language of their streets, let alone the language of the trenches. It was the language of an ancient civilization.

Léger, who'd been gassed at Verdun and after the war seemed to live every second as though he were on fire, wrote to a friend of how "the man who for four years has been exasperated, tense and anonymized finally lifts his head, opens his eyes, looks around, stretches, and finds his taste for life: a frenzy of dancing, thinking, yelling out loud, of finally walking erect, shouting, yelling, squandering. An eruption of energy fills the world." For some, amnesia was a side effect, a result of the violence and dislocation they'd experienced. For others, amnesia was a conscious strategy, a way to try to survive unstable times. It felt like the best possible answer to the era's particular demands: to approach time as a flurry of moments to be dealt with as they came. They were being not reckless but cautious.

And with such caution came the need for communion. All of them locked in the same tight spaces trying to sustain the perpetual nowness of their lives. There was nothing to find in the past but bad debts and dead bodies. And when they looked ahead, they ventured only so far as the next chance to talk, to fight, to dress up, to scheme, to be young together late at night.

7

WAKING DREAM SÉANCE

NEAR THE END OF SEPTEMBER 1922, KIKI, MAN Ray, Desnos, André and Simone Breton, and a few other friends listened as the writer René Crevel recounted the adventure he'd had on the Côte d'Azur over the summer holidays. He'd met a young woman in an orchard near a beach, and she'd invited him to her home. There among shelves sagging with esoteric books on the occult, she introduced him to a family friend, an elderly spiritualist calling herself Madame Dante. They held a séance in which Madame Dante put him into a hypnotic trance. Crevel remembered few of the evening's details but was sure that in his haze he'd made the most beautiful speeches.

Now in Paris, they wondered if they could adapt Madame Dante's methods to suit their own needs. To communicate not with the departed but with their own buried selves in a search for inspiration. Theirs would be a rational program for drawing out the irrational. They would derange their senses through exhaustion and then answer questions posed to them in their twilight states. Their dream-thoughts were sure to be poetic once brought to the surface. By making themselves into conduits between the sleeping world of truth and the waking world of lies, they would express themselves with absolute purity, unconcerned by the need to make sense or avoid taboos. Crevel and Desnos were twenty-two years old, Simone Breton twenty-five, and her husband twenty-six. Kiki was just shy of twenty-one. Man Ray

at thirty-two ranked as the senior figure. A few of them had read some Freud.

So started the stretch of months they came to call "the period of sleeping-fits." They held the first session in the Bretons' apartment above a cabaret on rue Fontaine, near the Moulin Rouge, in a darkness spoiled only by the neon glare from the street and a sliver of moon. Sitting around a circular table in a room cluttered with masks, statues, books, and carefully piled stacks of river stones, they clasped hands. The Bretons, Crevel, Desnos, and a few others took turns lulling themselves toward the fuzzy edge of sleep while the Bretons' dog Peticoco wriggled between their legs. Kiki, who grew up hearing folktales about the powerful and not always benevolent influence of visitors from the spirit world, watched anxiously and refused to take part. It's unclear if Man Ray joined in or merely observed.

Each participant rooted around his mind like a mole in the ground while the others recorded his ramblings. They spoke of trips to the equator with film stars; visits to floating lands populated only by giant plants. They sighed, chanted, scratched the table, laughed uncontrollably, and bore witness to confessions of infidelity, bloodshed, and ecstatic revolution. One of them predicted the assassination of another. Their sunken voices sounded oddly different from their normal ones. Kiki left the room terrified when a trembling Crevel ventriloquized the voice of an attorney defending a woman who'd honored her husband's request to drown him. The tales they spun, Simone Breton later told a friend, were as horrifying as the darkest passages from Lautréamont's *Maldoror*. No one had any memory of what he'd said. All swore the stories unfolded of their own volition. It felt as if they were taking dictation from the astral plane.

Over the next weeks, they repeated the experiment, and their group swelled. Man Ray documented one night's proceedings, or a re-creation of the proceedings staged for his camera. He photographed Simone Breton typing out Desnos's speech, crowded by a half-circle of men with brilliantined hair and black coats. André Breton commands the frame's center, peering down at the typewriter like a biologist at a

petri dish, his hand cupping his chin and mouth. Desnos below him has a palm out in supplication as though begging patience from his listeners. It's a picture of private dreaming elevated to public performance. Man Ray titled it *Waking Dream Séance*.

Desnos showed the greatest capacity for working in the realm of dream logic. He could put himself under in any noisy bar, or alone in his room with a pen and paper to record his automatic writing. Normally shy and secretive, he became effusive in slumber, answering any question he was asked. His pronouncements nearly made sense. He sleep-spoke of standing with Robespierre facing a crowd, a guillotine, and a bird of paradise. During one trance, he rose from his chair and, supposedly sleepwalking, grabbed a kitchen knife and chased Paul Éluard around the room. He recited telepathic communications he said came to him directly from *Rrose Sélavy* across the Atlantic—but never from *Rrose's* creator Duchamp. Another participant, Louis Aragon, wrote that Desnos delivered his prophecies in a voice so full of "magic, revelation and Revolution" that in a different time he could have started a religion, or overthrown a government, or founded a city.

Aragon must have had some special insight into the realms between consciousness and unconsciousness, having been buried in rubble from grenade explosions—several times—as an auxiliary battlefield doctor, once so deeply he was mistakenly declared dead on the field. He, Desnos, and the others met "like hunters, comparing . . . the tally of beasts we'd invented, the fantastic plants, the images we'd shot down." They grew desperate, as Aragon worded it, to spend as much time as possible "in oblivion."

They went from holding a séance every few weeks to holding several in an evening. They pushed each other to take things further and further, even while feeling shattered. No one wanted to be the one too scared or exhausted to continue. Crevel and Desnos competed to see who could fall asleep first and most productively. Desnos, who friends described as someone who seemed to burn with a perpetual fever, looked even closer to collapse than usual. They lost their appetites. They started second-guessing one another's motives.

They wondered whether their visions were truly improvised or staged performances. (To Aragon, the distinction was pointless. One way or another they'd been pushed to make something new, negating any discussion of whether the product was somehow "false.") They started to admit to each other their fears about the psychological toll of spending so much time drowned in their other worlds. The period of sleeping-fits wound down.

They'd found some of the inspiration they'd been seeking. The visions made their ways into poems and novels, whose effectiveness varies with the degree of patience one has for listening to other people's dreams. More important was that through their experiences, they'd seen how two incongruous ideas could be fused together to form a third one, how the rational and irrational could comfortably occupy the same place at once. Their minds had been unleashed, rewired to accept chaos without judgment, to welcome the unexpected. No longer bound by seeing reality and the unreal as polar opposites, they pushed past this binary to form a broader definition of experience and entered into the "shared horizon of religion, magic, poetry, dreaming, madness, intoxication, and this fluttering honeysuckle, puny little life," as Aragon wrote. Charged by this new approach to thinking and writing, they applied it to their reading, going back and discovering what Aragon called "a great poetic unity" running though earlier prophetic works—the poetry of Baudelaire and Rimbaud; Lautréamont; the Old and New Testaments—that held mysteries to be solved by those who knew how to single out those "certain words" containing the power to "exhilarate."

They were reaching toward the language of Surrealism. The word had been brought into being five years earlier by Apollinaire. Many in Montparnasse saw the late poet and critic, dead of Spanish flu two days before the Armistice, as the spiritual godfather of the avant-garde, one of the earliest champions of Cubism and of Duchamp. Apollinaire had witnessed firsthand the smashing of reason and reality while fighting for France (though born in Italy) as an infantry officer. He first used the term *sur-real* to describe the staging of the Ballets Russes

production of *Parade* (1917), created by Picasso, Cocteau, Satie, and the Russian choreographer Léonide Massine. But the word, the idea, lingered, holding other possibilities. The small group of explorers that had coalesced around the period of the sleeping-fits wondered if their subjective feelings of exhilaration and intoxication might be collectively channeled toward something beyond an artistic revolution: a fundamental change in the way people lived.

KIKI, FOR ONE, quickly lost interest in their nocturnal games. They never stopped talking, these poets so full of misdirection. She thought of them as silly kids from good families playing at being dangerous by poking around in the hidden depths of the mind. (She wasn't wrong: Breton, Tzara, Picabia, and a few of the others in their circle had trusts or inheritances that relieved them of much financial pressure.) She enjoyed talking with some of them, especially Aragon, Breton, and Desnos. "What I liked about them was that they were so clearly just a bunch of wise-asses. . . . They'd go see clairvoyants, played with their Ouija boards, talked to spirits." But she felt that as a group, they dealt too heavily in theories and abstractions. And she thought most of them were hypocrites. "Here were people who insulted the bourgeoisie . . . but who lived exactly like the people they were proposing to burn at the stake. . . . They were too cynical for me. I never understood them."

They were Surrealists. Kiki was a realist.

8

AN ITALIAN HEIR, A FRENCH NOVELIST, A JAPANESE PAINTER, AND AN AMERICAN COLLECTOR

IN A SUITE AT THE RITZ OVERLOOKING THE PLACE Vendôme, Man Ray photographed the Milanese textile heir Luisa, Marchesa Casati. Tall, skeletal, and terrifying, Casati was one of those glamorously disheveled aristocratic eccentrics who float in and out of the era's juicier anecdotes, flitting through gilded rooms across the continent, arriving at a dinner leading a cheetah by a diamond leash or walking her borzois at three in the morning through the Piazza San Marco naked but for a string of pearls around her neck. At the Ritz, they brought her live rabbits to feed to her pet boa constrictor. She dyed her hair bloodred and framed her eyes racoonishly with kohl, enhancing their darkness by powdering her skin pale white. She was one of the wealthiest women in Europe. Among her preferred ways to rid herself of that fortune was to commission portraits. "I want to be a living work of art," she said. She was the first of Man Ray's sitters to bear a title.

He deemed their session a failure. A blown circuit caused a lighting mishap that led him to blur and double-expose every shot he took. The Marchesa insisted on seeing some record of their time together, so he mailed her a hazy print. She saw herself with three sets of false-lashed eyes, pupils giant because of the belladonna drops she used to dilate them, and her mouth reduced to a muddy void. She loved it. He'd captured "her soul," she told him. She ordered prints to send her

friends, and many of them requested sittings, wanting to see their own souls similarly caught on film. Kiki, who may in a roundabout way have spotted a kindred spirit in Casati, judged Man Ray's shots of the Marchesa among the best work he did.

Man Ray, by the fall of 1922, had shot a few more photos of Gertrude Stein, meant to be used when publicizing her writing in America. One of them appeared in *Vanity Fair* that summer. (He meanwhile avoided Stein's Sunday salons, wanting to avoid making deep connections with other Americans). Other artists wanted their portraits done as well: Georges Braque, Juan Gris, Léger. André Breton stopped by the studio while he was shooting Matisse. "Breton, expecting to find a sympathetic iconoclast found himself facing an instructor in painting!" Man Ray reported to Stein. "And as they talked, it seemed to me that the two men were speaking entirely different languages."

He shot dozens of people with less famous names but healthier finances, who sought the affirmation that came from having his signature beneath their printed faces. He sold two photographs to the savvy designer Jacques Doucet, who was amassing one of the era's finest collections of modern art, placing Man Ray's works among a group that would soon include Picasso's *Les Demoiselles d'Avignon*. And in another major coup, his Rayographs appeared in America for the first time, in a full-page feature in *Vanity Fair*. Condé Nast Publications was trying to build both mass readership and highbrow cachet for the magazine, less than a decade old, by featuring images from artists with national reputations. Placing his Rayographs and the portrait of Stein in *Vanity Fair* not only introduced him into the lucrative Condé Nast fold but helped to establish his name as an emerging talent in front of an American audience.

As the steady work started coming in, he fell into a deep depression. Perhaps now that he'd established a beachhead in Paris, he was processing the full force of having abandoned his American life, his wife, his limited gallery connections. Or maybe his crash came from the recognition that he wasn't destined to be the great painter he'd imagined, that if he ever did make any contribution, it would come

through in a flimsier, more ephemeral medium. Whatever the reason, he struggled to get out of bed for a stretch in that fall of 1922. To his parents he mentioned only a "nasty cold." To Howald he apologized for having "been in bed . . . suffering from headaches, etc." In truth he entertained suicidal thoughts.

Kiki watched over him, cooked him healthy meals, brought newspapers to busy his mind, juggled finances so they had enough to keep the apartment well warmed, and barred him from drinking. She kept him on the Hay Diet his physician had prescribed, a newfangled regimen that required a strict balance among foods deemed acidic, alkaline, and neutral. Followers of the diet had to avoid eating potatoes on the same days as fruits, or fruits on the same day as meat, and were advised to drink huge amounts of liquid, especially orange juice and Perrier. Man Ray wrote to his parents that he was being well taken care of, that he "had a dozen friends working for me, bringing me things to eat, heating my studio." He made no mention of Kiki.

An unlikely assignment pulled Man Ray out of his torpor when Marcel Proust died of untreated pneumonia that November. Cocteau asked him to produce the lone deathbed portrait, having gotten permission from Proust's brother. Man Ray was summoned to the cork-lined bedroom on boulevard Haussmann and told to make a print for the family and another for Cocteau. Man Ray saw greatness two days dead before him. Using low light and a long exposure, he shot Proust supine, sunken eyes shut, shrouded to his neckline so that in the photograph his dark full-bearded head appears to float among the whiteness of linen.

Some saw an era's end in Proust's passing. So much of Proust's world had already died before he did. And what was left was being reborn or renamed. The French 75, prized as a field gun for its quick loading, now referred to a hard-hitting cocktail. The British transformed German shepherds into Alsatians. In Paris, you no longer ordered a *café viennois* but a *café liégeois*. Meanwhile Berliners who'd lifted pints at the city's Café Piccadilly and the Hotel Westminster returned to the Vaterland Café and the Hotel Lindenhof. Every map in the world

had been rendered nonsensical. *Republic of Armenia Union of Soviet Socialist Republics Second Hellenic Republic Somalia Italiana Lithuania Western Samoa Mandate Czechoslovakia Yugoslavia Petrograd.* History seemed to be nothing more than coming up with new names for old things.

AS SHE HELPED SEE Man Ray through his depression, Kiki's fame as a model was spreading quickly, thanks to a portrait done by a close friend.

Tsuguharu Foujita, descended from a noble samurai family, had left Tokyo and his young wife for Paris before the Great War. He fell in with Modigliani, Picasso, and Soutine and made unprecedented pictures by mixing his Japanese training with the latest Parisian techniques while nodding to the traditions of French folk art. He wore hoop earrings, bangs down to the tops of his circular glasses, and a toothbrush mustache. He made his own clothes on a Singer machine, cigar in mouth, working the pedal with his sandaled feet. He dressed sometimes as though heading to the ancient agora in a flowing tunic, feeding rumors that he led mad dances in the Bois de Boulogne with fellow members of a neo-Grecian cult. In the Quarter, they called him "Fou-Fou" (Crazy-Crazy). He was seen at every costume ball, opening night, charity gala, and studio party, recognizable in a noisy crowd by his high-pitched giggle. But he remained underappreciated by the critics and dealers and buyers, until Kiki helped him break through.

The first time Kiki posed for him, early in 1922 in his ragged studio near the Rotonde, she arrived silently, holding a finger to her smiling mouth before undraping her coat to reveal herself, a trick models used so they could arrive for a nude session without marks left by the elastic pull of underwear. Foujita recalled much singing and dancing, Kiki stepping on the Camembert cheese he left on the floor, and that he didn't get any painting done. Instead she took her place in front of his easel, low to the ground since he liked to paint seated on the floor, ordered him to stay still, and drew. After a while, Kiki stood up,

handed him his pencils now half-chewed, took her day's pay, and left with her portrait of Foujita.

At the Café du Dôme, Kiki sold the portrait to Roché. With a few clean lines, she'd captured Foujita's trademarks. Bangs, owlish glasses, mustache. He holds his right hand to his face as though using thumb and finger to measure something beyond the frame, his look cold and appraising. Along with an especially prominent Adam's apple, Kiki gave Foujita a more sharply defined chin than the double one he had in life, perhaps flattering her friend.

Painter and model kept to their assigned roles for the next session. Foujita had Kiki recline nude on a daybed of crinkled sheets, engaging the viewer directly, evoking the pose of Manet's *Olympia,* drawn in turn from Titian's *Venus of Urbino* and other predecessors. "He looked at me with such intensity that it was like he was undressing me a second time," Kiki wrote in her memoir. "Suddenly he would come right up to you and inspect a part of your anatomy so closely you'd start panicking. But then he'd go back to his canvas with a satisfied look." Foujita tucked Kiki's hair behind her ears to expose her high cheekbones. He rendered her face as smooth as water-pummeled stone, turning her naturally olive skin to ivory and her eyes from amber-speckled green to black, giving them a feline quality they lacked in life. (Foujita painted a lot of cats).

He framed the finished piece in an elaborately patterned toile de Jouy. After its unveiling in that year's Autumn Salon amid the Beaux-Arts splendor of the Grand Palais, *Reclining Nude with Toile de Jouy* sold for eight thousand francs and etched Foujita's name into the public consciousness. Its impossible glowing whites provoked jealousy among his peers, who never divined—since Foujita banned all rivals from his studio—that he mixed them to a viscosity that let him paint over them with a dark sooty hue like those produced by Japanese *sumi* (inksticks used for calligraphy and brush paintings), and that those crisp black strokes were what made his whites shine so lunar-bright.

Foujita would soon rank among the most financially successful painters in Paris, buying himself an expensive Ballot touring car, whose

yellow hood he ornamented with a cast of Auguste Rodin's *Man with a Broken Nose.* He was an astute self-promoter. Journalists in Japan mocked him for what they saw as his shamelessness, suggesting that French elementary schools used Foujita as an example to introduce the concept of racial tolerance, teaching students not to be "contemptuous of all Japanese because of him. It's alright for the students to be utterly contemptuous of Foujita alone."

When recounting the creation of *Reclining Nude,* Foujita wrote that neither he nor Kiki "could say for sure who among the two of us was its author." He told of sharing some of the money from the painting's sale with Kiki, pressing a stack of bills into her hands, and how an hour later Kiki had spent it all on a hat and a dress, closing with this detail not to dismiss her as a spendthrift but to underscore his admiration for how eager she was to grab whatever made her happy in the moment.

Many women in Paris were drawn to Foujita's playful, generous nature. Rumors circulated about an affair with Kiki. Foujita always maintained that their relationship, although very close, remained platonic. Kiki made no comment.

WHILE KIKI REVELED in her and Foujita's success at the Autumn Salon, Man Ray, though working steadily again, suffered another setback.

"Hallo, Boys. Cheer up. Dr. Barnes is among us." So went a piece in the *Montparnasse* review, anticipating another spree from the visiting American chemist Albert Barnes, who was using the fortune he'd made in antiseptics to amass one of the great collections of the era, which already included dozens of Cézannes and nearly two hundred Renoirs. Barnes spent two weeks that December touring studios, mostly in Montparnasse, often following a morning spent looking at works presented by little-known artists who gathered outside his hotel, rolled-up canvases in hand. He left with works by Utrillo, Kisling, Derain, Jules Pascin, Marie Laurencin, and the late Modigliani.

His purchase and subsequent stateside showing of nearly two dozen works by Soutine put Soutine on the course toward international recognition and high-priced sales.

Barnes returned to America having paid no visit to his fellow Philadelphian Man Ray.

9

A DADA DUST-UP

T RISTAN TZARA CAME CALLING AT KIKI AND MAN
Ray's studio to tell them about a show he had planned for the
next two nights, to be collectively called *Soirée du Coeur à barbe* (Eve-
ning of the Bearded Heart), a Dada mashup of calculated chaos with
Tzara in his preferred role as ringmaster. By then, the key Parisian
Dadaists could hardly sit in the same café without trading insults.
Breton had been lobbing petards at Tzara in the columns of various
journals, dismissing Dada as an antique. Picabia had pulled away from
the movement as well, explaining that "our head is round to allow
thoughts to change direction." *The Evening of the Bearded Heart*
would be a last manic gasp before Dada's break. Tzara showed Man
Ray and Kiki the playbill promising a festival of music by Auric, Mil-
haud, Satie, and Stravinsky; a play from himself; poetry from Cocteau,
Soupault, and others; and a new film from Man Ray, *Le Retour à la
raison* (Return to Reason).

Which was news to Man Ray. He'd been playing with his auto-
matic camera, which could be rigged to capture motion a few seconds
at a time, and had shown some early experiments to Tzara, referring to
them as a work in progress he was going to call *Le Retour à la raison*.
And a few months earlier he and Duchamp had filmed some rough
clips of twisting spiral cutouts, which they'd screened at a dinner
party. But while he'd once jokingly signed a letter to Tzara as *Man*

Ray, *directeur des mauvais movies*, he hardly thought himself a film-maker. All the footage he'd ever shot amounted to no more than half a minute.

Tzara saw no problem. All his friend had to do was produce another few minutes' worth of something and have it ready to show the following night.

Man Ray welcomed the challenge and had the idea to apply the Rayograph technique to long strips of film rather than to individual stills. When run through a projector, the movements of light and shadow on the photo paper would become animated. He used salt and pepper, thumbtacks and pins, and paper cutouts. By combining these new Rayographed strips with the short scenes he'd already shot, he had sixty feet of film by morning. He sliced the footage into sections that he glued back together in a different order, adjusting and rearranging as he went. He added a final sequence: Kiki, caught for a few seconds in a short burst of motion, her first performance in a moving picture. He handed Tzara just under three silent minutes of 35mm film held together by cheap glue. No one knew how it would look when projected.

As a symbolic shot aimed for the eye of conservative Paris, Tzara had booked out the Théâtre Michel for July 26 and 27, 1923. The playhouse was in the Right Bank neighborhood anchored by the Opéra Garnier, the antithesis of bohemia, a place of banks and department stores. Writers, musicians, artists, and actors arrived for the first night with their entourages. Some came to be scandalized, hoping to see a fight. Some came looking to behave badly themselves. An anticipatory energy skittered across the theater's packed rows.

There was already a playbook for this sort of thing. Everyone in that night's audience would have known of (and a few seen firsthand) the riotous debut of the Ballets Russes production of Stravinsky's *Le Sacre du printemps* (The Rite of Spring) a decade earlier, in the much grander Théâtre des Champs-Élysées. The Ballets Russes's impresario Serge Diaghilev had packed the place with members of feuding cliques knowing they would cause a scene. The crowd had started hissing and

booing from the first slowly creeping notes, matched by the equally daring jerky, repetitive movements of the dancers. The audience had found the primal energy of that pagan death-dance horrific, with its violent sounds and crude costumes, interpreting it as a work of nihilism and a harbinger of darkness to come. Chairs were thrown and the police called. Stravinsky had reacted calmly to the reception. "One must wait a long time before the public becomes accustomed to our language," he wrote to a friend.

By comparison, *Soirée du Coeur à barbe* began more calmly. The crowd in this case was also filled with rival artistic factions, and the atmosphere was charged. But the musical portion opening the show was light and mirthful and sparked only tepid applause. Only when Pierre de Massot took the stage did the night turn. He read a poem, really no more than a recitation of names of people he declared "dead on the field of honor." The death roll included the indeed deceased Apollinaire, Proust, and Sarah Bernhardt, but also Picasso, Duchamp, Picabia, and others still numbering among the living, some in attendance, and who having avoided the war had reason to be embarrassed hearing their names. At that time, any kind of performance even hinting at making light of the wartime loss of life would have been widely condemned as a heinous act. Though not mentioned on the list, the self-serious Breton, who although vehemently antiwar had served as a stretcher-bearer and an orderly (after failing his doctor's exams) in surgical and psychiatric wards, took Massot's mockery as a personal attack. He climbed onstage, tall and imposing with his Easter Island head, while Desnos, Crevel, and another poet, Benjamin Péret, left their seats for the stage in support. Breton smacked Massot hard enough with his walking stick to break his arm.

Tzara called the police, who ejected Breton, Desnos, and Péret, drawing a round of applause. The show picked up again as Massot finished his reading, broken arm and all, before yielding the stage to Tzara's one-act play, *Le Coeur à gaz* (The Gas Heart). This was a carnivalesque collection of nonsequiturs meant to subvert the basic elements of three-act drama, featuring the myopic Tzara prancing

around like a gamecock, weaving between his fellow actors, who wore bulky cardboard costumes designed by Sonia Delaunay. The play's nonstory zigzagged along for a few minutes until Paul Éluard rushed onstage to sabotage it, inciting a drunken punch-up, badly one-sided since the costumed actors struggled to dodge or return any blows and were kept from escaping to the wings by their boxy carapaces, limiting them to tiny steps. Éluard went to smack Tzara in the face but missed and stumbled into the footlights, smashing a few on his way down. Tzara later sent him a bill for the damages, which Éluard never paid.

All this before *Le Retour à la raison,* the title now especially apt. People settled back into their seats, and the projector hummed into motion as George Antheil played a cheery piano piece he'd written for the occasion. After a few moments, the poorly glued reel fell apart, throwing a blank shimmer onto the screen before sending the theater into darkness. The projectionist rigged it back up, and the whistles and hoots went quiet as the reel locked into place and Antheil returned to his piano. The audience witnessed a series of moving images unlike any seen before.

They flickered onto the screen in a seemingly haphazard order, though eventually you could detect a certain kinship of shared shapes and echoed tempos. There were cloudbursts of black and white; a turbulence of thumbtacks and spasmodic nails; odd scribbles; a crowd of circles like fusing cells; a hanging spiral dancing in the dark; whirling lights of a nighttime carousel; the word *Dancer* (or *Danger*) shrouded by a puff of smoke; strands of rope and twisting cords; black blizzards followed by frenzies of white dust; a slender strand (maybe hair) swaying; dark dashes pulsating against pale paper like redacted material from some secret dispatch; the hairlike strand again, unraveling to reveal its depth, morphing into a complicated cylinder with ridges and layers; the insides of an egg box twirling in its own shadow, double, triple exposed; and finally a naked woman's slowly turning torso, tiger-striped by soft sun seeping in through patterned blinds, spotted by the mottled windowpane's reflected raindrops, her arms lifted out of frame, the film's only living form and yet its most lifeless.

The lights came up. The audience left confused, electrified, heated. Seats were ripped and splintered, broken glass littered the floor. Filing out, they hollered slogans, esoteric chants, and rude songs. Strangers argued across the lobby about whether the evening's entertainments had been worth anything beyond their first transgressive throbs. Simmering resentments came to a boil. Fistfights spilled out onto the narrow street. Tzara canceled the second installment of the two-night affair. Dada had done what it had to. Surrealism was being born.

Cubism, Dadaism, Surrealism: the "isms grew like weeds," wrote Cocteau of this period. "Now it's no longer artists from the other bank of the river who detest each other, but artists from the same bank, who exploit the same cell, who exploit the same square foot of excavation." Among the modern artists and writers in Paris were more than a few who found rivalry, and sometimes outright hatred, effective stimuli for creating new work.

Man Ray emerged from the night having navigated peacefully among the warring camps, helped by his outlier status as a nonwriter, nonpainter American. Kiki, too, cared little for the petty squabbling among artistic cliques, and people similarly saw her as one who stood above the fray. "[Man Ray and I] run with a bunch who call themselves Dadaists and a few called Surrealists," she wrote. "I can't see much difference between them!"

Kiki gained an added boost of notoriety as the suspected owner of the torso in the film's indelible final scene, because, as people reasoned, who else could it have been? She was already living a low-rent version of the imagined film star's life. Now she could claim to be one, too, if briefly. And yet no one had seen her face up on the screen, and no credit had listed her name.

10

A SAILING AND SEVERAL STORIES

JUST OVER A WEEK AFTER *THE EVENING OF THE Bearded Heart,* Kiki and Man Ray watched the Bastille Day fireworks bursting above the Sacré-Coeur basilica. They were at a party in the studio of the Bulgarian painter Jules Pascin (born Julius Mordecai Pincas, the letters in his last name rearranged to create his adopted one), a giant top-floor space from which they could smell fresh waffles and cotton candy wafting up from boulevard Clichy below, mixed with the smoky perfume of firecrackers. Pascin's parties were always packed with a socially and racially diverse crowd that usually included most of the regulars from the Dôme and the Rotonde, as well as a few high-society figures, a couple of beggars from the boulevard invited up to share in the food and wine, and always a strong contingent of Pascin's favorite models. Though far from wealthy, Pascin always managed to put out a delicious spread accompanied by a full bar. Kiki described the typical Pascin gathering as "one long battle between bottles and bottle-openers." He wanted everyone to feel free and at ease. He hated seeing people arriving in formal evening dress.

Kiki felt a kinship with Pascin, who was deeply insecure and introverted by nature, usually coming across as melancholy and antisocial when with one or two friends, yet needing badly to let loose now and then in front of a big and noisy crowd. Many times she'd seen him go, in seconds, from laughing and clapping his hands with joy to picking

fistfights for no reason. Once when Pascin insulted Treize in front of a
nightclub, Kisling had to pull Treize off of him. Kisling himself, Pas-
cin's closest friend, thought that "he carried with him a secret wound
which life aggravated every day—a taste for suffering, a morbid desire
for obliteration amidst fog and ashes." Still, Kiki adored him. As she
wrote, "I can see a simple soft heart behind all his cruelty and mockery.
He's good like a loaf of bread is good." Pascin at some point bought
one of Kiki's watercolors, *Guesthouse* (undated), a cozy scene of a man,
a baby, and several women eating, drinking, and talking around a
large table.

From Pascin's party, Kiki and Man Ray rolled along with friends on
three days and nights of drinking and feasting, barely pausing to sleep.

A few nights later, over dinner, Kiki told Man Ray she loved him.
She was seeking reassurance about their relationship, whose terms
they'd never clearly defined although they'd been living together for
more than two years.

His answer was "Love? What's that? Huh, idiot? We don't love,
we screw."

By LATE JULY, Kiki was sailing to New York, accompanied by a
young American journalist, Mike (last name unknown), who'd been
passing through Paris. Treize, in an interview, explained Kiki's rea-
sons for going with him to America: Man Ray would "brush her off
when she said she loved him. She suffered when he wouldn't say he
loved her in words. He loved her also but he didn't have a good charac-
ter. He didn't understand." Mike, on the other hand, was "handsome
and a good lover . . . and it was a marvelous, sensual encounter." There
is no record of how Mike and Kiki first met.

Kiki left Man Ray a note: "I leave because you don't love me."

During the crossing, Kiki discovered she fared terribly on open
water. Looking out over a stretch of ocean with nothing to see but the
horizon made her uneasy, as did the boat's incessant creaking, unease
that turned to panic when the seas got rough. Drinking champagne to

try to calm herself—on a perpetually empty stomach since she felt too seasick to eat much—only made things worse. She missed Montparnasse. She worried that New York wouldn't live up to her expectations. She'd already seen it in so many pictures.

They arrived at night, staying at the Hotel Lafayette off of Washington Square Park, popular among French expats as it was run by a Frenchman who also ran the nearby Hotel Brevoort, Man Ray and Duchamp's former haunt.

Kiki and Mike spent a lot of time drinking. There was "good wine that reminded me of my beloved Paris," wrote Kiki, although she was annoyed to find that they served it in teacups owing to Prohibition. Mike took to calling Kiki "Butterbean." They apparently enjoyed themselves, but after a few weeks the fling petered out. Mike went back to his life in St. Louis, leaving her some money.

Kiki ended up spending three months in the city, walking or riding the bus with no destination in mind. She liked how New Yorkers left you alone to do what you liked. She wrote that she went to the cinema every afternoon of her stay, which could be true since she was crazy for American movies.

Kiki seems to have written her memoir's New York chapter mainly to frame a yarn about her own brush with the American movie business. She explains how a friend arranged a screen test at the Famous Players studios in Queens. When she reached the studio gate, she'd wanted to touch up her hair, which made her realize she'd forgotten her comb, which made her lose her temper, which made her so red in the face she knew she would look terrible on film, so she turned around and went home. A French reporter later gave this screen-test story another spin by suggesting that Kiki, feeling out of depth among so many English speakers, was too nervous to go through with the test. One of Kiki's cousins offered another take: Kiki did secure a small part in a picture, but her scene required her to jump into water, which she hated (she couldn't swim), so she walked off the set.

Whatever the truth, Kiki's tale reads like a wishful assertion of independence, describing her foray into an entirely new artistic milieu,

one she attempted, or nearly attempted, without help from Man Ray
or anyone else from Montparnasse. Telling this screen-test misadven-
ture as a farce, with herself the butt of the joke, also let her poke fun at
the grandiose notions of anyone who took seriously their own ambi-
tions of "making it" as a star of the American screen and who might
judge her harshly for failing to do the same. Kiki rejected America
before America could reject Kiki.

By the fall of 1923, Kiki wanted to go back to Paris. She wired Man
Ray asking for money to come home. He told her to go to Brooklyn to
see his married sister Dorothy Goodbread. Kiki called her "Mme. Bon
Pain." The two women got on well; Goodbread later described Kiki as
"a friendly, happy, bubbly person, a blithe spirit." Man Ray had written
to his other sister, Elsie, at the end of September 1923, asking her to
visit Kiki and see how she was doing, "as near as you can find out dis-
creetly," since he "was much worried."

Man Ray in his memoir makes no mention of rejecting Kiki's dec-
laration of love. He writes nothing about a Mike from St. Louis. He
blames her trip on an unnamed American couple who had come to
Europe, were enamored with Kiki, and promised her fame and fortune
in the theater or cinema. They said they would cover all her expenses,
but then split up when the man showed his interest in Kiki, and every-
thing fell apart from there.

Man Ray, too, wrote about Kiki going for a screen test. This time
the problem was Kiki getting lost trying to find the right building
in the studio complex. Disturbed by the informal arrangements, she
went back into Manhattan. And he gives his version of the incident
a self-serving ending: "After that, her one thought was to return to
Paris. She was happy now, was not interested in a career; would stay
with me forever."

It is possible that Mike from St. Louis had come into Kiki's life as
part of a couple. More likely the mysterious American twosome who
led Kiki astray in Man Ray's telling were his own invention, a fiction
told to obscure his pain and embarrassment at Kiki's choosing to
spend time with someone else.

Man Ray and Treize met occasionally at cafés while Kiki was away. Treize recalled that during this time he never once mentioned Kiki's name.

Treize and Man Ray's accounts concur on what happened after Kiki's return. Kiki and Man Ray picked up as though nothing had happened.

A few days later, though, Kiki found Man Ray sitting on the terrace with friends, waiting for her so they could go for dinner. She slapped him across the face, screaming that she knew he'd slept with "one of her acquaintances," as Man Ray worded it, while she was away. (In Man Ray's version, he was the only one with the potential to stray, not the one who got left. He never says if he did have an affair.)

Kiki took a room in a hotel. Man Ray followed her there, and they quarreled. She threw a bottle of ink at his head but missed. In Man Ray's telling, he "asked her quietly where she had gathered her information. There was no doubt about her sources, she said, and continued to call me names. I hit her so hard that she fell on the bed." Kiki, his story continues, put her fist through the window, screamed, and threatened to jump, until a maid came to check on the commotion, followed by the proprietor. After these two left, he and Kiki "fell into each other's arms, Kiki weeping and I laughing," while the bruise-colored ink dripped down the wall.

11

SHE WILL BE
THE ACTOR TOO

"IN THE OLD DAYS A MODEL WAS SIMPLY A MODEL. SHE broke men's hearts but not their traditions. She stood for hours upon the model stand, saying nothing, while the painter measured and planed and got her down upon canvas for the autumn salon. But times have changed." So wrote Djuna Barnes in 1924, reporting on the modeling trade for the readers of *Charm,* "The Magazine of New Jersey Home Interests." Her piece described the shifting relationship between artists and their muses in Paris. It doubled as a profile of the most shining example of this changing landscape.

By that point, Kiki had posed for Mendjizky, Kisling, Utrillo, Foujita, Kees van Dongen, probably Modigliani, and other artists whose names and works are lost to history. She'd been sketched and painted, filmed and photographed in dozens of different ways by Man Ray, who sold *Charm* a photo of Kiki to go with Barnes's piece. Through regular posing sessions, Kiki would have earned slightly more than she could have working full time in a shop. She remained a relative novelty in Paris as a French model. In France, posing was considered to be a lowly profession. Prostitutes reputedly considered themselves of higher social rank than models. Before the war, many of the models had come from Italy, where the job commanded more respect than in France, owing to the region's tradition of sculpture. Hopeful candidates lined up along the boulevard du Montparnasse to audition at the

Académie Colarossi, an art school run by a former model, with private rooms for appraising potential nudes. But with the war, Italian models were declared "aliens without profession," and many were deported or left willingly. By the time of the Armistice, the Colarossi "model market" was giving way to the less formal system at the cafés, the world Kiki had entered through the backroom of the Rotonde.

Among the reports on life along the Left Bank that Barnes produced for American readers in various magazines, she'd written an earlier profile of James Joyce for *Vanity Fair*, a few weeks after the publication of *Ulysses*, in which she deemed him "at present, one of the most significant figures in literature." So too, at that moment, was Kiki the most significant figure in her own field. And through Kiki, Barnes diagnosed something new unfolding in Montparnasse: models were being prized not for their looks but for their distinctive and disruptive personalities—the more mischievous the better.

Barnes posited that models, as the instigators of chance and chaos, had led artists to dream up so many new ideas that artists had become entirely dependent on their models for inspiration. She portrayed the male Surrealists as desperately fixated on the idea that inspiration should come exclusively from a beautiful woman. The idea that desire, love, and romantic turmoil could inspire creativity was hardly new, but the Surrealists made it central to their project. They were obsessed by the notion of *l'amour fou* (crazy love), the unforeseen and transformative romantic experience that would push them to make a work capable of producing an unforeseen and transformative aesthetic experience. Breton, for instance, returned again and again to a few words Apollinaire had tucked into a verse in 1913: "Desire is the great force." The Surrealists were forever on the lookout for that encounter with a new and seductive love object (requited or not) whose particular charge would yield unexpected magic.

While such thinking restricted women to the role of muse, functioning solely to adore and inspire the artist, Barnes imagined the possibility for them to have agency in such a system. An exceptionally bold and disruptive model, she suggested, could in her own way advance

art-making more profoundly than the person holding the brush. One muse could inspire many artists. A muse could shape the course of an entire era. The artists were the true supplicants, prostrating themselves before their sphinx who alone granted access to life's greatest riddles and the soul's farthest reaches.

To make her point, Barnes reported on how Man Ray came to "give Kiki credit" for one of his paintings, which was not a portrait of her but a seascape. "She stormed into the room, so dark, so bizarre, so perfidiously willful—crying, 'Never again will Kiki do the identical same thing three days running, never, never, never!'—that in a flash he became possessed of the knowledge of all unruly nature." Barnes may have been exaggerating to disarm her readers, but her argument was clear: Kiki deserved credit for firing Man Ray's creative spirit, which she did not through her beauty or a particular pose but with her actions and her words.

In this new era, the artist's model, fully cognizant of her power, "will no longer be the décor, she will be the actor too. And with it all she must have her fancies." Barnes offered as exhibit A Kiki, whose fancy was a pet mouse that, like her owner, took in boulevard du Montparnasse through similarly sharp and disillusioned eyes. Barnes ventriloquized Kiki's explanation for carrying around her familiar in its little basket wherever she went. "Life is, *au fond,* so limited, so robbed of new sins, so *diabolique . . .* that one must have a mouse, a small white mouse, *n'est-ce pas*? To run around between cocktails and *thé.*" This, Barnes implied, was exactly the kind of frivolous behavior that made Kiki so vital to the artists she inspired. "She is superbly irrelevant, magnificently disconnected, triumphantly trivial."

Worried about portraying Kiki as an empty-headed vessel for inspiration, Barnes was careful to add that Kiki was a hard-working and savvy creator in her own right. She mentioned that Kiki had started to paint and act but, unwilling to restrict herself to these arenas, had also designed a dress that had become the talk of Montparnasse. Kiki did make many of her own clothes, still a fairly common practice for women who couldn't afford to regularly order clothes made to measure,

and there is also record of Man Ray giving her two Schiaparelli dresses that she then cut in two, sewing the mismatched halves together to make two new creations. Barnes offers no detail about which specific creation of Kiki's she'd singled out for attention.

In closing her piece, Barnes did wonder if models, having surpassed their traditional role as the artist's romantic tormentor, might be in danger of having their own hearts destroyed. She ended by quoting Kiki:

"They have broken my heart? Not at all, I keep it for me. What will you have—*thé? Bon!*"

12

THE INTERPRETATION OF DREAMS

K IKI SITS ON THE TAPESTRY SPREAD ACROSS THE floor, its chessboard pattern splayed out like an invitation to a game. She pulls down the fabric wound around her hips so that some of it lies along the ridge of her thighs while the rest falls behind to reveal the summit of her backside. She tightens other fabric encircling the top of her head in a turban, leaving exposed a small wisp of hair.

After trying a few, they find the position that works, a simple configuration. Kiki faces away from the camera toward the dark wall, her head turned to profile, alert to the clean angles she creates, her chin held parallel to her shoulder, arms in front of her, or crossed against the coldness, or held outward, or resting on thighs or knees— whatever it takes to hold the desired posture. The goal is to sit so that shot straight-on, she'll look limbless, her lengthened back like marble soaked in light. Much as the Venus de Milo would have appeared to them when viewed from behind at the Louvre, her own drapery hanging halfway down her hips.

Maybe Aphrodite isn't the reference they reach for, if they're reaching for one at all. Maybe with her ear's ornament dangling like bait, they're going for Vermeer's *Girl with a Pearl Earring*. Or with her favorite shawl fashioned into a turban, they mean to conjure some cheap orientalist fantasia, Kiki as odalisque attuned to the noisy intruder spying from the other side of her seraglio with his camera. Or, antici-

pating the f-holes that will later be tattooed onto her back, maybe she channels the ancien régime criminal branded for her trespasses, her skin marked by de Sade's pen as much as by the darkroom's light.

They're puzzling, those twinned f-holes, now so much better known than the body onto which they've been inscribed. By indicating the depth of a cello's resonant chambers, those twinned f-holes, burned into the final print, mean to complete the illusion begun with the angling of Kiki's torso: her double act as woman and instrument. But it's a trick lacking polish or prestige. There's no effort to fool. The f-holes have been rendered too clearly superficial for that. Instead we're being challenged to hold both their visual artifice (we know these markings don't belong to that woman's body) and their analogical effectiveness (but her body does look like a cello) in our heads at the same time. The whole operation falls apart unless the viewer chooses to see the depth in those resonant chambers.

They seem locked in their own private contest, sitter and photographer. In the confines of this frame, they might be playing with each other on terms that, if not equal, feel at least unstable, being negotiated as we watch, as though we're glimpsing a moment of mutual pleasure not yet enjoyed, more delicious in the endlessness of its temptation than the act or its aftermath could ever be.

It's a scene of promised happiness. Which makes it a defiantly postwar picture, forward-looking and death-denying. The one final word that, five years after the Armistice, still hung in the air of every room has somehow been kept from this one. It's a picture of life.

Or the opposite: it's a fantasist's prelude to the inevitable disappointment of reality.

What looks like a game to outsiders can feel like a duel to its participants. Maybe Man Ray spoke plainly when he titled the finished print *Le Violon d'Ingres*. A former musician, the nineteenth-century painter Jean-Auguste-Dominique Ingres had a reputation for annoying his studio visitors by incessantly plinking on his violin, so that *un violin d'Ingres* came to function in French as *hobbyhorse* does in English. With his title, Man Ray told us how he saw the picture's unnamed

woman and how he wanted us to see her, too: as a plaything to be strummed and passed along for the next viewer. By marking her body in the darkroom (with her foreknowledge or not, we don't know) after she'd finished performing her role as model, did he not reduce Kiki to the mere canvas for those f-holes, the rough material from which he created his concept?

Maybe this is a picture of war after all. Maybe the picture has less to do with Man Ray's connection to the lively, modern Kiki in front of him than it does with his admiration for the pompous, reactionary Ingres, long dead. The easy allure of a woman's turned back caught in a private moment: Ingres was this trick's master, from the subjects of *The Half-Length Bather* (1807) and *The Valpincon Bather* (1808), seated, naked save for some fabric round their heads, to their doppel-gänger, showing up more than fifty years later holding a mandolin to provide the focal point at the center of the fleshy tangle of *The Turkish Bath* (1852–59), naked save for some fabric wound around her head and a patterned blanket covering her thigh. Man Ray would have seen *The Valpincon Bather* and *The Turkish Bath* at the Louvre.

We don't know if Man Ray was alone in coming up with the pic-ture's concept, staging, or titling. It requires less effort to imagine the person holding the camera as the sole commander of a shoot. It's the photographer who takes something from the sitter—her picture—even if he can't make it without her.

"The very beautiful women who expose their tresses night and day to the fierce lights in Man Ray's studio are certainly not aware that they are taking part in any kind of demonstration," wrote André Breton in his essay "On Man Ray." "How astonished they would be if I told them that they are participating for exactly the same reasons as a quartz gun, a bunch of keys, hoar-frost or fern!"

But Kiki was the more musical of the pair, as well as the performer. Maybe she thought of herself as the instrument and as its player. She might have felt the opposite of degraded when seeing the completed image. She might have seen it more as their duet than as his solo. Maybe she thought the solo was hers. Impossible now to decipher who

did what on that day in the studio. There's no instrument by which to gauge how much of the picture's rough magic is owed to his camera-work and how much to her performance in front of the lens.

Can you take a photograph of great feeling about someone for whom you're trying to feel nothing? If, after taking a photograph, a photographer alters and titles it in such a way that it reads as an attempt to dominate his model, do we, too, have to see her as submissive?

Would we have such an image if the two of them had never met and fallen into their particular dance? Man Ray might have tried to produce a similar image with someone else. Kiki might have found another portraitist to capture the energy she was putting out just then. We don't know. All we have is this picture, the lone tangible record of a certain quickening in the space separating Kiki's particular body from the camera manipulated by Man Ray's particular hands, in that room in Paris, for that moment in 1924. That crackling space between them is why the picture still feels so alive and unsettling a century after its creation.

LE VIOLIN D'INGRES appeared in public for the first time in the summer of 1924, occupying a full sheet in the thirteenth and final issue of the Surrealist magazine *Littérature,* where it would have been admired by a few dozen or hundred people before their attentions turned to the novelty of the next page.

Kiki appeared again in print that winter when Breton published the inaugural issue of *La Révolution surréaliste,* filled with the recounting of dreams and pseudo-scientific queries into suicide. Inside, an advertisement for the newly opened Bureau of Surrealist Research invited any interested research subjects to visit 15, rue de Grenelle, where they would have seen a mannequin hanging from the ceiling, an altarpiece made up of copies of the *Fantômas* books and Freud's *The Interpretation of Dreams* surrounded by metal spoons, and a willing listener at a desk waiting to record their secret thoughts and fantasies or, if preferred, to lecture them on Surrealism. A few pages later, wrapped

in a full page of text, comes a still from the final scene in *Return to Reason,* showing Kiki's headless torso, deeply shadowed. Uncredited and untitled, she is there to illustrate Breton's tedious recounting of a dream, the unknowable female body as stand-in for the unshowable male mind.

13

INTO THE LIGHT

K IKI AUDITIONED FOR THE FRENCH SILENT FILM star Jaque Catelain early in 1924. He was making his second movie as an actor-writer-director. *The Gallery of Monsters* would tell the story of star-crossed Spanish lovers who join a traveling circus. The cherubic Catelain and a fifteen-year-old American actress, Lois Moran, future model for the starlet Rosemary Hoyt in Fitzgerald's *Tender Is the Night,* played the couple.

Catelain wanted to showcase some of Montparnasse's most visually striking personalities alongside his parade of mermaids, wild monkeys, dancing bears, lions, tigers, strongmen, and sword swallowers. They would feature in cameos posing as members of the circus troupe. There was Flossie Martin, the former Ziegfeld showgirl; Bronia and Tylia Perlmutter, Polish-Jewish granddaughters of a famous rabbi, who'd moved to Paris from Holland and broken into the modeling world after Kiki invited them to sit with her at one of the cafés; Le Tarare, an actor with dwarfism who appeared in several films that decade; and Kiki.

It was Kiki's first role in a feature-length film, one with a plot you could follow and genuine production values. After location shooting in Spain, Catelain finished the movie at Studio Éclair in a suburb north of Paris. The shoot, for Kiki, was a comedy of errors. The monkeys were mean-spirited, the arc lights blinding, and the bear kept trying to

"make it" with her. The film's producer, Marcel L'Herbier, recounting the same shoot, added in his telling the caged lion who refused to act wild until tempted by the reward of a live bunny.

Kiki's is the first of the film's cameos. The star-crossed lovers join a crowd to watch the circus troupe piling onto the stage. The players vie for attention, bouncing off one another like whirligigs. They stand on their hands, swing Le Tarare circles, lift impossible weights, tickle monkeys. The barker introduces Kiki. Wearing a gossamer-thin dress printed with horseshoes, and a flower tucked behind her ear, she does a slinky belly dance and bangs a tambourine, backed by a white band in blackface, marking the film as a product of its time and place. Shots of Kiki's undulating hips alternate with reactions from the mostly male crowd, followed by a close-up of her face in the three-point lighting. She smiles widely and turns to her profile, the light glinting off the tip of her nose. For two seconds, she looks as if she belongs in that counterfeit world. She *shines*. The lovers grin up at Kiki, delighting in receiving her downward gaze. We, like the lovers, are meant to feel the magic in the act of watching her, to interpret her brief appearance as an attraction in and of itself. The camera gets up close to anoint her: a star. Her cameo ends with a shot of her gyrating her pelvis at the crowd before dashing off stage right. She returns a while later and dances away in the background for much of the film.

The Gallery of Monsters debuted that spring in the sumptuous, five-hundred-seat Artistic-Cinéma-Pathé on the Right Bank in the Saint-Georges neighborhood, home to many of the city's most popular theaters. It went on to screen to receptive audiences across France and Spain, with a print eventually traveling as far as Japan, a minor hit that turned a profit.

Kiki experienced what must have felt like a kind of apotheosis, seeing herself on screen—in full form, dancing and having fun, rather than as a headless and nameless torso—and again in the film's credits, her name listed as she'd requested: Kiki Ray.

She popped up on screen again that year in the prolific French film-maker and film theorist Jean Epstein's *The Lion of the Moguls*. Epit-

omizing the Montparnasse fast life for a few moments in a crowd scene, she dances in a shiny backless dress, her features accentuated by a dramatic scarf and big hoop earrings. She is mostly lost among the wild club crowd being entertained by a mockup jazz band led by a one-eyed piano player. During the filming she met and had a brief affair with the male lead, the Russian-born actor and occasional director Ivan Mosjoukine, a major star of French silent film, known for his gray eyes, bright yellow Chrysler, and prodigious spending, mostly on women and wine. Recalled Treize: "He drove fast in his sports car, was a charmer, a seducer, and also a simple person. He spoke French fairly well. Kiki went to see Mosjoukine at his place in a bachelor hotel." Kiki admired his acting, telling Mosjoukine he could make her laugh and cry as easily as Chaplin could. She wrote to him of waiting anxiously to spot his yellow car in the street, that she was both delighted and frightened by his physical beauty and the desire it provoked. They "were like beautiful cats together," said Treize. "His wife [Natalya Lysenko] was jealous, but she wasn't there."

Mosjoukine broke it off with Kiki after a few weeks. She gently asked that he return a ring she gave him, explaining that she was highly superstitious and thought it would be bad luck for both of them if he kept it.

For her next acting job, a few weeks later, she appeared topless, back to the camera, as an artist's model posing for a painter with a lushly sheeted daybed beckoning behind him, in *L'Inhumaine* by Marcel L'Herbier, who after meeting Kiki during the production of *Gallery of Monsters* saw her as ideally suited to the role. She reported to Mosjoukine that she thought her scene somewhat ridiculous and found L'Herbier an uninspiring director.

Also in 1924 Kiki appeared among a procession of mourners running and leaping in slow motion behind a camel-pulled coffin in the comic phantasmagoria *Entr'acte,* a twenty-two-minute Surrealist masterpiece. Picabia and Satie, who were making the ballet *Relâche* together, asked the French filmmaker and writer René Clair to produce a short film as an interlude. Clair had a sardonic view of the

world, sharpened by suffering an injury as an ambulance driver during the war, and his subsequent wrestling with the absurdity of his surviving when so many others died. The film featured a sequence of Man Ray and Duchamp playing chess on a rooftop until a cloudburst ruins their game. Man Ray likely recommended Kiki to Clair. As with the previous projects, the role called for her to do little more than serve as attractive scenery, a glorified extra.

Four movies made in quick succession. Four bit parts. For those few months in 1924, her life must have felt like a nonstop sequence of guest appearances in other people's stories. But then finally, before the year was up, Kiki made a prominent appearance in a film. "Prominent appearance" rather than "starring role" because her performance was not quite film acting in the usual sense but something closer to posing expertly before a moving picture camera.

That summer Fernand Léger was developing a long simmering idea for a movie with "no scenario," as he wrote, but only "reactions of rhythmic images, that's all." Léger had moved from painting portraits and still lifes infused with his silvery Machine Age aesthetic to doing studies of various objects, seen from such proximity they looked almost abstract. He wanted to experiment with a filmed version of this investigation into fragmentary, close-up views. He dreamed of turning machines and objects into the "leading actors" of a movie, as he wrote, imbuing them with a sense life and giving them dramatic trajectories by shooting them at various angles and distances and speeds, then assembling the footage as a series of linked montages. He called the project *Ballet mécanique*.

The visual anchor holding Léger's plot-free parade of images together was not in the end a machine but a human face: Kiki's. Man Ray may have suggested her to Léger, as he collaborated informally on the project, contributing ideas and shooting some of the footage. Three other Americans living in Europe contributed creatively as well: director Dudley Murphy, poet Ezra Pound, and George Antheil. Accounts differ as to who did exactly what.

Kiki didn't write about her experience but was surely thrilled to

be the movie's focus. Her natural charm lights up the otherwise pon-
derous film whenever she appears. Léger (or one of his collaborators)
filmed her through a specially designed kaleidoscopic lens, atomizing
and reconstituting her flour-white face piece by piece.

Ballet mécanique opens with a mock introduction from a Cub-
ist marionette meant to look like Charlie Chaplin. (Léger became a
huge fan of Charlot, as the French called his Tramp character, after
Apollinaire introduced him to Chaplin's films during leave from the
war.) After the marionette jerkily dances, the film shifts into a series of
montages of various objects—Christmas ornaments, frying pan lids,
corrugated sheet metal, a pearl necklace—as well as cutouts of shapes
and footage of machines at work. There is also a looping sequence of
Murphy's wife, Katherine, on a swing. As the object-machine mon-
tages continue, Kiki appears at increasing intervals, which come more
quickly as the film reaches its end.

Her face is displayed in full, in profile, in segmented close-up: there
are Kiki's cupid's bow lips opening into a wolfish toothy smile; this is
Kiki's plastered hair, slick and shimmering as her head slowly twists
from one side of the frame to the other; those are Kiki's laughing eyes,
opening, closing, opening again to look off at an angle as though sum-
moning some lost memory back into the light for reinspection, now
returned to center to meet the viewer head-on, now gazing out some-
where far beyond the theater's back row. Against the oppressive cold-
ness of Léger's machinery, Kiki radiates human heat.

The film debuted at a festival in Vienna in September 1924 and
later in Paris, the reception modest. When explaining the film's gene-
sis, Léger said that his war experience had thrust him into "a mechani-
cal atmosphere," leading him to discover "the beauty of the fragment. I
sensed a new reality in the detail of a machine, in the common object.
I tried to find the plastic value of these fragments of our modern life.
I rediscovered them on the screen in the close-ups of objects which
impressed and influenced me." He made no reference to Kiki.

Among the small number of people who watched *Ballet mécanique*
were some who recognized the importance of her contribution.

Henri-Pierre Roché wrote to compliment Kiki on her acting work
that year. (He was exploring moviemaking himself at that time, work-
ing with Abel Gance on a script for what would become Gance's epic
Napoléon.) Thanking him in her letter back, Kiki wrote, "I have to
wait and see what'll happen with films. There's nothing I'd like better
than to continue with it, but I'm waiting for someone to ask me. If you
hear of anything for me, don't forget." In his diary entries from this
time, Roché refers to Kiki as "Kiki Man Ray."

Roché bought another of Kiki's watercolors around this time. After
advising John Quinn on the purchase of Henri Rousseau's *The Sleep-
ing Gypsy*—Quinn's last acquisition before dying that year of cancer—
Roché spent part of his commission on work by Kiki. "Dinner with
Man Ray, Kiki, and Tzara," he wrote in his diary on April 15, 1924.
"Bought a beautiful watercolor, a 'super-Matisse' by Kiki."

Among the possible watercolors he might have been referring to
was one from that year that she titled *Family Posing for the Camera*.
It shows a couple in formal dress seated between a skinny standing
girl with short black hair and a striped dress. A dog sits to the right of
the frame. All face forward, staring blankly ahead, turning the viewer
into the camera for which they're posing. It's a picture at once full of
longing for the rituals of family life that Kiki missed out on having
and, with the hollow stares of its subjects, an indictment of such rit-
uals, a suggestion that the traditional family unit was itself a kind of
pose. Roché paid Kiki as well as he would have paid any other up-
and-coming artist. He would eventually own ten of Kiki's paintings.
His late, lucrative client would have disapproved of his taste. "Most
woman artists seem to want to paint like men," Quinn once wrote to
Roché, "and they only succeed in painting like hell."

Kiki wrote to Roché again that summer, answering a letter, now
lost, in which he praised her art making. "Your letter . . . gave me great
pleasure. Only I really hope that I have all the qualities and talent that
you find in me. I've been working and I already have two paintings in
oil with eight figures. You must come see."

On the back page of the July 1924 issue of Picabia's arts and litera-

ture magazine *391,* Roché announced an upcoming showing of Kiki's paintings at his apartment, without specifying a date. There's no evidence to confirm it took place.

FOR ALL THE EXCITEMENT of her first film appearances, her posing, her making and selling her watercolors, and her being the subject of Djuna Barnes's magazine piece, 1924 was a painful year for Kiki. Her grandmother, the one blood relation who'd truly cared for her, died on October 29 at seventy-six.

"You cannot know the sadness that invades the heart of a child who has no father, whose mother is far away, and whose only tenderness comes from a grandmother," Kiki wrote roughly a quarter-century later. "The kisses from her shriveled lips and the touch of her rough hands were the only sweet things I knew in my childhood."

In her memoir, she praised her grandmother as a plainspoken woman, accepting of whatever friends or lovers she brought to visit. She "never said there are things that are done or not done: she found everything natural." She enjoyed seeing her granddaughter in full makeup and liked nothing more than having Kiki comb and style her hair for her, the more outlandish the style the better, then to scrub her face for her with eau de cologne. Among her grandmother's most cherished stories, possibly embellished for patriotic effect, was of slapping a Prussian soldier who'd pinched her backside during the Franco-Prussian War of 1870.

"Death, among poor folks, isn't the catastrophe it is among the rich," wrote Kiki. "And when you've been fighting your whole life just to get enough to eat, the big send-off can be seen as a kind of deliverance."

MAN RAY WAS MEANWHILE circling the glittering, careless world of the American collector and patron Peggy Guggenheim and her husband, the British writer and painter Laurence Vail, informal heads of the small and self-contained colony of American and British expats of

exceeding wealth. Guggenheim admired Man Ray's photography and hired him for a portrait, posing in a dashing Poiret evening dress of patterned gold cloth worn over a blue and white top of embroidered crepe de chine, matched by a golden headband.

Guggenheim enjoyed Kiki's company, too, while regarding her chiefly as Man Ray's accessory. Echoing other Montparnasse memoirists, she claimed that Man Ray carefully applied Kiki's makeup for her each day. Guggenheim interpreted this supposed ritual as an act of artistic creation, describing the couple as "Man Ray and his remarkable hand-painted Kiki." She'd hosted them the previous June at the villa she'd rented in the seaside village of Villerville in Normandy. Guests were encouraged to paint al fresco in the garden, where Guggenheim herself picked up a brush for the first and last time of her life.

There Man Ray took informal shots of Kiki in a neoclassical dress of flowing white tied over one shoulder, lazing in the property's giant field of long grass alongside a smiling Guggenheim, who wears a dress in a simple floral pattern; Louis Aragon, stretching his long trim frame in a light suit; Guggenheim's sister-in-law, the painter Clotilde Vail, to whom Aragon would dedicate a play, in a loose-fitting white cotton dress; and in shirtsleeves and slacks, Robert McAlmon, the American writer and publisher, openly gay and in a marriage of convenience to the novelist and patron Bryher (pseudonym of Annie Winifred Ellerman, of the shipping Ellermans), earning McAlmon the nickname "McAlimony" among the expat crowd, even as he privately helped to support some of its artists and writers, using his wife's money. The peaceful scenes Man Ray documented in the villa's garden belie the frenetic pace at which Guggenheim and her husband were then living with their son and a baby nurse in tow.

More recently Guggenheim had invited Kiki and Man Ray to a gathering at her apartment on Faubourg Saint-Germain. They got into a vicious fight for reasons unknown, which ended with Kiki hitting Man Ray in the face and calling him a "dirty Jew." She chose her words perhaps not out of a general anti-Semitism but specifically to wound Man Ray, preying on his difficult relationship with his Jewish

identity and his family origins. The scene unfolded in front of Peggy Guggenheim and her shocked mother, Florette, who were Jewish. Florette let Kiki know her anger at what she'd said. The epithet outraged Florette far more than it did her daughter and son-in-law, busy writing their own torrid history of connubial violence and humiliation. Peggy found these kinds of theatrics merely boring, one of the annoyances that came with throwing her many parties. Man Ray, for his part, always chose to interpret Kiki's public outbursts as misguided displays of affection.

He worked feverishly through that summer of 1924, when Parisians felt they stood at the center of the world even more than usual, as the city played host to the Olympics. Cocteau's friend the French socialite and patron Count Étienne de Beaumont hired Man Ray to document what would be remembered as the most decadent of his costume balls, this one to cap a series of ballets and plays he'd funded. He stipulated that Man Ray wear a dinner jacket so he wouldn't look like the help.

That night Man Ray photographed Sara and Gerald Murphy for the first time. They were widely envied in Paris for their easy American elegance, as close to a golden couple as the era produced. With their three young children, they'd sailed for France in the same summer of 1921 as had Man Ray, though in a considerably more comfortable cabin. They wanted to escape what they saw as stifling lives in New York, where it felt as if people spoke endlessly about business, property, and possessions and cared nothing at all about what Sara called "the simplest, bottomest things—the earth and all the elements and our friends." Gerald had begged off a career in the family's leather goods business that had been waiting for him after his graduation from Yale. He wanted to paint and in France would develop into an exceptional artist. For all their complaints about the trappings of wealth, however, they lived off of family trusts.

In Man Ray's photo, Sara Murphy looks like unwrapped candy in a dress of crinkly foil, the shining spirit of the Machine Age, her neck roped by three loops of pearls, her eyes framed by the oversize goggles of a Grand Prix driver or a fighter pilot. Gerald, also goggled, stands

like a walking skyscraper, inhabiting a stainless steel contraption that he'd been welded into earlier in the evening, with a loudspeaker mounted to his shoulder and a giant tin-man headpiece adorned by circular lights. Posing stiffly in their silvery sarcophagi, they look like two misplaced pharaohs from some future civilization.

Man Ray also photographed friends who, unlike him, had come to the ball as invited guests. He shot Picasso dressed as a toreador standing between his Ballets Russes–dancer wife Olga Khokhlova and his patron, the Chilean-born Eugenia Errázuriz. Man Ray also caught Tzara kneeling to kiss the hand of a silver-suited and top-hatted Nancy Cunard, the British-American shipping heir, poet, and renegade, who later introduced Man Ray to some banker friends looking to have their own portraits photographed.

The lines between friendship and patronage were blurred when it came to Man Ray and high society. His desires were split in two, as he yearned for a solitary creative life but also for the lucrative work and sparkling chatter that he imagined would relieve him from the banal demands such a life presented. He understood that for all the era's changes, the aristocracy would persist, and its members would continue to wield great social power, so deeply entrenched in their positions that they would survive any upheavals. He befriended aristocratic *salonnières* such as the stately Élisabeth, Countess Greffulhe, one of the models for Proust's Duchesse de Guermantes (though it sometimes feels as if every titled French man or woman who ever shared a ballroom with Proust claimed some link to one of his characters), and heirs to industrial fortunes such as Bryher. But only because they'd hired him to give them lessons in photography.

But while he might have thought himself smarter than his wealthy clients and their equally fortunate friends—certainly he was more ambitious—Man Ray knew no one wanted party shots from a photographer who felt superior to his subjects. He tried to put some distance and irony between himself and the people whose revels he was paid to capture. He wore cufflinks made of flashing red lights, undercutting the suit and tie required of him, declaring himself just an artist, visit-

ing, observing, harmless. But he might also have wanted those blinking cufflinks to transmit a second message: kings and queens come and go, but a clever jester keeps laughing through many regimes.

It must have been hard, though, to resist trying to form an affinity with these people, so close at hand. Hard to act aloof as he navigated their ballrooms and gardens. Many of them defined themselves through the artists they patronized, and many would have known his name, especially once his work started to gain recognition, and even admired his photographs. And he had excellent bait with which to lure them into familiarity, because how many people can really resist the invitation to be granted the camera's undivided attention? "As a photographer, I was in demand," he would recall. "I was like a doctor. Everybody needed me. It was like selling bread and meat."

Without his camera, he was less of a draw. The most sought-after invitations eluded him. He was not yet benefiting from the loosening of social barriers resulting from the class-transcending trauma of the war that had people questioning traditional hierarchies, or from the endurance, beyond the Armistice, of wartime connections that had been forged across class lines. It was a time when, as the British writer Patrick Balfour would remark a few years after the decade's close, diagnosing changes in London that echoed those in Paris,

> peers became Socialists, and Socialists became peers, actors and actresses tried to be ladies and gentlemen and ladies and gentlemen behaved like actors and actresses, novelists were men-about-town and men-about-town wrote novels, persons of all ranks became shopkeepers and shopkeepers drew persons of rank to their houses.

For all those rearrangements and realignments, Man Ray—unlike Tzara, Picasso, Léger, and other artists in his circle—was not invited to the city's key social events, perhaps because he was seen as less refined than they were.

Kiki couldn't have cared less about that kind of thing. She loved a

good party and good wine as much as the next person but was happy to celebrate alongside anyone at all, so long as they could keep up with her.

DUCHAMP HAD BY THEN returned to Paris after four months of competitive chess in Brussels. He was a stylish player, possessing all the skill but only some of the ambition worthy of a professional. He liked playing a beautiful game more than winning a brutal one. Many of Duchamp's peers, notably Breton, were critical of what they regarded as his abandonment of art in favor of a board game. He moved into the Hôtel Istria, next door to Kiki and Man Ray. It was usually well stocked with artists and writers, a place favored variously by Picabia, Satie, and the poet Mayakovsky. Duchamp spent much of the time holed up in his room solving complex chess problems, venturing out occasionally, according to Treize, to carry on an affair with Léger's wife Jeanne. Treize was then also living at the Hôtel Istria, a few doors down from Duchamp.

For a time, Kiki and Man Ray took a small second apartment in the Hôtel Istria, too, on Duchamp's floor, so that Kiki could have a space that felt like more of her own. Germaine Everling, sometime lover of Francis Picabia and an influential champion of Dada as art critic and *salonnière,* would remember how Kiki "like a miracle . . . changed her makeup every day and looked like a different person. She would stand on the stairs and shout to her friends on other floors. . . . Man Ray often came to see her, climbing the steps with a sad air and descending with an even sadder one."

Kiki, Man Ray, Treize, and Duchamp went out often for midnight meals at the Dôme, which had replaced the Rotonde, standing directly south, as their most regular haunt. Its kitchen specialized in "foreign" delicacies such as chili con carne, baked beans, puffed wheat, sweet corn, and a Montparnasse favorite, *gras double* (the fattest), an inexpensive but filling tripe dish from Lyon. Duchamp always ordered the same lackluster soft-scrambled eggs.

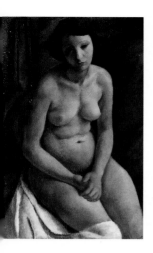

Maurice Mendjizky, *Kiki de Montparnasse* (ca. 1920), oil on canvas. *Collection of Marek Roefler / Villa la Fleur.*

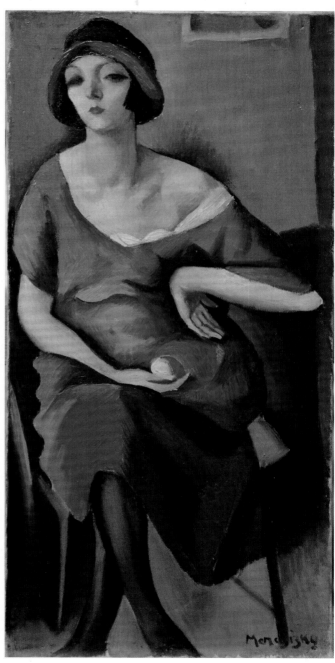

Maurice Mendjizky, *Kiki*
(1921), oil on canvas.
*Collection Fonds de Dotation
Mendjisky-Écoles de Paris.*

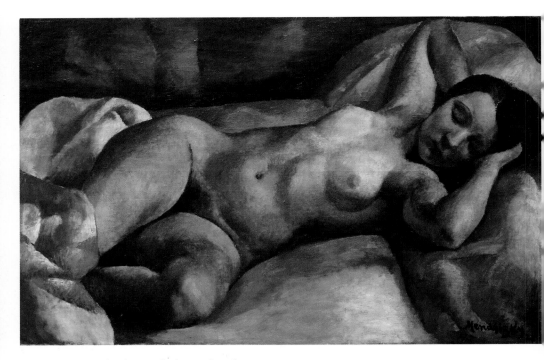

Maurice Mendjizky, *Kiki* (1921), oil on canvas. *Private collection.*

Kisling, *Kiki* (1920).
© *ADAGP, Paris and DACS, London
2022/Alamy Stock Photo/gravure française.*

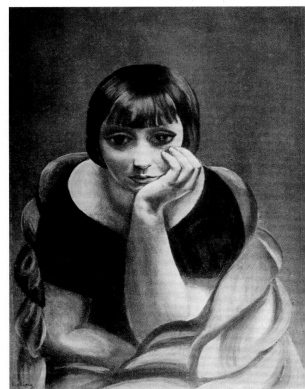

Man Ray, *Kiki* (ca. 1921).
© *Man Ray 2015 Trust/DACS, London 2022.*

Léonard Tsuguharu Foujita, *Nu Couché a la toile de Jouy* (1922), oil, ink, charcoal, and pencil on canvas. © *Fondation Foujita/ADAGP, Paris and DACS, London 2022.*

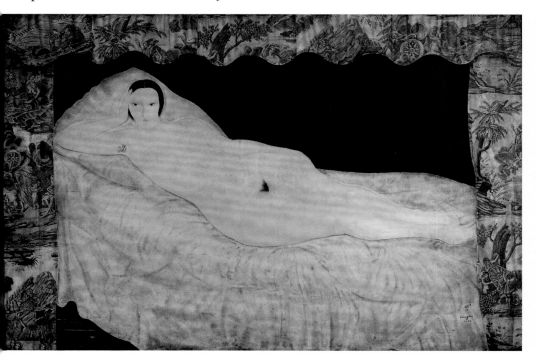

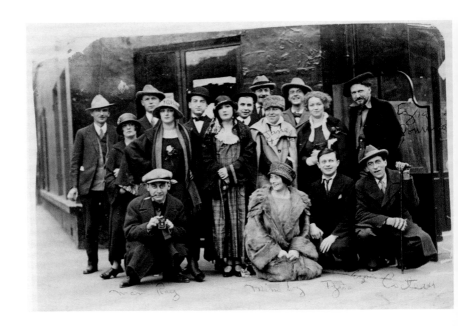

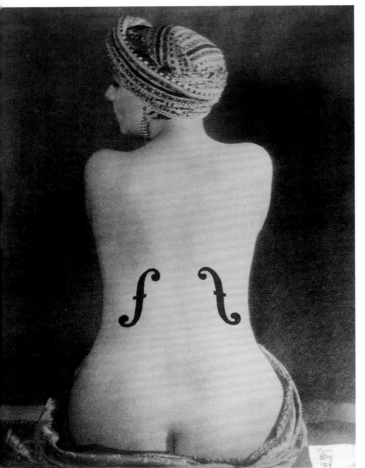

Above: Kiki (second row, left), Man Ray (first row, left), Tristan Tzara, Jean Cocteau, Mina Loy, Jane Heap, Ezra Pound, and others at the Jockey, 1923. *agefotostock / Alamy Stock Photo.*

Left: Man Ray, *Le Violon d'Ingres* (1924). Gelatin silver print, image: 29.6 x 22.7 cm. (11 5/8 x 8 15/16 in.). *The J. Paul Getty Museum, Los Angeles. © Man Ray 2015 Trust/DACS, London 2022.*

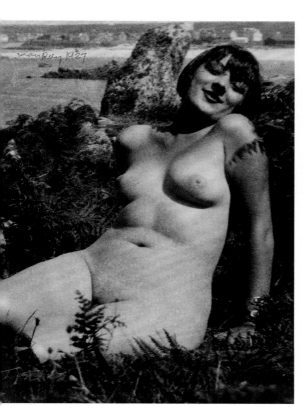

Man Ray [Kiki of Montparnasse, nude] (1927). Gelatin silver print, image: 17.3 x 12.9 cm. (6 13/16 x 5 1/16 in.).
The J. Paul Getty Museum, Los Angeles.
© Man Ray 2015 Trust/DACS, London 2022.

(The author believes this image to be Thérèse Treize's snapshot of Kiki in Brittany, ca. 1924.)

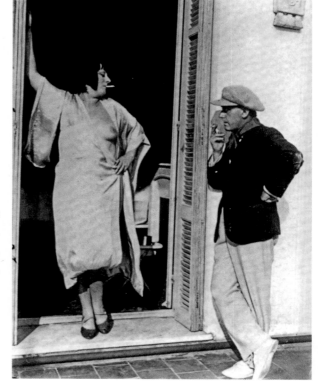

Kiki and Man Ray in the south of France, ca. 1925.
© Man Ray 2015 Trust/DACS, London 2022.

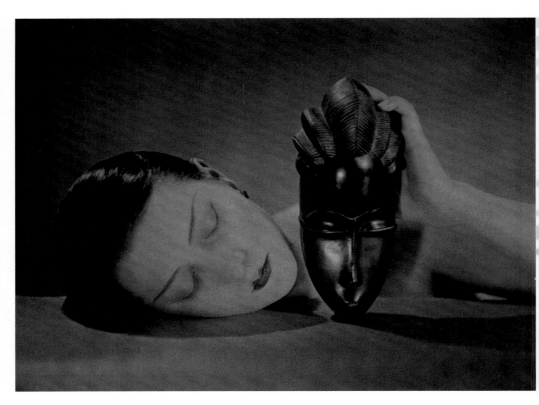

Man Ray, *Noire et blanche* (1926). © *Man Ray 2015 Trust/DACS, London 2022.*

Kiki, Man Ray (on right), and two unidentified friends, ca. 1928.
© *Man Ray 2015 Trust/DACS, London 2022.*

Kiki de Montparnasse, *L'acrobate* (1927), oil on canvas.
Private collection, image courtesy of FauveParis.

Kiki de Montparnasse, *Les lavandières* (1927), oil on canvas.
Kunstmuseum Basel—Martin P. Bühler.

Kiki de Montparnasse, *Gitans* (1928), oil on board.
Private collection, image courtesy of Bonhams.

The atmosphere at the Rotonde had changed since Papa Libion was forced to sell in 1920, undone by too much bad spending and too many bad friends, which invited unwanted attention from the tax authorities. Kiki and Man Ray found the Dôme the best alternative, good for keeping up with the latest gossip and the comings and goings of friends—the neighborhood's "living newspaper," as Cowley put it. They appreciated the small counter in the corner where you could buy tobacco and stamps. Hemingway liked the place too, writing in *A Moveable Feast* of how he would cross to the Dôme, where "there were people there who had worked. There were models who had worked and there were painters who had worked until the light was gone and there were writers who had finished a day's work for better or for worse, and there were drinkers and characters." Kiki felt so at ease on the Dôme's wide terrace that she would sometimes hike up her skirts and piss from the edge of her chair into bushes on the patio, saving her the long wait for the washroom.

But the crowd at the Dôme often got too "American" for Kiki and Man Ray's liking. And they found it too brightly lit, loud as well, filled with voices like fifty phonographs pitched to different speeds and volumes, each playing a different tune. Sometimes, headed for the Dôme, they detoured instead into the quiet *tabac* a couple of doors down, with its horseshoe steel-countered bar lined with laborers in their blue jumpsuits. Sometimes they dined at the nearby Select, whose specialty was a terrible Welsh rarebit.

Down the way at the corner of rue Campagne-Première and boulevard du Montparnasse, Kiki and Man Ray had watched a little bar, the Café Caméleon, being reinvented as the Jockey. This would soon become their new favorite spot.

The Jockey was the brainchild of a young Wharton dropout and budding impresario named Hilaire Hiler, who'd partnered with another American with tenuous claims to a horse-racing past, which gave the bar its name. Under the club's gaudy neon sign, Hiler painted the outside entrance with cartoonish scenes of what they would have called a cowboys and Indians theme. Inside, he plastered the walls

with jokey slogans: WE'VE ONLY LOST ONE CUSTOMER—HE DIED; IF YOU CAN'T TAKE A JOKE—TAKE A WALK. The regulars followed his lead and soon filled in the blank spaces with dirty limericks and quizzical haikus in several languages.

A photograph showing a small crowd out front of the Jockey marks one of the few instances of Kiki and Man Ray appearing in the same frame. Man Ray looks boyish, crouching and clutching his Kodak. Kiki stands behind him, icy and regal. Tzara crouches nearby, looking like the kind of aristocratic villain who would have been played in the movies by Erich von Stroheim. Cocteau in knitted gloves is there, as is Ezra Pound with his Van Dyke beard and floppy beret.

The Jockey in its first months was no more or less of a hot spot than anywhere else in Paris. At that time, all a club had to do was open its doors. Nearly all the city's four thousand cinemas, close to six hundred theaters, and hundred or so dance halls were already running close to capacity every night as people rushed out to embrace any kind of entertainment after years of depravation. But Kiki and Treize were instrumental in turning the Jockey into the Montparnasse crowd's chosen headquarters. They brought everyone they knew to it, like ambassadors for some fledgling nation. They felt as if they'd discovered the place and then made it their own just by going there so much.

"I don't know anywhere else in the world . . . where you could have so much fun and be so completely yourself," Kiki said of the Jockey. Desnos, escaping his studio crammed with piles of old records, a waxwork mermaid, and handmade ceramics, among other flea market finds, spent hours in a corner writing poems on napkins and peeled-off wine bottle labels, or releasing drops of water onto crumpled up paper straws so they'd crawl like inchworms. Pascin, bowler hat pulled down so low it covered his ears, came nearly every night to pick up women, talking softly so they had to lean in to hear him. "Almost anybody of the writing, painting, musical, gigoloing, whoring, pimping or drinking world was apt to turn up," according to the hard-drinking Robert McAlmon, another fixture at the club.

Lone occupant of a crumbling single-story building, the Jockey

stood like a massive boxcar stuck on the tracks, the stowaways crammed together at its lone wooden bar and at tables pressed against the back wall. It was one big open room, so that you always felt at the center of the unfolding action. The floor was sticky, the ceiling low, lighting and airflow almost nonexistent. Such luxuries could be found across the Seine in the fizzy nightclubs of the Champs-Élysées, with drinks quadruple the price. But those were the places whose regular clients were now coming to slum at the Jockey. Expensive cars lined the boulevard du Montparnasse. Nearly as many liveried men stood on the sidewalk smoking and waiting as there were people inside dancing. One memoirist reported hearing a chauffeur telling another, "The dirtier the place the more they love it." People came to drink Martinique rum, or beer shandies, or one of the many transatlantic inventions on offer at this *bar américain:* Manhattans (two ounces whisky, one sweet vermouth, a couple of dashes of Angostura bitters, stirred with ice, strained into a coupe garnished with a maraschino cherry); Alaskas (three parts dry gin to one part chartreuse, shaken well and strained into a coupe); and gin rickeys (a wineglass's worth of gin poured into a highball glass over a lump of ice and the juice of a quarter of lemon and a half of lime, and seltzer filled to the top).

The door was always opening and closing, especially after the nearby theaters let out and two hundred bodies squeezed into a space meant for fifty. Theatrical fisticuffs were frequent. It got so hot that people let their unbuttoned shirts hang to their waists, or threw items of clothing into the corners, or stripped down altogether. The crowd was constantly changing and racially and economically mixed. On a dance floor no bigger than a picnic blanket, a London banker's wife in fine taffeta and a suburban shop assistant in austere cotton might find themselves shimmying between a shaggy Russian painter in a fisherman's jersey and a veteran of the Harlem Hellfighters in a *smoking*.

Someone could walk a few hundred yards from her door and encounter notes and rhythms in combinations still unheard in all but a few tiny patches of the globe, and which seemed to speak to the present moment like no other music could. *Le Jazz,* as the French called

it, was first introduced to Paris by African American troops arriving in 1917 and 1918, and by the touring bands of James Reese Europe of the 369th Infantry (the Harlem Hellfighters) and Louis Mitchell's Jazz Kings. Many of the Black American expats in Paris during the twenties were veterans from among the two million American soldiers and support staff who'd been mobilized to France for the Great War, and who'd remained or had come back after brief, often disappointing returns to America. They frequented the bars and nightclubs of Montparnasse as customers, as performers, and soon as owners. While Paris in that era was far from a frictionless racial utopia, many Black expats remarked on feeling that they were treated with more dignity in France than in the United States. Meanwhile artists and writers among the Parisian avant-garde quickly co-opted African American music as both the soundtrack to their lives and fodder for their work. "Jazz," the French writer and politician Paul Morand recalled of his time in Parisian nightclubs in the first years after the war, "produced such sublime and heartbreaking accents we all understood that we must have a new form of expressing our own feelings."

Les Copeland, a Wichita-born vaudevillian, manned the Jockey's rattling piano. He played choppy jazz and ragtime, slow blues, old cowboy ballads, whatever came to mind, accompanied some nights by a couple of banjoists. He wrote his own stuff, too. With his Kansas drawl, people mistook him for a retired cowboy, and he was in no hurry to correct them. A bigger draw than Copeland because he appeared more rarely was Hilaire Hiler himself. Customers clanged silverware on the tables to get him to play. When he felt agreeable, he took over for Copeland. Hunching his tall frame over the piano, Hiler showed himself to be a gifted if less refined player, banging away, his mouth stretched into a grin that seemed to span to the lobes of his big jug ears. He recited poetry in nonsense Yiddish and sang old songs from the Caribbean or French folk tunes. Sometimes he picked up a saxophone and blew fairly well. The American novelist Kay Boyle remembered Hiler's "loose red mouth that was like a gaping wound. His enormous eyes were strangely glazed, either from drink or from

some excruciating mental pain." She recalled how whenever she and Hiler walked into any of the neighborhood's clubs, he went straight for the piano, replacing the regular player to "bang out current jazz and blues with such brilliant melancholy that girls would leave their escorts to come sit at Hiler's feet," and that the crowd kept asking him for more.

From those original calls for Hiler at the Jockey came the custom that whenever people wanted to hear a particular performer, they would clang their dishes and chant the desired musician's name, carrying on until they got their wish. Not every performer at the Jockey needed an invitation. In the club's first years, anyone could get up and sing or dance or play an instrument so long as they could stand being ignored by the chattering crowd, or at worst hissed out of the spotlight. It was an informal arrangement fueled by impulse and alcohol. Once in a while, someone managed to set themselves apart from the crowd, a civilian transformed briefly into a spectacle, exalted, illuminated by the gaze of others.

Kiki watched and listened like everyone else. Her friends had always enjoyed her singing when she entertained them after dinners, and they had encouraged her to do more of it, but she'd been far too nervous about the prospect of performing in public to give it any thought. She'd climbed onto the tabletops as a child to sing for coins, of course, but she'd been fearless then. For all the charisma she displayed in front of the camera, and among people she knew well, and at times among strangers in environments where she felt as comfortable as if she were in her own home, like the terraces of Montparnasse, Kiki grew panicky simply by going to unfamiliar places. She was, in her own way, an intensely shy person.

Something pulled at her while watching the amateurs vying for their time under the lights at the Jockey. Sometimes while watching and listening, she thought that what the moment's star was doing, she, too, could do. Maybe even better.

14

COME CLOSER

B Y THE END OF 1924, KIKI WAS PERFORMING REGU-
larly at the Jockey. It had started one night as a drunken lark, then
became something she did every so often for a thrill. Soon enough she
craved singing in public. And the Jockey crowd craved seeing her too.
Whenever Kiki was rumored to be performing, the doorman had to
turn people away.

Stylistically Kiki belonged among a small group of *chanteuses réal-
istes,* female singers such as Marie Dubas, Lucienne Boyer, and Kiki's
friend Yvonne George, who were having a moment by reimagining an
old form: that of the great Belle Époque performers who'd special-
ized in wistful ballads of the streets and the seas, singing hymns to the
small-time players of the underworld and eulogies for a France that
seemed to be disappearing, a victim to greed and progress. The form's
spiritual godmother was the single-named Fréhel, whom people asso-
ciated with the purportedly golden era before the Great War, though
she was only a decade older than Kiki. By the 1920s, Fréhel showed the
wear of years spent indulging her desires for drink, ether, and cocaine,
which added to her mystique as a ruined, romantic figure.

A *chanteuse* such as Kiki was easy to dismiss as a mere nostalgia act
with nothing to say about the present world. And yet the Jockey crowd
found her more refreshing to watch and listen to than many of her

contemporaries who sang the latest tunes. The gritty realism of Kiki's performances felt jarringly out of place when set against the decade's quick crazes and fast rhythms. There was something bordering on surreal in her putting forth such antiquated content, if somewhat altered by Desnos's occasional lyrical input, in Montparnasse's nightclub of the moment, there among so many forward-thinking urbanites.

While she claimed allegiance to no artistic movement, Kiki's shows were imbued with the spirit of artistic experimentation going on around her. In repurposing the culture of the streets for the cabaret stage, she exhibited some of the provocation and silliness of Dada and shared in the Surrealist fascination with found objects. And while she ranked among the most glamorous *parisiennes* of the moment, Kiki's country mannerisms and Burgundian accent contributed much to her allure. When she rolled her *r*'s as if there were three in a row (she said her birth name sounded like "Alice Prrrrin" to Parisians), the Jockey crowd went wild. It made her sound earthy and authentic to Parisian ears.

Kiki's reputation as a performer grew slowly across the city and beyond as 1924 gave way to 1925. Her voice, worn from smoke and drink, was "weary, burning, and broken," in the words of a reporter for *Le Petit Journal*. She had a "beautiful *parigote* [slang for Parisian] laugh, serious, mocking, inexhaustible, the laugh of a fatalist." Kay Boyle found her "heavy-featured and voluptuous, her voice as hoarse as that of a vegetable hawker, her hair smooth as a crow's glistening wing." To the teenaged Canadian poet John Glassco, recently arrived in Paris, there was "no mistaking the magnetism of her personality, the charm of her voice, or the eccentric beauty of her face, beautiful from every angle, but . . . best in full profile, when it had the lineal purity of a stuffed salmon." Thora Dardel described Kiki in simpler terms: "God! What an experience it was to see her!"

A typical Kiki performance at the Jockey would begin around midnight, when the crowd would start to chant for her. "Kiki! Kiki! We want Kiki!" She would slink into the lights, wait until there was something close to silence, and then sing.

Come closer
Come my little man
There's not too much shit
I may not look like much
But you'll see
I'll be your bad little piggy
I'll show you a good time!
And you'll give me twenty sous for the effort

She underplayed the song's naughtiness, which made the crowd laugh even more than if she'd turned it into an all-out burlesque. "While singing, Kiki would lower her head, moving it from side to side," recalled Jacqueline Barsotti. "All her movements were economical and rounded. She made a light dance with her hips, very slow and almost imperceptible."

Next Kiki would lean against the piano and start in on *"Nini peau d'chien"* (literally "Nini Dog-Skin," slang for a prostitute), a nod to the previous generation and the city's other bohemian enclave. A few decades earlier the legend of Montmartre's Le Chat Noir, the red-scarfed cabaret performer and impresario Aristide Bruant, had first made the song popular. These kinds of songs, with their grit and grime, helped bring the customers who'd come merely to slum, repeating, whether they knew it or not, an updated version of the nineteenth-century practice known as the Grand Duke's Tour, in which members of the middle and upper classes made titillating forays into the under-world. Treize, hat in hand, would seek them out among the crowd, knowing they tended to leave the most money.

Hilaire Hiler allowed the practice because it meant he didn't have to pay Kiki. But after a few weeks of Kiki appearing regularly, seeing how heavy Treize's hat could get, he started demanding a cut. Kiki and Treize took their revenge by pocketing bills and misrepresenting their final counts. Some nights they could pull in enough for them both to live well for a month. Kiki's relationship with Hiler could be adversarial at times, but there was always much affection between them. She

liked to poke fun at Hiler, who, as she wrote, "never lets you know what he's really thinking . . . as he hides behind his giant ears." One night when Hiler, talking to some friends, spent too long lamenting the loss of a woman who he said had abandoned him, Kiki, overhearing, announced that he was full of nonsense and that woman had been in the club the night before, yelling at him that he'd mistreated her, rather than the other way around.

At the Jockey, the tourists tended to sit or stand by the back wall, happy to carry on their conversations and turning occasionally to watch. Every so often Kiki would halt her song midway to keep them in check. One night she stopped singing in the middle of a line, waiting for everything to go silent except for a chattering British couple in the back. They stopped talking, mortified. Kiki savored the silence. Made sure the audience savored it too. And soon it became clear that Kiki had created this awkward moment on purpose, so that the audience, too, could feel theatricalized—had created the awkwardness precisely so she could break it, rescuing them all from the moment as she continued with her song. She sang, and the relieved crowd joined her for the happy chorus.

There were, of course, times when Kiki plain forgot the lyrics, and she used these pauses to buy time. In these cases, Treize with her indefatigable memory would whisk over and whisper the missing words.

Kiki would sometimes make the rounds for donations at the end of the night instead of Treize, continuing the connection with her audience that she'd begun on stage. She enjoyed having strangers giving her the attention and affection that were so hard to extract from Man Ray.

Seeing Kiki standing in front of him one night, waiting to collect, a young Austrian student and would-be writer, Frederick Kohner, felt so flustered that he handed her a fifty-franc note, worth a week of his budget. Kiki asked if he was an American, the likeliest candidate to throw around that kind of cash. He shook his head, leading her to hold the bill up to the light for closer inspection. Satisfied with its legitimacy, she lifted her skirt and slipped it between her garters. A few decades later, after Kohner and his wife fled Nazi Germany and

settled in California, he would craft his singular literary invention: Gidget, the princess of 1950s Malibu—perhaps inspired by his over-heated memories of Kiki, the queen of 1920s Montparnasse.

Kiki wrote of these kinds of postperformance encounters: "When strangers come talk to me I usually understand none of whatever story they're trying to tell . . . since I only know French and a bit of English. *Who's he? What's he saying?* It's probably better that way since the reality will be more disappointing than whatever I'm imagining."

Kohner wasn't Kiki's only Teutonic admirer to achieve future public notice. The architect and sculptor Arno Breker, who became Hitler's favorite sculptor and tried to represent Nazi ideology in physical form, thought Kiki "without question the most glorious [woman in Paris], a true phenomenon of carnal beauty and plenitude." Her "audacious" profile reminded him of Minoan statuary and her body of Venus de Milo's torso, only fleshier. He was surprised no one had yet tried to sculpt her. (He never approached her himself with the idea, for whatever reason.) He described Kiki's performances as equal parts singing and declaiming, rousing her "motley choir" of spectators to join in for the choruses. He recalled that her pull was as strong offstage as on. When strangers passed her in the street, their heads would swivel reflexively. Anywhere she sat, a crowd immediately gathered, everyone sitting "frozen in astonishment" at "this masterpiece of nature." Breker said it was impossible to describe Montparnasse in the twenties without first "conjuring the dream-image of a woman who looks like Kiki."

Not all of Kiki's interactions with her fans were so placid. The effectiveness of her night's performance depended largely on her presenting herself as a rough-hewn, streetwise woman, and some watchers struggled to see where Alice Prin ended and the character of Kiki began. One night a man groped her rear, while she was in the middle of the song. Without reacting, not even looking at him, she said: "Don't wear yourself out. I only feel my lover." Following her performances, she would sometimes have to push away men who'd decided she must be as available in life as her avatar had them believing she

was from the stage. Once when a man roughly grabbed her breast, she hit him in the face and chased him into the street until the Jockey's bartender, who'd followed her out, lifted Kiki up bodily and brought her back inside.

The more regularly she performed, the more Kiki grew anxious. An increasing number of strangers came to watch her, close enough to touch her, demanding to be entertained. She wrote in her memoir of the crushing responsibility she felt for putting every one of them at ease. She felt like she was throwing a party and had to make her guests feel as welcomed as they would feel in their own homes hosting her. She never thought of herself as above her audience. If anything, it was the other way around. She saw herself as someone there to serve them. And she felt pressured to bridge the gap between what was expected of her on stage and who she really was. "Getting ginny" helped, she wrote. "I can't sing when I'm not drunk. I'm shocked by these women who can sing just like they're going pee."

Cocaine helped, too. Fears about drug smuggling, a loss of army efficiency, and the potential dangers of the drug itself had led France to outlaw cocaine in 1916, along with opium, morphine, and their derivatives (except codeine), as well as marijuana, punishable by a maximum ten-thousand-franc fine and two years in prison. French parliamentarians arguing for the legislation suggested that the German army had introduced cocaine into France to weaken the country's helpless youth. But drugs remained as easy to come by as they had before the law passed, and Kiki, like many people in her circle, was a fairly regular user:

At the start, I thought it was great! I would get depressed sometimes, fixating too much on the past. I tried to put it out of my mind but it would always come back. So, a pinch of powder . . . and I felt lighter, no more worries, no more boredom. . . . The singer's job's not always easy. It's hard to be the cabaret's main attraction. It's great on the days when you want to have fun, but there are others when you just want to be home having a quiet time. But

then, and this is the horrible thing, all it takes to get you back on stage is one little sniff.

After only a few months of regular performing, she gained confidence in her form. She felt like the cabaret was a train, and she its conductor. "By the end of the night it's hard to tell who's the patron and who's the artist; we're just one big family coming together to enjoy the passing moment." But such happiness could be costly. Kiki found herself needing badly to be on stage, even as she struggled with it. She'd been seduced by the cabaret life. Soon she was going without a day's rest between performances. "Even while I was suffering" she wrote, "I was always at my post."

15

GOING AWAY

IN FEBRUARY 1925, KIKI TOOK WHAT SHE MEANT TO be a quick break from performing. She headed for the southern town of Villefranche-sur-Mer with Treize, who brought along her neighbor, the Norwegian painter Per Krohg, whose wife Lucy was enjoying her own fling in Saint-Tropez with Jules Pascin. (Treize believed that the day the Krohg marriage finally ended, she and Per would be together permanently. She would be heartbroken in 1932 when Per and Lucy did split but Per soon afterward married another Norwegian woman. Kiki made sure Treize ate and tried to soothe her with tarot card readings promising Krogh's return to her.)

One of the usual pleasures of a journey down to the coast was in finding gray Paris replaced by a seaside of blue, gold, and green. But when their train first reached the ocean, Kiki saw crashing waves through the window lashed by heavy rain. She regretted the impulsive trip and missed the Jockey.

They settled in on the fourth floor of the Welcome Hotel, where Cocteau was staying. With his skill for detecting beauty in some person, place, or practice before it became obvious to others, Cocteau had recently "discovered" the fishing village. He'd gone there to mourn the loss of his lover, the writer Raymond Radiguet, dead at twenty of tuberculosis on the precipice of what should have been a brilliant

career. (Cocteau would credit the cleanness of Radiguet's prose and the brutality of his editorial eye as lasting influences on his own work.)

By 1925 the charms of the Riviera were hardly secret. Along the coast, from Hyères to Monaco, hotel and casino owners, restaurateurs, and other resort stakeholders had been modernizing businesses that had been stuck in the late nineteenth century, the ranks of their aristocratic clientele decimated by the war and the Russian revolution. For the past few years, resort owners had been trying to attract younger visitors who were more down-market, more international, and more cosmopolitan in their outlook. In other words, people like Kiki, Treize, and Krohg.

With their strings of sunny days and stone walls dripping with fragrant bougainvillea, the coastal towns turned their backs on mainland concerns, leaning instead toward Corsica, Sardinia, and North Africa. They felt set apart from the rest of France, much as Montparnasse was set apart from the rest of Paris, which helped to make the coast a logical destination for pleasure-seekers from the Quarter. Malcolm Cowley deemed the entire Riviera a "suburb" of Montparnasse. Those who could afford the hard-to-come-by tickets traveled on the Blue Train, as the Calais-to–Côte d'Azur line was called, an all-first-class train with distinctive carriages of blue and gold. It went nonstop overnight from Paris's Gare de Lyon, reaching the seaside by morning.

Two of the greatest ambassadors for the Riviera, especially among Europe's wealthy and English-speaking expat crowd, were Gerald and Sara Murphy, who in the summer of 1922 rented a villa with Cole and Linda Porter in Cap d'Antibes. The Murphys returned the next summer and eventually built a property a few miles away in Antibes, which they named Villa America and considered their most permanent home for much of the 1920s. Their invitations to friends like Picasso, Olga Khokhlova, and the Fitzgeralds helped to spread word about the Riviera's qualities.

Cocteau, too, played no small role in helping to "invent" the modern Riviera, especially among the smart set in Paris and London. In 1924 he wrote the libretto for the Ballets Russes production *Le Train*

bleu (The Blue Train), which boasted a drop curtain by Picasso, costumes by Coco Chanel, music by Darius Milhaud, and choreography from Bronislava Nijinska, but was really just a helium-filled balloon, an empty spectacle of toned bodies having fun at an unnamed seaside resort. As such, it was also one of the truest portraits of the decade's glamorous, hedonistic Riviera lifestyle. "*Le Train bleu* is more than a frivolous work," said Cocteau. "It's a monument to frivolity!"

But for all the Riviera's popularity, seedy Villefranche with its small but lively port displayed too clearly the signs of industry to attract much of a following. You didn't go to there to gamble or take the cure. You didn't go to Villefranche to do much of anything.

Which was exactly why it so appealed to Cocteau, though with his loose crowd of hangers-on, he was starting to lend the place a kind of louche elegance. The main attraction was the Welcome Hotel itself, fronting onto the bay and its unusually deep harbor, while behind it the tight streets of the old town coiled upward like a resting snake. It wasn't much different from any of the other grimy seaside hotels peppered along the coast, but Cocteau prized it for allowing him to pursue his two current interests in a single location. Across the way stood the fishermen's chapel of St. Pierre, where he prayed daily, newly lit by religiosity, and where, he said, the Virgin Mary appeared to him in a vision he experienced shortly after meeting Father Jean Édouard Lamy, a Catholic mystic known for having had many visions of Mary, Joseph, and Lucifer, and of the deep past and distant future. And farther down the shoreline, the port's casual drug trade kept Cocteau in steady supply of half-decent opium, dark and gummy-like toffee, which he smoked unbothered in his room, sometimes venturing out to wander the wheat-colored halls in his opiate slumber. If he was short on cash, Cocteau could rent his room for a few hours to a prostitute and her sailor, as arranged by his new friend Aunt Fifi, the local madam, famous for her tattooed knees.

Kiki and her friends in Paris had been throwing themselves at life as fast as they could, shooting from here to here as if they were living *pneumatiques,* the capsules that sped their blue paper messages across

the metropolis by way of a several-hundred-kilometer underground network of tubes powered by compressed air. But now Kiki saw Cocteau on the coast, smoking to reach a state of meditative lethargy. He said he sought to live at the speed of a plant growing in a pot.

She ended up staying for a longer stretch than she had expected. After her initial disappointment with Villefranche, she found herself enjoying its slow southern rhythms. From her brightly painted room, she watched the fishermen tending their nets and lazing in the sun, and the dockside drifters conspiring over cards in the unreliable shade of swaying palms. She could stare for hours at the changing patterns of the Mediterranean, a sea "as mysteriously colored as the agates and cornelians of childhood, green as green milk, blue as laundry water, wine dark," as Fitzgerald described it in *Tender Is the Night*. She watched the bobbing cream-colored boats dwarfed by the *USS Pittsburgh,* flagship of the American Sixth Fleet, in port on a goodwill mission. As the days unfolded, she engaged in a few hijinks in her room with Treize and Per Krohg, who took turns giving her spankings although, as Kiki wrote, their encounters ultimately "left her cold." She did not write if she tried opium.

Kiki liked the nights most of all. This was when the sailors turned the place into "one roaring, sucking, mixed riot," as another Riviera visitor, the English writer Mary Butts, put it. "Villefranche at its best." The dancing started at five in the afternoon and ended at three in the morning. There were fistfights at the water's edge, caught by the spotlights from the American ship turned to illuminate the Welcome's Italian tromp-l'oeil facade. Women waved their handkerchiefs to the sailors from the balconies. "There are lots of women," wrote Kiki. "They come from Marseille, from Nice, following the ships from port to port to find their sweethearts. They're the nicest of whores, elegant, well-mannered, sentimental, even."

Kiki settled in at the Welcome's lobby bar, a natural among the pimps, petty thieves, counterfeiters, hustlers, and *filles de joie* ("pleasure girls," as French sex workers were called). She could swear as colorfully as any of the seamen and knew dirtier songs. "Cocteau and I had

the same passion for all that comes from the sea," she wrote, alluding to their mutual admiration for men in uniform. The walls thumped to the chaos of a house band consisting of a piano player, a banjoist, and a cross-eyed accordionist, who needed no drummer to compete with the woody racket put out by the drinkers banging along on counters and barrels. The songs mixed with the sounds of women for hire arguing over their territory, sailors smashing bottles, fists hitting flesh, and shanties bellowed by former enemies now with arms wrapped around one another declaring themselves brothers of the sea. Cocteau, whose room could be reached by a backdoor staircase leading from the bar, recalled feeling the noise through the floorboards.

By late March, Treize and Krohg had returned to Paris. But Kiki stayed on. She grew closer to Cocteau, who'd always given her a boost of confidence whenever he'd come to watch her perform and whose plainspokenness and easygoing charm made her feel like she'd known him her whole life. "I started to feel really comfortable in this hotel," she wrote in her memoir, "like I was part of a family. And all the sailors were my friends." She suffered moments of loneliness, and she missed Man Ray, but was in no hurry to get back home.

From the Welcome, she wrote to Man Ray, in a mix of French and broken English, decorating a corner of her letter with a tiny painting of herself nude and reclining, garlanded by flowers, her back turned to the viewer, a painting she did by dipping her fingernail into some watercolors that came with the purchase of a box of candy.

Bad little Man
Why you no write me
Big Mischievous. Still,
I am sorry [for] my Heart!
alas! Another girls Bitch
must have take your Heart, and something else too!
You forget me!
My Man dear I love You
You're my little blue flower!

Write me my little Man, it would
Make me so happy!
Last night I saw the Douglas [Fairbanks] movie
Don X [in reality *Q*], *Son of Zorro*. It's a marvel
Go see it.

In calling Man Ray her "blue flower," Kiki was likely trying to convey in English the figurative sense of *fleur bleue,* used to tease someone overly sentimental and naïve about love, as though chiding him for trying to pass himself off as romantically ruthless while she preferred to believe he was really the opposite.

ONE APRIL NIGHT IN VILLEFRANCHE, Kiki went out to an English bar called the Sprintz. She'd never been there before, but some sailors at the Welcome had invited her. At some point a fight broke out. In her telling, the problem started moments after she walked in, when the Sprintz's owner yelled at her from behind the counter, "No whores allowed here!" She answered by leaping up at him and throwing some dirty dishes at his face, sparking an all-out fistfight among the drinkers when her sailor friends jumped in to support her. But if the tumult started because someone mistook Kiki for a prostitute, it's unlikely that it was the owner who made the comment, since prostitutes were common at such seaside bars. More plausible is that another woman, or her pimp, had mistaken Kiki for an outsider infringing on the local trade, and said or did something that led to the fight.

Francis Rose, a British painter and a friend of Cocteau's, offered an alternate theory. He recalled wandering into the Sprintz and noticing most of the women filing out, as though sensing some kind of impending mayhem, leaving only Kiki and a couple of other women among dozens of drunken sailors. Rose, who would have been seventeen at the time, wrote that one of the sailors got him up to dance, but Kiki mistakenly thought Rose was being harassed and asked some other sailors to intervene on his behalf, prompting the donnybrook.

Whatever its cause, the brawl brought the naval police blowing their whistles, followed by the local gendarmes. Kiki slipped away without being questioned, but the authorities soon learned her identity, either because someone at the Sprintz knew who she was and reported her or because someone—police or civilian—spotted her leaving and tailed her back to the Welcome, having deduced that she was involved in the fight. Kiki thought that her staying at the Welcome contributed to her ensuing troubles with the law, since any suspicions about her were immediately confirmed by her association with the place, which, she said, had a terrible reputation.

The morning after the fight, someone on the Welcome's staff told Kiki that a man was waiting downstairs to see her. She went down to the lobby and saw outside a uniformed policeman waving at her to come speak to him. She stayed in the lobby. The policeman left and returned with Gaspar, a local constable, who told her he'd come to arrest her.

At some point during this encounter, Kiki hit Gaspar with her makeup case. She later claimed Gaspar, who "looked crazy and was trembling with rage" when he came to arrest her, had punched her in the side of the head because she was walking too slowly to the police car and that she'd only been fighting back, after which other officers handled her roughly and threw her in their vehicle. During the interrogation at the station, another policeman abused her so badly she was tempted to reach for the revolver on his desk to stop him. While figuring out where to jail her, they threw her into a supply closet, where she was squeezed between some rotting planks and a rusted bicycle. (In Man Ray's recounting of this event, one of the arresting officers grabbed Kiki forcefully by the arm and called her a name, which caused her to strike him.)

Kiki was charged with public indecency—a blanket charge to cover anything seen as threatening to "public morals"—as well as resisting arrest, damaging property, and assaulting a police officer. She was taken to the prison in Nice.

The Easter holidays delayed her trial. Her cell had a bed and a cham-

ber pot chained to the wall. She was there alone. Nights were pitch black and she'd never slept in such darkness. She had panic attacks and feared slipping into the madness she'd experienced years earlier in Paris, when she'd had to check herself into the public assistance hospital, back when she was still called Alice. She asked for a night-light, and the guards laughed. Watching the last strip of sunlit color disappear from the ceiling became the worst part of her days.

She felt like a cosmic joke was being played at her expense, as though she'd been dropped into an oubliette and no one knew where she was. To ground herself in time and space, she listened for the whistle of passing trains and focused on picturing the train station with its connection to other places and to friends. She read the one book on hand, *The Three Musketeers,* then started it again as soon as she finished. One of the guards showed her a Niçoise newspaper reporting on her arrest, describing her as Alice Prin, "a woman of easy virtue," and listing her age as ten years older than she was. Her chamber pot was left unchanged. It made her think of a vessel in which a painter mixes colors, everything congealed into a stinking mass. Eventually they took her for formal charging, in a hot van smelling of garlic, then brought her back to jail.

In Paris, Man Ray, Treize, and Desnos had learned of Kiki's troubles and worked on her defense. Desnos contacted the artist Georges Malkine, who lived in Nice, and through him connected to a prominent businessman, a Monsieur Verdier, who owned the city's largest private garbage collection company, to learn what he could about the case. The court had assigned a lawyer named Bonifacio to Kiki's case. Malkine reported back to Desnos that Bonifacio, after meeting with Kiki and hearing the facts of her case, took it as a given that his client was indeed a prostitute from Paris and was lying about her circumstances. Only a letter from Verdier, dictated by Malkine and meant to be presented as evidence of her good character at the trial, could convince the lawyer otherwise.

Bonifacio knew Gaspar and went to see him, pleading with the constable to go easy on Kiki when he gave his deposition, especially in

relation to the most serious charge of assaulting an officer. Meanwhile Man Ray tried to get down to Nice as quickly as he could.

Because Malkine had learned about Kiki's arrest only during the Easter holidays that had brought the courts to a temporary standstill, no amount of intervening could get her out on bail, nor her trial date moved up. After spending twelve nights in prison, she went to court in Nice, riding again in the garlicky van. One of the officers said she should come away from the other prisoners and sit up front on his lap. She refused.

At the courthouse, Bonifacio advised Kiki that even with his best efforts, she would likely get six months. Resisting arrest and assaulting an officer were serious charges. He gave her a vial of smelling salts in case she fainted. She'd lost ten pounds since going in and had trouble seeing straight. She was filled with hatred, she wrote, without specifying at whom this hatred was directed. While waiting in the hallway, she watched another defendant writhing on the floor in an apparent seizure. People stood over him debating whether he was faking it to delay his trial on charges of driving with a falsified license. When they called in Kiki, she had to climb over the crumpled man to reach the courtroom.

On entering, she saw Man Ray in the crowd and began to cry. She watched the quick trials preceding her own: the sad old woman who'd stolen a tiny golden cross from a sewing basket: acquitted; the large and lawyerless woman with a shaved head accused of having stolen a man's wallet after having sex: given three months; the knife-thin fifteen-year-old who'd threatened the life of a vice squad officer who'd been harassing her because she'd refused to become his snitch: two months. "Shit!" she heard the teenager mutter on her way out, "another two more months of picking off crabs."

Her turn came. The court wanted to know if Kiki had been drunk on the night in question. She said no. The response was that her actions were worse done sober than drunk. Gaspar testified that Kiki had struck and insulted him. But then he downplayed the severity of those actions. Next, a witness said Kiki had done no more than give the con-

stable a little tap with her handbag. And the owner of the Sprintz said he was willing to withdraw his complaint so long as his court expenses were paid.

Man Ray thought that Bonifacio "lacked brilliance" when making his arguments. In truth, as Malkine reported to Desnos, Kiki's judge had a reputation for varying the lengths of sentences according to how much sermonizing he had to endure. So Bonifacio argued quickly, framing his defense around the idea that artists were fragile souls occasionally led astray by their heightened sensibilities. He presented three letters: the first from Louis Aragon attesting to Kiki being "a serious artist"; the second from a Paris doctor describing how she suffered from "nervous trouble"; and the third from a Niçoise doctor labeling her "high-strung." Desnos had procured the documents and given them to Man Ray to bring to Bonifacio. The Parisian doctor enlisted to Kiki's cause was the artist Théodore Fraenkel, a practicing physician, one among the small group of Dadaists who'd welcomed Man Ray to Paris on his first night in the city. It's unclear how well he knew Kiki.

The doctors' notes seemed to move the judge somewhat. The letter from the Surrealist poet from Paris, less so.

Bonifacio advised Kiki to apologize to the court and to "thank all of the gentlemen present." At first her voice wouldn't come to her, but she managed to croak out a few words of shame and gratitude. The judge gave her six months' suspended sentence and two years' probation. Man Ray paid her small fine. Kiki wrote that if the verdict had turned out differently, she would have killed herself before going back to jail.

Le Petit Niçois, the same paper that had earlier tagged her as a "woman of easy virtue" and gotten her age wrong, now reported the release of "Mlle. Alice Prin, a charming brunette of 22," who "caused a bit of a scandal while drinking a few too many rounds." In this version of the events, "the commissioner invited her to his office for questioning but she obstinately refused and insulted him . . . driven to the

point of hitting him in the face with her handbag, for which this hot-tempered beauty has apologized."

Kiki mailed Desnos a postcard as a thank you. She drew the port of Marseille with a sardine in the foreground and wrote under-neath: "She's the one who choked the port," playing off of an old bit of slang—"the sardine that choked the port of Marseille"—used to describe a wild exaggeration, supposedly a Marseillaise trait. Possibly she meant to soothe the delicate Desnos, signaling to him that any-thing he'd heard or imagined about her imprisonment was overblown. She signed herself "the troublemaker." Desnos had already received a telegram from Georges Malkine: "Kiki is free, in excellent shape."

After the trial, back in Villefranche, Kiki and Man Ray posed for a photograph shot either on a timer or by someone else. In the image, Kiki plays the role of prostitute to Man Ray's john, leaning out into the sun from her shaded room, the black of her hair melting into the black of the room, her silk gown opened to expose her breasts while he leers from the side of the frame. He's on the street, shadowed by his cap, appraising; she stands higher than him, commanding and defiant. They both look worn out.

Maybe Kiki proposed the picture to turn her ordeal into self-parody, or wanted simply to luxuriate in her freedom. Or maybe Man Ray staged the tableau, wanting to show, protected by the guise of comedy, how he saw their relationship in light of the narrow but unbridgeable gap in their respective origins, hers to him troubling because rural and slightly poorer than his own. In the courtroom, lis-tening to letters attesting to the artistic talents and psychological dif-ficulties of the woman with whom his life had become so entangled, maybe he was thinking of escape, one he figured would be that much easier if he could see himself as just another tourist and she another seaside whore.

A few nights later Man Ray and Kiki were back in Paris. Welcomed as a prodigal daughter returned, she sang to the packed Jockey and went on to drink at the Dôme, whose owner, Chambon, greeted her

with, "Ah! there you are, the queen bitch." She teased Chambon's teen-age son by asking if he'd finally managed to lose his virginity while she was gone. A few nights later she was seen dancing with the Spanish painter Joan Miró to celebrate the opening of his show at a gallery on rue Bonaparte.

Her friends treated the Villefranche affair as a romp. By striking an uptight policeman, Kiki had struck a symbolic blow against all reac-tionaries and hypocrites. It was the kind of prank that would make any former Dadaist proud. And then to get away with it? Defending your actions in a court of law on the grounds that you were an artist? Duchamp himself couldn't have thought up a more radical work of conceptual art.

Treize said that Kiki's arrest had some practical advantages. When-ever she ran too wild, all Treize had to do was whisper "probation" in her ear to get her back in line.

16

KIKI WITH AFRICAN MASK

EARLY 1926. THERE ARE THREE OF THEM IN THE room: Kiki, Man Ray, and George Sakier, recently hired as junior art director for *Vogue,* whose French edition had launched six years earlier. Sakier's family had lived near the Radnitzkys in Brooklyn. He used to play tennis with Man Ray's youngest sister, Elsie. He'd moved to Paris not long after Man Ray, longing to become a great painter or designer.

They have no directive to peg the image to any specific cultural event, nor to display any clothing from one of the magazine's advertisers. They're free to experiment. Sakier has brought a mask of polished wood, as tall as a human head but half the width. Skilled carvers of the Baule peoples of the Ivory Coast make similar-looking masks to praise a specific woman's beauty or dancing skill, or as a commission to honor a particular woman. Dancers donned such masks for performances, but only if the mask's "double," the woman portrayed, was present to witness the masquerade. Maybe Sakier's mask is an original imported from the Ivory Coast, at that time a French colony. More likely it was produced with the tourist trade in mind, an inexpensive mass-made replica of some original piece or newly created to mimic the style of Baule portraits masks. (The mask they used for the photo has been lost for decades.)

For a fashion editor, photographer, and model to come up with the

idea of presenting a European woman as modern and alluring through her interaction with some aspect of African culture is hardly a radical move by this time in Paris. Industrial capitalism has led people astray, and Western civilization is in decline, goes the local logic, and white modern artists must look far beyond their homes for vital inspiration. There are so many precedents from which Man Ray, Kiki, and Sakier may be drawing: Paul Gauguin's fever dreams of Brittany and Tahiti; Rousseau's jungle scenes (conjured by a man who never left France); Picasso's *Demoiselles d'Avignon*. Critics, collectors, and other artists in their circle have started to amass collections of African objects. The influential dealer and critic Paul Guillaume writes in his magazine, *Les arts de Paris,* about "The Discovery and Appreciation of Primitive Negro Sculpture," which in his view has revitalized the spirit of European art, until then "menaced by extinction."

But if primitivism is by 1926 a well-worn concept, Kiki, Man Ray, and Sakier are taking it into a new realm. Rather than providing the fodder for a painting or an object, they're channeling such thinking into a photograph, a recording of reality, if staged as a Surrealist juxtaposition: "civilized" white woman and "primitive" Black mask.

To the three of them, the mask may be no more than a piece of useful ephemera to offer up to the camera's insatiable eye. Maybe they see it as a flea market find, no different from an obscure jazz record discovered at the back of a crate, or a Eugène Atget print of a desolate street, bought for a few francs from the old man himself (Atget lived in the same building as Kiki and Man Ray), or some strange sign salvaged from an abandoned construction site. They likely know very little about the mask's origins, or would not care much about them if they did.

Likely they value the mask for something more than its formal uses or beauty. It allows them to explore their ideas, however misguided, about African culture, which for them is something to be slipped on and off like a dress. They may be channeling all that they would have heard and read and seen from countless ethnographers, racial theorists, colonial propagandists, and hacks pitching exotic travel adventure stories, all claiming special knowledge of the continent. When viewed

through their distorted perspective, the mask can stand for danger, debauchery, demonic energy, unadorned and so authentic expression. They may see it as the carrier of nocturnal secrets, black magic, or the harbinger of unsettling eros. To them, it may be a monolithic Blackness, an all-encompassing story of "Africa."

Maybe they're thinking, too, about America. They've heard Debussy, Stravinsky, Antheil, and other European composers appropriating elements of African American performance in their works. No doubt they know of the wildly popular *Revue nègre* at the Théâtre des Champs-Élysées, featuring, among its African American cast of players, Sidney Bechet, the saxophonist, clarinetist, and composer, and most dazzling of all, Josephine Baker, who'd debuted with the show the previous year, not yet twenty, and had quickly established herself as the most famous cultural figure in Paris. The critic André Levinson, in attendance on opening night, making use of multiple stereotypes, suggested that "certain of Miss Baker's poses, back arched, haunches protruding, arms entwined and uplifted in a phallic symbol, had the compelling potency of the finest examples of Negro sculpture." Flanner, recalling the same night, described Baker as "an unforgettable female ebony statue."

With such thoughts in their heads, the mask is meant to make Kiki wild through sympathetic magic as she poses with it. And at the same time, the mask heightens Kiki's sense of privilege by visually reinforcing the degree of freedom she has to play at being uncivilized. Seeing her as set apart from both Black people and from white bourgeois norms, the magazine's majority white readership can indulge in the double-fantasy of bohemian whiteness. Kiki, Man Ray, and Sakier are making an image for French *Vogue* perfectly attuned to the French vogue for fetishizing Blackness: *négrophilia*. They're making an image perfectly attuned to a time when at parties, filled with "a great deal of stamping and shouting, and primitive dancing and singing, . . . the ambition of the moment seemed to be to become as African-Negroid as possible," according to Robert McAlmon (implying fashionable white people in Paris as the group pursuing this "ambition").

Had you asked Kiki or Man Ray, they would likely have denied being scornful of anyone on the basis of their difference, and more likely would have claimed the opposite, pointing to their socializing, working with, and desiring people of many races. But they both demonstrated the ugly views on race typical among many people of their time and respective backgrounds, views thoughtless and condescending at best, at once fascinated by, fearful of, and filled with contempt for the Other. They idealized, exoticized, and demonized Black people. Kiki recounted in her memoir how at a desperate point in her teenage years she considered prostitution and went to a known area for picking up men. "A Negro looked at me. He scared me. . . . He was so black. . . . Tears came to my eyes and I was discouraged." After remarking on Man Ray's tendency to paint exclusively in the same three tones as his photographs—blacks, whites, and grays—Kiki wrote that he was "in despair because I have Negro tastes: I'm too in love with bright colors! And yet he loves the black race." Man Ray references the same "joke" in his own book.

Man Ray photographs Kiki in a few different poses with the mask, perhaps to leave himself the chance to submit a photo-story told over a series of frames, more likely searching for the composition that works. He shoots Kiki topless, hair slicked back to resemble the mask's rendering of hair, her hands holding the object to her left cheek, her eyes open, looking off to her left wistfully, a large diamond-shaped earring dangling from her left ear and some silver bangles accenting her wrist. He photographs the mask on its own. He sketches Kiki in pen and ink, holding the mask to her cheek, fudging the dimensions of her face so that it shares the same contours as the mask.

Eventually they find the pose. Kiki bends down low, ear to the table as though listening to the wood, eyes closed in concentration, holding the mask at a right angle to her own face. Two disembodied heads standing nearly perpendicular.

The image that *Vogue* readers saw in the May 1, 1926, issue shows a young woman resting her head along the top of a table hiding most of her unclothed body from view. Her left hand grips the carved rep-

resentation of hair on a wooden mask, dark and slim, its chin sitting straight on the tabletop. Light falls in a wavy band along the woman's dark, wet hair and heightens the pallor of her skin, whitened with heavy powder, throwing into relief her eyebrows like taut string above her closed, mascaraed eyes and the plummy darkness of her heart-shaped mouth. Light catches, too, along the mask's glossier surfaces, capping its peaks of cross-hatched hair, illuminating its high forehead and cheeks and lending a faint glow to the two convex horizontals representing eyes. Beneath the woman's head, a pool of shadow seeps onto the table like blood from a wound to the neck, an oval shadow echoed by the contours of the mask.

It is less a photograph than the documentation of a piece of theater. Its effectiveness comes down to props, lighting, costuming, blocking, and casting. The camerawork is incidental. The woman seems completely in control of her performance, eyes closed, far away, lost in her own dream, posing and not posing, present and absent at once, unreadable, inaccessible, her face a mask.

The caption reads: "*MOTHER-OF-PEARL FACE and EBONY MASK*." *Vogue*'s opposite page tells of a music hall show that debuted on the Champs-Élysées that February featuring Chinese swordsmen. This news item's accompanying photo, of two shirtless swordsmen, has also been shot and printed to maximize any contrasts between black and white. *Vogue*'s editors have cropped and positioned the swordsmen image to occupy exactly the same space on the page as that given over to the photo of the white woman holding an African mask across the fold: twinned glimpses into two exotic worlds.

Man Ray is listed as the image's author. His name would have been familiar to many *Vogue* readers, as the magazine had run a profile on him a few months earlier. The model's name is not given. There is an accompanying paragraph, its author uncredited:

Face of a woman, calm transparent egg straining to shake off the thick head of hair through which she remains bound to primitive nature. It is through women that the evolution of the species

to a place full of mystery will be accomplished. Sometimes plaintive, she returns with a feeling of curiosity and dread to one of the stages through which she has passed, perhaps before becoming today the evolved white creature.

French readers who'd gotten their fill of Baudelaire in school might have spotted in this caption a reference to his poem *La Chevelure* ("Head of Hair," "Her Hair," "The Fleece," or "Of Her Hair," depending on the translator), one of several poems he wrote for or about his longtime lover and possibly common-law wife, Jeanne Duval, whom he dubbed *Vénus noire,* and who likely had a grandmother of African descent. Duval posed for Baudelaire's friend Manet, who completed her portrait in 1862. Her name is absent from the work's title. Manet called it *Baudelaire's Mistress, Reclining.*

AT SOME POINT IN 1926 Man Ray sold one of the prints of the photograph he'd taken of Kiki holding an African mask to Jacques Doucet. Now known as the Doucet print, it was produced by combining four different negatives. Doucet added it to his substantial collection, which included Brancusi's *Muse endormie II,* a sleeping muse whose ovoid head rests at an angle similar to Kiki's in the print. Unclear how much he paid for the print. Whatever Doucet and Man Ray called the work at the moment of their exchange, it wasn't *Noire et blanche.* In a letter to his sister Elsie, Man Ray referred to the picture as "Kiki holding the African sculpture head" and on the backs of a couple of prints he wrote "Kiki with African Mask." The retitling was performed by unnamed others, removing Kiki from the story. In 1928 a reproduction of the photo would appear as *Woman with a Mask* in a Belgian magazine, and in 1931 in a German magazine it became *Noire et blanche,* the title by which it is commonly known today.

Some experts regard the Doucet print as the finest Man Ray produced from the original photograph. But there are several versions in circulation. Man Ray fussed with the image long after its creation,

returning to it again and again, reediting it across decades, producing two dozen variations. He reshaped Kiki in many ways, softening her, darkening her, erasing parts of her, touching her up, drawing in shadows to emphasize the angles of her nose or to give depth to her eyes. He thinned out her eyebrows, adjusted the thickness of individual lashes, removed a stray strand of hair, a mole. He filled out her lips and buffed her skin so its luster would more closely match that of the mask. He seems to have been perpetually dissatisfied with how Kiki looked. The mask itself he never touched.

Kiki and Man Ray sucked so much of Paris in the decade's first blazing half into this one rectangle, without leaving the confines of a bare room. Paris as the height of fashion. Paris at the heart of Empire. Paris that fetishized Africans as primitive and African Americans as modern. *Noire et blanche* is a picture about everything that isn't shown.

17

LEAVE ME ALONE

THOUGH HE WAS FAR FROM FINANCIALLY SECURE, Man Ray was earning well through portrait commissions, by selling prints of his more avant-garde photography to collectors, and by providing visual content for magazines, whose global reach and need for pictures kept expanding as the decade progressed. "Busy as a cockroach," he wrote to his sister Elsie. From one spread for American *Vogue* he'd made enough to live on for five months. He, Picasso, Foujita, Kisling, and Derain were known as the only artists in Paris able to buy new cars entirely from their income. And to the great displeasure of Gertrude Stein, Djuna Barnes, and others, he had no qualms about charging his friends high prices for portraits if he knew they could afford it. He took pride in not coming cheaply.

Early in 1926, the Americans Arthur and Rose Wheeler visited Man Ray's studio to have Rose "done" by Man Ray. As Sylvia Beach said, "To be done by Man Ray or Berenice Abbott meant you rated as someone." After looking over Man Ray's work, Arthur Wheeler told him he should stop the photography and make a film, since cinema held "the future for all art and money-making." He proposed to stake Man Ray in making a movie and offered as a shooting location his cliffside villa in Bidart, at the foot of the Pyrenees, in French Basque country. Wheeler knew little about Man Ray and less about the movie business but was rich enough not to have to worry about the sound-

ness of his judgments. He also missed seeing how shooting the world's Rose Wheelers was Man Ray's way to finance his painting, which he saw as his real work. Man Ray liked that he could pursue photography with little overhead and working alone, or at worst with an assistant or two. He didn't advertise, had no plans to expand into a major operation. Filmmaking was costly and complicated, and he'd shown little interest in pursuing it further after his first experiment with *Return to Reason,* which in the first place he'd embarked on almost passively, answering Tzara's challenge. He was very happy being an amateur. He loved film as a medium, not as a profession.

Which didn't mean he was unwilling to take the Wheelers' money. In the several pages he devoted in his memoir to the occasionally brilliant but mostly meandering sixteen-minute film he made, Man Ray is most eager to talk about the paycheck, claiming the Wheelers paid him ten thousand dollars, only half of which he spent on production. The evidence points to him getting three thousand, still a giant sum, which would support him in Paris for three years. Apparently able to produce the film using whatever equipment and cash he already had on hand, he sent the entire paycheck to Elsie, who had an account set up for him. Man Ray told her it was to "put away for when I come back to New York, or if an emergency happens here." He also asked her to use some to send him photo supplies and, for Kiki, "half a dozen pairs of good but not too expensive stockings, one pair black and the others nice flesh tints, for between a dollar and one-fifty, smallest size."

He completed the shoot in an offhand manner: he had no script, no plot, and planned to shoot "whatever seemed interesting," gathering just enough footage for a short film, after which he'd figure out some kind of progression for the sequences, discovering the narrative as he went. Rose Wheeler appeared in a few scenes, possibly a stipulation of the commission, offering the Wheelers one more way to show that they had been "done" by Man Ray. The poet Jacques Rigaut appeared as well, brought in for his movie-star looks, dubbed by Man Ray the "dandy of the Dadaists." Working no more than a couple hours each day, Man Ray spent the remainder "on the beaches lolling in the sun,

at elaborate dinners with other guests [of the Wheelers], and dancing in the night clubs." It all unfolded like "a holiday."

He titled the resulting film *Emak Bakia,* after the name of the Wheelers' rented property, a Basque expression loosely translated as "Leave me alone." He kept in contact with the couple after the shoot, writing to Stein a year later to ask if Rose could come with him on his next visit. In all his letters to Stein, there is no mention of him ever asking to bring Kiki.

Kiki didn't join Man Ray on the *Emak Bakia* joyride. But he did film her, once back in Paris, for the climactic final sequence. Four years into their volatile relationship, perhaps he took the assignment to get away from Kiki for a while. He might instead have wanted to keep Kiki away from Rose, his film's nominal star, so that the Wheelers could feel the spotlight was on her alone; or away from the reputedly lecherous Arthur Wheeler. But it might equally have been Kiki, seeking momentary refuge, who encouraged Man Ray to go alone.

WHEN MAN RAY LEFT PARIS for the Wheelers' villa overlooking the Atlantic, Kiki moved into Treize's apartment in the Hôtel Raspail, overlooking the Montparnasse cemetery. There she enjoyed an unprecedented combination: a close friend, enough money to get by, a sense of stability, and large swaths of time free from tending to the needs of another. And during this time Kiki produced a great amount of art.

She set up a place to paint in the apartment, while down the block Treize ran an exercise studio for women, teaching calisthenics and weightlifting. Treize tried to get Kiki to partake, but as she'd explained to Treize after another exhausting failure, "I can do it, but my ass won't move."

In a photograph Treize took that summer, Kiki smiles broadly as, bare-armed and barefoot, she tosses out a pail of water into the Hôtel Raspail's sun-dappled courtyard. Treize took another in the courtyard of Kiki in a wooden chair, balancing a canvas on her lap, holding it with one hand and painting on it with the other. She looks happy in

this shot, too, sitting stiff-backed in her smock by an ivy wall. More striking than her smile is the look in her eyes, fixed intently on something or someone in the distance, not shown in the photo, a look that calls to mind Simone Weil's definition of prayer as nothing more than "absolutely unmixed attention."

This wasn't the first time Treize caught Kiki in a moment of joy on camera. A couple of years earlier she'd taken a picture of Kiki in Brittany, likely using a Kodak Brownie or other inexpensive handheld camera using roll film that had been in common use since the turn of the century, giving millions of people like her and Kiki the newfound power to document their travels. Mass access to photography was then helping to spur the growth of mass tourism, and vice versa, as people sought ever more picturesque settings in front of which to display themselves for the camera.

Aside from Kiki's nudity, Treize's Brittany photograph has all the familiarity and ease of a snapshot. Smiling, wearing nothing, on a grassy ridge overlooking the ocean, Kiki leans back so that her hands, pressed to the ground, support her weight, her left hand visible, fingers splayed, the resistance pushing her shoulder up to graze against her cheek. Her calves and feet curl beneath her thighs, shielded by vegetation. There's a beach in the distance fronting the low-slung structures of a town's edge. Beyond that the horizon line under a cloudless sky.

Of all the pictures taken of Kiki, this is the one where she looks most comfortable in her own skin. She's still posing, unable to resist thinking of how her positioning will influence the final image, an occupational hazard. But the result looks completely natural. She smiles for no other reason than to show her pleasure, her happiness for the day, her surroundings, and her friend. She lies naked not to become The Nude but because it's warm and she feels like it. She looks freed from concern for anything beyond the person in front of her, and for how the grass and sun feel to her, and what she smells, and what she hears. In so many photographs and paintings of women from those years, the subjects are meant to look unmoored, aimless, pining for some other place. Kiki doesn't pine. She meets the camera head on

and bursts out laughing. She gives herself to Treize's camera freely, just as she will later offer the recording of this moment to another friend as a gift.

Kiki sent a print of the photo from Brittany to Kisling, with the inscription, "To my very dear Kiki Kisling. In love, I give myself to you" a declaration seemingly meant platonically, as they'd been friends for years. Kisling kept the picture but scratched out the inscription's last sentence. He was apparently a devoted husband and father. "I was no worse a husband than any other," Kisling said of marriage, with his usual dryness. And Kiki adored Kisling's wife, Renée Gros, who according to Kiki had the best laugh in Paris. So it seems unlikely that Treize and Kiki were trying to produce a work of art meant for public display when they made it.

And yet it is among the finest portraits of Kiki. To look at Treize's photograph alongside all Man Ray's photographs of Kiki is to try to understand what the artist Dora Maar meant when she spoke of her own posing for Pablo Picasso, with whom she was involved in the 1930s and '40s.

"All his portraits of me are lies. They're all Picassos. Not one is Dora Maar."

KIKI IN THAT SUMMER with Treize at the Hôtel Raspail produced many paintings. The majority concerned village life. Conjuring memories of the countryside from her Paris studio, she portrayed peasant women feeding fat-cheeked babies; sailors in taverns; a street peddler hawking his wares; circus performers; luminous washerwomen; wandering musicians; a farmhand on his day off. She never reduced subjects to oddities or romanticized them as types. She saw her people rather than watched them. And she examined herself as well. Some of Kiki's dark-haired female figures look to be self-portraits, if more figurative than literal. In one she pulled directly from her pose for Treize in Brittany.

Connecting all the images is her style. Her lines are clean, joyful,

and unguarded, her colors vivid, her outlook forgiving, even nostal-
gic, occasionally bordering on surreal, with exaggerated human fea-
tures and eerie, impossible angles. The sunny skies pulse with a blue
you could fly into. The foregrounds, earthy browns and leafy greens,
are populated by people out of scale with their surroundings, as when
a child draws herself as big as a house. Kiki often turns her figures
to stand at a forty-five-degree angle relative to the viewer, like theater
actors who cheat toward the audience as much as possible while still
engaging with each other across the stage. One sees in the number
of paintings and their variety that Kiki is honing her vision, learning
through the work, even as the overall effect is one of effortlessness.

Along with her village scenes, Kiki painted people closer at hand:
Cocteau; La Tarare; and least successfully Man Ray, looking more car-
toon vampire than human. Modigliani's influence is there in Kiki's
impossibly slim faces with close-set eyes and in the lightness of her
lines—"supremely elegant . . . the mere ghost of a line, but it is never
blurred," as Cocteau described Modigliani's strokes. The portraits
read primarily as documentations of her neighborhood and her scene.
When she focuses on lone sitters, she places them as close to the viewer
as you might stand when talking to a good friend. It's as if the portrait
has served as an excuse for Kiki to make a connection, to sit across
from someone and soak in everything they say and do. In paintings
featuring several people, she's more often at a remove. Still, she places
her subjects on the same plane relative to the viewer, so that you feel
part of the crowd, looking neither up at nor down on these people.

Whether portraits or pastorals, Kiki stripped all her pictures down
to the basics, reminding the viewer, through everything she chose to
omit, that much of the modern world is unnecessary. She focused
on life's essentials: affection, music, friendship, dancing, food, wine,
adventure, nature, labor, beauty, sex.

ALONG WITH HER WORK, Kiki had fun while Man Ray was away.
She was out at her favorite cafés, enjoying seeing friends. The Surrealist

writer Jean Gegenbach, who'd taken to donning ecclesiastical cloth-
ing, half as a prank and half in hoping a religious turn would help him
combat his suicidal despair, spent time with her on the terraces. He
recounted how a certain "fat and Polish *monsieur*, Catholic, was out-
raged to see a young clergyman, roses in his boutonnière, sipping his
cherry brandy in the company of Kiki Ray. But I reminded him that
the Christ never shunned the company of courtesans."

And yet Treize remembered, too, the late afternoons when Kiki
could grow melancholy, singing and crying along to Ethel Waters's
"Dinah," one of the year's hits, which she played again and again on
Treize's phonograph.

> *Dinah*
> *Is there anyone finer*
> *In the state of Carolina?*
> *If there is and you know her*
> *Show her . . .*

At summer's end, Kiki and Per Krohg hosted an informal joint
exhibition at the Hôtel Raspail, held in the building's ground-floor
antique shop. (Two years later Kiki would pose for Krohg, who titled
the painting *The Model Kiki*.) Their show failed to make a mark in
the press or with the public beyond their few square blocks. We don't
know how many paintings were sold, if any. Yet it was important as
the first known instance of Kiki showing her work publicly. The show
gave way to a raucous block party that night. Man Ray, still off film-
ing, wasn't there.

A FEW MONTHS LATER, in late November, Man Ray screened
Emak Bakia at the Théâtre du Vieux Colombier, an art house the-
ater in the sixth arrondissement. A jazz band accompanied his film
(or *cinépoeme*, as he'd advertised it) for a mildly enthused audience of
about fifty, including Kiki and the Wheelers.

The film opens with a self-portrait, Man Ray in profile cranking the works of a movie camera while a woman's eye is reflected in the mechanism. It ends with a woman sleeping, though jarringly so because she has wide-open eyes painted in makeup onto her closed eyelids, which suddenly open to reveal her actual eyes, opened just long enough so that when paired with her sharp-toothed grin she's recognizable as Kiki. She glances to one side, brings her gaze back to center, and returns to her closed-lids-with-false-eyes masquerade, a visual evocation of the Surrealist séances and their exploration of the slippery line between wake and slumber. Man Ray said he'd gotten the idea for Kiki's "double awakening" from her "penchant for excessive makeup."

Seeking American affirmation for his film, he and Kiki traveled to New York in February 1927 to screen *Emak Bakia* at Manhattan's Guild Theater, Man Ray's first time back in six years. His family came to the screening. His five-year-old niece reported being disturbed by the images.

The group went postscreening to the family house on Kosciuszko Street. In pictures from the evening, Kiki, surrounded by Man Ray's relations, looks to be enjoying herself immensely, despite (or thanks to) the language barrier. In one photo she sits on Max's lap. And Minnie appreciated how chivalrously her son acted in Kiki's presence. Later they popped around the corner to Quincy Street, where Man Ray's sister Do lived with her husband, Israel, and their children. Sister-in-law Lena, wife of Man Ray's soft-spoken brother Sam, called to tell them she was getting dinner ready for everyone but had misplaced her soup ladle and asked could Do bring one over. They all walked up DeKalb Avenue, Kiki leading the way, waving the silver ladle in her hand, conducting as the group sang the *Marseillaise*. She pulled up her skirts to jump over a fire hydrant, which the kids loved, passing a bemused policeman.

LEAVING MAN RAY IN NEW YORK, where he would continue promoting *Emak Bakia* and show some paintings and photographs at

the Daniel Gallery, Kiki returned to France, having received favorable reviews from his family. *Emak Bakia* fared less well. The *New Republic*'s critic called it boring, "gone straight to hell with good intentions."

Shortly after returning to Paris, Kiki secured her first solo show, at the Au Sacre du Printemps gallery near the Saint-Sulpice church. A rumpled Polish musician and writer, Jan Sliwinski, ran the boxy storefront space, which also sold books, musical instruments, and sheet music. He had named it for his hero Stravinsky's seminal work.

Sliwinski had likely attended Kiki's show with Krohg, enjoyed her work, and approached her about a solo showing. It's also possible their mutual friend Tzara suggested Kiki to Sliwinski as a worthy candidate for an exhibition.

"Paintings by KiKi, Alice Prin" read the flyer, listing the twenty-seven canvases to go on display, starting March 25, 1927. Kiki titled each one as prosaically as possible. *Woman Doing Her Hair; The Chickens' Meal; Child with Bananas; Sailors; 2 Nude Women and 2 Men; A Cow Between 2 Women; The Street Vendor.* She wrote no artist's statement. The paintings were hung in cheap-looking, mismatched frames.

Desnos penned an introduction for the gallery catalog, titling it "Life of Kiki: To Man Ray." He opened the piece by asking Kiki the one question that, in all her years of being looked at, no one else had asked.

You have, my dear Kiki such beautiful eyes, that the world you see through them must be beautiful. What do you see?

In an age of irony, and at the center of a community of artists who wore their sense of detachment like a badge, Kiki with her paintings outdid them all for provocation. She went for the heart. Nothing in her pictures is pale, little is shaded. They are suffused with sadness, but only because they try so hard to deny there is such a thing as sadness altogether. Which makes them, in their own way, dangerous. By fighting against sadness, Kiki's paintings take on a madcap quality, blatant in their desire for peace and happiness and blue skies. She presents the

most dangerous idea of all: tenderness. She wants to evoke genuine sentiment, without any hedges, or guile, or winking asides. Her paintings ask, with no sense of embarrassment: isn't the world such a beautiful place?

"The habitués of the Quarter" packed in for opening night, according to the *Paris Tribune*. "They came in a steady stream, and the little gallery seethed with excited comments. It was, so far as we know, the most successful *vernissage* of the year. Those who came to smile remained to buy, and before the night was over, a large number of the canvases were decorated with little white *sold* cards." Kiki charmed one of the night's notable guests, the minister of the interior, Albert Sarrault, a radical socialist and art collector. "You're a good guy, but you're out of place with all those stupid ministers," she told him. "Come and live with us, and you can pose for me." A reporter overheard talk of sending the pictures to Berlin for another showing.

By the end of the exhibit's run—March 25 to April 9—every familiar face in the neighborhood had passed through, along with even more strangers. The British journalist Sisley Huddleston described the show as "the sensation not only of Montparnasse but *tout Paris*." And Kiki sold all twenty-seven works. Henri-Pierre Roché likely bought some of them. The influential Viennese collector Frederick "Fritz" Wolff-Knize reportedly bought one, too. And two works had already been sold prior to showing and were on loan: the portrait of La Tarare, owned by its subject, and *La Charrette* (The Cart), owned by Théodore Fraenkel, the physician and artist who'd written to testify about Kiki's nerves for her trial. She may have given it to him as a gift in return for his help.

Aside from a few quibbles, Kiki got good reviews. Janet Flanner wrote that the show left her with an "impression of simplicity, faith, and tenderness." One of the city's weekly arts and culture guides deemed Kiki's colors undeniably beautiful, capable of evoking meadows after rainfall, even though, as the critic wrote, they looked as though they'd been applied with about as much care as a baby sticking alphabet letters into a book. Huddleston, even while deciding that Kiki's skill

must have come thanks to mentorship by the men in her life rather than from some internal gift, praised her "simple amusing paintings" as being "worth as much as many of the paintings of professional artists who sophisticatedly pretended to react against sophistication."

At the time, the major artist with whom Kiki's style and coloring most closely aligned, Henri Matisse, was still struggling to sell paintings. The boldness of his vision was still too raw for most tastes. Kiki's paintings have much the same boldness, with less of their skillfulness. It is worth considering if some of Kiki's buyers may have been partially driven by more than the beauty of the paintings. Some may also have been receptive to her subject matter, the work and pleasures of the field and the table, of special appeal to urbanites sharing in the enduring French romance with its countryside, the place to escape everything wrong with industrial capitalism. Some buyers might also have valued these pictures as the closest thing they could get to documents of Kiki's performances. Seeking some way to pin down this increasingly public personality, they might have been thinking ahead, betting that these pictures by Kiki would one day be worth a great deal of money.

THERE'S A PHOTO FROM the show's opening night of Kiki posing for a Montparnasse-based photographer. Standing in front of one of her canvases, she wears a fur-trimmed coat, and while she smiles in so many pictures, her smile here is enormous. Likely meant to accompany a newspaper item, it was taken by André Kertesz, who'd moved to Paris in 1925, one among several Hungarian artists drawn to the Quarter after war's end. He titled his print of the photo "The Famous Model Kiki." At the time working freelance for magazines, still a long way from establishing himself as one of the century's great photographers, Kertesz was also starting to gain recognition in Paris thanks to his own first solo show. It closed at Au Sacre du Printemps three days before Kiki's opened.

Along with Kertesz's exhibit, the other solo show at the gallery bookending Kiki's showcased yet another Paris-based photographer

on her way to becoming a major modern artist, Berenice Abbott. She'd modeled for Man Ray several times in New York, including for one of his earliest Dada photographs, *Portmanteau,* in 1920, standing nude behind a mannequin designed to obscure only Abbott's face, head, shoulders, and arms. In 1923, after she'd moved to Paris, Man Ray had hired her as a studio assistant, paying meager wages (25 francs a day, equivalent to $1.50) while she worked, in her words, "like a dog," handling everything from mixing chemicals to developing negatives and making proofs, enlarging or cropping as needed, while honing her own craft. Like Man Ray, and Stieglitz before them, Abbott in her own work would do much to advance the idea that the photographer's ability to conceive of an arresting image was as paramount as her technical mastery.

Lately Abbott had secured financial backing from Peggy Guggenheim, infuriating Man Ray, who continued to think of her as his protégée. He'd barred her from shooting Guggenheim after the latter requested her portrait be done by Abbott rather than by him, which led her to strike out on her own. Abbott's show at Au Sacre du Printemps featured portraits of some of the same people he'd photographed (Barnes, Cocteau, Joyce) and got press notices he found enraging.

Man Ray would eventually get to show some of his work at Au Sacre du Printemps, too. But he did so a full year after Kiki, Abbott, and Kertesz, and only as part of a group exhibit, alongside major artists Hans Arp, Giorgio de Chirico, Max Ernst, Georges Malkine, André Masson, Francis Picabia, and Yves Tanguy.

KIKI MADE NO MENTION OF the Au Sacre du Printemps show in any of her writing. We can only speculate about what she wanted out of it, and how she felt about its success. Was it her bid to join the Montparnasse crowd of painters, declaring herself more than a cabaret performer but an artist worthy of the same kind of admiration and critique given to Vassilieff, or Kisling, or Man Ray? Or did it have nothing at all to do with how she saw herself in relation to Man Ray,

or anyone else in her orbit? Maybe she wanted only to express herself, to reveal herself to her friends and strangers in a way she couldn't do through any other means, to communicate the joy she felt for living at that particular time in that particular place.

Clearly moving out of one space dominated by Man Ray and into another shared with someone who was neither mentor nor rival energized her in some way. It might simply have been that in those summer months of 1926 she finally had the time and space to process everything she'd seen and learned over the past few years—and to process the traumas of the repeated abandonments to which she'd been subjected. Maybe, like just about everyone she knew, she was looking for another way to earn her living. There was a lot money being spent around Paris on art just then, as the art market was starting to boom.

Man Ray described Kiki's works in his memoir as "naïve but boldly brushed in, the drawing heightened by strong pencil lines, the colors bright and fresh . . . rural scenes with peasants, circus scenes and strong men at fairs, portraits of painters and girl friends." He noted how when artists stopped by the studio, she would occasionally paint their portraits, and that some would buy them from her. He was meanwhile proud of her being the "main attraction" at the Jockey with her "naughty French songs," and acknowledged that she'd made "some interesting snapshots" with his camera that he'd enlarged.

But he stopped well short of acknowledging her as anything close to an artistic peer. He denigrated her practice, claiming (without any supporting evidence) that she'd turned to painting only as a way to fight off boredom and because he'd offered to buy everything she made. His diminishing Kiki as an artist cannot be attributed solely to his misogyny; he considered photographer Germaine Krull, for instance, as a colleague and equal.

He described Kiki's show as though it were something that had merely happened to her: "An exhibition was arranged for Kiki at a local gallery." And while he wrote that "all Montparnasse turned out for the opening—it was a great success, both artistically and financially— most of the pictures were sold," he failed to mention that Kiki's reach

stretched well beyond the neighborhood crowd or that in truth she sold not "most of" but all the pictures on display.

He hadn't been there to see it, in any case. He returned to Paris from New York in late April 1927, after her run had ended. Still, the event clearly held some significance for him. He was likely prouder—and more envious of Kiki's skill—than he let on. Discovered among his papers after his death were clipped reviews for the show. And among the collection of his negatives he stored for decades in cigar boxes were several photographs documenting Kiki's paintings.

Whether or not Kiki's paintings merit standing alongside the canonical artists from that time and place, they make clear that by the summer of 1926, she was starting to see herself as more than a model and singer. She'd been formulating her own ideas about what constituted an effective image, her own ways of seeing and representing the world, which must also have influenced how she tried to shape herself into becoming the images she helped other artists to produce.

Unlike with Man Ray, we have no abundance of words to quote about how Kiki felt about her own art making, about what aims she had when producing her pictures, what they might have meant to her, what she hoped they might mean to others. In all her autobiographical writing, she devoted only a single sentence to her paintings, a tidbit about Cocteau, in which she said that she painted his portrait from memory, that "a few people thought it wasn't bad," and that it was sold to someone in London.

Whatever thoughts Kiki had about those two seasons alone in Paris, free to make and show her paintings, she kept them to herself.

18

THE YEARS OF MADNESS

A CROSS MONTPARNASSE THE BAR OWNERS WERE offering free champagne and brandy to Americans. Kiki and Man Ray joined in the seven nights of whooping and dancing and reliving the aviator's feat from all angles: Charles Lindbergh had landed northeast of Paris, thirty-three and a half hours after leaving Roosevelt Field on Long Island, in a single-engine plane lacking fuel gauge, parachute, radio, and any instrument other than a compass to guide his flight, during which he hallucinated ghosts shooting into the cockpit.

It was late May 1927. Hundreds of thousands went to see the *Spirit of St. Louis* swooping down in the klieg-lit night to land in the capital of America's sister republic. Along their way to Le Bourget airfield, they invented France's first traffic jam, drivers ditching vehicles midroad to march along with the throng. They missed seeing the new hero up close. As soon as Lindbergh landed, a car pulled alongside so the plane could be cordoned off by a phalanx of soldiers. Lindbergh, dressed in common army gear, was led to a hangar while French pilots lifted decoy Lindberghs onto their shoulders at various points around his cooling plane, the French linen of its wings and fuselage already shredded by those seeking souvenirs. During the drive into the city, Lindbergh asked to stop to buy some bouquets of roses and cornflowers, then to be taken to the Arc de Triomphe, where he laid them on

the tomb of the Unknown Soldier. It was one in the morning. He hadn't slept in three days. This was how heavily the memory of the Great War weighed on a twenty-five-year-old American who'd been too young to serve, nearly a decade after the Armistice.

Lindbergh had descended into a Paris that was running at an unprecedented pitch, a city at the summit of what would be remembered as *les années folles,* the crazy years. As the spread of modern industrial technology sent goods, people, ideas, and money around the globe at whiplash speeds, the treasures of imperial trade rushed in and out from the stations and the Seine: rubber tapped from the trees of Indochina, ivory pulled from the elephants and feathers from the ostriches of Africa. Businesses got built in days on the strength of novelties lasting weeks. The brightest display in the City of Light belonged to the maker of some of its fastest machines, as the glittering letters C-I-T-R-O-Ë-N climbed the Eiffel Tower with the power of a quarter-million bulbs and four hundred miles of electrical cable.

Kiki, too, was then at her most incandescent, flitting back and forth across town to perform at the Jockey and, increasingly, at Le Boeuf sur le Toit, in the upscale eighth arrondissement on the Right Bank, within earshot of the great organ of the Madeleine church. For Kiki, Le Boeuf sur le Toit inspired its own form of devotion, one of several cabaret-bars opened by the impresario Louis Moyses that felt to her "like beautiful churches."

Along with the Montmartre clubs run by the African American dancer, singer, actress, and entrepreneur Ada "Bricktop" Smith—the Music Box and Chez Bricktop, where Kiki often went to drink but not to perform—Le Boeuf sur le Toit rivaled the Jockey as the city's hotspot that year. It attracted just as motley a crowd as the Jockey's, though veering higher end. "A not unassuming place," as the composer Virgil Thomson described it to a friend back in America, "frequented by English upper-class bohemians, wealthy Americans, French aristocrats, lesbian novelists from Rumania, Spanish princes, fashionable pederasts, modern literary & musical figures, pale and precious young men, and distinguished diplomats towing bright-eyed youths." Coc-

teau, the club's unofficial mascot, sometimes tried his hand at playing drums with the house band. Alongside a few Man Ray photographs on the wall, Picabia's *L'Oeil cacodylate* (The Cacodylic Eye) surveyed the dance floor, the canvas filled with signatures and messages from many of the artists and musicians who haunted the place, each one marking up Picabia's painting like someone's cast. Man Ray signed himself *directeur des mauvais movies.*

Kiki sang at restaurants, too, all over the city, weaving between the tables with champagne in hand. Best for her were the moments near closing, after she'd finished, when she would hear some otherwise shy drinker in the corner, blood loosened by her performance, singing to his friends "more soulfully than could any of the greats."

She was still posing, occasionally, mostly for close friends with whom she was comfortable. Kisling painted her nude in *Kiki* (1927), legs splayed, with a daringly intimate representation of her sex, a detailed rendering not found in any other of her posing work nor any other of Kisling's nudes.

And people started approaching her with all sorts of projects that echoed the zaniness of the time. The would-be filmmaker and future gallerist Julien Levy wanted to make a movie starring her based on T. S. Eliot's *The Wasteland.* The project fell apart, with Levy later blaming his and Kiki's inability to get along after he'd turned down her advances. According to Levy, when he refused her invitation to sleep with her, she told him, *"Tu n'es pas un homme, mais un hommelette!"* a play on words that doesn't translate its wit neatly into English.

Meanwhile death circled the Quarter. The tubercular Ernest Walsh, editor of *This Quarter*—Hemingway called him the poet "marked for death" in *A Moveable Feast*—died from hemorrhaging in October 1926, not long before the birth of the daughter he fathered with Kiki's friend Kay Boyle. The inventive modern dancer Isadora Duncan, who'd based herself in Paris since 1900—her brother Raymond had influenced Foujita and others in Montparnasse with his Greek revivalism and founded a cultlike colony whose members briefly included

Boyle—died in September 1927, choked by her scarf when it caught in the wheel of her car as it sped along the Promenade des Anglais in Nice. Elsa von Freytag-Loringhoven was asphyxiated by gas one night that December in her Paris apartment, along with her dog, closing a life "spent in poverty, adventures, liberty, logic, and eccentricities," as Flanner eulogized.

Cocteau, sensing that he was coming close to the edge, checked into a clinic in the Parisian suburb of Saint-Cloud in late 1928 to kick his opium addiction. He survived the times, but others did not. Soon to come were the deaths of Serge Diaghilev, friend and patron to so many in Montparnasse, in Venice in August 1929; of the dissolute American expat writer Harry Crosby in a murder-suicide or suicide pact five months later; and of Jules Pascin the following summer, by suicide, just as money and fame were coming to him. (Kisling discovered his body; Pascin had written *Adieu Lucy* in blood on his closet door, a message for his great love and the subject of many of his paintings, model Lucy Krohg, wife of Per.) One night two young women in Kiki's orbit, the dancer Lena Amsel, who'd copied Kiki's habit of keeping a pet mouse, and Lena's friend Florence Pitron, were speeding down to Barbizon while tailing André Derain's Bugatti, when Amsel's car hit an oil slick caused by greasy leaves fallen from farmers' carts during the sugar beet harvest. Both were killed. Amsel, Pitron and Derain had been watching Kiki perform at Le Boeuf sur le Toit hours before.

Kiki was especially shaken by Amsel and Pitron's deaths. Amsel, "very beautiful, very sporting, and very rich," as Kiki described her, had asked Kiki to join her on the drive to Barbizon. But she'd thought the better of it "after a night when we'd been drinking a lot more than just water," though she didn't try to stop Amsel or Derain from driving.

Kiki was someone who covered her face in fear when riding in a car. She may have been in the fast life, but she was never of it. Lingering on stage in the lights, drawing out her words, playing with silence, Kiki always remained a step removed from the action, narrating the night from her bird's-eye post as it unfolded. She wondered "what they

were all searching for, these people at the cabaret; what do they think they'll find?" as she wrote in her memoir. Over her years of watching, she'd learned to become, she thought, "a kind of seer."

And what she saw she found fascinating: the minor dramas of the cabaret, "where every instinct is allowed to come out." She grouped audience members into types: the addicts, who came every night, almost as if hypnotized, and the loud ones "who feel entitled to every-thing" because they were paying. While entertaining her audiences, Kiki started entertaining herself by making up stories about their lives. She would dream up love stories to connect two strangers seated on the same banquette.

"These nighttime revelers come to binge," she wrote. "They deliver themselves before me. And I, in observing them, come to know them much better than do their daytime companions." Everyone she sang for fascinated her in their own way. Soon she would channel some of their stories into her finest work yet.

19

SHE BECAME RESTLESS

EARLY IN 1928, KIKI AND MAN RAY THREW A GOING-away dinner for Robert Desnos, who was headed for a writers conference in Cuba and a two-month tour of the Caribbean. Desnos often gave himself professional reasons to take trips to far-off places, following the Surrealist tenet that artists had to constantly uproot themselves to avoid growing too accustomed to any one way of living. Breton had laid out this strategy a few years earlier, as a series of commands at the end of his prose poem "Leave Everything":

> *Leave everything.*
> *Leave Dada.*
> *Leave your wife, leave your mistress.*
> *Leave your hopes and your fears.*
> *Lose your kids in the woods.*
> *Drop the spoils for the shadow.*
> *Leave, as needed, your comfortable life, your promising future.*
> *Take to the highways.*

The music hall singer Yvonne George joined Kiki, Man Ray, and Desnos for the dinner. Desnos had been in love with George since seeing her sing in 1924, not long after she'd arrived in Paris from her native Belgium. Tall and waifish, with expressive violet eyes, she was

an ethereal presence on stage in her long-sleeved dresses. Desnos plied her with gifts and looked after her cats when she went on tour, but his devotion wasn't returned.

George and Kiki had much in common. Both were sensitive and battled stage fright. Both were heavy drinkers, smokers, and at varying times drug users. George preferred opium to Kiki's cocaine. Both sang sad sailor songs brilliantly. (Kiki when singing sea shanties would wrap herself tightly in her shawl, as if shielding herself from a storm.) Both charmed Parisian audiences with their non-Parisian accents.

Stylistically they differed. George had none of Kiki's knack for comedy. Kiki couldn't match George's crystalline enunciation and broader vocal range.

And George was the more financially successful performer. She'd already made several records. This caused no tension in their friendship. That each had her own distinct approach to her craft may have diffused any professional jealousy. If Kiki did feel competitive with George—and there is nothing to indicate that she did—she may have been comforted by knowing that George's talent wasn't the truly fiery kind that could propel her to being an idol rather than a peer. "She could magnetize only small groups," Janet Flanner wrote of George. "She was unpopular with the masses, who were uncowed by such slight perfection as was hers."

Desnos thanked his friends with a postdinner poem inspired by a discovery at a secondhand store in the Marais. He'd bought a starfish in a jar of formaldehyde that had come to function for him as a kind of symbol. He told them he stared at the starfish and meditated on the pain of losing love. No doubt he wanted to convey something to the unattainable George. According to his later partner Youki, Desnos never managed to see George as a real person but could only mythologize her. He would allude to her often as *starfish* or *star* in his writing.

Man Ray told Desnos that he could "see" Desnos's poem. Not as a photograph or painting but as a film. He hadn't touched a movie camera since the previous summer, filming revelers filing out of a church after the wedding of Marcel Duchamp to Lydie Sarazin-Levassor,

daughter of a rich industrialist. "When Marcel told me of his getting married it had the same effect on me as if he had told me he was going to paint impressionist landscapes from now on," Man Ray had written to their mutual friend Katharine Dreier. Kiki had helped him with the shoot. The marriage was over by the end of the year.

The idea of making a movie thrilled Desnos. He would sometimes watch several movies a day. He loved everything from popular crime fare (*Les Mystères de New York*; the *Fantômas* films) to German expressionist works (*The Vampire Nosferatu; The Cabinet of Doctor Caligari*) with their weird camera angles and creeping shots of labyrinthine streets. He left it to Man Ray to start the project while he was overseas.

At first he regretted rushing into the project but soon found his rhythm, drafting a scenario they finished together when Desnos returned. Kiki described Desnos as someone "you always saw running; you'd think he was in a hurry to live." He was overflowing with ideas for the film and for a soundtrack that would mix popular tunes with human grunts, bursts of ecstatic shouting, and stretches of silence. They called the work *L'Étoile de mer* (The Starfish), subtitled *Poem by Robert Desnos, as Man Ray saw it.*

Following the title card, the first thing anyone saw was Kiki, topping the credits, playing "A Woman," the femme fatale who inspires a poet's obsession. She was listed not as Kiki Ray nor as Kiki Man Ray, as in the past, but as Alice (Kiki) Prin.

Man Ray said that "Kiki was the most natural choice for the woman's part." Desnos would play one of the two men obsessed with Kiki's "Woman," while Desnos's young neighbor André de la Rivière played the other. They lacked the budget for professional actors. But in any case, the actors "would be mere puppets," Man Ray claimed, dismissing Kiki's importance to a project whose entire premise is founded on the intense magnetism of its female lead.

In truth, Kiki was the project's third collaborator. Her presence electrifies the film and is vital to its effectiveness. Looking to produce a woozy effect, Man Ray shot most of the footage through a plate of stained glass or a lens coated with gelatin. The bulk of the action

unfolds as if seen through a thick curtain of jelly, giving the viewer the sense of floating, like a starfish in a jar of formaldehyde. This gave the filmmakers an artful way of getting past the censors, who would otherwise have found issue with Kiki's being fully nude on screen. (They did call for the removal of one short sequence showing Kiki undressing.) Nearly all of her performance was obscured by a hazy lens. But where a weaker personality would have faded completely into the background, Kiki shines through, grounding her character in reality even within such a surreal environment. She is constantly in motion, moving around the frame. She is the story's unstable force, while her two suitors are slower and more passive, reacting to her actions.

They made the movie quickly, filming in a rented studio, and outside a parking garage, and in the Parc Montsouris south of Montparnasse. They made things up as they went, the three of them working madly under the "influence" of the starfish, as Desnos put it.

Their informal, collaborative way of working followed Montparnasse's prevailing ethos of open artistic exchange. For all the gossiping, sniping, and public airing of minor differences in dogma, people in the Quarter for the most part encouraged each other in their artistic development. After all, the rewards for anyone's individual breakthrough, however blazing, were still relatively small. Expertise was meant to be shared. Man Ray, for instance, had taught Brancusi how to take and develop photographs, and he accompanied him to buy a camera. And Man Ray's visits to Brancusi's studio, in turn, must have influenced his own sculptural and assemblage work, and perhaps how he thought about composing his photographs as well.

Few among the Montparnasse crowd felt pressured to restrict themselves exclusively to one medium. Desnos, a poet now trying filmmaking, also pursued painting and wrote criticism, film reviews, short stories, and later radio features, while trying to absorb as much knowledge as he could from friends working in these fields. Kiki had gone from posing and drawing to acting and painting. You couldn't help but be swept up by the Quarter's collective energy. "Every day was different," said Gerald Murphy. "There was a tension and an excite-

ment in the air that was almost physical. Always a new exhibition, or a recital of the new music of Les Six, or a Dadaist manifestation, or a costume ball in Montparnasse, or a premiere of a new play or ballet. . . . There was such a passionate interest in everything that was going on, and it seemed to engender activity."

L'Étoile de mer plays out as something between a drunken conversation and a half-remembered dream, as though the scenario could have sprung straight from someone's ramblings during "the period of sleeping-fits" six years earlier. Fragments of Desnos's poetry appear interspersed among disjointed sequences, leaving it to the audience to piece together the puzzle of an erotically charged encounter involving two men and a woman. His words weigh the momentary pleasures of new love against the eternal pain of lost love, ultimately leaning in favor of pursuing love despite its heavy and inevitable toll. The film tries to make concrete the abstract notion of *l'amour fou,* which Luis Buñuel called "the irresistible force that thrusts two people together [and] the impossibility of their ever becoming one."

The early scenes between Kiki and Rivière show a couple engaged in typical activities: walking in a leafy lane, climbing the stairs to her apartment. The story turns when Kiki undresses on a bed and lies back, but Rivière, rather than joining her, kisses her hand coldly and leaves. The film becomes more tense in scenes of Kiki sloshing red wine, lying on a floor littered with broken glass; of her and Rivière briefly reunited, though she wears an ominous domino mask, like Fantômas; and of her murderously holding a knife as she climbs stairs, followed by gauzy shots of the high walls of Paris's La Santé prison, as though she can see where her crime will lead her. We then find her coolly smoking a cigarette by an untamed fire, and next posing proudly as Marianne, the symbol of France. In the final scene, she walks seemingly united with Rivière, until a second man (Desnos) appears and takes her away as Rivière watches. Rivière returns alone to his starfish floating in a jar. Kiki's face is reflected in a mirror on which *belle* is written. The mirror smashes. A windowed door closes.

Breaking up these narrative scenes are sequences that are more

abstract but similarly seem to be about the pain of leaving and being left. Trains leave stations, and ships leave harbors. Disembodied objects float in space. Glasses shatter. Nothing is fixed. There are spinning wheels, spinning bottles, spinning starfish. Newspapers get swept away by the wind. Relationships unravel. People fail to see each other clearly.

The Starfish debuted that spring of 1928 at Studio des Ursulines, the city's premier venue for avant-garde film, built on the site of a former Ursuline convent. Man Ray hired a trio of musicians to perform the accompaniment, heavy on Cuban songs learned from records Desnos brought back from his travels.

The reviews were mixed but never indifferent. A writer for *Variétés* enjoyed the film's hallucinatory qualities, describing its characters "circulating in a kind of Milky Way ... or appearing as if one had taken hashish. Everything dissolves and then is reborn, evolving arbitrarily." Those same "hallucinatory qualities" drew ire from the critic in *La Nouvelle Revue française,* who complained that you had to guess at what was happening for three quarters of the film, since the camera effect reduced the characters to "puddles of goo."

On its opening night, *L'Étoile de mer* was paired with Josef von Sternberg's *The Blue Angel,* starring Marlene Dietrich. It must have thrilled Kiki to watch the two films in sequence, to see Marlene Dietrich created on the same screen by the same beam of light that had created her as well, minutes earlier. And yet in this film, where her name featured most prominently in the credits, Kiki was also at her most unreachable, veiled by Man Ray's tricky camerawork. It was her first and last proper lead role in a film. And it was the last film she made with Man Ray.

L'Étoile de mer at that time marked Man Ray's most successful presentation of any kind of work in Paris. A young Simone de Beauvoir was apparently among those who found the film enchanting. It would be shown regularly for the next few years as an opener to others debuting in Paris, including popular comedic fare such as Howard Hawks's

A Girl in Every Port, with Groucho Marx. (Nearly three-quarters of the films shown in France at that time were imports from America, as the war had decimated the French movie industry.)

L'ÉTOILE DE MER CLOSED WITH Kiki leaving one lover to take up with another. Life would soon mimic art. Of that spring and summer of 1928, their friends would tell stories of Kiki and Man Ray shouting while at cafés and parties, of thrown chairs and thrown bottles, more than in previous years. Man Ray continued to mock Kiki and the idea of romantic love as childish. People who knew him recalled Man Ray in this period playing at being the local misanthrope, growing silent and withdrawn even among old friends. In the middle of a casual chat about the neighborhood with a bartender, he'd burst out, "I can see no reason for the continuance of the human race. The sooner it dies, the better. Montparnasse has done much to help the cause." He meanwhile wrote to Elsie of being "very homesick after my visit last year." He'd seen a photograph of his new niece, Naomi, and thought she "resembled [him]. . . . One way or another the family is being perpetuated, it seems!"

By the summer, Man Ray had taken a second studio, this one across from the Paris Observatory, to paint, escaping the demands of his professional photography work, and escaping his and Kiki's problems. He busied himself making furniture out of canvas and leather over ergonomic metal frames, which he'd designed to get the most use out of the space. Where the Campagne-Première apartment reflected all the chaotic comings and goings of his and Kiki's domestic and professional lives, he tailored everything in the Observatory studio to fit snugly into place, from his own paintings and photographs, to the African masks he'd started collecting, to his rows of favorite jazz records, all carefully displayed.

Even with Man Ray often absent, working at the second studio, Kiki would stay away from their apartment for nights at a time. Hav-

ing arrived somewhere with Man Ray, she would find another man to leave with. She would move in for a while with Treize and then return to Man Ray.

He was never fully able to hide how much he resented Kiki for having talent, even as he encouraged her to use it. He wanted her, after singing at the Jockey, to become "again the simple country girl, in love with me and the domestic setup." When his own work kept him out late, he wanted her "home waiting to entertain me with the day's gossip." His descriptions of some of their socializing give evidence of the ways he tried to diminish her in public.

> I did take Kiki with me sometimes to the cafés of my more intellectual friends, or to their homes. She was perfectly at ease and amused everyone with her quips, but got bored if the conversation became too abstract for her. Unlike the wives or mistresses of the others, who tried to keep up with the current or kept silent, she became restless; I took her back to her beloved Montparnasse. Someone once asked me whether she was intelligent: I replied shortly that I had enough intelligence for the two of us.

The relationship tore apart, either in late 1928 or early 1929. Kiki wrote nothing about why or how it happened. Man Ray insinuated in his memoir that she was the one to leave him, claiming that she wanted to have a child with him and he "disappointed" her. Of the three paintings by Kiki that we know for certain Man Ray owned, one is titled *Babies* (undated), a bizarre watercolor showing a woman who looks much like Kiki seated next to a massive chubby baby, twice the size of the woman, wearing a bib on which is written BABY. But Man Ray insinuated many things about Kiki that can't be verified, for instance that he caught a "social disease" during a time of fidelity to her alone, prompting her to secure certificates from two separate doctors attesting to her health when he blamed her.

Man Ray also implied that their relationship's end had something to do with Kiki's rising popularity, as if it were the needs of her audi-

ence that ultimately pulled her away from him. Kiki left him "gradually," he wrote, for the man with whom she was "collaborating on the editing and printing [of Kiki's memoir]. She began frequenting the other night places that sprang up in Montparnasse. Her singing was in demand everywhere; her presence attracted the tourists who were now flooding the quarter." If Man Ray was truly saddened by Kiki's becoming increasingly "in demand" as an artist, perhaps it was because she was no longer as eager to shop and cook and clean and answer the phones for him as she'd once been.

Sometime in the first months of 1929, Man Ray accepted an invitation from the wealthy aristocratic couple Charles and Marie-Laure de Noailles to make a film set at their villa in the hills above Hyères. The French architect Robert Mallet-Stevens had recently completed the building after three years of difficult construction. The Cubist-inspired house of reinforced steel and heavy stone, fronted by a zig-zagging garden, constituted a modernist masterpiece in its own right. The Noailles commission was similar to the one Man Ray took from the Wheelers to make *Emak Bakia,* a kind of portrait of the patrons and their property posing as an avant-garde film. His ability to attract wealthy patrons had grown substantially in just a few years. He was no longer the outsider taking snapshots of people like the de Noailles at someone else's parties. In another reversal from his early days in Paris, he refused to travel to design houses for fashion shoots, as he had to Poiret's atelier back in 1921, but insisted that clients such as Coco Chanel and Elsa Schiaparelli send the models and outfits to the Campagne-Première studio, which he was building into a larger-scale operation with a complex multipoint lighting system.

After the success of *L'Étoile de mer,* Man Ray had grown bored with filmmaking. He saw little future for the kinds of movies he wanted to make in a medium now dominated by "talkies." He did very little to promote the result that came from the Noailles commission, a maddening work titled *Les Mystères du Château du Dé* (The Mysteries of Dice Castle). Which raises the possibility that he took the assignment in part to give himself a reason to keep away from Paris for a few weeks,

to put up a barrier of distance to stop himself or Kiki from yielding to the temptation to reconcile. He might have wanted to delay having to see her in public. Or maybe, sensing that she was about to leave him, he scurried to position himself as the one to make the definitive move to end their relationship, by disappearing to the Southwest of France for a few weeks rather than by facing her.

"There were no scenes nor explanations between us," Man Ray wrote of his and Kiki's break.

But in an interview, Kay Boyle said she remembered clearly Kiki's reaction when she saw Man Ray come through the saloon-style doors of La Coupole, the neighborhood's sleek new restaurant and nightclub, shortly after they'd split. "Kiki would be sitting at the bar. When she spotted him, she would pick up anything that was not nailed down and begin to throw it at him, shouting the most incredible obscenities. Man Ray would go down on all fours and crawl under the swinging doors."

20

DON'T HESITATE!
COME TO MONTPARNASSE!

S OMETIME IN 1929 KIKI MOVED IN WITH A CARTOON-
ist named Henri Broca. They'd met the previous year when he'd
interviewed her for *Don't Hesitate! Come to Montparnasse!,* Broca's
self-published illustrated guidebook to their neighborhood. The title
came from the ever-ironic Cocteau. Rather than offering the standard
tips on what to see and where to go, Broca framed the book as a guide
to who you had to know to understand the Quarter, and Kiki figured
prominently. One of the pages shows a cartoon of Kiki singing at the
Jockey in a diaphanous dress, Broca's pen repeating the local rumor
that she wore no underwear.

On the opposite page, Broca got a dig at his romantic rival with
another drawing. "Not having found a Pekingese to her taste, Kiki
adored the gentle Man Ray, who tried to make her life easy, and who
is quite right to do so," reads the caption beneath Broca's caricature of
the photographer, popeyed, puppyish, and squat, trailing a voluptuous
Kiki, who in print towers over him by a head as she did in life. Not
that she's spared a lashing either. "Kiki's no longer what she had been,"
the caption continues, "but she nevertheless represents a heroic era of
Montparnasse." Man Ray kept a copy of the drawing, whose caption
he'd scribbled out and written below "This is shit—made by an ass-
hole." Marie Vassilieff added her signature below as "the witness" to
this judgment.

Henri Broca was the son of one doctor and the grandson of another, the renowned surgeon and anthropologist Paul Broca, for whom Broca's area in the brain's frontal lobe is named, as is the Broca Hospital just east of Montparnasse, where Paul conducted the research that made him famous. Henri ran away from a strict if comfortable upbringing in Bordeaux, seeking adventure, spending his teenage years working on one of the last of the old three-masted ships still sailing, then as a stagehand before drifting to Paris in 1925 and talking his way into drawing caricatures for some of the papers. Hard drinking and high-strung, he dressed like a well-to-do-banker, all silken pocket squares, Malacca canes, and pinstriped suits, compensating for his lack of education by being the snarkiest person in the room, a Gallic Noël Coward *avant la lettre*. Kiki said that meeting him was the first time she fell for someone who wasn't handsome. His charm was sufficient. "His hold over me was incredible," she wrote.

His guidebook sold well. He followed it with an equally idiosyncratic monthly arts and culture magazine called *Paris-Montparnasse,* which highlighted the latest exhibitions, films, plays, and records, while also lampooning the local scene with sardonic pieces written by some of its key players, such as Foujita, Vassilieff, André Salmon, and Broca's other friends and sometimes enemies. The first issue appeared in February 1929, the house style pitched to give tourists the feeling of peeking behind a curtain, with enough self-regarding gossip and rose-colored reminiscences to hold the attention of the most seasoned locals, and a dose of neighborhood boosterism sufficient to secure regular advertising from the places anyone reading the magazine would likely already have frequented. Kiki makes an appearance in every issue: as the subject of a reported bit of gossip, in a drawing, in a photograph, occasionally in all three in the same issue. Most mentions of Kiki in the magazine somehow reinforce her bona fides as a painter, performer, and writer. Broca, for example, described how Edouard Ramond, head of the National Museums, a man of discerning tastes, had recently bought one of her paintings. Broca would repeat the

claim (unconfirmed by any archival evidence) whenever talking to the press about Kiki.

Broca listed himself as editor in chief, while Kiki's name was absent from *Paris-Montparnasse*'s masthead. But she could have insisted on whatever title she liked, since according to her private writing, she paid for the whole production. Broca had a problem with money, namely holding on to it, and *Paris-Montparnasse* lost money from the start. But Kiki was then earning well from her singing, secure enough, for instance, to be able to pay for her cousin Madeleine's child, born with a clubfoot, to come to Paris for a costly surgery. Madeleine and her child ended up staying for nearly nine months, with Marie Prin. Kiki reportedly visited the child often, the only indication we have of some kind of reconciliation between Kiki and Marie since their break a decade earlier.

Friends would recall Kiki's generosity over the years. The Danish sculptor Lena Börjeson told of how at La Coupole, Kiki learned that a young woman crying nearby had lost her child and had no money to pay for the burial; after getting the bartender to bring the woman some brandy and a sandwich, Kiki went from table to table in the dining room "and lifted her skirt in a cancan movement, saying, 'Please, that will cost you a franc or two.' And it wasn't long before she returned and put a whole pile of money in front of the girl."

For the cover of the April 1929 issue of *Paris-Montparnasse,* Broca and Kiki chose a rather staid head-and-shoulders photo of Kiki in a patterned dress looking longingly at the camera. It was taken by Man Ray, who contributed to the magazine despite his animosity toward Broca. The cover text said only KIKI above the image and PHOTO MAN RAY below it, in the same equal-size font.

Inside the magazine, Broca and Kiki announced a new venture, in a piece presented as what we would now call an advertorial, under the headline "Kiki Has Written Her Memoirs." The piece promised that *Paris-Montparnasse* was branching into book publishing, with Kiki's book as the first title, and presented a facsimile of the memoir's first

page in Kiki's childlike handwriting, adorned by a drawing she did of herself as she would have appeared when first arriving in Paris. This was followed a few pages later by short excerpts of some early chapters, accompanied by two more Man Ray photos of Kiki. Both dated from a few years earlier, and neither was particularly strong: the first a cheese-cake full-length pose of Kiki smiling, lounging in a white dress, heavy makeup on and wearing high heels, the second a blurry head-and-shoulders portrait in which Kiki looks rueful. Finally came a reprint of Desnos's introduction to her show at Au Sacre du Printemps, with two of Kiki's canvases—the first of washerwomen, the second of her village's clock tower—reproduced at the bottom of the page.

Man Ray later claimed he was the first to tell Kiki to write about her life, after she'd sent him pages about her childhood during one of her trips back to Châtillon-sur-Seine. The Paris bookseller Edward Titus (about whom more later) suggested that he was the one who first approached Kiki about a memoir and that she'd agreed to let him publish it. However, Titus believed that only Broca could convince Kiki to actually finish the project.

Most likely Kiki came to the writing on her own. Multiple reasons may have compelled her. She must have been excited by the chance to produce a representation of herself unmediated by any other artist, the written analogue to her self-interrogating paintings. She could have been pragmatic, thinking that a memoir would make money or increase her fame, keeping her booked on stages and appearing in movies. She may have wanted to be the first to present her versions of stories she anticipated would one day be told by others, like Man Ray. And the project offered her a way to make sense of herself, especially her memories of a troubling childhood and adolescence. It cost her only the time to sit there and think and write and not be onstage or painting. Later, to an interviewer seeking more insight into her process, all she said was that the writing had been "kind of a drag."

Five days after announcing the book in *Paris-Montparnasse,* Kiki and Broca drafted a contract with each other to publish two hundred deluxe copies, each one to be signed by Kiki, as well as a subsequent

run of a regular edition. They would split whatever they had after covering their expenses.

They designed the book as an art object worth prizing, with a light board cover and thickly coated pages, and a trim size large enough to make it worth displaying, with at least one picture for nearly every two pages of text. They filled it with twenty of Kiki's drawings and paintings, mostly illustrating scenes from her recollections, and a gorgeous photograph she'd taken of her grandmother, as well as Treize's photo of Kiki throwing her pail of water in the courtyard of the Hôtel Raspail. The book also included portraits of her by Montparnasse artists Hermine David, Toño Salazar, Krohg, Foujita and others. And there were ten photographs Man Ray had taken of her. Rather than drawing from the more mysterious and unsettling images they'd made together, she chose some of their plainest if well-executed portraits, mostly head-and-shoulders shots, most often of Kiki looking playful, only one of which shows her nude and then with her body shadowed and shielded somewhat by a gown.

For the cover art, Kiki chose a sketchy, somewhat rough portrait done by Kisling, an image that by that time was a decade old, in which her face is somber but full of expressive character, stripped down to its basic elements and completely beguiling. She is recognizable as Kiki by her large nose and sharply cut bangs, the once-radical fashion choice that by 1929 was ubiquitous. And so Kiki, when telling her own story, bypassed Man Ray's glamorous, sexualized photographs of her and highlighted an understated painting done by an old friend, one in which she looks down-to-earth and approachable. It was an image in line with how she saw herself, and one that nodded to where her career, her adult life, really, had started: being seen by Kisling and modeling for him.

Given how much of Kiki's sense of self came from belonging to her particular group, it makes sense for her to have wanted to cram the book so full of contributions from her friends, making the project appear more like a collective effort than a self-centered act. And who better to endorse this book, by a Burgundian outsider offering the

ultimate insider's account of Montparnasse, than the shape-shifting Foujita, who, as one French critic wrote, had "reached a remarkable situation: of passing for a French painter in the eyes of the Japanese and for a Japanese in those of Westerners." Then at the height of his own celebrity, Foujita avoided any overblown rhetoric when writing his warm and whimsical preface. "Montparnasse has changed," he wrote. "But Kiki doesn't."

Kiki's book would be a life's story presented in the form of a block party, a celebratory group sketch of a particular community caught as if in amber in a particularly heady time, as seen, lovingly and unsparingly, by one of its own. The manuscript ready, Kiki and Broca sent it off to the printers in Dijon, planning on a release that summer.

21

1929

A MAN AND WOMAN HAVING SEX; HER LEGS SPREAD, him on top of her; shot at midrange, capturing her thighs, backside, and genitals; and his back, thighs, backside, and genitals, to be titled *Spring*.

The same man and woman having sex; her legs spread, him on top of her; shot close-up from above, cropped tightly to focus on the point of their connection, titled *Summer*.

The cupid's bow lips of the woman fellating the man; shot very close-up, titled *Autumn*.

The man inside the woman from behind, shot close-up at hip level, titled *Winter*.

These were the four photographs Man Ray gave to Louis Aragon in 1929 for publication in an art book they were working on, to be titled *1929*.

Sometime prior to that transaction, there had been a meeting of Surrealists at the Café Radio on the Place Blanche to discuss the plight of a Belgian comrade whose little avant-garde magazine *Variétés* was foundering. One among the group, Benjamin Péret, suggested a special one-off issue to raise some emergency cash, something sure to capture public attention, an issue filled with sex poems written by himself and Aragon. The idea grew. It would be more

than a special issue; it would be a standalone chapbook devoted to the subject of sex. They would design it to look as plain as the content inside was meant to be shocking, to mislead the censors, to be ironic.

1929 would mimic a calendar, a dirty catechism, framed in sections named for the four seasons, riffing on the almanacs the post offices and fire stations printed each year for their employees to sell door to door to earn their Christmas bonuses.

Aragon and Péret wrote their poetry. And then Aragon went to Man Ray seeking visual content.

Two hundred and fifteen copies of *1929* were printed, secretly and relatively luxuriously, in Brussels. French customs officials seized most of the run, but some got through to Paris.

While their eyes aren't shown, people in Montparnasse would have been able to quickly guess the identity of the couple in the photographs by the available data: the man's small, thin, hairy frame and the woman's trademark cupid's bow lips; their skin tones; and the angles of certain of the photographs, all four signed Man Ray, indicating that the same man doing the photographing was the one being caught on film. These may well have been the "photos of love-making between a man and a woman," as Henri-Pierre Roché described them, that Man Ray showed to him back in 1922.

The poems in *1929* are self-consciously blasphemous, meant to titillate and provoke. The four photographs are explicit. In tone and content, they're light-years away from any of the nudes Man Ray and Kiki produced in their time together.

It's not known when they rigged up a camera to capture their coupling or what eventual purposes each one had in mind for the pictures. To an outsider, they would seem to be private photographs, taken for the pleasure of the two people involved.

There is no record of Man Ray consulting with Kiki about releasing the photographs publicly before giving them to Aragon.

There is no record of how the timing of Man Ray's giving Aragon

the photographs fell in relation to Kiki's leaving Man Ray, nor of Man Ray's learning that Kiki would soon be sharing the details of her life (and presumably his) in a book.

There is no record of Kiki's reaction to the photographs circulating among her friends and acquaintances.

22

QUEEN OF THE UNDERGROUND

KIKI WATCHED HER NEIGHBORHOOD CHANGING. IN a piece written during World War I but published posthumously in 1920, Guillaume Apollinaire had prophesied, "without wishing it to come true," that one day "Montparnasse would have its nightclubs and cabaret singers to go along with the painters and poets," and that "Cook's Tours would bring its busloads." By the closing years of the decade, Apollinaire's prediction had largely come to pass.

As early as the summer of 1926, an estimated one thousand to two thousand American tourists were visiting Montparnasse daily. Between June and September of that year, more than a hundred passenger ocean liners sailed from New York to Le Havre or Cherbourg. The publication of Hemingway's *The Sun Also Rises,* also in 1926, played a huge role in increasing the neighborhood's international appeal. Travelers to Paris wanted to see where Jake Barnes and Brett Ashley had played out their drama. Their mutually frustrating tussles would surely have taken place in the Hôtel Istria, according to some ingenious tour guides happy to point out the specific room for a sum. And they wanted to see the already legendary Rotonde, even if it was to imagine themselves too in-the-know to bother going inside a place already past its prime. They'd been tipped off, after all, by Jake Barnes himself. "No matter what café in Montparnasse you ask a taxi-driver

to bring you to from the right bank of the river, they always take you to the Rotonde," he complains in the novel.

In 1927 an American woman could write home about making the "inevitable" visit to Montparnasse: "Telling about the Café du Dôme and its sister the Café de la Rotonde is like reciting 'to be or not to be.' There's so much precedent." Rare was the visitor arriving without some preformed opinion of the neighborhood. It was too loud; too neon; too Jewish; too American (even the Brits thought so); too crowded; too ugly.

Kiki's friends tended to go out of their way to ignore the tourists. But Kiki enjoyed them. Most of all she enjoyed teasing them. If she happened to notice a conservative-looking family gawking at her from across one of the café terraces, she would stand up, ask the crowd in French, "What can we do for those nice people?" and then turn around, hike up her skirt, and moon them.

Already people were talking of the recent past as a bygone era. Kay Boyle recalled McAlmon, on a desultory summer night at La Coupole, seeing Kiki and Hilaire Hiler and remarking that they "were no more than survivors of another and far gayer company and of a wilder, more adventurous time." McAlmon judged that "the lines that people spoke now were as flat as stale beer . . . and the props, the scenery, no longer had any meaning. So as to change the look of things, there was nothing to do except have one more drink . . . and then one more, and then another after that."

Life on the terraces held less of a spark than it once had. Where once you could sit back and wait to see who would show up, knowing that eventually someone would appear to turn the evening into an impromptu adventure, now there were fewer chance encounters and more and more prearranged outings. "The telephone was the death of Montparnasse," said Jacqueline Barsotti, decades later. And those organized parties unfolded just as they were expected to unfold. If giddiness remained the prevailing feeling at these gatherings, it was no longer due the group collectively experiencing a spontaneous burst of energy but because everyone in attendance knew they were expected

to act giddily. They would disappoint one another if they didn't try to do something wild. They'd gone from ingénues to seasoned veterans in just a few years.

Kiki was changing, too, as the decade neared its end. The Canadian writer Morley Callaghan described her at a party (when she would have been roughly twenty-eight to his twenty-six):

> She was still beautiful, but quite plump now, and there was something of the clown in her lovely face. . . . Going up the stairs ahead of me was Kiki, and being the lovely clown she was, she began to go up the stairs on all fours. Whereupon I reached down, and threw her skirt up over her head. Undisturbed, she continued to go on up on all fours while I played a drumbeat with both hands on her plump behind.

In early May 1929, Kiki completed what would be her last posing session of the twenties, sitting for the first time for the then relatively unknown Alexander Calder. He would recall his attraction to her "wonderful nose that seemed to spring out into space." In his ratty studio a half-block south of the Montparnasse cemetery, Calder fashioned a wire sculpture of Kiki's likeness while a Pathé camera rolled to collect footage for an English newsreel titled *Montparnasse, Where the Muses Hold Sway,* a three-minute tour through the studios of what it called "this famous suburb of Paris [where] eighty thousand artists are neighbors." Foujita, described as "a well-known painter of women," also appears briefly, as do several unidentified artists, while Foujita's wife Youki, and Kiki represent the "muses." The newsreel captured Calder brusquely swiveling Kiki's head with his hand to stand in perfect unison with the profile of his sculpture, as she smiles nervously. Calder holds up the wire sculpture to show how neatly its pointy nose matches Kiki's.

ON MAY 30, 1929, *Paris-Montparnasse* hosted a variety show at the Bobino, a popular music hall on rue de la Gaîté. While the main goal

was to promote the fledgling magazine, some of the ticket sales went to support a food bank for artists—"to help fight the miseries our modern bohemians so often hide behind their masks of eccentricities," as one reporter put it. Man Ray did not attend.

The crowd watched a trapeze artist leaping from the balcony; a jazz orchestra and dance troupe pulled together from some of the nightclub players; a child singer billed as the Youngest Artist in France; and a handsome oddball calling himself the Cowboy of Montparnasse, who when out of character was the painter, occasional model, and part-time janitor Samuel Granowsky, and whose act consisted of dressing up in a check shirt and cowboy hat to shout American words in an accent that, if meant to be American, came out American by way of Ukraine, with a good deal of Yiddish thrown in. Foujita did a mime routine in a garish clown costume; Vassilieff sang and danced to Russian folk songs; a local boutique gave a fashion show; a diminutive singer named Chiffon belted out some tunes; and for the penultimate act, Treize, Kiki, and a few other women under the name Les Montparnasse Girls danced a cancan. Each woman moved to her own rhythm. Treize had to stop them midway through to try to get them into unison, going so far as to bring each dancer a glass of Pernod to calm their apparent nerves, which failed to improve their performance, adding to the hilarity.

The event's main draw and final act was Kiki, solo, reprising her best-known songs, a move meant to publicize the upcoming publication of *Kiki Souvenirs*.

Alone on the wide stage, bathed in bright light, a peasant blouse draped to reveal a shoulder, a flower behind her ear, she sang *"Les Filles de Camaret,"* nodding toward Robert Desnos in the audience.

Unlike the grandstanding performers who had preceded her, Kiki moved lightly about the stage. Her gestures were far more reserved here than at the Jockey, as if she sensed, counterintuitively, that doing less in this big venue would go further with the audience than trying to do too much. The effect on the crowd, at least according to Broca's summary of the show in *Paris-Montparnasse,* was "astonishing."

The gala ended with an elaborate mock ceremony in which Kiki was crowned as Queen of Montparnasse. From then on, she would be remembered as Kiki de Montparnasse. The *de* mimicked royal lineage but held a double meaning, reinforcing that she was Kiki *of* Montparnasse, literally descended from the neighborhood. For those who knew their local history, there was a further tongue-in-cheek connotation to Kiki's being named Queen, owing to the nineteenth-century tradition of giving the title "queen of the *bal* [dance hall]" to a particular prostitute deemed by popular acclaim as especially charismatic or desirable, cementing her place in the public imagination and elevating her rank to one of the select grand courtesans who could have their pick from among the city's wealthiest clients.

A few hours after the show, a few dozen friends celebrated Kiki's title in the big dining room of La Coupole, showering her with roses and playing at being her courtiers, paying homage to their sovereign while the waiters whisked between the tables like nurses in their medical whites.

There among her chosen family, plates and glasses filled, talking, listening, taking note, being noticed, her story off at the printers waiting to be told, Kiki was likely as happy as she'd ever been in her life.

23

THE PATH OF DUTY

"I was born October 2, 1901, in Burgundy. My mother left for Paris, leaving me with my grandmother who was already caring for five other little children that her three other daughters had given her to raise. We were six little love children: our fathers had forgotten to recognize us." So begins *Kiki Souvenirs*, laying out in three sentences its central concerns: the warring pulls of countryside and metropolis; the search for love; the wounds of abandonment; and the responsibilities people decide to live up to, or not.

Before writing about any of her fascinating friends in Montparnasse, Kiki trusts readers to spend half her book immersed in the life of a lonely girl growing up poor in the countryside, turning into a restless young woman on the margins of Paris doing nothing more exciting than trying to earn a living. The importance of this backstory becomes clear as we see her drawing on everything she experienced as Alice Prin, illegitimate child of Châtillon-sur-Seine, to craft the character of Kiki, queen of Montparnasse. With every bawdy joke, outmoded regional expression, naughty story, and homespun dress, Kiki presents an amplified version of herself—a self-described "bumpkin"—to enchant her Parisian friends and eventually her fans.

As with her painting, much of Kiki's writing concerns the pleasure she takes in other people. She almost always positions herself in relation to someone else. She seeks connection to her absent father and

distant mother; to mysterious aunts and mistreated cousins; to men who make her promises; to women with miseries worse than her own; and to the artists who draw and paint and film her. And by sketching their portraits in words, her own portrait comes into focus. *Kiki Souvenirs* tells the story of a young woman becoming the person she is by finding the people who make her feel free.

New faces excite her. New sensations. Food features prominently: how to get the money to buy it; sharing it with friends when you have it; dreaming about it when you don't. But new knowledge excites her most of all.

She writes about sex as a form of learning. In pursuing it, or having it, or talking about it, people reveal themselves to Kiki. In an early chapter, a friend advises her to "let herself be seduced" by an old man, since "they're the best for deflowering you painlessly." Kiki discovers that the would-be deflowerer is a professional clown and more interested in showing her his costumes and playing his guitar than anything else. She's coy about their night together, saying only "he did a thousand wonderful things to me," and that afterward she remained a virgin. Instead she focuses on reproducing verbatim the tender lyrics of the song with which the clown serenaded her.

Kiki shows herself as having absorbed so much knowledge about the adult world so quickly that, while still a teenager, she is jaded enough about sex that she can find eating the more appealing activity. She describes staying with a friend named Eva who was "kept" by an old Corsican laborer who gave the young woman a daily allowance of two francs, sausage, and cheese. "I was in the little room with them and they went to bed. They made love. I watched without much excitement and took the opportunity to eat their good sausage."

As Kiki finds a home among the misfits of Montparnasse, she watches and listens to everything they do and say, amassing her arsenal of details. And by chronicling several small moments in their lives together, she realizes the outsider's ultimate fantasy: to understand a place better than its so-called natives. She understands Montparnasse as a community that encourages artists to blossom, rather than as a

point on a map in which artists happen to live. She understands how across the Quarter's few blocks, everyone is influencing everyone else, whether they're Russian painters or Spanish butchers or French landlords or Dutch models. "All the peoples of the earth have pitched their tents here and yet it's one big family," she writes.

Once her narrative settles on Montparnasse, Kiki lets little information in from outside to disturb its dreamers. The biggest problem among her friends "is deciding where to go for dinner." She gives no sense of what anyone thought about other places. She doesn't write of wars or refugees or the Spanish flu, nor of the question of the revolution of the working classes that vexed so many people in her circle and informed their art making; nor of the global outcry over the executions of the immigrant anarchists Sacco and Vanzetti, which in Paris prompted protesters to storm onto Montparnasse's terraces, rattling and thumping the tables. There is no mention of Hemingway's or Fitzgerald's novels or Lindbergh's landing. Aside from Man Ray, Americans exist for Kiki as an energetic, faceless throng, dancing madly. "They're like kids!" she writes.

But hers is a myopia born under the sign of love. She recognizes that the forces of family history, economic necessity, and her own desire for adventure, love, and self-discovery have her bound so tightly to Montparnasse that she can never leave. She writes: "I feel free here. I can sing my songs and mess up now and then without worrying about going back to eating nothing but baked beans. People here are open-minded. Things that would be hanging crimes in other places are treated here like minor sins."

Kiki delivers her story in short popping sentences, as though we're overhearing her sharing a drink with a friend and she's hurrying to get it all out. This yields chapters of usually no more than a couple of pages, most often ending with some kind of punch line, sometimes stamped by an exclamation point. She's smoothed her words down until they flow like water. Her sentences travel in one direction only. There is no doubling back, no tentative language. Maybe she took a long time to finish the book not because she was lazy about the

undertaking, as Man Ray and Edward Titus respectively implied, but because she needed to keep refining her prose until she was satisfied that she sounded as confident on the page as she did on the stage.

She gets up close to her subjects, writing with her aperture wide open to let in lots of light while limiting herself to the tightest depth of field. She tends to capture people in a line or two. Famous names get no more ink than obscure ones. Her first boyfriend Dédé is "a big frog-faced blonde." Kisling has the look of someone who's been "well-cooked by the sun." Derain "laughs at his own stories as he tells them." Her cruel lover Robert wears "socks missing their ends, like mittens without tips. He told me this was the fashion and I believed him."

For all its freewheeling talk of sex, drugs, and heavy drinking, *Kiki Souvenirs* is in the end a somewhat conservative work, focused on a young woman's quest for acceptance from her group and love from the people she loves. Though she starts out a rebel—defining herself in opposition to her uncaring mother, her controlling teachers, the ignorant villagers representing the traditions and prejudices dictating how her life was expected to unfold—once she finds her way to Montparnasse, she becomes a conformist. It's only that she conforms with nonconformists. She prides herself on how smoothly her life runs in tandem with those of her chosen community of outsiders, how easily she moves among them.

Kiki presents herself as a liberated woman, which she truly was. And yet her sense of freedom is intimately linked to her sense of service to others. She's no cynical networker but treats each new friendship made as a kind of victory. She delights in the commitments these connections present. She finds pleasure in many forms throughout the book, but it seems nothing makes her happier than having someone to watch out for.

Kay Boyle called attention to that generosity of spirit when sketching Kiki in her own memoir of the 1920s. "This much I know: when you knocked at Kiki's white stone flesh for entry, she too opened wide her heart and moved the furniture aside so that you could come in."

Even when she's onstage, a setting that actively encourages narcissism and rewards self-aggrandizing behavior, Kiki sees herself chiefly as a servant, someone who has volunteered for the duty of providing a night's enjoyment.

In a book so concerned with the search for connection, Kiki's shortest and most evasive chapter concerns the person she'd known intimately for longer than any other. While *Kiki Souvenirs* features Man Ray's photographs, giving him ten pages in which to tell his version of her story in images, she in return assesses him in an anodyne three-page chapter, "Man Ray," that discloses nothing. She compliments his "pretty photos" and "absolutely extraordinary paintings" and tells the reader she finds him very attractive, "like the devil in the flesh." But that's about it. He garners another sentence in a later chapter as she surveys the Quarter at decade's end, although she might as well be describing a passing acquaintance: "There is Man Ray, lost to the world as he stares into little pieces of glass—lost in his imagination—or else dreaming about some new-fangled sort of photographic apparatus." In his own memoir, Man Ray chose to interpret the brevity of Kiki's writing about their life together not as an insult but as an act of discretion.

Above all, *Kiki Souvenirs* makes clear that in her various incarnations, Kiki had always been a storyteller. She told stories in song, on canvas and paper and celluloid, and in the way she carried herself in front of other artists trying to tell their own stories through their portraits of her. The book stands as an expert performance of self, her most sustained and public step in presenting the character of Kiki de Montparnasse that she'd been crafting onstage and off for a decade.

On the page, Kiki is earthy, hungry, wounded, loving, haunted, excitable, impulsive, messy, clear-eyed. And loyal above all, grateful to the place that opened up her life to so much possibility and change and movement, even as she'd tethered herself to it so tightly that a walk across the Seine could feel like a betrayal.

She ends her story

My friends, through their talent, made Montparnasse what it
is. . . . Some nights, I'll admit, they tried to turn me from the path
of duty to take me to Montmartre. But I refused to be a deserter.

KIKI,

Montparnasse, 1929

On June 25, Kiki and Broca hosted a launch party at one of the
Quarter's most expensive restaurants (and James Joyce's favorite), the
Falstaff. Drinks were provided by the neighborhood's beloved Liver-
pudlian bartender, the former prizefighter Jimmie Charters, recently
poached from the nearby Dingo, the bar whose reputation he'd helped
to make with his rough-hewn charm and strong cocktails.

The Parisian press had helped to publicize the book in the days lead-
ing up to the event: "Who doesn't know Kiki, in Montparnasse, and
therefore the whole world?" asked a columnist in the arts and letters
review *Comoedia*. "Kiki, the Quarter's mistress of ceremonies since
the day she arrived [has] written her memoirs—and she has some sto-
ries to tell!" Most of the artists whose portraits of Kiki appear in the
book attended the launch. Man Ray did not.

Kiki had planned to sign books as people bought them at the
event, but the shipment from the printer failed to reach Paris in time.
Instead she posed for photos holding a clunky mockup of the cover
while Treize took preorders. A photo from the night shows a grin-
ning Treize holding the mockup in one hand and a wad of bills in
the other.

Kiki reached the peak of her fame that summer as anticipation
for her book ran high and the Parisian papers started covering it.
A columnist for *Paris-Soir* began reporting regularly on everything
Kiki, from her random pronouncements ("I dream of visiting the
Orient," Kiki tells us, "to hear the chanting of the muezzin and to
paint women lounging on beautiful carpets"), to her collection of
home remedies ("Kiki has sulfur, veronal, venotrope, mercury, ether,
camphor, and a thousand other products with sonorous names"), to

the state of her mental health ("Yesterday over drinks Kiki told us that she'd been tempted, several times, to kill herself. We didn't want to believe it. . . . The woman we've always considered the Queen of Joy has had her moments of despair. But then who hasn't?"). Meanwhile Broca and Kiki contributed to the hype in the pages of *Paris-Montparnasse,* planting pieces such as an "official bulletin" describing how the florist next to La Coupole was facing difficulties ever since Kiki's "election" as queen of Montparnasse, since "the admirers of Kiki are so numerous that his store is out of red roses by nine o'clock in the evening."

Coco Chanel, who'd never before had any interaction with Kiki, chose her as one of two dozen guests she gathered to celebrate the closing of *Le Fils prodigue* (The Prodigal Son) created by George Balanchine with music by Sergei Prokofiev, which had run at the Théâtre Sarah Bernhardt, the last ever Ballets Russes work under Serge Diaghilev, in what was to be the company's final season in Paris. Kiki had never seen such piles of caviar as she did *chez* Chanel. The French writer Maurice Sachs, another attendee, noted in his journal: "Kiki, who had too much to drink, sang very obscene songs."

A few nights later, with Foujita, Desnos, Kisling, Pascin, Boyle, Nancy Cunard, Duchamp, Brancusi, and other friends (but not Man Ray), Kiki went to a Bastille Day party that Hilaire Hiler hosted in a rented hall near Place Denfert-Rochereau. Hiler "installed a long wooden table, tubs full of bottled beer on ice, and jugs full of a potent punch, and let the party rip wide open," as Robert McAlmon described. And in a leafy outdoor square adjoining the building, Hiler set up a grand piano, upon which Kiki sat and sang under the faerie lights and branches while he played, "surrounded by a constant but changing mob." Many of them had seen some of the recent Ballets Russes shows, and much of the night's energy went into dancing madly while Kiki and Hiler performed. "McAlmon was Nijinsky that night, leaping to incredible heights over the lighted paper lanterns," wrote Boyle. "I did a wild ring-around-a-rosy dance hours after hour, while

Desnos glided and stamped in an apache tango, flinging an imaginary partner to the other end of the leafy illuminated square, and dragging her back again." It was, for their group, one of the great parties of the decade and one of the last.

FINALLY, KIKI HAD A proper book release at the Edouard Loewy bookstore on boulevard Raspail. It took place on the last Saturday night in October, on the uneasy weekend between the span of Black days (Black Thursday, Black Monday, Black Tuesday), when the American market shed close to a third of its value. "Kiki was kissing all comers," reported the American journalist Wambly Bald in his column "*La Vie de Bohème* (As Lived on the Left Bank)" for the Paris edition of the *Chicago Tribune*. "The line formed about 9 o'clock outside the book shop when the news swept the Quarter that for 30 francs, one could get a copy [and] her autograph and a kiss in the bargain. Men forgot their *demis,* dates and dignity and scampered over. One snow-bearded octogenarian . . . hobbled along to the party and came out with two books under his arm." To accompany her signature, Kiki sometimes drew a little doodle of herself in profile, or head on, or a scene that the receiver would recognize as a shared memory. That night Kiki set aside a copy for Broca, which she inscribed, "to Baby, my Mouth is red, my eyes soft, and our bed is ringed in red lace curtains. Kiki, 1929."

Kiki Souvenirs attracted immediate attention from the French- and English-language press across Paris, both for its subject matter and for its style. As journalists covered the book, they focused on the facts of Kiki's life as much as on her telling of them. They played up how little the world beyond the French capital knew of Kiki, with how vital she was to her small corner of it, framing her rise as the quintessential only-in-Paris story. They loved her all the more for being their local secret. No coverage of Kiki's writing failed to mention her physical beauty. Many reviewers, however, also took her seriously as an artist

working in several media who'd chosen literature as one more avenue through which to tell her stories.

Le Temps, one of the city's major newspapers, ran a front-page story under the headline "A Model's Memories," framing the book as a brave piece of writing from someone who'd made the most of a tough childhood to produce "something beautiful and touching," a surprise coming from someone so young, and a work that didn't feel derivative of anything else. Nodding to Kiki's experience as a painter ("not without skill, totally untrained, but with a kind of naïve intelligence that reveals the great mimetic abilities of this wild child of nature") *Le Temps*'s critic wondered if perhaps Kiki had been driven to write her memoirs because she knew that no painter could represent her as well as she could represent herself. "Her name may not go down in the history of art, but she helped a young generation to dream, by entertaining it," he wrote. "By the time her young court painters have turned into wise old men, she'll make her entrance into the Louvre, in effigy, by Kisling, Hermine David, or Foujita. But the museum-goers won't know the name of this pretty girl whose attractive anatomy has already inspired so many canvases and deserves to survive longer than they do." And he judged that while Kiki did an excellent job of making Montparnasse sound like the most exciting place in the world in the early 1920s, she more importantly conveyed how it was a place where "lightheartedness never got in the way of caring for one another, where a joke always held some tender feeling to it." Kiki, he wrote, "teaches us far more about this world apart than can the learned aestheticians."

A critic from *Paris-Soir* compared reading Kiki to eating a simple, hearty, and delicious meal and appreciated that she seemed guided solely by the desire to write about whatever it was that she found interesting, and that she was unafraid to offer no more than that. The critic for *L'Intransigeant,* appreciating Kiki's "simple sentences, short, incisive, trenchant, sometimes exceptionally tender," pointed to how Kiki, "educated in the streets [must have] learned by necessity how to size

someone up in a single glance." And he closed with a line guaranteed to increase sales: "Her book is . . . instructive for all sorts of reasons, but it's not appropriate reading for young people."

Another daily, *Paris-Midi,* while excerpting the book, featured a large reproduction of one of Kiki's paintings of sailors. "She's a true original and an innocent," wrote the *Paris-Midi* reviewer, "even when singing dirty songs and propping her leg up on the table. She's a good painter. And she's beautiful."

One of the most unexpected reviews came from the stodgy critic for another major Paris daily, *Le Figaro.* Kiki's book "was not—certainly not!—a work of literature, even though it's so tempting these days to pass off primitive stammering as the purest form of art." And yet he considered it valuable as an unflinching document of a particular historical moment, commending Kiki on making the jump from model, to painter, to "resident ethnologist" of Montparnasse. She even managed a few "piercing anecdotes" about her painter friends, he wrote. "And although we'd prefer to keep it a secret, it's true that as we romped our way through her irreverent tales of misery and amorous couplings, certain pages gripped us by the heart and held on tightly."

By August Kiki and Broca had also collected positive reviews from the *Berliner Tageblatt,* Vienna's *Neue Freie Presse*, as well as uncredited reviews written in Russian and Hungarian, all of which they reproduced in the pages of *Paris-Montparnasse.*

This reception did not go ignored by Kiki's friends. For a time, she stood alone in their crowd. Kisling, Foujita, Léger, Picabia, and Man Ray might have gotten their names in the papers from time to time, usually when they had new work to debut, but none of them had written a book. Neither Matisse nor Picasso could say that. And yet there was Kiki on the front page of *Le Temps,* praised for being "clearly in step with her era." There was Kiki being described as "everything" by Sisley Huddleston ("There are lively girls, heedless of convention; there are rowdy painters and bohemian poets; but Kiki is a lively girl, rowdy painter, and bohemian writer, rolled into one. She is everything.")

And she was not yet thirty. Three years later, when Gertrude Stein began writing *The Autobiography of Alice B. Toklas,* she was driven in part by jealousy toward the people she'd known who'd already written well-received autobiographical works, including Kiki.

WAMBLY BALD AND GERTRUDE STEIN weren't the only English-speakers in Paris following the Kiki story that fall. Also intrigued by the "hubbub" in the French papers, as he put it, was Edward Titus, husband of Helena Rubinstein. Before marrying, Titus had written copy for her then-small business in face creams and cosmetics. Rubinstein became rich and famous, and Titus continued to write her copy. By the 1920s (Titus's fifties), he'd wanted something of his own, or Rubinstein had wanted it for him, and so borrowing against some of her many properties, she'd set him up with a two-story apartment next to the Dôme, the ground floor of which he filled with rare books and called At the Sign of the Black Manikin. The storefront served mainly as a respectable cover for his mania for books—he collected everything from Verlaine first editions to George Washington's correspondence—all nominally for sale, although Titus rarely looked up from his reading to meet the gaze of browsers. The store's other function was to put him in the orbit of writers he admired, who enjoyed the unhurried bohemian atmosphere.

At the Sign of the Black Manikin, unsurprisingly, leaked money, a situation made far worse when after two years of not selling books on the ground floor, Titus installed a printing press on the second, turning out small batches of titles for the city's English readers, mostly chapbooks experimental in subject and style, often designed or illustrated by artists he knew in the Quarter. Rubinstein, who when in Paris lived separately from Titus, kept her distance from the enterprise. "How was I to know all those writers were worth a sou," she later said. "I never had a moment to read their books. To me they were all *meshugga* . . . and I always had to pay for their meals!"

That fall Titus had been enjoying his first real success, albeit a minor one then, having published D. H. Lawrence's *Lady Chatterley's Lover*. Titus looked to Kiki for his next coup. He'd known her for a few years and, seeing all the praise, figured he could turn a profit with an English translation, to be called *Kiki's Memoirs*. He admired her writing, which he found "rough and ready." He did think the French edition a bit slim and had Kiki add twenty pages that had been cut from her original manuscript, while he rounded things out with more of her drawings and a few extra portraits of her done by other artists.

Titus's biggest feat was to arrange for Hemingway to write an introduction to the English edition. By then he was a figure of international renown, the author of *In Our Time, The Sun Also Rises,* and *A Farewell to Arms,* which had just come out that September. Titus had taken over editing the modernist literary journal *This Quarter,* to which Hemingway would later contribute, and they likely knew one another through the journal's small community.

Hemingway wrote that Kiki's was "the only book I've ever written an introduction for and, God help me, the only one I ever will." He nearly kept that promise, writing only one other introduction in his career, for another friend from the neighborhood, the bartender Jimmie Charters, who penned his own Montparnasse memoir, *This Must Be the Place,* four years after Kiki's.

As two of the biggest personalities on the Left Bank, Hemingway and Kiki must have had their brushes over the years. Hemingway knew Man Ray, who though generally not keen to spend time with his fellow Americans was charmed by the writer, who brought him to some boxing matches. Man Ray shot some of Hemingway's publicity stills and a favorite portrait of him with his son, Jack. In the spring of 1928, he took a photograph of Hemingway after the writer had pulled what he thought was a toilet chain and brought a skylight crashing down on him, giving him one of the several serious concussions he would suffer from. The image is playful, satirizing Hemingway's macho persona, as

Man Ray caught his boyish smile, a jaunty felt hat propped up on his head bandage. Aside from the Man Ray connection, the closest we come to seeing Kiki crossing paths with Hemingway is a photo of her from 1925 sharing a table out front of the Dingo with Lady Duff Twysden, Hemingway's model for Lady Brett Ashley, the two women flanking a happy American sailor, name lost to history. Standing behind them is Jimmie Charters.

Hemingway described his reasons for writing the introduction in a letter to an American bookseller who was compiling a bibliography of his work: "I wrote the introduction to please Kiki—look at a couple of the photographs of her in old days and youll [*sic*] see why—But would not have written it if was not, in parts, the early childhood [chapters] and [the first chapter on the] Quarter a damned fine extraordinary book—Read it in French."

In referring, in this letter dated from early 1930, to "photographs of her in the old days," Hemingway was calling back to images less than ten years old. In 1930 Kiki was twenty-nine and Hemingway thirty. But then in those ten years he'd lived in three countries, had two sons, blown up one marriage and started another, and written two of the century's major novels and some of its finest short stories while working as a journalist. His introduction to *Kiki's Memoirs* reads like a eulogy, full of grumbling and score settling.

"Kiki now looks like a monument to herself and to the era of Montparnasse that was definitely marked as closed when she, Kiki, published this book" he wrote. "When, in one year, Kiki became monumental and Montparnasse became rich, prosperous, brightly lighted . . . and they sold caviar at the Dôme, well, the Era for what it was worth, and personally I don't think it was worth much, was over."

If his introduction was as much about Ernest Hemingway as about Kiki, it made plain how much he admired Kiki's writing, even as he cloaked that admiration in flippant and misogynistic language. He praised her "wonderfully beautiful body" and her "fine voice," specifying that he meant her talking voice, not her singing one. He con-

gratulated Kiki on keeping that voice intact, as well as her kidneys. He wrote that "her face is as fine a work of art as ever. It is just that she has more material to work with now." But following that insult, and then hedging somewhat by joking that "the people who tell me which books are great lasting works of art are all out of town so I cannot make an intelligent judgment," Hemingway deemed *Kiki's Memoirs* among "the best I have read since [E. E. Cummings's] *The Enormous Room*," and added that parts of it brought to mind a modern *Moll Flanders*. He also made a reference to Virginia Woolf, citing that Kiki had never had "a Room of Her Own." He did worry that Kiki's writing might not come across well in English, advising "if it does not seem any good to you, learn French. . . . It is a crime to translate it." And while poking fun at her reputation by saying she was "a woman who was never a lady at any time," he acknowledged the heights she'd reached: "For about ten years she was about as close as people get nowadays to being a Queen but that, of course, is very different from being a lady."

TITUS PUBLISHED *KIKI'S MEMOIRS* in June 1930 with a run of a thousand copies printed on thick, glossy paper by Darantière, the same printing house that had produced the first run of Joyce's *Ulysses* with its eye-catching cover of murky blue-green. Titus had the cream-colored cover to Kiki's book wrapped in a red band of glassine, squat enough to allow for "Introduction by Ernest Hemingway" to be visible above it, and dubbing the contents beneath it "The Book of Montparnasse," promising that Kiki's book would be the only one you needed to read to understand the place. Titus meanwhile displayed some of Kiki's paintings on the walls and in the windows of his bookshop.

If the stiff English translation from the journeyman writer Samuel Putnam does fall as short of its task as Hemingway anticipated, Putnam at least anticipated that failure from the start. "The problem is not to translate Kiki's text, but to translate Kiki," he wrote in his translator's note, more apology than introduction. "To be able to do this, one

must have the *feel* of Kiki, the feel of the Café du Dôme at five o'clock on a rainy, bleary, alcoholic morning. Yet, this is not enough; it does not give the picture; it is unfair to Kiki."

THAT SAME JUNE 1930, Bennett Cerf, editor in chief of Random House, was in Paris to handle a contract with André Gide. He met with Titus to discuss publishing an American edition of *Kiki's Memoirs*. He left without finalizing anything but in early July ordered 150 copies from Titus, paying him $300.

Later in the month Wambly Bald was telling *Tribune* readers how "on the terrace of the Dôme and the Coupole, in the quiet studios of artists and writers, at the Deux Magots and on the Right Bank, everyone is discussing the English version of Kiki's *Memoirs* [which is] the most daring event of the year." He praised Kiki for revealing "a world wherein life is as simple as breathing" while suggesting "to orderly people new possibilities." Her "intuitive reactions [to Montparnasse's] individuals and crowds are more revealing than the thundering and fictionalized word-excursions of the literary gentry," he wrote. "Her experiences are told . . . without emotion or exaggeration. . . . Never was she daunted by the magnitude of her courtiers."

Titus sent the 150 copies to Cerf on July 22, 1930. But American customs officials confiscated the cargo as soon as it landed in New York, tipped off about the "obscenities" within, though, as Man Ray noted, the book contained not a single word of foul language. "As we gravely feared, the shipment of *Kiki's Memoirs* was held up by the U.S Customs," Cerf wrote to Titus in August. Cerf asked him to mail another batch in shipments small enough to escape notice, ten separate mailings of fifteen books each, to be spread across ten employees of Random House. He provided Titus with their home addresses. But Titus waffled for reasons unknown. Cerf wrote again a few weeks later to demand the books, now giving Titus his home address and telling him there were people eagerly waiting to read them.

Titus seems not to have sent any more copies to Cerf or to any-

one else. Random House never published *Kiki's Memoirs*. Kiki and Broca printed only a small second run of the French edition. Titus, who would close At the Sign of the Black Manikin in 1932, printed no more of the English edition.

WHEN WORD REACHED PARIS of how American officials had seized the first shipment of *Kiki's Memoirs*, Wambly Bald sought out its author for comment.

"The village queen was informed of the bad news yesterday while sharing a cracker with her little [dog] Péky on the terrace of the Coupole," he wrote. "Laconically and with a characteristic shrug, she remarked: 'I'm not losing any weight over it.'"

Her book was not to become an international hit. It was apparently enough, for her, to have been a hit in the neighborhood. Enough to have sung of herself and her friends and their moment.

24

WHEN I GET THE BLUES, I CHANGE ERAS

HEMINGWAY WAS RIGHT TO RECOGNIZE THAT KIKI'S book memorialized an era at its end. As the decade closed, Kiki and her friends saw they were headed for the comedown. "You paid some way for everything that was any good," Hemingway wrote in *The Sun Also Rises*. Much of the thrill of those years had come through testing how far they could push the pace of their lives before everything fell apart. Each new sleepless night scored another reprieve against time.

The Wall Street crash of late 1929 made the break clear. Rarely does the passing of a historical era dovetail so neatly with that of a decade, and in a form so legible to those living through it. People's energies flagged alongside the miserable economy. Their postwar prosperity had been built on quicksand. Complex flows of international capital and massive borrowing had propped up a faulty system, while the world had meanwhile preferred dreaming about Gatsby-level fortunes made overnight to confronting the reality of widespread unemployment throughout the decade and other signs of vulnerability.

Small shops and restaurants started failing. The Jockey closed in 1930 after Helena Rubinstein bought a group of buildings on its corner of rue Campagne-Première and turned them into apartment buildings. "Montparnasse has ceased to exist," Djuna Barnes wrote the following year. "There's nothing left but a big crowd." For many in

Montparnasse, the hangover of the 1930s must have come partly as a relief. They no longer had to fulfill their duty to dance nightly on the edge of the volcano. "Paris resumed a life that was calmer, more stable, less feverish, less excessive," wrote André Warnod in 1930. "Everything returned to its logical pace."

KIKI HAD EMBARKED ON her new life with Broca. From their apartment on the boulevard du Montparnasse, they worked on *Paris-Montparnasse*, trying whatever they could to grow its readership. There were publicity stunts like the endurance kiss they performed in the first week of the new decade, locking lips as they walked from the Falstaff bar to La Coupole as reporters followed along. They fought often. Broca grew jealous over Kiki's fame even as he worked to increase it. His mental health deteriorated. A few days after their endurance kiss he suffered a breakdown. Kiki found him pacing the carrefour Vavin, naked from the waist down, screaming her name. She took him home.

They folded *Paris-Montparnasse* in March 1930. Seeking quiet, they moved to a house in Arcueil, one of the city's southern suburbs, where they lived off of Kiki's earnings from occasional nightclub performances. Broca behaved erratically, which Kiki initially attributed to his usual nervous disposition. That October, as his words and actions grew more bizarre and more threatening, she was overheard in Montparnasse telling friends she wanted to buy a gun.

In late 1930 or early 1931, Kiki, with the help of Henri's sister, had Broca committed to Paris's Sainte-Anne hospital, specializing in psychiatric and neurological disorders. He was diagnosed as suffering from schizophrenia. Kiki described the period of his convalescence as "a living nightmare." Broca's sister remembered Kiki as a constant presence and a devoted caretaker.

To help pay for his treatment, Kiki took an offer to do shows in Berlin in February and March 1932. It was the first and last time she performed outside France. She was by then also paying for her moth-

er's medical care. Marie Prin was at a low point. She had married Noël Delecoeuillerie, the wounded solider who'd pretended to be her boarder, in 1918, but he'd recently left her for another woman. The new couple took an apartment on the same street as Marie. She'd long struggled with alcoholism and fell ill from its effects. She died while Kiki was performing in Germany.

By the end of 1932, Broca was discharged from the sanatorium and afterward continued to hang around Montparnasse, ashen-faced and weak. He and Kiki saw each other at cafés and the occasional party but weren't reunited romantically. Broca put out two final issues of *Paris-Montparnasse,* without Kiki's involvement, in February 1933. He wanted to prove, as he announced in the first of the two issues, that "Montparnasse isn't dead!" And yet this same issue opened with a eulogy, to Rosalie Tobia, who had died a few months earlier. Broca filled *Paris-Montparnasse*'s pages with reminiscences about meals at Chez Rosalie, "when we were young and Montparnasse was young." After publishing the final issue, Broca returned to his family in Bordeaux. He died there in 1935.

Kiki battled her own health issues. She felt uneasy about weighing nearly eighty pounds more than she had in her late twenties. Doctors blamed her drinking. Several tried convincing her to quit. But whenever she cut down on her drinking, she found herself taking more cocaine and decided it was best to maintain her usual equilibrium.

She kept painting. In December 1929 she'd shown new work for the first time since her show at Au Sacre du Printemps, as part of a group exhibit at the Trémois Gallery, alongside nearly two dozen Parisian artists including Suzanne Duchamp (sister of Marcel), Hermine David, Per Krohg, and Jules Pascin.

She had her final public exhibition in January 1931. It was a solo show in an informal gallery space that the young collector Jean Charpentier had set up in the courtyard of his stately home on the Faubourg Saint-Honoré, opposite a corner of the Élysée Palace, residence of the president of France. Newspaper coverage highlighted that "the famous Kiki" had been there to present her paintings in person, shak-

ing hands and signing autographs, but said little about the work. One reporter told Kiki how impressed he was by how much she'd accomplished in such a short time and in so many different arenas. He said she seemed much wiser than her years. She answered only, "I've seen a thing or two."

Her paintings from the late 1920s and early '30s retained the same casual feel as her earlier work, though now she showed greater skill in rendering perspective and scale. Some of her tableaus of rough-looking sailors and prostitutes seem inspired by her episode in Villefranche. She painted herself as a child standing in the corner of a classroom with a dunce cap on her head, a work she gave or sold to Man Ray. She produced a placid scene of "gypsies," as she called them in the painting's title, lounging barefoot by a campfire in a field alongside their animals and their caravan. She painted her dog, Péky. And as Man Ray had done a decade earlier, she took a tightrope walker as the subject of the finest of all her paintings.

Kiki's *L'Acrobate* (The Acrobat), painted in 1927, is a feast of color and movement, capturing in oil the thrills of watching and being watched. At the picture's center, a muscular woman in a pink dress navigates a tightrope that slashes through a fairground scene at a sharp angle. Back turned to the viewer, she holds a patterned parasol with one hand while raising the other above her head as though to right herself from falling, drawing the crowd toward her with this theatrical moment of tension. The walker shares Kiki's short dark hair and olive skin. Below her, the fairgoers, a street peddler, and a few stray dogs all gaze up at her performance with expressions ranging from happiness, to awe, to puzzlement, to indifference. Theirs are the faces Kiki might have seen when singing from her stages, locked in her own nightly balancing act.

In 1929 she'd made a portrait of the Russian director Sergei Eisenstein, the only one of her sitters to leave a record, if tantalizingly brief, of what the experience was like. In his memoir, Eisenstein recalled meeting "the incomparable Kiki, the model for all the greatest artists of Montparnasse," in the cellar of Le Boeuf sur le Toit. She was

"doing a belly dance in Spanish shawls on top of a grand piano" played by Georges Henri Rivière, a curator at the Musée du Trocadéro. Kiki gave Eisenstein a copy of her memoir, inscribing it, *"Car moi aussie j'aime les gros bateaux et les matelots"* (Since I too love big ships and sailors), referencing his film *Battleship Potemkin*.

Eisenstein had come to Paris to study sound film techniques, sponsored by the Soviet state, a figure of international renown and the center of controversy. French authorities banned his films, concerned about their power as Communist propaganda. Of his sitting he wrote:

> Kiki, having herself begun to paint, draws my portrait. Grisha [Grigori Alexandrov, Eisenstein's sometime assistant director] comes in unexpectedly toward the end of the second sitting. She screws up her enormous almond-shaped eyes, the eyes of an unfailingly good-natured mare, as she looks at Alexandrov, and my portrait turns out to have the lips of the future director of *Merry Lads* [the 1934 Alexandrov film].

Kiki created a decent likeness of Eisenstein, emphasizing his unruly hair and long nose, setting him at the edge of a sea on which a battleship sails. But she did indeed get Eisenstein's lips wrong. They have the cupid's bow aspect that can be seen in photographs of a young Alexandrov. Still, Kiki's Eisenstein is much more enjoyable to look at than Man Ray's photograph of the director from the same year, in which a dour Eisenstein cradles a phone to his ear and stares down the viewer, as if interrupted in the middle of an important conversation. The photo feels like a bad head shot of someone trying to break into the film industry rather than a portrait of one of its founding figures.

In 1932 Kiki found an enduring companion in a minor tax official named André Laroque. She approached him one night at a bar after mistaking him for her favorite film star, Jean Gabin. Laroque was a musician, too, and soon started accompanying Kiki on accor-

dion, occasionally piano, for some of her shows, at nights after he got off work. She nicknamed him Dédé. Friends remembered her on the Dôme's terrace happily gushing about their relationship.

They started performing together regularly at a bar called Cabaret des Fleurs on rue du Montparnasse. Brassaï photographed them there one night, midsong, tucked in a corner, Kiki beaming and Laroque looking up at her, dark walls patterned with tiny stars and two star-shaped light fixtures the only decor behind them. There were a few stretches when they secured enough bookings for Laroque to take a leave from the tax office and work with her full time, playing every-where from cramped clubs, to private parties, to music halls on the Champs-Élysées. They shared Laroque's apartment above a tobacco-nist at 2, rue Bréa, a block from the Rotonde.

IN JULY 1929 Man Ray, about to turn thirty-nine, met the twenty-two-year-old Canadian-American model Lee Miller. She'd gotten her start when the publisher Condé Nast (the man, not the company) pulled her from a busy New York street, away from an oncoming car she hadn't seen coming. While working in New York, she'd seen some of Man Ray's images and had heard Frank Crowninshield, head of *Vanity Fair,* and others working in the Condé Nast fold praise his talent. Wanting to do more than model, she'd gone to study art in Italy but had been disappointed by the academic training she received. That July she decided to seek out Man Ray in Paris to see if he might mentor her in photography. She'd tried ringing him at his studio, then after a quick search of the cafés found him around the corner at Le Bateau Ivre (The Drunken Boat, named for the Rimbaud poem). He'd made it his new favorite bar—not coincidentally, one that Kiki didn't frequent—and had gone there for a glass of white wine before leaving for Biarritz, the last among his peers to make the usual summertime exodus, when those with the means to do so cleared out of Paris for its hottest weeks. Miller recalled seeing Man Ray coming up the winding steel staircase from the venue's subterranean bar, which was crowded

and louder than its main floor: "He looked like a bull, with an extraordinary torso and very dark eyebrows and dark hair. I told him boldly that I was his new student. He said he didn't take students, and anyway he was leaving Paris for his holiday. I said, I know, I'm going with you—and I did." They traveled together to the coast to vacation with the Wheelers at the villa where Man Ray had filmed *Emak Bakia* three years earlier.

Miller and Man Ray were together for three years, the first six months of which she worked as his receptionist and technical assistant. Their relationship was tumultuous. At one point Man Ray bought a gun and vowed to kill Miller's new lover. "The men were expected to be very free sexually," wrote Eileen Agar, about her time among the Surrealist crowd in Paris in the thirties, "but when a woman like Lee Miller adopted the same attitude while living with Man Ray, the hypocritical upset was tremendous. . . . Double-standards seem to have proliferated, and the women came off worst."

After some initial coldness, Kiki and Miller were cordial whenever they saw each other around Montparnasse. "When [Kiki] realized I had moved in with [Man Ray], she was a little bit piqued," Miller told an interviewer. "Not that she hadn't already moved out, but it piqued her anyway! And she used to eye me and I used to eye her and finally I met her and we got along fine because I admired her very much. She was absolutely a gazelle, had an extraordinary complexion which you could put makeup [on] in any form, and she did, too."

Miller claimed to be the true author of certain shots attributed to Man Ray because of their informal working conditions, in which they shared materials and a small darkroom while casually exchanging ideas. Miller claimed, too, that she'd been the one to discover the process Man Ray called "Solarization." She told an interviewer she'd been scared when something, perhaps a mouse, brushed against her foot in the darkroom and had impulsively turned on the lights, while some negatives lay in their tanks, nearly finished developing. It created an eerie halo-like effect all around the outline of the body of model Suzy Solidor, shot against a black background. When asked later about

Solarization, Man Ray said that it had resulted from an accident, without mentioning Miller.

Between 1932 and 1934, as Man Ray obsessed over Miller, whose leaving him took him to the edge of suicide, he produced his single iconic painting, *À l'heure de l'observatoire—les amoureux* (Observatory Time—The Lovers), a kitschy rendering of giant lips levitating in a dreamscape sky above the trees of the Luxembourg Garden, the outline of the Paris Observatory seen in the distance. He first got the idea for an image of free-floating lips from Kiki's practice of kissing his white collar with her red lips before he went out for dinner with a female client. He'd started the painting while consulting a photograph of Kiki, using her lips as a guide. Six months into working on it, however, as he kept rounding Kiki's lips to try to make them look like an object that could actually float in the sky, somewhat like a flying saucer, he decided that Miller's lips would be the better model. He threw out the original and started again. The finished work, a massive three-by-eight-foot canvas, can be seen as an abstracted portrait of both women.

ARTISTS WHO'D ONCE DELIGHTED IN having Kiki pose for them stopped hiring her. Or she decided to retire from posing. Neither Foujita, Kisling, nor Krohg painted her after the end of the 1920s. Calder did a second wire sculpture of her in 1930 but never worked with her again. In 1934 the Spanish sculptor Pablo Gargallo, in his first and last time working with Kiki, fashioned a whimsical semiabstract rendering of her head in gilt bronze.

Man Ray photographed Kiki a few times in the early 1930s, most often with her seated alongside Laroque. The shots were likely produced as favors to Kiki, since most of them look like publicity stills. In one photograph from 1933, they pose against a bare wall, maybe in their apartment, seated close together, facing each other, André in an overcoat, collar turned up, his hair brilliantined and parted, Kiki in an extravagant fur-trimmed coat and a black beret worn at an angle to

show off her curled hairdo. Neither looks at the other. Laroque looks down, his heavy eyelids hiding his eyes so that he looks tired, resigned. Kiki, her head turned away from André, looks straight into the camera, with a slight smile, as though she and the camera are sharing some secret about the man seated across from her. This was likely the last picture Man Ray ever took of Kiki.

The offers for film roles slowed down alongside those for her to pose. In late 1929 the director Anders Wilhelm Sandberg heard Kiki singing at Le Boeuf sur le Toit and decided he needed her in his next project, *Capitaine jaune,* a film about a sailor who goes on the lam after being falsely accused of murder. Kiki appears as a singer in a seaside dive in Marseille. She described the shoot to an interviewer: "You know how it goes: a shady bar, sailors, a few punches, a big drama." She said that she'd never liked doing "loves scenes" in films, but that "in this one I get to seduce some sailors. We flirt, we yell at each other. . . . That's the kind of scene I like! You know I like when things get a bit vulgar." Sandberg's film came out after some delay in 1931 and closed after screening for a week at Paris's Gaumont-Palace.

In 1933 Kiki played the leader of a gang in a women's prison, in Anatole Litvak's *Cette vieille canaille.* In her one scene, a young carnival worker wrongly accused of stealing gets put into a cell where Kiki and her followers are waiting. They initiate the new inmate by giving her spankings until a prison guard hears her screams and takes her away. Kiki gives the guard an earful as he leaves, cheered on by her gang. This was her final appearance in a moving picture.

FOR KIKI, the one constant in the 1930s was performing on stage. She continued to sing in Paris throughout the decade, often at the Jungle, a nightclub catering to tourists, which opened in the late 1920s. She sang there backed by a full jazz orchestra. The atmosphere was a world apart from the intimacy and looseness of the Jockey. She also played regularly at the Concert Mayol, a glitzy cabaret specializing in nude reviews. Built on a former convent in the tenth arrondisse-

ment on the Right Bank, it was likely the largest venue in which Kiki ever sang. She appeared there as an interlude, performing what was billed as a set of "sailor's shanties," in between acts of *Parade du nu,* the club's nude review. She sometimes traveled down to Saint-Tropez to play for the resort crowd at a club called Jeanne Duc's, in a duet with a male singer who went by Jamblan. She kept singing at Le Boeuf sur le Toit and at a place named Gypsy's and another called the Océanic. Most often and most regularly, she appeared at the Cabaret des Fleurs, accompanied by Laroque, holding his accordion on his lap and looking up at her face to follow her cues.

While living with Laroque, Kiki also enjoyed a relationship with a young dancer, Marguerite Bullier, who went by the stage name Margot Vega. They met one night in 1935 when both performed at the Cabaret des Fleurs. Vega, then twenty-two, was twelve years younger than Kiki and had also grown up in Burgundy, also without a father. Margot's husband had the idea for the two women to perform as a duo. They called themselves Les Vega Sisters, using the English word, and had a few shows with Kiki dyeing her hair blond to match Margot's.

Among those who saw the duo during their brief time together was Anaïs Nin, who wrote in her journal in August 1935 of a "frivolous" night out with friends from New York: "Bright lights, savory dinner at Maxim's, Cabaret aux Fleurs to watch Kiki, but it was not Kiki who seemed attractive to me, Kiki with her bangs and short tight skirt, but her aide-de-camp, a woman so humorous and alive she vivified the entire place." When Nin went to tell Margot she was "wonderful," Margot answered only by asking Nin to make sure to tell the owner, who was in the corner counting money, which Nin did.

IN JANUARY 1937 Kiki published a revelatory piece in *Confessions,* a French magazine that invited well-known personalities to write about their lives. Here Kiki finally described her professional and romantic relationship with Man Ray with the candor she avoided in her memoir, if still sparingly.

She knew early on that Man Ray would become a great artist, but only as a photographer, and only because of her contributions, she wrote. "He made his best photos with me, he understood my body, my type. In the end, me, the model—I was the one who gave him his genius." She blamed herself for making their relationship so "full of drama," since she "loved the good life too much." Man Ray rarely went to watch her at the Jockey since he was "always upset about this one or that one with whom I was amusing myself." She claimed that during one jealous rage, he chased her from their studio into the street with a revolver. She often threatened to leave him during their years together, but she always went back. "I had him under my skin. I would promise him I'd quit fooling around . . . and then the next day I'd be back at the Jockey and the down-and-out life would continue." With Man Ray, she wrote, it was "a great passion. He had no time for sentimentality. He was a real man."

She wrote that she regretted nothing about their time together. "The point was that we were free to choose who we wanted. We were liberated women. We invented the concept, and what's more, without even knowing we were doing it."

Kiki ended her confession: "They turned me into an image: 'Kiki.' And I was obligated to live up to it, even when I didn't feel like it. Because it wouldn't be Montparnasse without Kiki. I'm part of the scenery."

IN THE SUMMER OF 1937, some nightclub owners hired Kiki to run a club on rue Vavin, which they named Le Babel, a nod to the world's fair then taking place on the grounds around the Eiffel Tower on both sides of the Seine. Everyone called the place Chez Kiki. Along with managing the club, she also presided nightly in the role of impresario with long silk gloves, slender cigarette holder, feather boa, and slicked-back hair. She performed every night—technically morning, as she went on stage around two or three—often with Laroque on accordion. The place was popular but lost money since no one involved

was especially good at running a business or keeping books. Chez Kiki closed less than a year after it opened.

As Kiki became more deeply entrenched in the nightclub scene, her cocaine consumption increased, and she occasionally used heroin. Her relationship with Thérèse Treize, by then known as Thérèse Cano de Castro, having married the Cuban artist Manuel Cano de Castro, became strained, though they remained close. "When Kiki took up with Laroque, she frequented another world," Thérèse told an interviewer. "But with Broca and before Broca, with Man Ray, they were wonderful the friends of Kiki. . . . It was a chosen world."

Meanwhile she was working too hard for too little pay. Today, a century later, the narrative has become a cliché: after a brief, exuberant period of brilliance in which a young star seems to be channeling every new move of the culture in real time, she flames out in tandem with the passing of her era, dulling her talents and ruining her looks with her vices as she coasts on the goodwill of audiences attracted by the intertwined appeals of remembering brighter days and bearing witness to her present romantic decay. Laroque, Thérèse, and Desnos urged Kiki many times to undergo a rehabilitation program for her drug addiction. She completed one program in the fall of 1936 but soon afterward suffered a relapse.

In 1938, after her friends again pushed her to quit drinking and drugs, Kiki agreed to undergo what she described as a "detoxification cure." Laroque told people she was away in Châtillon-sur-Seine. When she was released from the clinic after eight days, Laroque forbade her to perform or take on any other kind of work, despite the strain it put on their finances, at least until he was sure she'd gotten better. He also cut her off from seeing Margot, whom Kiki had introduced to drugs and was now a regular user.

To give herself something to focus on during her convalescence, Kiki returned to her memoir. She made changes to the original manuscript and then added new material, taking comfort in returning to her heyday. She would have commiserated with the character of Tania, played by Fréhel in the 1937 gangster film *Pépé le Moko,* who, when

the titular Pépé (Jean Gabin) complains that he sometimes gets so low he could kill himself, answers, "Me, when I get the blues, I change eras!" Winding a gramophone to play a song dating from when she'd sold out music halls, Tania loses herself in her memories: "I'd get up on stage . . . the red spotlight shining in my pale face—and I'd sing!"

Every day during her recovery, Kiki would dictate a few paragraphs to Laroque, who typed them out on a typewriter he'd pilfered from the tax bureau. She returned to her childhood, adding vignettes about her trips out to the dump and the pub with her godfather, and about the village rumors about her half-sister, as well as more details about her grandmother.

While retaining nearly all the same events discussed in her original book, Kiki changed nearly every single sentence of the manuscript in some way, and her words struck a different tone. She still had the power to unleash some choice turns of phrase: she described how as a girl at the pub, she would "lick the ass of every glass" to get as much of the leftover alcohol as possible, and she titled her chapter on her biological father "A Bastard's Memories of Her Father." But revisiting her memories from the vantage point of her late thirties, when as with Fréhel "the red spotlight" was no longer shining in her face as often as it had before, Kiki's prose reads as more wounded and rueful than in the original.

And she was more open to conflicting interpretations. She repeated a scene from the original version, of her mother telling her, "You were born with dirt in your ass, and a dirt-ass you'll remain." But now she added her rejoinder: "I'm not ashamed of that dirt. I think if the dirt ever came off of me it would take the rest of me with it." She also added a difficult scene describing how she had helped her grandfather as he died, when she was nine, wiping the saliva from his beard as he told her he was "going on a great journey." She slept with her cousins, her aunt and her grandmother all crowded into a little alcove, their feet spilling onto her grandfather's deathbed. She admitted that she had few memories of him "other than of his agony." And in another section, after assessing her mother's failures as a parent, she concluded that "in the

236 KIKI MAN RAY

end, my faults are my own. I'm the only guilty party. I don't risk con-
taminating others, or letting others contaminate me."

She also made an intriguing editorial decision. For this new ver-
sion, she completely excised the short chapter she'd written about Man
Ray. In its place, she left a few of the photographed portraits they'd
made together, collected without any commentary under the heading
"Man Ray."

She wrote little about the years between the publication of her first
memoir and this revision. Mostly she praised Laroque. "I've had a love
for six years!" she wrote. "He gave me the courage to get sober. That
was the most horrible time, but also the most hopeful."

Kiki completed a final draft of her revised memoirs by the end of
1938. It closes:

> Little by little, I've regained my taste for life, regained my strength.
> We're not rich, but my love forbids me from working, from return-
> ing to the place that nearly buried me, until I'm *certain* I can resist
> the temptation. And now I'm happy, lighthearted, and regaining
> my strength. I live, I breathe, I believe in the future. I have a lover
> who loves me, who I love, and we're happy. All goes well.
>
> KIKI

Early in 1939, with André's encouragement, she returned to per-
forming, at Le Boeuf sur le Toit, which led to a minor professional
triumph. In May she and André signed a record contract with Polydor
and were paid a modest advance. That July Polydor released a record-
ing of "*Les trois marins de Groix*," a sailor ballad she and Laroque per-
formed, likely recorded in late 1938 or early 1939, with another ballad
as a B-side. "*Les trois marins de Groix*" was an old Breton song, telling
the stories of three sailors trying to get home in a storm. One of the
three is pulled overboard by the winds and swept away by the waves,
never to see his wife and child again. Kiki's voice is plaintive, tremu-
lous, the song as melancholy in sound as in content. Laroque's accor-
dion is steady. The production is spare, the atmosphere in the studio

arid, microphones placed closely to singer and the instrument with little added reverberation to make the room sound bigger.

It's surprising that Kiki had made no recordings earlier in her career. In 1929, people in France bought more than ten million records. Had no one thought that a record by Kiki, who was then appearing so frequently in the papers, could have counted among them? Perhaps the professionals with the expertise and money to make such decisions anticipated that her appeal wouldn't translate outside the nightclub environment, that her performances would struggle to find an audience if divorced from their visual components. And yet Kiki and André's first record sold well enough that Polydor asked them to make another.

By the fall of 1939, Laroque had been conscripted to the French army, and Kiki was back on cocaine. Meanwhile many of the clubs in which she sang were shutting down as the country mobilized for war. Kiki was arrested for possession of intoxicants that winter. She was kept for two weeks in the psychiatric ward of Paris's massive Pitié-Salpêtrière hospital and avoided a prison sentence, in a then-typical handling of minor drug cases, as drug addiction was considered an illness.

Polydor released a final Kiki and André recording sometime in 1940, before the German occupation, recorded while André was on leave. By that time, however, Kiki was no longer as closely in sync with the spirit of her times as she'd once been. Her detached style, almost passive, didn't fit those violent, frightening years in the way the expressive, high drama of Edith Piaf did so well. Piaf would later say that in her early years she felt intimidated by Kiki's brilliance, and that she was lucky to no longer have her as a true competitor by the time she was making her own way on Parisian stages in the second half of the 1930s.

MAN RAY REMAINED IN PARIS throughout the thirties, as Hemingway, the Fitzgeralds, the Murphys, and other Left Bank American

expatriates returned home. They'd never held much attraction for him in any case. He made empty promises to his family that he would return to New York. He asked often after his niece, Naomi, daughter of his favorite sister Elsie, promising he would teach her photography. But at the same time, he was advising America-bound friends such as André Kertesz that they were ruining themselves by going there, that the country was the worst possible place for an artist to develop. In 1935 his troubled younger brother Samuel, a failed poet who suffered multiple breakdowns after losing his job as an assistant to an importer, died at forty-two; Man Ray didn't make the trip for the funeral.

"He's a genius and he's living in Paris, and we never see him anymore," his mother answered a friend who'd told her she'd liked some of his pictures she'd seen in *The New York Times*. At one point, Man Ray's siblings were shocked to learn that the famous and seemingly successful genius in Paris was still asking his parents to wire him money. Because of the Depression, some of them had been forced to move back in with Max and Minnie, while Max, who'd gone gaunt and gray, kept working into his old age.

Man Ray, meanwhile, held the exclusive contract to photograph the Paris spring shows for *Harper's Bazaar* and was having expensive suits cut in the minimalist splendor of the Adolf Loos–designed Knize haberdashery on the Champs-Élysées. He took little joy in his fashion photography and continued to complain about being pigeonholed in the medium at which he so clearly excelled, his comments about his photography work verging on self-hatred. He could fill any "respectable" New York gallery with his paintings, he wrote to Elsie, "but these one-track minded Americans" refused to see him as anything other than a photographer.

He did make one brief stateside trip for a few weeks in the winter of 1936, when Alfred Barr, director of the Museum of Modern Art, launched a show, "Fantastic Art, Dada, and Surrealism," featuring, alongside some of Man Ray's photographs and his massive lips painting, roughly seventeen hundred pieces from different artists, many of whom had worked alongside him and Kiki in Paris. Man Ray arrived

in New York for the opening of its three-month run, already a famous figure in the city and beyond, followed by reporters for the dailies, featured in *The New Yorker*'s "Talk of the Town" section, and seeing his photograph of Salvador Dalí gracing the cover of *Time*. Barr chose a Rayograph for the cover of the show catalog.

In July 1940 Man Ray left Paris amid the fall of the French Republic, one of roughly eight million people the war would displace that summer. Regardless of whatever he might have privately thought about his Jewish identity, he was Jewish in the eyes of the Reich and the collaborators of Vichy France. Amid the chaos, scrambling to place artworks safely with dealers and acquaintances and selling off whatever photo equipment he could, he made two visits in Paris to say goodbye: first to the Italian sculptor Alberto Giacometti, and second to Kiki.

He left with two cameras around his neck and two small suitcases packed with some Rayographs, a few small paintings, and a Picasso etching, *Minotauromachy,* which he would sell as soon as he reached New York to cover his travel costs. Leaving Europe meant parting from his most recent companion, the twenty-five-year-old Guadeloupean model and dancer Adrienne (Ady) Fidelin, who posed often for Man Ray in photographs, paintings, and illustrations, as well as modeling for Picasso and for Lee Miller. (In September 1937 Fidelin had become the first Black model to be featured in a major North American fashion magazine when *Harper's Bazaar* ran Man Ray's portrait of her as a full page in a photo-story tied to a Parisian gallery show displaying headdresses from the Belgian Congo.) Fidelin remained in France to care for family members. With other friends, she helped to keep several of Man Ray's works safe during the war.

Man Ray reached Lisbon, after difficulties with German officers at the Spanish border, and sailed on August 6, sleeping, like many others, on mattresses that had been laid out in the ship's library. Among the thousands on board, he found his friends Virgil Thomson, Gala and Salvador Dalí, and René Clair. Their ship docked in Hoboken ten days later. Man Ray was just shy of his fiftieth birthday, exhausted, somewhat jowly.

In the fall of 1940 he took a trip to Los Angeles, where he fell in love with Juliet Browner, a twenty-eight-year-old dancer and model who also played the violin. They moved into a split-level apartment in Hollywood, similar in layout to the Campagne-Première apartment he'd shared with Kiki. He draped *Tapestry* from the railing. "California is a beautiful prison," he wrote to his sister.

Man Ray and Juliet were wed in the fall of 1946 in a double ceremony with the artists Max Ernst and Dorothea Tanning in Beverly Hills. Juliet afterward went by Juliet Man Ray. In March 1951 the couple sailed from New York bound for Paris. Duchamp, who'd again settled in New York, came aboard their ship to see them off.

In Paris they moved into a high-ceilinged garage-like studio on rue Férou between the Saint-Sulpice church and the northern end of the Luxembourg Garden. Man Ray decorated the studio almost exclusively with his own artworks.

KIKI'S NAME POPS UP RARELY in the 1940s, most often in the back pages of newspapers advertising an appearance at some local dive, and in the sad reminiscences of writers who knew her in her prime. There is evidence pointing to Kiki living in the Loire valley with a plumber between 1941 and 1944. About Kiki's experience of the Second World War, all we know for certain is that she survived.

Many people whom Kiki knew did not. They fell as victims to a man of their same generation, born a year earlier than Man Ray, and who, like many people in Kiki and Man Ray's circle, spent the 1920s as a misfit, an aspiring artist who never went to college and felt uneasy about mainstream society, as convinced of his own special genius as anyone in Montparnasse. To Hitler, the Quarter represented everything he would weaponize to commit his evil: disorder, transience, internationalism, cosmopolitanism, nonconformism, modern art and modern thought, the mingling of races, the opening of minds, the free questioning and critiquing of tradition, authority, and religious dogma.

Hitler and his legion of willing collaborators claimed the lives of, among so many others: Robert Desnos, arrested in 1944 for his Resistance activities, deported to Buchenwald and finally to Theresienstadt, where he died from typhus; Samuel "the Cowboy" Granowsky, arrested by French police during the Vél' d'Hiv roundup of July 17, 1942, interned at Drancy, deported to Auschwitz, and murdered by the Nazis that same year; and Claude Mendjizky, son of Maurice and active in the Resistance, tortured and then killed by the Nazis, days before the liberation of France.

LAROQUE AND KIKI RECONNECTED in Paris a few months after the end of the war. By that time Laroque had fallen in love with a woman named Flo Fontaine. He still did his best to care for Kiki, insisting on going in person to settle her bills in the neighborhood rather than giving her cash he knew she would spend on drugs or drink. But she found ways to escape his watch. In February 1946 French authorities imprisoned her for creating fake prescriptions for psychotropic substances. After waiting nearly a month in jail for trial, she was sentenced to two months suspended sentence.

That same year, forty-five-year-old Kiki described herself to her friend, the photographer Marc Vaux, as being in the "twilight" of her life. "I regret having had my tongue tied. Because I would've made a revolution," she scribbled in Vaux's notebook without specifying any further as to what she meant by having her tongue tied.

By the end of 1946, Laroque had asked Kiki to move in with him and Fontaine, despite Fontaine's threats to leave him if he did. The three of them lived together in the apartment on rue Bréa that Laroque and Kiki had once shared. Until the end of her life, Kiki would live in a small room upstairs from Laroque and Flo Fontaine, who later became Flo Fontaine-Laroque.

In the summer of 1947, Kiki made some of the Parisian newspapers when a woman named Marie-Thérèse Bonnet was sent to prison for setting up a fake laundry service and then selling the clothes that

people gave her. Throughout her arrest and charging, Bonnet insisted that she was Kiki de Montparnasse, the former cabaret star. She misled some reporters into believing her until Laroque wrote to several newspapers demanding justice for the true Kiki.

That year Kiki sang occasionally at a piano bar on rue Vavin called Chez Adrien, passing a plate around after her performances. By 1948 she'd lost all her teeth, a blow for anyone, but a loss that must have hit especially hard given how vital her feline smile had been to the singular charm of her face; two impeccable rows of bright, straight, deliciously pointed teeth, each one a miracle really, considering the state of orthodontics at the time and that Kiki had likely had no access to anything but the most rudimentary kind of dental work in her youth.

As people who'd been away started returning to Paris after the end of the Second World War, so did reports of Kiki sightings. Kay Boyle wrote to a friend in the late 1940s of seeing Kiki

> singing in various little night-clubs, and remembering nothing from one night to the next. Dope, I suppose. Every time we had a drink together she asked me about Mary [Reynolds, Marcel Duchamp's companion], and I told her in detail every time what had happened, and it never made any effect. Finally, one evening, I took off a pair of white earrings which Mary had left me (among little ornaments she knew I loved) and I put them on Kiki and told her I knew Mary would like for her to have them. Then tears came into her eyes, and she looked so bewildered, and had to sing a couple of dirty songs to get back in the groove again.

For a few summer days in 1950, Kiki garnered attention in Paris for the final time in her life. The weekly magazine *Ici Paris* published some of the revised chapters from her memoir. It's not clear how she connected with the magazine, but she or Laroque likely approached editors with the chapters, hoping to capitalize on the appetite for prewar nostalgia. *Ici Paris* serialized some of Kiki's short pieces across a few issues. They came with no introductory context and offered no

insight into what Kiki had been doing for the last twenty years. There was only Kiki as she was then, growing up rough in Châtillon-sur-Seine before the Great War and then charming her way to the center of Montparnasse's café society in its aftermath. She was fixed in the public memory—by those few who still remembered—in the few years of her own Belle Époque, now so quaint. Presumably she was thankful, after so long a silence, just to have the chance to tell her story, however brief, however old, and for pay. She returned to pick over the same scraps, to run, in the pages of a magazine, the same loop that must have played so often in her mind over the past two decades.

One of the most haunting portraits of Kiki's later life appeared that same year, when the English artist Ronald Searle, best known as the creator of the St. Trinian's School cartoons, and his then-wife, journalist Kaye Webb, drew and described Kiki as part of their *Paris Sketchbook,* a collection of recent impressions of the city. In Searle's line drawing of Kiki, who would then have been forty-eight or forty-nine, her hair is withered and her face ravaged and emaciated. She is recognizable as Kiki only by her pointy nose. Searle draws throughout the book in a realistic mode, leaving no reason to assume he exaggerated her decline.

The sketch in words is sadder still. It described Kiki wandering about "like a reproachful shadow through the streets and cafés where she was once so bright a star." Searle and Webb reported that they "discovered" her one night singing and dancing for odd francs at a piano bar filled with loudmouthed students and tourists who had no problem letting her know when she'd overstayed her welcome. "She was stumbling about the floor, holding onto a chair to do an arabesque, clumsily throwing her skirt over her face to display her orange silk knickers, making play with the jazz handkerchiefs slotted through her garters," they wrote. "Her audience looked disgusted or pitiful (depending on whether they had heard her story)." Kiki, they wrote, stopped in the middle of a song because some students were laughing at her. She "swore at them in *argot,* viciously and with gusto, so that they subsided red-faced. Then passionately, and very much out of

tune, she sang a traditional song of the streets, '*Les Moms de la Cloche*,' and silenced the room." Afterward she carefully smoothed the various twenty-franc notes she'd collected, gave a handful to her accompanist, and spent nearly all the rest on drinks for herself and the barman and anyone she recognized. Searle and Webb closed their piece on Kiki by recounting a story told to them by the Danish engraver and writer Lars Bo, who would then have been twenty-four or twenty-five: "One evening he was sitting in a café where she sang. Afterwards she came up to him and said 'you look hungry, son—come and have something to eat.' Lars *was* hungry and he went. She bought him a meal which cost all she had just earned."

One of Kiki's admirers from the twenties, the poet John Glassco, was shocked when he first saw Kiki in *Paris Sketchbook*. But then he admonished himself for being surprised by the wreckage of her life, which anyone with any sense could have foreseen a quarter-century earlier. He wrote:

Kiki was always a *savagesse* who didn't care what happened to her. It is terrible, to *us,* to compare her as she was in Modigliani's and Kisling's paintings and in Man Ray's photographs, with what she became.... But I don't think it bothered her at all. She always did just what she wanted. All she ever craved was fun, liquor and *attention:* she knew how fleeting all physical beauty is, above all her own. She used to say "Modi and [Kisling] have done me: what more can a tart want than that? I look at their pretty pictures and I think: *That's me, you know.* (Then the beautiful up-from-under look and the husky laugh). It's nice, eh?"

25

A WINTER AND A SPRING

WHEN THEY MET AGAIN, IN THE WINTER OF 1952, Kiki was carrying a bag filled with old clothes and orphaned shoes. Man Ray recognized her laugh, loud and guttural from across the room, before seeing her. She was so happy to see him she screamed and nearly knocked him over as she put her arms around him. He saw in her face the same "clean oval of former days," as he wrote, made up as always to be admired from a distance. They shared some red wine and he invited her to dinner, but she told a story about needing to deliver her package to a charity nearby before it closed.

She said she was still in the neighborhood, a few blocks from where they'd lived. She no longer painted. She told him she sang sometimes accompanied by her friend Laroque who worked at the tax office. He might have remembered shooting them together two decades earlier, brighter years, a cigarette dangling from Laroque's lip, an accordion resting on his meaty thighs.

She told him she was quite ill and was going to check herself into a hospital for treatment. Dropsy, she called it. He gave her some money. She came by his studio a few times, then disappeared. They felt no need to document their brief reunion. Or if they did we don't have the pictures.

ON MARCH 23, 1953, Kiki collapsed in front of the apartment on rue Bréa, in a small triangular patch of sidewalk shaded by empress trees. She fell by one of the dark green Wallace drinking fountains still found in public spaces across Paris, their domed peaks supported by four robed caryatids representing Kindness, Simplicity, Charity, and Sobriety, installed in the late-nineteenth century to help curb alcohol abuse by providing free potable water to the poor.

She died two hours after her collapse, at Laennec Hospital. Laroque said that in the days just before her death, she was as happy as she'd ever been. He and Kiki had just returned from a weekend at a friend's country house in northern France, playing cards on the porch and toasting the first day of spring, Kiki wrapped in an old sailor's jacket to keep warm.

MAN RAY READ ABOUT her funeral in a Paris newspaper. Some of her friends had taken up a collection for a procession through Montparnasse. He refused to attend, though he lived a fifteen-minute walk away. He hung up on journalists calling to ask for comments and editors looking for photos. He saw the shot of Kiki's catafalque where in gold lettering were listed the sites of her triumphs like Napoleon's battlefields: *La Rotonde. Le Jockey. Le Dôme.* He saw the shot of a white-haired Foujita laying flowers on her coffin; faithful Foujita who, accompanied by Laroque and Thérèse, escorted her body south of the city to the massive Thiais cemetery, where in the alabaster vaults of the Jardin de la Fraternité the penniless and unidentifiable may be buried without charge. Her friends were unable to raise enough money to see her buried in the Montparnasse cemetery, a hope she'd expressed while alive.

THAT JUNE *Life* magazine ran a three-page spread about Kiki, near the back of an issue boasting exclusive shots of "Hillary and Tenzing's Victory over Everest" and an interview with dancer Cyd Charisse. The

piece's lead photo was one of theirs: her face angled just short enough from a profile to hold its mystery, an earring falling perfectly down to the intersection of her chin and neck, her back turned to the camera and burned black with its f-holes by some paper, a blade, and light. Beneath the image an editor had added, "For Arty Picture by Avant-Garde Photographer Man Ray, Kiki Wore Two Musical Symbols."

Next came a gallery of portraits from many of the men who'd tried to capture her on paper, canvas, and film, each captioned as though to reveal some new facet of her identity. *Somber Kiki. Gay Kiki. Clownish Kiki. Flapper Kiki. Demure Kiki. Languid Kiki. Delicate Kiki. Tough Kiki.*

Life's memorial offered no words from its relentlessly quotable subject. After a cursory description of this "friend of tramps, prostitutes and stray cats, darling of poets and painters," the piece ended with a quote from an unnamed acquaintance, who said only, "We laughed, *mon Dieu,* how we laughed."

Epilogue

MEMORIES AND PHOTOGRAPHS

A FTER KIKI'S DEATH, LAROQUE TRIED FINDING A publisher for the revised version of her memoirs, which he still had carefully stored in the original envelope from 1938. He connected with André Breton's agent at one point, but they found no takers for the manuscript.

More than fifty years after Kiki's death, when a Parisian property changed hands, someone discovered among dozens of cardboard boxes one labeled "Infinitely Precious."

Inside was an envelope bearing the mark of the French tax bureau and an assertion in bold penciled letters:

de KiKi
Souvenirs
plus photos

Laroque (and Kiki when she was still living) apparently never discovered that three years before Kiki's death her original memoir had been publicly reissued without her permission.

In 1950 a New York huckster named Samuel Roth published a book titled *The Education of a French Model: Kiki's Memoirs.* It was a reproduction of the 1930 Titus edition, reprinted word for word,

complete with Hemingway's introduction. Referencing Titus's imprint At the Sign of the Black Mannikin, Roth invented his own, At the Sign of the Boar's Head. This was one among a revolving set of imprint names he used to keep a step ahead of postal inspectors looking to charge him for various obscenity-related infractions. (Titles in Roth's catalogs around this time: *American Aphrodite; Her Candle Burns Hot; I Was Hitler's Doctor.*) He'd been subject to police raids ever since publishing unauthorized excerpts from Joyce's *Ulysses* in America in 1927, making him the subject of an international protest.

By the time Roth put out *The Education of a French Model,* he was a pariah of the New York publishing world, with a few prison stints in his past. He felt safe publishing the book because he knew the authorities had confiscated the original shipment of *Kiki's Memoirs* twenty years earlier, meaning her writing never received a proper American copyright. (Hemingway and Titus had, however, made sure that Hemingway's introduction did receive an American copyright, so its inclusion in the bootlegged version was a bolder risk).

The Education of a French Model's saucy cover teased that inside "Kiki tells ALL, including an attempt on the virtue of her grandmother by an American soldier." Savvy readers would have known the words "French Model" promised titillation, with "French" a winking code for any kind of arty erotica. The book did feature a few images of nude women, with no connection to Kiki, though they were captioned as being some of Kiki's friends.

Roth published a softcover fifty-cent edition of *The Education of a French Model* in 1955, shortly before being charged with twenty-six counts of obscenity relating to other publications, resulting in a five-year sentence in federal prison. As with the previous edition, the cover illustration looks nothing like Kiki. The jacket copy now adds the false claim that she started posing nude at the age of twelve. And in this edition Roth included an additional ten chapters. They were introduced as having been written by Kiki as the sequel to her original

memoirs, though in truth Roth invented them out of nothing. And they're bizarre. In the new chapters, Kiki contemplates suicide along the Seine before befriending a talking fish, then travels with the fish to New York, more than a quarter-century after her original visit, where she meets Hemingway, the Radio City Rockettes (one of whom marries the talking fish), and Samuel Roth himself.

Roth lived into his eighties. Having arrived on New York's Lower East Side as a four-year-old Galician immigrant, he sold enough copies of titles like *The Education of a French Model* over the decades to retire in a comfortable, book-lined apartment on Central Park West.

IN 1971 Helen Faden, daughter of Man Ray's brother Sam, went to Paris to seek out the uncle she'd last seen half a century earlier, when she was a child and he a young man about to sail for Europe for the first time. Faden found Man Ray frail, his back bent from scoliosis, and initially as cold as his cavernous studio. As they talked, seated across from each other uncomfortably on a couch, he made her promise to never tell journalists about "any family history." She'd brought some pictures of their relatives. What finally drew them together was when she showed him a scratchy print of a photograph, the studio stamp beneath the image announcing in the natty cursive of another era: *Goodman, 191 Broadway B'lyn, N.Y.*

The photo was of Emmanuel Radnitzky, aged thirteen, standing proudly in his woolen bar mitzvah suit, the bottom half of the suit not of full pants but knickerbockers, his left arm pressed to his hip so that the elbow flares out to best display his prayer shawl, the fringes falling to his thighs, his right hand gripping a *siddur,* the Jewish book of prayer, or a reasonable stand-in. He wears a defiant look, betrayed somewhat by the mischief around the edges of his dark eyes, his face carefully lit so that its right half is shadowed and its left exposed to the light, perfectly bisected between darkness and light.

Man Ray grabbed the photograph from his niece's hands and then hugged her tightly, their first touch since the formal handshake with which he'd welcomed her. "This is so nostalgic!" he told her, and said that he would like to keep it. In return he gave her another picture made long before, and also loaded with meaning. A photograph (we don't know which one) of Kiki.

Closing his chapter on Kiki in his memoir, *Self Portrait,* Man Ray wrote, "I have resented the death of many friends: not blaming the inhumanity of society so much—in many cases it was mainly the individual's fault—as feeling that the departure of a being who had been close to me was a sort of evasion, a betrayal." This is among the least guarded statements about another person Man Ray made in his book, one in which by his own admission he was "the only one in it who is sharp; everyone else is out of focus."

After Man Ray's death in November 1976, a photo of his and Juliet's studio showed a sculpted likeness of Kiki hanging on one wall, presumably crafted by Man Ray. After Juliet's death in 1991, archivists found, neatly stored among Man Ray's archives, clippings from Kiki's 1927 gallery debut and an inscribed copy of the Titus edition of *Kiki's Memoirs.*

Man Ray and Juliet Man Ray lie in the Montparnasse cemetery, not far from the grave of Samuel Beckett, with the tombs of Baudelaire, Brancusi, Desnos, Simone de Beauvoir, Jean-Paul Sartre, and other luminaries close by. Man Ray's grave was vandalized in 2019, motivations unclear, though anti-Semitism is suspected.

Kiki's grave in the Thiais paupers' vault was vacated in February 1974. In Châtillon-sur-Seine, a plaque commemorates her life, marking the house in which she was born (actually a reconstructed version of the original structure, destroyed in World War II). The town also boasts the Kiki de Montparnasse performance space and park, which houses a local theater group. And since 2015, at the southern edge of the fourteenth arrondissement in Paris, an area that could generously be called Outer Montparnasse, there is a 112-room retirement home

run by the city's social welfare center: Résidence Alice Prin, *dite* Kiki de Montparnasse.

"KIKI DOMINATED THAT ERA [from 1919 to 1929] of Montparnasse more than Queen Victoria ever dominated the Victorian era." This according to Hemingway in *Kiki's Memoirs*. While he may have been exaggerating the extent of her reach to make his point, it wasn't by much. Kiki did hold a kind of sovereignty. So long as she could find some way to eat and had a place to sleep, she bowed to no power greater than her own desires.

But Hemingway's "dominated" is the wrong word for what Kiki did in Montparnasse. Too forceful. "Experienced" hits closer to the mark. For a few years after the First World War, Kiki experienced her time in Montparnasse as intensely as anyone whose life unfolded alongside hers. She paid attention to everyone and everything around her, watching closely, listening carefully, and then tried to communicate some of what she'd learned through her writing, her posing, her acting, her drawing and painting, and through her performing on the cabaret stage.

And as she experienced her era and channeled that experience into her art, Kiki shared drinks and cigarettes and ideas with many of the people who would shape how their century saw and thought and spoke: Modigliani, Stein, Picasso, Barnes, Matisse, Guggenheim, Calder, Duchamp, Breton, Cocteau, Flanner, Hemingway. And Man Ray, whose emergence as a modern artist must be understood as intimately linked to her own.

Kiki didn't dominate any of these people. But she did influence them, as they influenced her. Evolving in concert with them, watching them become who they were, challenging them and joking with them, working with them and through them, Kiki, too, played her role in shaping the cultural history of the past hundred years.

Kiki as much as anyone in her circle anticipated our moment by

embracing the Wildean idea of treating her life as an ongoing work of art, and by going further than Oscar Wilde himself in turning her daily problems and pleasures and those of her friends into an interconnected and ongoing story to be consumed across several media. With her confessional writing, her paintings and drawings, her performances on stages and screens and in coverage by the mass press, in her audio recordings, and in posing for so many portraits, Kiki, without knowing it, helped to invent the idea that you could present several heightened and more colorful versions of yourself as a single, coherent piece of entertainment. She presented herself how she wanted, when she wanted, and in whatever forum she felt like. Kiki was a reality star for surreal times. She didn't dominate an era. She created her own era, on her own schedule.

Kiki undoubtedly functioned as Man Ray's muse in a traditional sense. She inspired his work through her physical presence, her erotic charms, her joyfulness, and her mental quickness, and because through their mutual attraction and romantic engagement, she let him escape for short bursts of time from the jail of himself. Though Man Ray was not a great photographer of Paris, he was the greatest photographer of one particular *parisienne*, by way of Châtillon-sur-Seine. But if Kiki functioned as a muse to Man Ray, could it also have been because he saw her as a rival, someone who sparked his creativity chiefly by provoking professional jealousy? Perhaps Man Ray, despite his dismissive statements to the contrary, did in truth recognize that Kiki's experiments, in their various forms, were as unexpected and innovative as any of his. And that while he often spoke of the need for total liberty in his art, he on some level recognized that Kiki, because she was less concerned with money and reputation, was the artist among the two of them who was truly free.

Perhaps Man Ray in some way served as one of Kiki's muses as well. Perhaps the "drama" of their relationship, as she put it, helped fuel her desire to create new art. Perhaps watching what he did behind cameras and in the studio and darkroom, seeing how he told his stories through

the manipulation of light, shadow, form, and movement, informed how Kiki thought about her painting, performing, and writing.

The traces of Kiki that have accrued over the past century don't amount to much. That she was a woman partly accounts for her relative erasure from the history of modern art. But she also remains underappreciated because so little of her creative output ever existed as products to be bought or sold. Aside from a few dozen paintings, her short book in its original and revised forms, some film performances adding up to less than an hour of footage, a few vinyl recordings amounting to less than half an hour, and the representations of her likeness by other artists, all we have to go on are memories and speculations. Kiki's best work was her most ephemeral.

A perfectly timed pause that makes everyone in a nightclub go still in uneasy anticipation isn't something you can trademark and bottle. You can't sell a dance at auction. You can't sell a pose.

You can, however, sell a photographer's recording of a pose. In 2017 Christie's Paris sold a print of the 1926 work *Noire et blanche,* attributed to Man Ray, showing an unnamed young woman with closed eyes holding a mask from the Ivory Coast, for more than $3 million, the highest price ever paid at auction for an early twentieth-century photograph.

ACKNOWLEDGMENTS

I'M GRATEFUL FOR THE GENEROUS SUPPORT AND IDEALLY-timed encouragement that came from the American Library in Paris and the de Groot Foundation, the BC Arts Council, the Canada Council for the Arts, and the Robert B. Silvers Foundation.

Thank you to the staffs of the Bibliothèque historique de la ville de Paris, the Bibliothèque nationale de France, the Centre Pompidou, the University of British Columbia and Stanford University libraries, the Vancouver Public Library, and the New York Public Library. I'm indebted to Billy Kluver and Julie Martin's work on Kiki and to Neil Baldwin's on Man Ray. Thank you to the many friends, mentors, and students at UBC, NYU, USC, Stanford, and in Paris who helped to shape my understanding of the City of Light.

Eternal gratitude to Vanessa Agard-Jones, Daniela Bleichmar, Audrey Chapuis, JP Daughton, Dan Edelstein, Matt Fox-Amato, Karen Halttunen, Deb Harkness, Bertrand Hogg, Chris Friedrichs, Pico Iyer, the late Dominique Kalifa, Linda Lichter, Julie Martin, Patricia Mendjisky, Francis Naumann, Mark Roefler, Lucy Sante, Vanessa Schwartz, Jerrold Seigel, Ken Silver, Amanda and Zack Silverman, Nancy Troy, Artur Winiarski, and Tobias Wolff. And to Ayelet, Daylan, Eleanor, Jeremy, Jon, and Poppy.

Thank you to Laura Braude, Kate Fox-Amato, and Alice McCrum for reading and commenting on early versions of the manuscript.

Special thanks to Ingsu Liu, Meredith McGinnis, Gabrielle Nugent, Huneeya Siddiqui, and everyone at W. W. Norton; to Kate Craigie and everyone at Two Roads; to Kimberly Burns; and to Erin Files, Chelsey Heller, David Kuhn, Allison Warren, and everyone at Aevitas.

Amy Cherry and Becky Sweren: without you there would be no book.

Laura, Lucinda, and Eloise: without you there would be no point.

NOTES

Sources for quotations, as well as explanatory notes, are listed as numbered endnotes below. A general list of works used for each chapter follows these endnotes, on a chapter-by-chapter basis.

ABBREVIATIONS

BMR Baldwin, Neil. *Man Ray, American Artist* (Clarkson Potter, 1988).

KMK Billy Kluver and Julie Martin, *Kiki's Paris: Artists and Lovers, 1900–1930* (Harry N. Abrams, 1989).

KS Kiki de Montparnasse, *Kiki Souvenirs,* introduction and commentary by Billy Kluver and Julie Martin (Hazan, 1996).

KSR Kiki de Montparnasse, *Souvenirs retrouvés* (Jose Corti, 2005).

MRSP Man Ray, *Self Portrait* (Little, Brown, 1963).

PROLOGUE: THE JOCKEY, SUMMER 1925, EVENING

2 **"A beautiful animal":** Thora Dardel in KMK, 154.
3 **"Every girl from Camaret":** Kiki in KMK, 230, translation my own.

ADDITIONAL SOURCES

Calhoun, Don. "The Latin Quarter's Famous Kiki Writes Her Memoirs." *St. Louis Dispatch,* February 8, 1931; Egger, Anne. *Robert Desnos.* Fayard, 2007, vii; Kohner, Frederick. *Kiki of Montparnasse.* Cassell, 1968, 27–49; KSR, 219–30, 294–97; Lagarde, Pierre. "Paris en liberté: en écoutant Kiki de Montparnasse parmi les marguerites du Cabaret des Fleurs." *Comoedia,* June 25, 1936; Liaut, Jean-Noel. *Madeleine Castaing: mécène à Montparnasse, décoratrice à Saint-Germain-des-Prés.* Payot, 2008, 36; MRSP, 149. Sound Recordings: Montparnasse, Kiki de. "La boucle retrouvée." EPM Musique, 2011; Montparnasse, Kiki de, with André Laroque.

"La volerie / Sur les marches du Palais." Polydor 524502, 1939, and "Les marins de Groix / Le retour du Marin." Polydor 524503, 1939; George, Yvonne. *Kiki de Montparnasse. 1925–1940.* Disques Chansophone, 1991.

1. OLD SONGS SUNG FROM A MARBLE TABLETOP

5 **"fortune dictated":** KSR, 20.
6 **All of them:** The town of Châtillon-sur-Seine commemorates Alice Prin's being born at 9, rue de la Cygne, which was destroyed during World War II and later rebuilt. My research points to her being born at 9, rue de la Cygne but growing up at her grandmother's house on rue de la Charme.
6 **"You wouldn't believe":** KSR, 37.
7 **"Grandmother often screamed":** KS, 185.
7 **"one was just":** KS, 187.
8 **"just like the others":** KS, 190.
8 **"playing Alice":** KS, 183.
9 **"I know how":** KS, 71.
10 **"a feeling between":** KSR, 57.
12 **"never see one":** KS, 83.
12 **"Two or three":** KS, 84.
12 **"small, stocky, and mean-looking":** KS, 86.
12 **"I wanted to run":** KS, 83.
12 **"little tart":** KS, 87.
13 **"shivering as much":** KSR, 78.
13 **"My first contact":** KS, 87.
14 **"miserable whore":** KS, 88.
15 **"made me think":** KS, 94.
15 **"no longer had any":** KSR, 102.
16 **"Life was beautiful":** KSR, 102.
16 **"He beat me":** KS, 95.
16 **"It made me happy":** KS, 105.
17 **"problem of the nerves":** KS, 120.
17 **"didn't have the courage ":** Kiki in Guy de la Brosse, "Ateliers et Académies," *Paris-soir,* July 12, 1929.
18 **"the navel":** Henry Miller in Dominique Kalifa, *The Belle Époque,* trans. Susan Emanuel (Columbia University Press, 2021), 33.
19 *Azoy gliklich wi a yid:* Ghez Collection Catalog, University of Haifa, 2019.
20 **Places like Montparnasse:** See Jerrold Seigel, *Bohemian Paris: Culture, Politics, and the Boundaries of Bourgeois Life, 1830–1930* (Viking, 1986).
21 **"international patriotism":** Jean Cocteau, *My Contemporaries* (Chilton Book Company, 1968), 78.
22 **"I like all":** Gertrude Stein in Diana Souhami, *No Modernism Without Lesbians* (Head of Zeus, 2020), 295.
22 **"the first really international":** Marcel Duchamp in Kenneth Wayne, *Modigliani and the Artists of Montparnasse* (Harry N. Abrams, 2002), 16.
22 **"good business":** Victor Libion in Gustave Fuss-Amoré and Maurice des Ombiaux, *Montparnasse* (Albin Michel, 1925), 114–15.
23 **"I would have put":** KSR, 134.
23 **"I'm not a great":** KSR, 145.
24 **"For god's sake":** KS, 206.
24 **"When you went":** KSR, 136.
25 **"sad, desperate":** KSR, 155.

25 **a fairly common nickname:** Thank you to Lucy Sante for sharing her thoughts with me on possible origins for Kiki as a nickname.
26 **"true love":** KSR, 166.
26 **"Tell me, Papa":** KSR, 143.
26 **"syphilitic old bitch":** KMK, 96.
27 **"pure painter":** Jean Cocteau in Joseph Kessel, *Kisling,* ed. Jean Kisling (Harry N. Abrams, 1971), 20.
27 **"charged with a profound":** Antonin Artaud in Kessel, *Kisling,* 20.
28 **"I can say":** KSR, 101.
28 **"What do you think":** *Paris Journal,* March 28, 1924.
29 **"treated to an":** KS, 128–29.
29 **"unsettled me":** KS, 112.
29 **"a man's hat":** KS, 112.
30 **"His shouts":** KS, 116.
30 **"The painters":** KS, 211.
31 **"I get five":** KS, 122.

ADDITIONAL SOURCES

Tables décennales des actes de naissances, mariages et décès, État civil de la Côte-d'Or, Châtillon-sur-Seine, 1893–1902, and 1903–1932: FRAD0213E161/015 and FRAD0213E161/016, Archives départementales de la Côte d'Or; Bainbridge, John. *Another Way of Living.* Holt, Rinehart, & Winston, 1968; Balas, Edith, ed. *Joseph Csáky: A Pioneer of Modern Sculpture.* American Philosophical Society, 1998, 171–72; Blower, Brooke L. *Becoming Americans in Paris: Transatlantic Politics and Culture Between the World Wars.* Oxford University Press, 2011; Blume, Mary. *Côte d'Azur: Inventing the French Riviera.* Thames & Hudson, 1992, 107–8; Blume, Mary. "Marie Vassilieff: A Splash of Montparnasse Color." *New York Times,* October 3, 1998; Buisson, Sylvie, and Martine Frésia. *La Ruche: Cité des Artistes.* Éditions Alternatives, 2009; Carpenter, Humphrey. *Geniuses Together: American Writers in Paris in the 1920s.* Unwin Hyman, 1987, 90; Collections photographiques, MOD 4023, Boite M2, Bibliothèque Kandinsky, Centre Pompidou; Cocteau, *Contemporaries,* 70; Cody, Morrill, and Hugh D. Ford. *The Women of Montparnasse.* Cornwall Books, 1984, 108; Crespelle, Jean-Paul. *La vie quotidienne à Montparnasse à la grande époque, 1905–1930.* Hachette, 1976, 129; Ehrenburg, Ilya. *Truce: 1921–1933.* MacGibbon & Kee, 1963; Eksteins, Modris. *Rites of Spring: The Great War and the Birth of the Modern Age.* Mariner Books, 2000, 158–59; Emile-Bayard, Jean. *Montparnasse hier et aujourd'hui.* Jouve, 1927, 394–98, 402–5; Fabre, Michel. "Rediscovering Aïcha, Lucy and D'al-Al, Colored French Stage Artists." *Scholar and Feminist Online* 6, nos. 1–2 (Fall 2007/ Spring 2008); Gustave Fuss-Amoré and Maurice des Ombiaux. *Montparnasse.* Albin Michel, 1925, 141; Ghez Collection Catalog. University of Haifa, 2019; Hussey, Andrew. *Paris: The Secret History.* Bloomsbury, 2008, 319–22; Jiminez, Jill Berk, ed. *Dictionary of Artists' Models.* Fitzroy Dearborn, 2001; Kalifa, Dominique. *Tu entreras dans le siècle en lisant Fantômas.* Vendémaire, 2017; Kessel, *Kisling,*15–38; KMK, KS, and KSR, various; MacMillan, Margaret. *Paris 1919: Six Months That Changed the World.* Random House, 2003, 26; Marevna [Marie Vorobieff]. *Life with the Painters of La Ruche.* Macmillan, 1974, 61; Meisler, Stanley. *Shocking Paris: Soutine, Chagall and the Outsiders of Montparnasse.* St. Martin's, 2015; Musée Mendjizky. *Catalogue Rétrospective Maurice Mendjizky, du 11 avril au 12 juillet 2014.* Paris, 2014; Museum Tinguely. *Impasse Ronsin: Murder, Love, and Art in the Heart of Paris.* Kehrer Verlag, 2021, especially Sante's introduction; Rearick, Charles. *The French in Love and War: Popular Culture in the Era of the World Wars.* Yale University Press, 1997; Roberts, Marie-Louise. *Civilization Without Sexes: Reconstructing Gender in Postwar France, 1917–1927.* University of Chicago Press, 1994, 63; Roe, Sue. *In Montparnasse: The Emergence of Surrealism in Paris, from Duchamp to Dali.* Penguin Press, 2019; Sante, Lucy. *The Other Paris.* Farrar, Straus & Giroux, 2016; Silver, Kenneth E., and Romy Golan, *Circle of Montparnasse: Jewish Artists in Paris, 1900 to 1945.* Jewish Museum and Universe Books, 1985; Smith, Leonard, Stéphane Audoin-Rouzeau, and Annette Becker. *France and the Great War, 1914–1918.* Cambridge University

Press, 2003; Walz, Robin. *Pulp Surrealism: Insolent Popular Culture in Early Twentieth-Century Paris.* University of California Press, 2000; Kenneth Wayne. *Modigliani and the Artists of Montparnasse.* Harry N. Abrams, 2002, 20–21; Weber, Eugen. *Peasants Into Frenchmen.* Stanford University Press, 1976.

2. A CAFÉ ISN'T A CHURCH

33 **"A café isn't":** MRSP, 140.
34 **"as gracefully":** MRSP, 142.
35 **Kiki remembered them:** Though filmed in 1921 in America with Rudolph Valentino and Alla Nazimova, *Camille* debuted in Paris in 1923, at the Electric Palace.
35 **"factual":** MRSP, 143.
35 **"physical defect":** MRSP, 143.
35 **"Light can do":** Man Ray in BMR, 106.
35 **"a magician":** MRSP, 144.

ADDITIONAL SOURCES
BMR, 105–6; KMK, 234; KS, 133–34, 249; KSR, 135; MRSP, 140–44; Tomkins, Calvin. *Duchamp.* Holt, 2014, 225.

3. SEE THE DISAPPEARING BOY

37 **Melach Radnitzky:** It would seem more plausible that his name was Melech, a relatively common Hebrew name that means "king." Perhaps an official wrote it down wrong when he arrived in America.
38 **"privileged and sacred":** MRSP, 6.
40 **"Sex had been":** MRSP, 12.
42 **To become no man:** Mason Klein suggests that "in changing his name from the colloquial 'Manny' to the nameless 'Man,' Man Ray lost and found himself in anonymity." Mason Klein, *Alias Man Ray: The Art of Reinvention* (Jewish Museum / Yale University Press, 2009), 18.
43 **"explosion in a shingle":** "Explosion in a Shingle Factory," *New York Times,* August 3, 1975.
45 **"Oh talk about":** Man Ray in BMR, 35.
46 **"to make oneself":** Arthur Rimbaud in Calvin Tomkins, *Duchamp* (Holt, 2014), 66.
46 **"as beautiful":** Comte de Lautréamont, *Maldoror and the Complete Works,* trans. Alexis Lykiard (Exact Change, 2004).
46 **"an epitome":** BMR, 40.
48 **"I do not go":** Marcel Duchamp in Jacquelynn Baas, *Marcel Duchamp and the Art of Life* (MIT Press, 2019), 141.
48 **"of some great man":** Duchamp in Tomkins, *Duchamp,* 66.
48 **Physically and by temperament:** On contrasting Duchamp's detachment with Man Ray's frenetic energy, see BMR and Tomkins, *Duchamp,* respectively.
49 **"were like two":** Georges Braque in Tomkins, *Duchamp,* 40.
52 **"a rough-diamond":** Natalie Clifford Barney in Suzanne Rodriguez, *Wild Heart, A Life: Natalie Clifford Barney's Journey from Victorian American to Belle Époque Paris* (Ecco, 2002), 282.
53 **"said it had been painted":** MRSP, 86.
53 **"The machine":** Francis Picabia in Merry Foresta et al., *Perpetual Motif: The Art of Man Ray* (Abbeville Press, 1989), 65.

54 **"to protect their nose"**: Francesco Aimone, "The 1918 Influenza Epidemic in New York City: A Review of the Public Health Response." *Public Health Reports* 125 (2010): 71–79.

55 **"the orders"**: Martin Puchner, *Poetry of the Revolution: Marx, Manifestoes, and the Avant Garde* (Princeton, 2006), 140.

55 **"No more painters"**: Louis Aragon in Maurice Nadeau, *Histoire du surréalisme* (Maurice Nadeau, 2016), 48, translation my own.

56 **"dada cannot live"**: Man Ray in Jean-Michel Bouhours and Patrick de Haas, eds., *Man Ray: Directeur du mauvais movies* (Centre Georges Pompidou, 1997), 8–9.

57 **The move into photography:** On photography as a kind of readymade, see Richard Whelan, *Alfred Stieglitz: A Biography* (Little, Brown, 1995).

59 **"She's not a futurist"**: Marcel Duchamp in Zing Tsjeng, *Forgotten Women: The Artists* (Octopus Books, 2018), 99.

62 **"They do things better"**: Malcolm Cowley, *Exile's Return: A Literary Odyssey of the 1920s* (Bodley Head, 1951), 74. I used the same quote to make a similar point in Mark Braude, *Making Monte Carlo: A History of Speculation and Spectacle* (Simon & Schuster, 2016).

ADDITIONAL SOURCES

Aimone, Francesco. "The 1918 Influenza Epidemic in New York City: A Review of the Public Health Response." *Public Health Reports* 125 (2010): 71–79; Bainbridge, *Another Way,* 14; Benjamin, "Surrealism"; Blake, Jody. *Le Tumulte Noir: Modernist Art and Popular Entertainment in Paris, 1900–1930.* Pennsylvania State University Press, 1999, 13–14; BMR, 2–6, 8, 11, 13, 16, 23, 25, 30–31, 35–39, 46–53, 64–71, 79, 83, 212–13, 232; Blower, *Becoming Americans,* 2–4, 17; Bogart, Michele H. *Artists, Advertising, and the Borders of Art.* University of Chicago Press, 1995, 171–73; Bourgeade, Pierre. *Bonsoir, Man Ray.* Belfond, 1972, 10, 15–16, 19, 43, 78; Brown, Milton. *The Story of the Armory Show.* Hirshhorn Foundation, 1963, 179; Chéroux, Clément, ed. *Man Ray Portraits: Paris Hollywood Paris.* Schirmer/Mosel, 2011, 30, 54; Cowley, *Exile's Return,* 74, 151; Douglas, Ann. *Terrible Honesty: Mongrel Manhattan in the 1920s.* Farrar, Straus, & Giroux, 1995, 17, 179–180; Flanner, Janet. *Paris Was Yesterday.* Harvest/ HBJ, 1998, 3; Foresta, *Perpetual Motif,* 14–15, 53, 55, 90, 94; Gammel, Irene. *Baroness Elsa: Gender, Dada, and Everyday Modernity.* MIT Press, 2003; Glueck, Grace. "They Were Two Wild Ones, Make No Mistake," *New York Times,* May 3, 2002; Huelsenbeck, Richard. *Memoirs of a Dada Drummer.* Edited by Hans Kleinschmidt. Viking, 1969, 85–86; Jones, Colin. *Paris: Biography of a City.* Penguin, 2006; 389; Klein, Mason. *Alias Man Ray: The Art of Reinvention.* Jewish Museum/Yale University Press, 2009, 16, 18, 26, 33, 80, 129, 162; KMK, 225; Lebel, Robert. *Marcel Duchamp.* Translated by George H. Hamilton. Grove Press, 1959, 79; Ledgers of Man Ray and Marcel Duchamp's chess games from April 1921, Fonds Man Ray, Bibliothèque Kandinsky, Centre Pompidou; Lottman, Herbert. *Man Ray's Montparnasse.* Harry N. Abrams, 2001, 45, 48; Lowe, Sue Davidson. *Stieglitz.* MFA Publications, 2002, 167; Marcus, Greil. *Lipstick Traces: A Secret History of the Twentieth Century.* Harvard University Press, 1990; Melillo, John. *The Poetics of Noise from Dada to Punk.* Bloomsbury, 2020, 65; MRSP, 4–7, 10–13, 18–19, 30, 59–61, 68, 77–80, 104; Naumann, Francis. *Conversion to Modernism: The Early Works of Man Ray.* Rutgers University Press, 2003; Naumann, Francis. *Man Ray: The New York Years, 1913–1921.* Zabriskie Gallery, 1988; Parker, Graham. "The Forgotten Story of Jack Johnson's Fight with Oscar Wilde's Poet Nephew." *Guardian.* April 22, 2016; Passeron, René. *Max Ernst.* Filipacchi, 1971, 8; Pincus-Witten, Robert. "Man Ray: The Homonymic Pun and American Vernacular." *Artforum,* April 1975; Puchner, Martin. *Poetry of the Revolution: Marx, Manifestoes, and the Avant Garde.* Princeton, 2006, 135–40; Rabinovitz, Lauren. "Independent Journeyman: Man Ray, Dada and Surrealist Film-Maker." *Southwest Review* 64, no. 4 (1979); Ray, Man. *In Focus: Man Ray, Photographs from the J. Paul Getty Museum.* Getty Publications, 1998, 101; Roe, *In Montparnasse,* 19; Schwarz, Arturo. *Man Ray: The Rigour of Imagination.* Rizzoli, 1977, 26–32, 72, 322; Seigel, Jerrold. *Bohemian Paris: Culture, Politics, and the Boundaries of Bourgeois Life, 1830–1930.* Viking, 1986, 367–68; Silver, Kenneth E. *Esprit*

de Corps: The Art of the Parisian Avant-Garde and the First World War, 1914–1925. Thames & Hudson, 1989; Spurling, Hilary. *Matisse the Master: A Life of Henri Matisse, the Conquest of Colour, 1909–1954.* Knopf, 2005, 136; Steinke, René. "My Heart Belongs to Dada." *New York Times,* August 18, 2002; Strasbaugh, Jon. *The Village.* Ecco, 2013, 139; Tomkins, *Duchamp,* 46, 65, 71, 113–19, 136, 143–44, 150, 159–61, 165, 173, 225, 228; Calvin Tomkins, *Living Well is the Best Revenge.* Museum of Modern Art, 2013, 21; Van Haaften, Julia. *Berenice Abbott: A Life in Photography.* Norton, 2018, 49; Walz, *Pulp Surrealism,* 2, 15, 21; Ward, Geoffrey C. *Unforgiveable Blackness: The Rise and Fall of Jack Johnson.* Vintage, 2006; Whelan, Richard. *Alfred Stieglitz: A Biography.* Little, Brown, 1995, 113–14, 306–7, 313–15, 348; Wickes, George. *Americans in Paris, 1903–1939.* Doubleday, 1969, 123.

4. SESSIONS

64 **He would have seen:** Since 1986 Ingres's *The Source* (1856) has hung at the Musée d'Orsay.
65 **"He wasn't handsome":** Jacqueline Barsotti in Veronica Horwell, "Jacqueline Barsotti," *Guardian,* June 30, 2003.
65 **"Kiki! Don't look":** KS, 133.
65 **"I got her":** MRSP, 144.
65 **"All I need":** KS, 36.
66 **"who were doing":** Man Ray in Herbert Lottman, *Man Ray's Montparnasse* (Harry N. Abrams, 2001), 18.
66 **"Everyone is on":** Man Ray in BMR, 83.

ADDITIONAL SOURCES
Blower, *Becoming Americans,* 20; BMR, 110–11, 192; Foresta, *Perpetual Motif,* 94; Glassco, John. *Memoirs of Montparnasse.* New York Review of Books, 2007, 192; Frederick Kohner, *Kiki of Montparnasse.* Cassell, 1968, 37–38; KS, 14, 114, 133, 239–41; MRSP, 144–45; Powers, Lyall H. "Biography: Leon Edel: The Life of a Biographer." *American Scholar* 66, no. 4 (1997): 598–607; Wickes, *Americans in Paris,* 134.

5. GRAND HÔTEL

68 **"infant":** Man Ray in BMR, 84.
70 **"a coal miner":** "Librairie six, 5, avenue Lowendal, Paris 7e, Exposition dada Man Ray, du 3 au 31 décembre 1921," Jedermann Collection, Beinecke Library, Yale University. See also Foresta, *Perpetual Motif,* 101.
70 **"very bourgeois":** Matthew Josephson, *Life Among the Surrealists* (Holt, Rinehart, & Winston, 1961), 109.
71 **"All our friends":** Man Ray in Lottman, *Montparnasse,* 62.
72 **"at once but rather":** Thérèse Cano de Castro in KMK, 227.
72 **"Our two noses":** Kiki in KMK, 109.
72 **"I have never seen":** Gertrude Stein, *The Autobiography of Alice B. Toklas* (Vintage, 1990), 197–98.
74 **"amuse, annoy, bewilder":** Man Ray in "Ray in Love," *New Yorker,* September 30, 1996.
75 **"Others had tried":** Clarence Bull in David Fahey and Linda Rich, *Masters of Starlight: Photographers in Hollywood* (Los Angeles County Museum of Art, 1987), 101.
76 **"1922, all my love":** Kiki in KMK, 109.

ADDITIONAL SOURCES

Agar, Eileen, *A Look at My Life*. Methuen, 1989, 86; BMR, 88–92, 110–11, 245, 257; Bourge-ade, *Bonsoir,* 35–37; Bowen, Stella. *Drawn from Life*. Collins, 1941, 119; Burke, Carolyn. *Lee Miller: A Life*. University of Chicago Press, 2007, 79; Chéroux, *Man Ray Portraits*, 30–32, 36–40, 53; Cocteau, *Contemporaries*, 48, 70; Cocteau, Jean. *Opium: The Diary of a Cure*. Translated by Margaret Crosland and Sinclair Road. Peter Owen, 1957, 72; Cocteau, Jean. *Professional Secrets*. Edited by Robert Phelps. Translated by Richard Howard. Farrar, Straus, & Giroux, 1970, 70–71; Emile-Bayard, *Montparnasse hier et aujourd'hui*, 370–405; Fitch, Noel Riley. *Sylvia Beach and the Lost Generation: A History of Literary Paris in the Twenties and Thirties*. Norton, 1985, 42–43; Foresta, *Perpetual Motif,* 95–96, 102–4; Gramont, Sanche de. "Remember Dada—Man Ray at 80." *New York Times Magazine*, September 6, 1970; Hentea, Marius. *TaTa Dada: The Real Life and Celestial Adventures of Tristan Tzara*. MIT Press, 2014, 175; Huddleston, Sisley. *Back to Montparnasse*. George G. Harrap, 1931, 132; Kalifa, *Belle Épo-que,* 8–11; Klein, *Alias Man Ray,* 62, 112; KMK, 11, 108, 227; Koda, Harold, and Andrew Bolton, introduction by Nancy J. Troy. *Poiret*. Met Publications, 2007; Lanzmann, Jacques. *Paris des années trentes*. Éditions de la Martinière, 1992, 26; Lottman, *Montparnasse,* 51–68; Man Ray, *In Focus,* 111; MRSP, 115–119; O'Neal, Hank. *"Life is Painful, Nasty & Short...": Djuna Barnes, 1978–981: An Informal Memoir*. Paragon House, 1990, 32–33; Ross, Alex J. *The Rest Is Noise: Listening to the Twentieth Century*. Picador, 2007, 108–9; Diana Souhami. *No Modernism Without Lesbians*. Head of Zeus, 2020, 295; Stein, *Autobiography*, 10–14, 47, 197; Stein, Gertrude. *Paris, France*. Liveright, 2013, 17; Toklas, Alice B. *What is Remembered*. North Point Press, 1985, 110; Tomkins, *Duchamp,* 250; Tomkins, *Living,* 30; Troy, Nancy. *Couture Culture: A Study in Modern Art and Fashion*. MIT Press, 2004; Van Haaften, *Berenice Abbott,* 84.

6. ALL TOMORROW'S PARTIES

77 **"You shouldn't"**: Kiki in KMK, 108.
78 **"Dear beloved-Tzara"**: Kiki in Lou Mollgaard, *Kiki, reine de Montparnasse* (Robert Laffont, 1988), 99–100.
78 **"from the sticky medium"**: Man Ray in BMR, 99.
79 **Man Ray wasn't the first**: László Moholy-Nagy developed a similar process around the same time as Man Ray started experimenting with Rayography. A longer history of draw-ing on film can be traced from Fox Talbot onward and includes, among others, Hip-polyte Baraduc and Louis Darget.
79 **"invents a new world"**: Georges Ribemont-Dessaignes, "Dada Painting or the Oil-Eye." *Little Review* 9, no. 4 (Autumn/Winter 1923–24): 11.
79 **"the fierce competition"**: Man Ray to Howald, May 28, 1922, Ohio State University Library, https://library.osu.edu/site/rarebooks/2014/08/27/happy-birthday-man-ray/.
80 **"her own problem"**: MRSP, 148.
80 **"general introducer"**: Stein in Tomkins, *Duchamp,* 170.
81 **"very moving pictures"**: Roché in KMK, 111, 227.
81 **In his memoir**: In the 1930s, Man Ray produced images featuring two nude models lying down together, for instance of Ady Fidelin and Nusch Éluard in 1937, but these don't seem to be the photographs he describes in the section of his memoir quoted below, which from the context would place it chronologically around 1922.
81 **"were more at ease"**: MRSP, 131–32.
81 **"love-making"**: Roché in KMK, 111.
81 **"started [his career]"**: Barsotti in John Baxter, "Man Ray Laid Bare," *Tate Magazine* no. 3.
82 **"little life"**: KS, 134.

82 **"Kiki had been"**: MRSP, 148.
82 **"bedside dictionary"**: Cowley in BMR, 108.
83 **"Certainly, a dominant"**: Janet Flanner in John Bainbridge, *Another Way of Living* (Holt, Rinehart, & Winston, 1968), 19.
83 **"I spread out"**: KS, 134.
85 **"an extraordinary"**: Treize in Anne Egger, *Robert Desnos* (Fayard, 2007), 155.
85 **"a walking encyclopedia"**: Kiki in Egger, *Robert Desnos,* 156.
85 **"She and I"**: KS, 140.
85 **oyster-colored eyes**: This is taken verbatim from a description of Desnos's eyes by Youki Desnos, in KMK, 244.
85 **"the liberation"**: Zinah Picard in KMK, 116.
86 **"We were not"**: Cocteau, *Contemporaries,* 72.
88 **"Those who in early"**: Philippe Soupault in Josephson, *Life Among Surrealists,* 122–23.
89 **"the man who"**: Fernand Léger in Colin Jones, *Paris: Biography of a City* (Penguin, 2006), 388.

ADDITIONAL SOURCES

Barnes, Djuna. *I Could Never Be Lonely Without a Husband: Interviews.* Edited by Alice Barry. Virago, 1987, 299; BMR, 96–99, 107–9, 147; Bowen, *Drawn from Life,* 120; Carpenter, *Geniuses Together,* 95; Cocteau, Jean. "Lettre ouverte a Man Ray." *Les feuilles libres,* April–May 1922; Cowley, Malcolm. *A Second Flowering: Works and Days of the Lost Generation.* Penguin, 1973; Douglas, *Terrible Honesty,* 182; Egger, *Robert Desnos,* 155–56; Flanner, *Paris Was Yesterday,* xxiii; Foresta, *Perpetual Motif,* 33, 111–12; Glassco, *Memoirs of Montparnasse,* 18; Homans, Jennifer. *Apollo's Angels: A History of Ballet.* Random House, 2010, 314; Horwell, Veronica. "Jacqueline Barsotti," *Guardian,* June 30, 2003; Imbs, Bravig. *Confessions of Another Young Man.* Henle-Yewdale House, 1936, 99; Jouffroy, Alain. *La vie réinventée: L'Explosion des années 20 à Paris.* Paris, 1982, 17; Kalifa, *Belle Époque,* 34; Kern, Stephen. *The Culture of Time and Space: 1880–1918.* Harvard University Press, 2003, 1; KMK, 106, 111–12, 115, 154, 182, 224, 227–28, 231, 234–35; KS, 134–36, 140; Laxton, Susan. *"Flou:* Rayographs and the Dada Automatic." *October* 127 (Winter 2009): 25–48; L'Écotais, Emmanuelle de, and Katherine Ware. *Man Ray.* Edited by Manfred Heiting. Taschen, 2004, 75, 88; Lottman, *Montparnasse,* 82–83; Mackillop, Ian. *Free Spirits: Henri-Pierre Roché, Francois Truffaut, and the Two English Girls.* Bloomsbury, 2000, 140–41; MacMillan, *Six Months,* 28; Mundy, Jennifer, ed. *Surrealism: Desire Unbound.* Princeton University Press, 2001, 44; MRSP, 146–48; Panchasi, Roxanne. *Future Tense: The Culture of Anticipation in France Between The Wars.* Cornell University Press, 2009; Perl, Jed. *Calder: The Conquest of Time.* Knopf, 2017, 286; Roe, *In Montparnasse,* 120; Sante, Lucy. *Maybe the People Would Be the Times.* Verse Chorus Press, 2020, 179; Souhami, *No Modernism,* 26; Wayne, *Modigliani and Artists,* 17.

7. WAKING DREAM SÉANCE

91 **"the period"**: René Crevel, "La période des sommeils," *This Quarter* 5 no. 1 (September 1932).
91 **They held the first:** My research into that year's lunar phases revealed that the night before was a new moon.
92 **"like hunters, comparing"**: Louis Aragon, *A Wave of Dreams,* trans. Susan de Muth (Thin Man Press, 2010).
93 **"shared horizon of religion"**: Ibid.
93 **Apollinaire had witnessed:** On Apollinaire and surreal experiences at the front, see Modris Eksteins, *Rites of Spring: The Great War and the Birth of the Modern Age* (Mariner Books, 2000), 146.
94 **The small group:** On translating subjective exhilaration into collective revolution, see

Walter Benjamin, "Surrealism: The Last Snapshot of the European Intelligentsia," trans. Edmund Jephcott, *New Left Review*, no. 108 (March–April 1978).
94 **"What I liked about"**: KSR, 233–35.

ADDITIONAL SOURCES

Louis Aragon. *A Wave of Dreams,* trans. Susan de Muth. Thin Man Press, 2010; Baecque, Antoine de. *Les nuits parisiennes: XVIII–XXI siècles.* Seuil, 2015, 144; Barnet, Marie-Claire, Eric Robertson, and Nigel Saint, eds. *Robert Desnos: Surrealism in the Twenty-First Century.* Peter Lang, 2006; Bauduin, Tessel M. *Surrealism and the Occult.* Amsterdam University Press, 2014; Walter Benjamin, "Surrealism: The Last Snapshot of the European Intelligentsia," trans. Edmund Jephcott, *New Left Review,* no. 108 (March–April 1978); Berger, Pierre. *Robert Desnos.* Seghers, 1966; BMR, 194; Brandon, Ruth. *Surreal Lives: The Surrealists 1917–1945.* Macmillan, 1999, 199–206; Breton, André. *Entretiens.* Idées-Gallimard, 1969, 83; Breton, André. *Manifestos of Surrealism.* Translated by Richard Seaver and Helen R. Lane. University of Michigan Press, 1969, 12; Breton, André. "The Mediums Enter," in *The Lost Steps.* Translated by Mark Polizzotti. University of Nebraska Press, 1996; Breton, André, et al. "Le Bureau de Recherches surréalistes." *La Révolution surréaliste,* no. 2 (January 15, 1925); Breton, Simone. *Lettres à Denise Levy, 1919–1929.* Joelle Losfeld, 2005, 106–11; Buñuel, Luis. *My Last Sigh.* Translated by Abigail Israel. Vintage, 2013, 107; Caws, Mary Ann. *The Surrealist Voice of Robert Desnos.* University of Massachusetts Press, 1977, 14; Conley, Katharine. *Robert Desnos, Surrealism, and the Marvelous in Everyday Life.* University of Nebraska, 2008, 15–18; Crevel, René. "La période des sommeils." *This Quarter* 5 no. 1 (September 1932); Desnos, Robert. *Nouvelles Hébrides et autres textes, 1922–1930.* Gallimard, 1978; Desnos, Robert. *Dessins automatiques* (1922), Ms 50675 (bis)-Ms 50679, Bibliothèque Littéraire Jacques Doucet; Desnos, Youki. *Les Confidences de Youki.* Fayard, 1999; Egger, *Robert Desnos,* ix, 103–29; Frey, John G. "From Dada to Surrealism." *Parnassus* 8, no.7 (December 1936): 14; Gibson, Jennifer. "Surrealism Before Freud: Dynamic Psychiatry's 'Simple Recording Instrument.'" *Art Journal* 46 (Spring 1987): 56–60; Josephson, *Life Among Surrealists,* 214; KMK, 43, 112; KSR, 233–35; Lomas, David. "Becoming Machine: Surrealist Automatism and Some Contemporary Instances: Involuntary Drawing." *Tate Papers,* no. 18 (Autumn 2012); Mundy, *Desire Unbound,* 12, 75; Polizzotti, Mark. *Revolution of the Mind: The Life of André Breton.* Farrar, Straus, & Giroux, 1995; Roe, *In Montparnasse,* 58; Sante, Lucy. *Kill All Your Darlings.* Yeti Books, 2007, 219; Soupault, Philippe. *Lost Profiles.* Translated by Alan Bernheimer. City Lights Books, 2016, 31–36; Thévenin, Paule, ed. *Archives du surréalisme.* Vol.1: *Bureau de recherches surréalistes,* Paris 1988.

8. AN ITALIAN HEIR, A FRENCH NOVELIST, A JAPANESE PAINTER, AND AN AMERICAN COLLECTOR

95 **"I want"**: Marchesa Casati in Judith Thurman, "The Divine Marquise," *New Yorker,* September 14, 2003.
95 **"her soul"**: MRSP, 161.
96 **"Breton, expecting"**: Man Ray to Gertrude Stein, August 23, 1922, in MSS 76, Gertrude Stein and Alice B. Toklas Papers, Yale Collection of American Literature (YCAL), Beinecke Library, Yale University.
97 **"nasty cold"**: Man Ray in Eric Garcia, *Man Ray in Paris* (Getty Publications, 2011), 15.
97 **Using low light:** On the floating effect of Proust's head in Man Ray's photo, see Zoë Roth, "'You can change your noses, but you can't change your Moses': Olfactory Aesthetics and the Jewish 'Race,'" *L'Esprit créateur* 59, no. 2 (2019): 72–87.
99 **"He looked at me"**: KSR, 197.
100 **"contemptuous of all"**: As quoted in Phyllis Birnbaum, *Glory in a Line: A Life of Foujita, the Artist Caught Between East and West* (Farrar, Straus, Giroux, 2007), 150.

100 **"could say for sure"**: Foujita in KS, 44.
100 **"Hallo, Boys"**: KMK, 122.

ADDITIONAL SOURCES

Birnbaum, *Glory in a Line,* 3, 5–6, 142–50; BMR, 106–9; Breker, Arno. *Paris, Hitler et moi.* Presses de la Cité, 1970, 214; Bogart, *Artists, Advertising,* 179; Braude, Mark. "Best Year Ever: How 1922 Birthed Modernism." *Daily Beast,* September 2013; Buisson, Sylvie, and Dominique Buisson. *Léonard-Tsuguharu Foujita.* ACR-Édition, 2001, 94–97; Carter, William C. *Marcel Proust: A Life.* Yale University Press, 2002, 809–10; Cowley, *Exile's Return,* 124–26; Garcia, *Ray in Paris,* 15; Hotchner, A. E. "A Legend as Big as the Ritz." *Vanity Fair,* June 21, 2012; Klein, *Alias Man Ray,* 110; KMK, 12, 180, 230; KS, 232; KSR, 197–200; Jackson, Kevin. *Constellation of Genius: Modernism Year One.* Farrar, Straus & Giroux, 2013; Lottman, *Montparnasse,* 78; Mak, Geert. *In Europe.* Vintage, 2008, 76; Man Ray to Gertrude Stein, n.d., ca. 1922, MSS 76, Gertrude Stein and Alice B. Toklas Papers, Yale Collection of American Literature (YCAL), Beinecke Library, Yale University; Miller, Lee. "My Man Ray, an Interview with Lee Miller by Mario Amaya." *Art in America,* May–June 1975, 54–61; MRSP, 160–68, 176–77, 219; Man Ray, *In Focus,* 111; Meisler, Stanley. "Albert Barnes." *Los Angeles Times,* May 1, 2015; Roth, Zoë. "'You can change your noses, but you can't change your Moses': Olfactory Aesthetics and the Jewish 'Race.'" *L'Esprit créateur* 59, no. 2 (2019): 72–87; Roe, *In Montparnasse,* 47, 136; Ryersson, Scott D., and Michael Orlando Yaccarino. *Infinite Variety: The Life and Legend of the Marchesa Casati.* University of Minnesota Press, 2004; Secrest, Meryle. *Between Me and Life: A Biography of Romaine Brooks.* Doubleday, 1974, 297; Spurling, 324–25; Steegmuller, Francis. *Cocteau: A Biography.* Little, Brown, 1970, 296; Thurman, Judith. "The Divine Marquise," *New Yorker,* September 14, 2003; Van Haaften, *Berenice Abbott,* 70.

9. A Dada Dust-Up

102 **"our head is round"**: Picabia in Jed Rasula, *Destruction Was My Beatrice: Dada and the Unmaking of the Twentieth Century* (Basic Books, 2015), 195.
104 **"One must wait"**: Stravinsky in Jennifer Homans, *Apollo's Angels: A History of Ballet* (Random House, 2010), 312.
104 **"dead on the field"**: Massot in Lottman, *Montparnasse,* 93–94.
105 **All this before:** *The Evening of the Bearded Heart* also featured a film by Hans Richter.
106 **"Now it's no longer"**: Cocteau, *Contemporaries,* 53.
106 **"run with a bunch"**: KS, 134.

ADDITIONAL SOURCES

BMR, 122–23; Carpenter, *Geniuses Together,* 88; Cocteau, *Opium,* 47; KS, 134; Homans, *Apollo's Angels,* 309–20; Lottman, *Montparnasse,* 93–94; Rasula, *Destruction,* 195–96; Roe, *In Montparnasse,* 40, 67; Sanouillet, Michel. *Dada in Paris.* MIT Press, 2009, 278–81.

FILMS
Le Retour à la Raison (1923), dir. Man Ray.

10. A Sailing and Several Stories

107 **"one long battle"**: KS, 176.
108 **"he carried"**: Kessel, *Kisling,* 32.
108 **"I can see"**: KS, 173.
108 **"Love? What's that?"**: KMK, 230. "Idiot" is my version, as it feels truer to me to how

Man Ray would speak than Kluver and Martin's more literally translated "imbecile," from their interview with Cano de Castro.

108 **"brush her off"**: Cano de Castro in KMK, 124, 230.

109 **"good wine"**: KS, 144.

110 **"a friendly"**: Do Ray Goodbread in KMK, 124.

110 **"as near as"**: Man Ray in KMK, 230.

110 **More likely the mysterious:** Kluver and Martin make a solid argument for why Man Ray's story about a couple enamored with Kiki's talent was almost certainly a face-saving fabrication, chiefly by noting that in the summer of 1923 Kiki had not yet started singing in public, let alone acting. KMK, 230.

111 **"one of her acquaintances"**: MRSP, 152.

111 **"asked her quietly"**: MRSP, 153.

ADDITIONAL SOURCES

Kiki de Montparnasse, *Guesthouse* (undated), reproduced in *Kiki Souvenirs* (Broca, 1929) 5; KMK, 114, 124, 179, 230, 234, 240–41, 245; KS, 143–46, 173, 176, 262–64; MRSP, 153; Schwarz, *Man Ray,* 323.

11. SHE WILL BE THE ACTOR TOO

112 **"In the old"**: Djuna Barnes, "The Models Have Come to Town," *Charm,* November, 1924, in Barnes, *I Could Never Be Lonely Without a Husband: Interviews,* ed. Alice Barry (Virago, 1987), 297–303.

113 **"at present"**: Djuna Barnes, "James Joyce," *Vanity Fair,* no. 18, April 1922, in Barnes, *I Could Never,* 288–96.

113 **"Desire is the great"**: André Breton and Guillaume Apollinaire in Jennifer Mundy, ed. *Surrealism: Desire Unbound* (Princeton University Press, 2001), 11.

114 **"give Kiki credit"**: Barnes, "Models."

114 **"will no longer be"**: Ibid.

ADDITIONAL SOURCES

Barnes, "Models"; Douglas, *Terrible Honesty,* 188; Emile-Bayard, *Montparnasse hier et aujourd'hui,* 394–98; KMK, 18; Krauss, Rosalind. *L'Amour Fou: Photography and Surrealism.* Abbeville Press, 1985; Mundy, *Desire Unbound,* 11, 49–50.

12. THE INTERPRETATION OF DREAMS

116 **Kiki sits:** In describing *Le Violon d'Ingres* here, I refer specifically to the largest print in circulation, the so-called Jacobs print, in which Man Ray produced the F-holes by burning the print. In other prints, notably the Breton print held by the Centre Pompidou, Man Ray painted the f-holes in gouache onto a print of the original shot of Kiki, then rephotographed the altered prints. Man Ray spoke of *Le Violon d'Ingres* as a combination of photography and Rayography. Along with the iconic print, I also draw on Man Ray, *Etude pour le Violin d'Ingres* (1926), showing an alternate angle, as well as other alternate prints, with etches down the middle of the frame mimicking the strings of a violin or cello, all housed in the Pompidou's collection. When listing what Kiki wore, I omit the thin watch pushed high up on her forearm that one sees in alternate shots from this session since because her arms are hidden, I can't say for sure whether she was wearing it at the moment of the shot that became *Le Violon d'Ingres.* In my reading of this photograph, I've assumed that Man Ray and Kiki were the only people present for

the shoot. Man Ray employed a series of assistants, one at a time, during his time in Paris in the 1920s, including Berenice Abbott. Given that this is a picture of his romantic partner and had a relatively simple setup, very likely in their home studio, it seems likely he worked without an assistant. Bate suggests that Kiki's scarf-cum-turban was in fact a hat fashioned to look like a turban so you wouldn't have to tie it each time you wanted to wear it, a product regularly produced by Parisian milliners. David Bate, *Photography and Surrealism: Sexuality, Colonialism, and Social Dissent* (I. B. Tauris, 2004), 116. I instead agree with the research of Billy Kluver and Julie Martin, who suggest that Kiki fashioned the turban out of her shawl, which has the same pattern and which she wore often, including in other shots that Man Ray took of her. KMK, 134.

118 **as a plaything:** Kiki's pose for Man Ray's camera brings to mind Mary Ann Caws's opening sentences to her essay, "Seeing the Surrealist Woman: We Are a Problem": "Headless. And also footless. Often armless too: and always unarmed, except with poetry and passion. There they are, the surrealist women so shot and painted, so stressed and dismembered, punctured and severed: is it any wonder she has (we have) gone to pieces?"

118 **The easy allure:** On the subjects of Ingres's *The Half-Length Bather* (1807) and *The Valpincon Bather* (1808) being naked save for fabric on their head, note that in the latter, the subject has some bed linen around her arm as well.

118 **"The very beautiful":** Breton in Emmanuelle de L'Écotais and Katherine Ware, *Man Ray,* ed. Manfred Heiting (Taschen, 2004), 16.

ADDITIONAL SOURCES

Bate, David. *Photography and Surrealism* 116; Caws, Mary Ann, Rudolf E. Kuenzli, and Gwen Raaberg, eds. *Surrealism and Women.* MIT Press, 1991, 11; Mahon, Alyce. *The Marquis de Sade and the Avant Garde.* Princeton University Press, 2020; Man Ray, *In Focus,* 116; Messier, Paul. "Materials and Techniques of Man Ray's *Le Violon d'Ingres,*" in *The Long Arm of Coincidence: Selections from the Rosalind and Melvin Jacobs Collection.* Edited by Wendy Grossman, Paul Messier, and F. M. Naumann. Pace/MacGill Gallery, 2009; Penrose, Roland. *Man Ray.* Thames & Hudson, 1989, 92; Powell, Kirsten Hoving. "*Le violin d'Ingres:* Man Ray's Variations on Ingres, Deformation, Desire and de Sade." *Art History* 23, no. 5 (December 2000): 772–99.

13. INTO THE LIGHT

122 **"make it":** KS, 146.

123 **"were like beautiful":** Cano de Castro in KMK, 231.

124 **"no scenario":** Léger in Rudolf E. Kuenzli, ed., *Dada and Surrealist Film* (Willis Locker and Owens, 1987), 29, 38.

125 **"a mechanical atmosphere":** Léger in Scott MacDonald, ed., *Art in Cinema: Documents Toward a History of the Film Society* (Temple University Press, 2006), 85.

126 **"I have to wait":** Kiki in KMK, 129.

126 **"Kiki Man Ray":** Roché in KMK, 161, 231.

126 **"Bought a beautiful":** Roché in KMK, 161, 231.

126 **"Most woman artists":** John Quinn in Brice Rhyne, "John Quinn: The New York 'Stein,'" *Artforum,* October 1978.

126 **"Your letter":** Kiki in KMK, 161.

127 **"You cannot know":** KSR, 34–35.

127 **"never said":** KS, 106.

127 **"Death, among":** KSR, 47.

128 **"dirty Jew":** Kiki in Lottman, *Montparnasse,* 100.

129 **They were widely envied:** Some of the language and content concerning the Murphys here draws on Braude, *Making Monte Carlo,* 145–53.

129 **"the simplest"**: Sara Murphy in Deborah Rothschild, *Making It New: The Art and Style of Sara and Gerald Murphy* (University of California Press, 2007), 25.

131 **excellent bait:** On the camera as a form of bait, see Diane Arbus in Susan Sontag, *On Photography* (Farrar, Straus & Giroux, 1997), 191.

131 **"As a photographer"**: Man Ray in Lottman, *Montparnasse*, 53.

131 **"peers became Socialists"**: Patrick Balfour in D. J. Taylor, *Bright Young People* (Farrar, Straus & Giroux, 2007), 41.

132 **"like a miracle"**: Germaine Everling, *L'Anneau de Saturne*. Fayard, 1970, 155.

133 **"living newspaper"**: Malcolm Cowley, *A Second Flowering: Works and Days of the Lost Generation* (Penguin, 1973), 57.

133 **"there were people"**: Ernest Hemingway, *A Moveable Feast* (Scribner, 2010), 83.

134 **"I don't know"**: KSR, 220.

134 **"Almost anybody"**: Robert McAlmon in McAlmon and Kay Boyle, *Being Geniuses Together 1920–1930* (Doubleday, 1968), 103.

135 **"The dirtier"**: André Warnod, *Fils de Montmartre* (Fayard, 1955), 256.

136 **"produced such sublime"**: Paul Morand in Kalifa, *Belle Époque*, 34.

136 **"loose red mouth"**: Kay Boyle in McAlmon and Boyle, *Being Geniuses*, 326.

ADDITIONAL SOURCES

391, no. 18 (July 1924): 5; État civil de la Côte-d'Or, Châtillon-sur-Seine, 1893–1902, and 1903–1932, Archives départementales de la Côte d'Or; Bainbridge, *Another Way*, 27; Barnet, Robertson, and Saint, *Robert Desnos*, 25; Berliner, Brett A. *Ambivalent Desire: The Exotic Black Other in Jazz-Age France*. University of Massachusetts Press, 2002; Blake, *Tumulte Noir;* Blower, *Becoming Americans*, 6; BMR, 124, 184–85; Boittin, Jennifer. *Colonial Metropolis: The Urban Grounds of Anti-Imperialism and Feminism in Interwar Paris*. University of Nebraska Press, 2010; Bouhours, Jean-Michel, and Patrick de Haas, eds. *Man Ray: Directeur du mauvais movies*. Centre Georges Pompidou, 1997, 43–45; Bryher, *The Heart to Artemis*. Harcourt, Brace, & World, 1962, 220–23; Burke, *Lee Miller*, 101; Catelain, Jaque. *Jaque Catelain présente Marcel L'Herbier*. Vautrain, 1950; Charles-Roux, Edmonde. *Chanel*. Translated by Nancy Amphoux. Collins Harvill, 1989, 223; Chéroux, *Man Ray Portraits*, 31; Crespelle, *La vie quotidienne*, 130; Delson, *Dudley*; Dearborn, Mary. *Mistress of Modernism: The Life of Peggy Guggenheim*. Houghton Mifflin, 2004, 49–51; Dolmatovskaya, G. Y. "Kiki de Montparnasse and Ivan Mozzhukhin." *Vestnik VGIK: Journal of Film Arts and Film Studies* 5, no. 1 (2013): 80–90; Douglas, *Terrible Honesty*, 77; Elder, Bruce. *Cubism and Futurism: Spiritual Machines and the Cinematic Effect*. Wilfrid Laurier Press, 2018; Flanner, *Paris Was Yesterday*, xxii–xxiii; Foresta, *Perpetual Motif*, 114–15; Gendron, Bernard. "Jamming at Le Boeuf: Jazz and the Paris Avant-Garde." *Discourse* 1, no.1 (1990); Guggenheim, Peggy. *Out of This Century: Confessions of an Art Addict*. Universe Books, 1979, 41, 49; Harris, Mark. "A Cautionary Tale for the New Roaring Twenties." *New York Times*, September 6, 2021; Hemingway, Ernest. "A Canadian with $1000 a Year Can Live Very Comfortably and Enjoyably in Paris," *Toronto Star*, February 4, 1922; Hentea, *TaTa Dada*, 200; Huddleston, *Back to Montparnasse*, 138–39; Huelsenbeck, *Dada Drummer*, 88; Jackson, Jeffery H. *Making Jazz French: Music and Modern Life in Interwar Paris*. Duke University Press, 2003; Kalifa, *Belle Époque*, 34–35; Josephson, *Life Among Surrealists*, 315; Kiki de Montparnasse, *Family Posing for the Photographer* (1924) reproduced in *Kiki Souvenirs* (Broca, 1929), 3, credited as belonging to "Collection Roché"; KMK, 116, 124, 126, 129, 134, 137, 230, 232, 244; Kohner, *Kiki of Montparnasse*, 26–29; Kristeva, Julia. *The Sense and Non-Sense of Revolt*. Translated by Jeanine Herman. Columbia University Press, 2001, 132; Kuenzli, Rudolf E., ed. *Dada and Surrealist Film*. Willis Locker and Owens, 1987, 28–42; KS, various; Lanzmann, *Paris des années trentes*, 36, 110; Latham, Aaron. "The Real Nicole and Dick," *New York Times*, February 13, 1983; L'Herbier, Marcel. *La tête qui tourne*. Belfond, 1979, 111; Liaut, *Madeleine Castaing*, 36; Lottman, *Montparnasse*, 99–100; MacDonald, Scott, ed. *Art in Cinema: Documents Toward a History of the Film Society*. Temple University Press, 2006, 122; MacLeish, Archibald. *Riders on the Earth*. Houghton Mifflin, 1978, 124; Mayer, Arno J. *The Persistence*

of the Old Regime: Europe to the Great War. Pantheon, 1981, McAlmon and Boyle, *Being Geniuses,* 103, 287, 326; MRSP, 149; Roe, *In Montparnasse,* 38, 58–59, 137; Ross, *Rest Is Noise,* 109, 116; Rothschild, Deborah. *Making it New: The Art and Style of Sara and Gerald Murphy.* University of California Press, 2007, 25; Stovall, Tyler. *Paris Noir: African Americans in the City of Light.* Houghton Mifflin, 1996; Tomkins, *Duchamp,* 250; Tomkins, *Living,* various; Turner, Elizabeth Hutton. *Americans in Paris (1921–1931): Man Ray, Gerald Murphy, Stuart Davis, Alexander Calder.* Phillips Collection, 1996, 26; Vail, Karole, and Thomas M. Messer, *Peggy Guggenheim: A Celebration.* Guggenheim Museum, 1998, 24, 137; Vaill, Amanda. *Everybody Was So Young.* Broadway Books, 1999; Weber, Caroline. *Proust's Duchess: How Three Celebrated Women Captured the Imagination of Fin-de-Siècle Paris.* Knopf, 2018.

FILMS

Galerie des monstres (1924), dir. Jaque Catelain; *The Lion of the Moguls* (1924), dir. Jean Epstein; *Ballet mécanique* (1924), dir. Fernand Léger; *L'inhumaine* (1924), dir. Marcel L'Herbier; *Entr'acte* (1924), dir. René Clair.

14. COME CLOSER

139 **"Alice Prrrrin"**: KSR, 84.
139 **"weary, burning"**: X. de Hautecloque, "Montparnasse: Carrefour du monde," *Le Petit Journal,* December 24, 1929.
139 **"heavy-featured"**: Boyle in McAlmon and Boyle, *Being Geniuses,* 327.
139 **"no mistaking"**: Glassco, *Memoirs of Montparnasse,* 18.
139 **"God!"**: Dardel in KMK, 154.
139 **A typical Kiki performance:** I have presented Kiki's performance as a single night for the sake of clarity and chronology, based on various reports on what it was like to watch Kiki at the Jockey on any given night circa 1924–25, as well as Kiki's own writing about her performances.
139 **"Kiki! Kiki!"**: Kohner, *Kiki of Montparnasse,* 29.
140 **"Come closer"**: Kiki in Alain Jouffroy, *La vie réinventée: L'Explosion des années 20 à Paris* (Paris, 1982), 182; translation my own.
140 **"While singing"**: Barsotti in KMK, 230.
141 **"never lets you"**: KS, 138.
142 **"When strangers"**: KSR, 294–495.
142 **"without question the most"**: Arno Breker, *Paris, Hitler et moi* (Presses de la Cité, 1970), 210–15.
142 **"Don't wear"**: Kiki in KMK, 154.
143 **"I can't sing"**: KS, 140.
143 **"At the start"**: KSR, 293–94.
144 **"By the end"**: KSR, 294, 296.

ADDITIONAL SOURCES

Breker, *Paris, Hitler et moi,* 210–15; G.O. "Ki-ki preside le diner Ki-ki a Montparnasse." *Paris Midi.* May 4, 1929; Hautecloque, "Carrefour du monde"; Jouffroy, *La vie réinventée,* 182; Kalifa, *Belle Époque,* 41–42; Dominique Kalifa, *Les bas-fonds: Histoire d'un imaginaire.* Seuil, 2013; Kohner, *Kiki of Montparnasse,* 31; KS, various, KSR, 84, 253, 259, 294–96; Lagarde, "Paris en liberté"; Sante, *Other Paris,* 182; Yvorel, Jean-Jacques. "La loi du 12 juillet 1916. Première incrimination de la consommation de drogue." *Les Cahiers Dynamiques* 56, no. 3 (2012): 128–33.

15. GOING AWAY

146 **With their strings:** I make similar arguments about the Riviera in the 1920s, the train trip to the coast, the Murphys, and *Le Train bleu* in Braude, *Making Monte Carlo.*

146 **"suburb":** Cowley, *Exile's Return,* 6.

146 **"*Le Train bleu*":** Cocteau in Alex J. Ross, *The Rest Is Noise: Listening to the Twentieth Century* (Picador, 2007), 14.

148 **"as mysteriously colored":** F. Scott Fitzgerald, *Tender Is the Night* (Scribner's, 1934), 23.

148 **"left her cold":** KS, 148.

148 **"one roaring":** Mary Butts, *The Journals of Mary Butts,* ed. Nathalie Blondel (Yale University Press, 2002), 287.

148 **"There are lots":** KS, 148.

148 **"Cocteau and I":** KS, 168.

149 **"I started to feel":** KS, 147.

149 **"Why you no":** Kiki in KMK, 235, translation my own.

150 **"No whores":** KS, 150.

151 **"looked crazy":** KS, 151.

152 **"a woman of easy virtue":** "Villefranche-sur-Mer," *Le Petit Niçois,* April 5, 1925.

153 **"Shit!":** KS, 162.

154 **"lacked brilliance":** Man Ray in KMK, 233.

154 **"thank all":** KS, 164.

154 **"Mlle. Alice Prin":** "Villefranche-sur-Mer," *Le Petit Niçois,* April 16, 1925.

155 **"She's the one":** Kiki in Egger, *Robert Desnos,* 211.

155 **"Kiki is free":** Georges Malkine in KMK, 144.

156 **"Ah! there you are":** KS, 164.

156 **whisper "probation":** Cano de Castro in KMK, 233.

ADDITIONAL SOURCES

Arnaud, Claude. *Jean Cocteau: A Life.* Translated by Lauren Elkin and Charlotte Mandell. Yale University Press, 2016, 419–20; Biagini, Jacques, ed. *Jean Cocteau de Villefranche sur mer.* Serre, 2007, 64; Mary Blume, "Kiki de Montparnasse Is Brought Back to Life." *New York Times,* June 12, 1999; Blume, *Côte,* 101–3; Cocteau, *Contemporaries,* 50–51; Cocteau, *Opium,* 31, 36, 44, 53, 63; Cocteau, *Professional Secrets,* 106; Egger, *Robert Desnos,* 211; Girard, Xavier. *French Riviera.* Assouline, 2002, 33; Jones, Ted. *The French Riviera: A Literary Guide for Travelers.* Tauris Parke, 2007, 142–43; KMK, 143, 152, 207, 233–35; KS, 147–53, 270–71; Rose, Francis. *Saying Life: The Memoirs of Sir Francis Rose.* Cassel, 1961; Scholes, Robert. *Paradoxy of Modernism.* Yale University Press, 2008, 254; Silver, Kenneth. *Making Paradise: Art, Modernity, and the Myth of the French Riviera.* MIT Press, 2001, 105; Sontag, Susan. *On Photography.* Farrar, Straus & Giroux, 1997, 54.

16. KIKI WITH AFRICAN MASK

158 **"menaced by extinction":** Paul Guillaume in Jody Blake, *Le Tumulte Noir: Modernist Art and Popular Entertainment in Paris, 1900–1930* (Pennsylvania State University Press, 1999), 1.

159 **To them, it may be:** On an "all-encompassing" story of Africa, see James Clifford's suggestion that "a mask or statue or any shred of black culture could effectively summon a complete world of dreams and possibilities—passionate, rhythmic, concrete, mystical, unchained: an 'Africa.'" James Clifford, *The Predicament of Culture: Twentieth-Century Ethnography, Literature, and Art* (Harvard University Press, 1988), 136.

159 **They've heard:** See Blake's suggestion that the African American influence on music

and performance in the 1920s needs to be understood as intertwined with the African influence on the visual arts in the 1920s. *Tumulte Noir,* 1–3.

159 **"certain of Miss Baker's":** André Levinson in Wendy Grossman, *Man Ray, African Art, and the Modernist Lens* (International Art and Artists, 2009), 128.

159 **"an unforgettable":** Janet Flanner, *Paris Was Yesterday* (Harvest / HBJ, 1998), xx.

159 **With such thoughts:** I am indebted to Grossman's research. I first encountered the Levisohn quote through Grossman's work, from which I also learned of the reference to Baudelaire in the *Vogue* caption.

159 **"a great deal":** McAlmon in McAlmon and Boyle, *Being Geniuses,* 122.

160 **"A Negro looked":** KS, 96.

160 **"in despair":** KS, 136.

160 **He shoots Kiki topless:** Man Ray also printed a reversed version of this shot, so that Kiki looks off to the left of the frame.

161 **The caption reads:** On the swordsmen show debuting on the Champs-Élysées, see *Le Figaro*'s theater listings for February 12, 1926.

161 **"Face of a woman":** Grossman, *Man Ray, African Art,* 130.

162 **"Kiki holding":** Man Ray in Wendy A. Grossman and Steven Manford, "Unmasking Man Ray's *Noire et blanche,*" *American Art* 20, no. 2 (Summer 2006): 140.

163 **Paris that fetishized:** See Carole Sweeney, *From Fetish to Subject: Race, Modernism, and Primitivism, 1919–1935* (Praeger, 2004), and Tyler Stovall, *Paris Noir: African Americans in the City of Light* (Houghton Mifflin, 1996), respectively.

ADDITIONAL SOURCES

Abdurraqib, Hanif. *A Little Devil in America: Notes in Praise of Black Performance.* Random House, 2021; Archer-Shaw, Petrine. *Negrophilia: Avant-Garde Paris and Black Culture in the 1920s.* Thames & Hudson, 2000; Barkan, Elazar, and Ronald Bush, eds. *Prehistories of the Future: The Primitivist Project and the Culture of Modernism.* Stanford University Press, 1995; Berliner, *Ambivalent Desire*; Blake, *Tumulte Noir,* various, especially 1–3, 23, 112–15; Bois, Yves-Alain, and Rosalind E. Krauss. *Formless: A User's Guide.* Zone Books, 1997; Chadwick, Whitney, ed. *Mirror Images: Women, Surrealism, and Self-Representation.* MIT Press, 1998; Lot Essay, "Man Ray, *Noire et Blanche* (1926)." Christie's, Live Auction 7864, April 19, 1994; Lot Essay, "Man Ray, *Noire et Blanche* (1926): Stripped Bare: Photographs from the Collection of Thomas Koerfer." Christie's, Live Auction 15059, November 8, 2017; Lot Essay, "Photographs, Part 1, Man Ray, *Noire et Blanche, Paris.*" Christie's, Live Auction 8262, October 5, 1995; Clifford, James. *The Predicament of Culture: Twentieth-Century Ethnography, Literature, and Art.* Harvard University Press, 1988, various, esp. 136, 197; Debray, Cécile, ed. *Le modèle noir de Géricault à Matisse.* Musée d'Orsay and Flammarion, 2019; Dolan, Therese. "Skirting the Issue: Manet's Portrait of Baudelaire's Mistress, Reclining." *Art Bulletin* 79, no. 4 (1997); Ezra, Elizabeth. *The Colonial Unconscious: Race and Culture in Interwar France.* Cornell University Press, 2000; Fabre, "Rediscovering Aïcha"; Grossman, *Man Ray, African Art,* various pages, esp. 131, 139–43; Grossman and Manford, "Unmasking"; Description for *Portrait Mask (Gba gba),* Baule peoples, prior to 1913, Metropolitan Museum of Art; Mitchell, Robin. *Vénus Noire: Black Women and Colonial Fantasies in Nineteenth-Century France.* University of Georgia Press, 2020; Miller, "My Man Ray"; MRSP, 155; Murrell, Denise. *Posing Modernity: The Black Model from Manet and Matisse to Today.* Yale University Press, 2018; Perry, Gill. *Primitivism, Cubism, Abstraction.* Yale University Press, 1993; Price, Sally. *Primitive Art in Civilized Places.* University of Chicago Press, 2001; Sweeney, Carole. *From Fetish to Subject: Race, Modernism, and Primitivism, 1919–1935.* Praeger, 2004; Stovall, *Paris Noir*; Torgovnick, Marianna. *Gone Primitive: Savage Intellects, Modern Lives.* University of Chicago Press, 1990; Tythacott, Louise. *Surrealism and the Exotic.* Routledge, 2003; *Variétés,* July 15, 1928; "Visage de nacre et masque d'ébène," *Vogue* [Paris] 7, no. 5 (May 1, 1926): 37.

17. Leave Me Alone

164 **"Busy as a cockroach"**: Man Ray in BMR, 129.
164 **"To be done"**: Sylvia Beach, *Shakespeare and Company* (Harcourt, Brace & Co., 1959).
164 **"the future"**: MRSP, 268.
165 **"put away"**: Man Ray in BMR, 131–32.
165 **"whatever seemed"**: MRSP, 270.
166 **He titled**: *Emak Bakia* (sometimes rendered as *Emak Bakea*) has also been translated as "Give us some peace."
166 **"I can do it"**: Kiki in KMK, 158.
166 **In a photograph**: I agree with the research of Julie Martin and Billy Kluver that points strongly to Treize as this shot's photographer. They reproduce the original card sent to Kisling with Kiki's inscription and list the photo-credit for the image as belonging to the private collection of Thérèse Cano de Castro (Thérèse Treize's married name), with whom they conducted interviews, and presumably they were able to question her directly about the photograph's provenance. I have seen the shot attributed in some cases not to Treize but to Man Ray. The J. Paul Getty collection, for instance, has a print of the image with "Man Ray 1927" written in what looks to be pen across the front of photograph, toward the top of the image in a way that distracts from the image itself, and listed by the Getty with the descriptor (rather than officially titled) as "[Kiki of Montparnasse, nude]." This print was apparently sold to the museum by Arnold Crane, who in turn bought it from Man Ray. The Getty lists the image copyright as belonging to the Man Ray Trust. But I think they're mistaken in making the leap in attributing the original photograph to Man Ray rather than allowing for the possibility that it could have been a print given to him by Kiki and/or Treize and dated for his collection of prints. In photographs unquestionably shot by Man Ray at that period, I have seen no similar signature pattern; they tend to be more discreet, at the bottom of the print. KMK, 97.
167 **"absolutely unmixed"**: Simone Weil, *Gravity and Grace,* trans. Emma Crawford and Mario van der Ruhr (Routledge, 2002).
168 **"To my very"**: Kiki in KMK, 97.
168 **"I was no worse"**: Kessel, *Kisling,* 29.
168 **"All his portraits"**: Dora Maar in Louise Baring, *Dora Maar: Paris in the Time of Man Ray, Jean Cocteau, and Picasso* (Rizzoli, 2017), 35.
169 **"supremely elegant"**: Cocteau, *Contemporaries,* 72.
170 **"fat and Polish"**: Ernst [Jean] Gegenbach to André Breton, July 13, 1926, at Andrebreton.fr.
170 **"Dinah"**: "Dinah" (1925), lyrics by Sam M. Lewis and Joe Young. I have guessed that Ethel Waters's version was the one Kiki listened to, given its popularity at that time, and that it was a relatively slow and melancholy rendition of the song. I don't think Josephine Baker's version, another logical candidate, had yet been recorded or made available for release by that summer of 1926.
171 **"double awakening"**: MRSP, 272.
171 **In pictures from the evening**: In tracing Kiki's reception at the Rays, I am grateful for the work of Baldwin, who interviewed Do Ray Goodbread about this moment.
172 **"gone straight"**: Gilbert Seldes in BMR, 135.
172 **"Paintings by KiKi"**: The full list of works on display at Kiki's solo debut: *Woman Doing Her Hair; The Chickens' Meal; Family Dinner; Horse; Child with Bananas; Child in the Countryside; Village House; Sleeping Woman; the Cows; Baby Doll; Sailors; Nude in the Grass; 2 Nude Women and 2 Men; Flowerpot; The Washing Women; Traveling Circus; The Bell Tower; The Cart; A Cow Between 2 Women; The Woman in Red; The Bather; The Mother; The Street Vendor; Portrait.*
172 **"You have"**: Robert Desnos, preface to exhibition catalog, "Peintures de Kiki Alice Prin. Au Sacre Printemps, 1927," translation my own, RLPF 803, RLGF 934, Bibliothèque Kandinsky, Centre Pompidou.

173 "The habitués": Huddleston in KMK, 161.
173 "the sensation": Sisley Huddleston, *Back to Montparnasse* (George G. Harrap, 1931), 133.
173 "impression of simplicity": Flanner in Shari Benstock, *Women of the Left Bank: Paris, 1900–1940* (University of Texas Press, 1986), 109.
174 "simple amusing": Huddleston, *Back to Montparnasse,* 134.
174 He titled: Andre Kertesz, "The Famous Model Kiki" (1927), Médiathèque de l'Architecture et du Patrimoine, Charenton-le-Pont, 08-549159.
175 "like a dog": Berenice Abbott in Julia Van Haaften, *Berenice Abbott: A Life in Photography* (Norton, 2018), 72.
176 "naïve but boldly": MRSP, 269–70.
176 "An exhibition was": MRSP, 149.
177 "a few people": KS, 168. In her memoir Kiki does write briefly about doing Foujita's portrait and about sketching people at the café, but in both cases she is talking about quickly done drawings rather than the paintings she displayed in public.

ADDITIONAL SOURCES
Aiken, Edward A. " 'Emak Bakia' Reconsidered." *Art Journal* 43, no. 3 (1983): 240–46; "Alice Prin," *La Semaine à Paris,* April 8, 1927; BMR, 129–37, 155, 162; " 'Carton d'invitation à l'Exposition surréaliste, la peinture surréaliste existe-t-elle': Arp, De Chirico, Ernst, Malkine, Masson, Miro, Picabia, Man Ray, Tanguy, April 2–15, 1928, Au Sacre du Printemps." Surr 1928 827, Bibliothèque Kandinsky, Centre Pompidou; Chéroux, *Man Ray Portraits,* 19, 34; Foresta, *Perpetual Motif,* 38–39; Garcia, *Ray in Paris,* 18; Glassco, *Memoirs of Montparnasse,* 18; Gramont, "Remember Dada"; KMK, 159, 161, 233, 236; KSR, 239–41; Lottmann, *Montparnasse,* 176; Man Ray to Gertrude Stein, September 4, 1926, May 24, 1927, and February 12, 1930, and Gertrude Stein to Man Ray, ca. February 1930, all in Stein and Toklas Papers; MRSP, 148–50, 268–72; Rabinovitz, "Independent Journeyman"; Reynolds, Anita. *American Cocktail: A "Colored Girl" in the World.* Harvard University Press, 2014, 128–31; Richardson, John. *Picasso: The Triumphant Years, 1917–1932.* Knopf, 2007, 316; Van Haaften, *Berenice Abbott,* 72–74, 84–88.

18. THE YEARS OF MADNESS

179 "like beautiful churches": KSR, 259.
179 "A not unassuming": Virgil Thomson in Ross, *Rest Is Noise,* 110.
180 "more soulfully": KSR, 296.
180 "*Tu n'es pas*": Levy in KS, 38–39.
181 "spent in poverty": Flanner, *Paris Was Yesterday,* 39.
181 "very beautiful": KSR, 267.
181 "what they were all": KSR, 294–95.

ADDITIONAL SOURCES
Allen, Frederick Lewis. *Only Yesterday.* Perennial Classics, 2000, 188; Blower, *Becoming Americans,* 5; Cowley, *Exile's Return,* 135; Ehrenburg, *Truce,* 93; Eksteins, *Rites of Spring,* 242–45, 261; Flanner, *Paris Was Yesterday,* 22; KMK, 154, 196, 245; KSR, 293–96; Levy, Julien. *Memoir of an Art Gallery.* Putnam, 1977, 30–33, 90–93, 97; Lottmann, *Montparnasse,* 142; McAlmon and Boyle, *Being Geniuses,* 325; Ross, *Rest Is Noise,* 110; Steinke, "My Heart." I also consulted various Lindbergh-related Pathé and AP Newsreels online, and various pages of the Smithsonian web site concerning their *Spirit of St. Louis* display.

19. SHE BECAME RESTLESS

183 **"Leave everything"**: André Breton, "Lâchez tout," *Littérature*, no. 2, new series (April 1922), translation my own.

184 **"She could magnetize"**: Flanner, *Paris Was Yesterday*, 67.

185 **"When Marcel"**: Man Ray to Katherine Dreier, July 23, 1927, MSS101, Katharine Dreier Papers / Société Anonyme Archive, Yale Collection of American Literature (YCAL), Beinecke Library, Yale University.

185 **"you always saw"**: KSR, 215.

185 **"Kiki was the most"**: MRSP, 276.

186 **"influence"**: Desnos in Marie-Claire Dumas, *Robert Desnos ou l'exploration des limites* (Klincksieck, 1982), 387.

186 **"Every day"**: Gerald Murphy in Calvin Tomkins, *Living Well Is the Best Revenge* (Museum of Modern Art, 2013), 30.

187 **"the irresistible force"**: Luis Buñuel, *My Last Sigh*, trans. Abigail Israel (Vintage, 2013), 117.

188 **"circulating in a kind"**: As quoted in Bouhours and de Haas, *Directeur du mauvais movies*, 82,

188 **"puddles of goo"**: Jean Prévost, "*Étoile de mer*, par Robert Desnos et Man Ray," *La Nouvelle Revue française* 182 (November 1928).

189 **"I can see"**: Man Ray in Jimmie Charters, *This Must Be the Place: Memoirs of Montparnasse*, ed. Morrill Cody (Lee Furman, 1937), 156.

189 **"very homesick"**: Man Ray in BMR, 145.

190 **"again the simple country"**: MRSP, 150.

190 **"I did take"**: MRSP, 151.

190 **"disappointed"**: MRSP, 148.

191 **"gradually"**: MRSP, 155–56.

192 **"There were no"**: MRSP, 156.

192 **"Kiki would be"**: Boyle in KMK, 244.

ADDITIONAL SOURCES

Abel, Richard. *French Cinema: The First Wave, 1915–1929*. Princeton University Press, 1984; Barnet, Robertson, and Saint, *Robert Desnos*, 23–26; 263–84; BMR, 139–52, 189, 232; Catel, Muller, and José-Louis Bocquet, *Kiki de Montparnasse*. Galera Record, 2010, 376–77; Borhan, Pierre, ed. *Andre Kertesz: His Life and Work*. Bullfinch Press, 1994, 84; Bouhours and de Haas, *Directeur du mauvais movies*, 21, 58–83; Caws, *Surrealist Voice*, 28; Egger, *Robert Desnos*, 102, 329–33; Hamnett, Nina. *Laughing Torso*. Long & Smith, 1932, 123; Hedges, Inez. "Constellated Visions: Robert Desnos's and Man Ray's *L'Étoile de mer*." *Dada/Surrealism* 15 (1986): 99–109; Hedges, Inez. "Robert Desnos's and Man Ray's Manuscript Scenario for *L'Etoile de mer*." *Dada/Surrealism* 15 (1986): 207–19; Kalifa, *Belle Époque*, 34; Klein, *Alias Man Ray*, 151; Kiki de Montparnasse, *Babies* (undated), reproduced in *Kiki Souvenirs* (Broca, 1929), 7; KMK, 106, 183–84, 231, 234, 242, 244; Kuenzli, *Dada and Surrealist Film*; Lottman, *Montparnasse*, 86–101; Man Ray and Robert Desnos, *L'Étoile de Mer* (1928); McAlmon and Boyle, *Being Geniuses*, 40; Mollgaard, Lou. *Kiki, reine de Montparnasse*. Robert Laffont, 1988, 240–41; MRSP, 148–51; Rasula, *Destruction*, 196; Sarazin-Levassor, Lydie. "The Marcel Duchamp I Married." *Independent*, February 11, 2008; Schwarz, *Man Ray*, 194, 297; Vasquez, Carmen. *Robert Desnos et Cuba: Un carrefour du monde*. Harmattan, 1999; Wickes, *Americans in Paris*.

20. DON'T HESITATE! COME TO MONTPARNASSE!

193 **"Not having found"**: Henri Broca, *T'en fais pas! Viens à Montparnasse* (SCIE, 1928).

193 **"This is shit"**: Man Ray in KMK, 239.

194 **"His hold"**: KSR, 265.

195 **"and lifted"**: Lena Börjeson in KMK, 235.
195 **"Kiki Has Written"**: *Paris-Montparnasse,* April 1929.
196 **"kind of a drag"**: Kiki in "Kiki," *Pour vous,* December 26, 1929.
198 **"reached a remarkable"**: As quoted in Aaron Peck, "Foujita: Imperial Japan Meets Bohemian Paris," *New York Review of Books,* May 27, 2018.
198 **"Montparnasse has changed"**: Foujita in KS, 47.

ADDITIONAL SOURCES
KMK, 243; KS, various pages.

21. 1929

ADDITIONAL SOURCES
Ades, Dawn. *Dada and Surrealism Reviewed.* Arts Council of Great Britain, 1978, 101; Mahon, *Sade and Avant Garde,* 106–7; Parr, Martin, and Gerry Badger, *The Photobook: A History.* Phaidon, 2014, 2:138; Pia, Pascal. *Les livres de l'enfer: bibliographie critique des ouvrages érotiques dans leurs différentes éditions du XVI siècle à nos jours.* C. Coulet et A. Faure, 1978, 2:937; Pierre, José, ed. *Investigating Sex: Surrealist Research, 1928–1932.* Verso, 1992, 21–29; Aragon, Louis, Man Ray, and Benjamin Péret, *1929.* Reproduced by Editions Allia, 2013.

22. QUEEN OF THE UNDERGROUND

202 **"without wishing"**: Guillaume Apollinaire, *La Femme assise* (Nouvelle Revue française, 1920), 2:44. Thank you to Kluver and Martin's research for introducing me to this quote. KMK, 170.
202 **"No matter what"**: Ernest Hemingway, *The Sun Also Rises* (Simon & Schuster, 2016), 35.
203 **"Telling about"**: As quoted in Blower, *Becoming Americans,* 42.
203 **"What can we do"**: Kiki in KMK,168.
203 **"were no more"**: Boyle in McAlmon and Boyle, *Being Geniuses,* 325.
203 **"The telephone"**: Barsotti in Horwell, "Jacqueline Barsotti."
204 **"She was still"**: Morley Callaghan, *That Summer in Paris* (Exile Editions, 2013), 167.
204 **"wonderful nose"**: Calder in Jed Perl, *Calder: The Conquest of Time* (Knopf, 2017), 285.
204 **"this famous suburb"**: *Where the Muses Hold Sway,* Pathé Cinema, Paris, May 1929.
205 **"to help fight"**: "Music-hall," *La Volonté,* June 3, 1929.
205 **"astonishing"**: P.L., "Un Gala," *Paris-Montparnasse,* no. 5 (June 15, 1929).

ADDITIONAL SOURCES
Bowen, *Drawn from Life,* 125; Egger, *Robert Desnos,* 411; KMK, 170, 237–39, 244; MRSP, 150; Taylor, D. J. *Bright Young People.* Farrar, Straus & Giroux, 2007, 1888.

23. THE PATH OF DUTY

207 **"I was born"**: This and all subsequent *Kiki Souvenirs* quotes in this chapter are from KS, various pages.
210 **"This much"**: Boyle in McAlmon and Boyle, *Being Geniuses,* 327.
212 **"Kiki, the Quarter's"**: A.W., "Les Mémoires de Kiki," *Comoedia,* June 24, 1929.

212 ("I dream of visiting"): Guy de la Brosse, "Ateliers et académies," *Paris-soir*, July 5, July 12 and 17, and August 14, 1929.

213 "the admirers of Kiki": *Paris-Montparnasse*, June 22, 1929.

213 "Kiki, who had": Maurice Sachs in Muller Catel and José-Louis Bocquet, *Kiki de Montparnasse* (Galera Record, 2010), 378.

213 "installed a long wooden": McAlmon and Boyle, *Being Geniuses*, 300–1, 310.

214 "Kiki was kissing": Wambly Bald, *On the Left Bank, 1929–1933* (Ohio University Press, 1987), 2.

215 "something beautiful": E.H., "Souvenirs d'une modèle," *Le Temps*, October 7, 1929.

215 "simple sentences": Les Treize, "Les lettres: Kiki Souvenirs," *L'Intransigeant*, July 17, 1929.

216 "She's a true": Omer, "Kiki publie ses mémoires," *Paris-Midi*, July 31, 1929.

216 "was not—certainly": Jean Fréteval, "Le Carnet du lecteur: Souvenirs de Kiki," *Le Figaro*, October 9, 1929.

216 "clearly in step": E.H., "Souvenirs d'une modèle."

216 ("There are lively"): Huddleston, *Back to Montparnasse*, 130.

217 "hubbub": This and all subsequent Titus, Hemingway, and Putnam quotes in this chapter are from Kiki de Montparnasse, *Kiki's Memoirs* (Black Manikin Press, 1930), 11–13.

217 "How was I": Helena Rubinstein in Hugh Ford, *Published in Paris: American and British Writers, Printers, and Publishers in Paris, 1920–1939* (Macmillan, 1975), 117.

218 That fall Titus: Lawrence's *Lady* had previously been published privately in a very limited run in Florence.

219 "I wrote the introduction": Ernest Hemingway, *The Letters of Ernest Hemingway*, ed. Sandra Spanier and Miriam B. Mandel (Cambridge University Press, 2017), 4:475.

221 "on the terrace": Bald, *On the Left Bank*, 4–9.

221 But American customs officials: The New York Public Library held some of the seized copies from Titus's original shipment to Cerf in its banned books section until as late as the 1970s.

221 "As we gravely": Cerf in KMK, 188.

222 "The village queen": Bald, *On the Left Bank*, 28.

ADDITIONAL SOURCES

Bainbridge, *Another Way*, 19, 20, 25, 28; Morley Callaghan, *That Summer in Paris*. Exile Editions, 2013, 93, 109–10; Caracalla, Jean-Paul. *Les Exilés de Montparnasse: 1920–1940*. Gallimard, 2006, 111, 118–20; Charters, Jimmie. *This Must Be the Place: Memoirs of Montparnasse*, ed. Morrill Cody. Lee Furman, 1937, 54; Fitch, *Sylvia Beach*, 280; Fitoussi, Michele. *Helena Rubinstein: The Woman Who Invented Beauty*. Translated by Kate Bignold and Lakshmi Iyer. Gallic Books, 2014; Ford, Hugh. *Published in Paris: American and British Writers, Printers, and Publishers in Paris, 1920–1939*. Macmillan, 1975, 17, 145–49; Gaipa, Mark, and Robert Scholes. "She 'Never Had a Room of her Own': Hemingway and the New Edition of *Kiki's Memoirs*." *Hemingway Review* 19, no. 1 (1999); Hanneman, Audre. *Ernest Hemingway: A Comprehensive Bibliography*. Princeton University Press, 2015, 31; Klein, Mason. *Helena Rubinstein: Beauty Is Power*. Jewish Museum, 2014; KMK, 63, 154, 170, 188, 208, 235, 238–39, 243; "Les mémoires de Kiki." *Paris-soir*, June 26, 1929; KSR, 10; MRSP, 155–56; *Paris-Montparnasse*, various issues 1929–30; Wagner-Martin, Linda. *Favored Strangers: Gertrude Stein and Her Family*. Rutgers University Press, 1997.

24. When I Get the Blues, I Change Eras

223 "You paid some": Hemingway, *Sun*, 119.

223 "Montparnasse has ceased": Barnes in Bald, *On the Left Bank*, 74.

224 "Paris resumed": Warnod in Kalifa, *Belle Époque*, 38.

224 **"a living nightmare":** KSR, 282.
225 **"Montparnasse isn't dead!":** *Paris-Montparnasse,* February 1933.
226 **"I've seen a thing":** Kiki in "L'Exposition de Kiki," *L'Africain: hebdomadaire illustré,* January 16, 1931.
226 **"the incomparable Kiki":** Sergei Eisenstein, *Immoral Memories: An Autobiography,* trans. Herbert Marshall (Houghton Mifflin, 1983), 124.
229 **"He looked":** Lee Miller, "My Man Ray, an Interview with Lee Miller by Mario Amaya," *Art in America,* May–June 1975, 60.
229 **"The men were":** Eileen Agar, *A Look at My Life* (Methuen, 1989), 120–21.
229 **"When [Kiki] realized":** Miller, "My Man Ray," 60.
231 **"You know how":** Kiki in "Kiki," *Pour vous,* December 26, 1929.
232 **"Bright lights":** Anaïs Nin, *The Journals of Anaïs Nin* (Quartet Books, 1967), 2:60.
233 **"He made his best":** Kiki de Montparnasse, "Kiki de Montparnasse," *Confessions,* January 7, 1937.
234 **"When Kiki":** Cano de Castro in KMK, 208.
234 **"detoxification cure":** KSR, 305.
235 **"Me, when I get":** *Pépé le Moko* (1937), dir. Julien Duvivier.
235 **"You were born":** KSR, 135.
235 **"going on a great":** KSR, 45–47.
235 **"in the end":** KSR, 487.
236 **"I've had a love":** KSR, 305.
236 **"Little by little":** KSR, 308–9.
238 **"He's a genius":** Minnie Ray in BMR, 177.
238 **"but these one-track":** Man Ray in BMR, 194.
239 **Leaving Europe:** I have guessed at Fidelin's age being twenty-five in 1940 based on knowing that she was born in 1915; I couldn't discover her exact birthdate, so she may still have been twenty-four in the summer of 1940.
240 **"California is a beautiful":** Man Ray in BMR, 240.
241 **"I regret having":** Twelve photographs of Kiki's paintings from 1929–30, MV 820 12, CRE-2-78, Marc Vaux Papers, Bibliothèque Kandinsky, Centre Pompidou.
242 **"singing in various":** Kay Boyle, *A Twentieth Century Life in Letters,* ed. Sandra Spanier (University of Illinois Press, 2015), 482.
243 **"like a reproachful":** Ronald Searle and Kaye Webb, *Paris Sketchbook* (Saturn Press, 1950), 60–61.
244 **"Kiki was always":** Glassco, *Memoirs of Montparnasse,* 216–17.

ADDITIONAL SOURCES

Ackerman, Ada. "Sergei Eisenstein: A Man of Books." *Encyclopédie pour une histoire numérique de l'Europe,* June 22, 2020; Bald, Wambly. *On the Left Bank, 1929–1933.* Ohio University Press, 1987, 14; BMR, 155–59, 167, 175–80, 192, 195, 204–6, 219, 223, 225, 233, 236–37, 240, 253, 273; Brosse, Guy de la. "Ateliers et académies," *Paris-soir,* December 24, 1929; Burke, *Lee Miller,* 74; Charters, *This Must Be,* 287; Floret, Robert. "Mon quartier à ses secrets," publication unknown, 1948, CRE-2-54, Marc Vaux Papers, Bibliothèque Kandinsky, Centre Pompidou; Grossman, Wendy A. "Unmasking Adrienne Fidelin: Picasso, Man Ray, and the (In)Visibility of Racial Difference." *Modernism / Modernity* 5, cycle 1 (April 24, 2020); Hobsbawm, Eric. *The Age of Extremes: 1914–1991.* Vintage, 1994, 90–91; Kalifa, *Belle Époque,* 10, 34, 38; "Kiki à Berlin," *Paris-soir,* February 16, 1932; "Kiki de Montparnasse," *Ce Soir,* August 5, 1947; KMK, 170, 208, 245; KSR, various; Mollgaard, *Kiki, reine de Montparnasse,* 241, 257, 268–69, 287, 292, 299; Nieszawer, Nadine, et al. *Artistes juifs de l'école de Paris, 1905–1939.* Somogy Éditions, 2015; Patterson, Sala Elise. "Yo, Adrienne." *New York Times,* February 25, 2007; Schwarz, *Man Ray,* 61; Seton, Marie. *Sergei M. Eisenstein: A Biography.* Grove, 1960, 148–49; "Témoignages sur Kiki de Montparnasse," INA video, December 29, 1994, https://m.ina.fr/video/I00008128/temoignages-sur-kiki-de-montparnasse-video.html.

FILMS
La Capitaine jaune (1930), dir. Anders Wilhelm Sandberg; *Cette vieille canaille* (1933), Anatole Litvak.

25. A WINTER AND A SPRING

245 **"clean oval"**: MRSP, 157.

ADDITIONAL SOURCES
Bate, *Photography and Surrealism,* 125; Crespelle, *La vie quotidienne,* 129; KS, 38, 194; KMK, 134; Lomont, Fred. "La petite Kiki." *Paris-Match,* April 4–11, 1953; Mollgaard, *Kiki, reine de Montparnasse,* 302–6; MRSP, 157–59; "Speaking of Pictures," *Life Magazine,* June 29, 1953.

EPILOGUE: MEMORIES AND PHOTOGRAPHS

251 **"any family history"**: Man Ray in BMR, 348–49.
252 **"I have resented"**: MRSP, 159.
252 **"the only one"**: Man Ray in Bainbridge, *Another Way,* 25.
253 **"Kiki dominated"**: Hemingway in *Kiki's Memoirs,* introduction.
254 **"drama"**: Kiki de Montparnasse, "Kiki de Montparnasse," *Confessions,* January 7, 1937.

ADDITIONAL SOURCES
Bald, *On the Left Bank,* 19–20, 28; Bainbridge, *Another Way,* 25; BMR, 349; Callaghan, *That Summer,* 93, 109–10; Fitch, *Sylvia Beach,* 280; Fitoussi, *Helena Rubinstein;* Ford, *Published in Paris,* 117, 145–49; Gaipa, Mark. "The Avant-Garde as Erotica: Kiki and Samuel Roth at the Margins of Modernist Art." http://castle.eiu.edu/~modernity/gaipa; Gaipa and Scholes, "'Never Had a Room'"; Gertzman, Jay A. *Samuel Roth: Infamous Modernist.* University of British Columbia Press, 2015; Hamalian, Leo. "Nobody Knows My Names: Samuel Roth and the Underside of Modern Letters." *Journal of Modern Literature* 3, no. 4 (1974): 889–921; Hanneman, *Hemingway Bibliography,* 31; Putnam, Hemingway, and Titus quotes from *Kiki's Memoirs,* 11–13; KMK, 63, 188, 243; KS, 11, 31. *Roth v. United States,* 534 US 476 (1957); Kiki de Montparnasse, *The Education of a French Model.* Boar's Head Books, 1950 (as pirated by Samuel Roth, and in subsequent editions under different imprints: Bridgehead Books, 1955; Fawcett Publications, 1956; Belmont Publishing, 1962).

INDEX